THE
ILLUMINATING ICON

THE
ILLUMINATING ICON

by

ANTHONY UGOLNIK

WILLIAM B. EERDMANS PUBLISHING COMPANY
GRAND RAPIDS, MICHIGAN

Copyright © 1989 by Wm. B. Eerdmans Publishing Co.
255 Jefferson Ave. S.E., Grand Rapids, Mich. 49503

Library of Congress Cataloging-in-Publication Data

Ugolnik, Anthony, 1944—
 The illuminating icon / by Anthony Ugolnik.
 p. cm.
 ISBN 0-8028-3652-6
 1. Russkaia pravoslavnaia tserkov '. 2. Orthodox Eastern
Church—Soviet Union. 3. Orthodox Eastern Church—
United States. 4. Christianity and culture. 5. Civil religion—
United States. 6. Soviet Union—Church history. 7. United
States—Church history. 8. Soviet Union—Relations—
United States. 9. United States—Relations—Soviet Union.
I. Title.
BX510.U36 1988
281.9'47—dc19 88-28597
 CIP

This book is dedicated to
the Orthodox Christian believers in the Soviet Union—

Sergei,	Georgii,
Tatyana,	Viktor,
Galina,	Gleb,
Oleg,	Natalya,
Aleksandr,	Vladimir,
Aleksei,	Olga,
Lludmila,	Anya,
Mikhail,	Zurab

—and to the new Christian martyrs of this century
throughout the USSR,

especially his Holiness, Tikhon, sainted patriarch of Moscow and former presiding hierarch of the United States, who led the Orthodox martyrs with courage and inspired them with his example.

May their memory be eternal!

May our children in the USSR and the USA grow into
their legacy.

See the wooden churches of Russia—
their warped and ancient walls:
Come close, and ask them questions.
In their timbers beats a heart, lives a faith.

The window is nailed over with boards
in the sign of the cross, like a shoddy decoration.
In return these old walls take a measure
Of the soul, and of simple steadfastness.

> —translation of verses from
> "Vladimirskaya Rus'," song
> by the Soviet hard-rock group
> Chernii Kofe ("Black Coffee")*

*Vocals by Dimitrii Varshavsky, lyrics by A. Shaganov, from the album *Perestupi Porog* ("Step Over the Threshold"), Melodia Records, 1987

CONTENTS

FOREWORD

*I*n a sense, I'm sorry to see this book appear. It means that I
am losing control over some of my favorite borrowed mate-
rial.

Not that Anthony Ugolnik has exactly been a well-kept
secret up until now. But in the religious environment where
I make my home, not too many people have heard of him.
And I have very much enjoyed exercising some control over
my community's access to his thoughts. In my lectures and
speeches I have regularly tossed out lines of this sort: "I have
a Russian Orthodox friend who likes to tell a story about . . ."
and "A friend of mine who speaks fluent Russian overheard
an interesting conversation in Leningrad last month" My
friendship with Tony Ugolnik has provided me with material
that, used discreetly, has allowed me to seem very ecumeni-
cal and worldly wise.

But my much stronger impulse is to rejoice over the
publication of this book. Tony's message is now being made
available to a wide reading audience. Many Christians will
now have the opportunity to reflect carefully on what he has
to say. And I will take immense satisfaction from this increase
in the public awareness of his contribution.

Tony Ugolnik has been a key influence on my own
thinking during the past decade. This influence has occurred
primarily under the auspices of the Institute for Ecumenical

and Cultural Research in Collegeville, Minnesota. There I've experienced an ecumenical "conversion" of sorts, and Tony has been a very important element in that process.

Collegeville's method of ecumenical dialogue places a strong emphasis on first-person reporting. My initial involvement at Collegeville—which was where I first met Tony—was in the "meaning of ecumenism" project. Instead of debating various conceptions of ecumenism, we talked about the ways in which each of us had experienced ecumenical relationships in our own lives. We focused on these kinds of questions: What sorts of things have happened to me that I now think of as "ecumenical" in a positive sense? Where have I felt least understood and most affirmed in my encounters with other Christians?

There is, of course, a real danger that this autobiographical approach will reduce serious theological discussion to a relativistic "sharing of pilgrimages." But the Collegeville discussions avoided that trivialization; instead, the first-person orientation created the trust that permitted a serious engagement with the issues. For me, first-person reportage was a crucial means for overcoming the alienation that I had typically experienced in previous ecumenical discussion. I had regularly felt misunderstood, and the Collegeville setting gave me permission to address that sense of alienation as a legitimate ecumenical topic. To do so was a liberating experience.

Tony Ugolnik was one of my crucial liberators. He obviously takes his theology very seriously. But he is also an empathetic and thoughtful listener. Both the style and the content of his ecumenical participation have greatly enriched my understanding of the catholicity of the Christian faith.

And the testimony of a Russian-American Orthodox Christian is good medicine for those others of us who feel we have been seriously misunderstood in ecumenical discussion. Having a positive self-image about Russian ethnicity has not been an easy thing for someone raised in North America during the cold-war era. And when that sense of ethnic identity is intertwined with a fidelity to Russian Orthodoxy, the task is not made any easier.

Tony Ugolnik is uniquely equipped to help others un-

derstand something of what this kind of pilgrimage involves. A gifted storyteller, he is well-suited for Collegeville's first-person method of ecumenical dialogue. And this book is essentially an extended and finely crafted Collegeville-type narrative in which one pilgrim's story becomes a compelling invitation for others to wrestle with matters that are crucial to the health of all who follow Jesus.

The late Father Alexander Schmemann once complained that for the Russian Orthodox to join into North American ecumenical discussion is a lot like their agreeing to provide a recipe for the local newspaper's "ethnic cooking" column. The whole enterprise seems to be set up to satisfy people who enjoy doing a little sampling. But Orthodoxy, Schmemann insisted, does not lend itself to polite sampling.

No serious theology really does. But Orthodoxy does seem even less susceptible than other systems to mere sampling. This is due to the fact that it cannot be treated simply as another mere system of "thought." Nor is it a mere "spirituality."

Tony Ugolnik asks us to make a serious effort to understand what he calls "the orthodox sensibility." This requires more than the cultivation of a fondness for icons or an occasional reading of the Desert Fathers. It means trying to grasp a very different way of understanding God's relationship to the material realm than many of us are used to. And it also requires imagining a sense of the Gospel's relationship to cultural context that does not fit easily into our handy schemes for sorting out "Christ and culture" viewpoints.

There is no better way of beginning these efforts than to allow oneself to become engaged by a person who knows the world of Orthodoxy from the inside, but who also knows how difficult it is for many of us to gain the sensibility that is necessary for understanding that world. This book is written for people who need that sort of reliable guide.

Tony Ugolnik is a new breed of apologist for Orthodoxy in the West. He is very much a Westerner, and he is by both training and natural inclination an astute observer of, and participant in, his cultural surroundings. He is intensely committed to bringing "the Orthodox sensibility" to bear on his

life as a husband, father, teacher of Western literature, rock-music fan, hockey coach, and Vietnam-era vet.

This is a book that will reduce much of the unnecessary mystery that surrounds Orthodoxy for many of us. But I hope and pray it will also serve to increase a very necessary sense of mystery. Many of the mysteries *about* Orthodoxy will fade quite quickly as we set aside our misunderstandings and stereotypes. But Orthodox Christians are also very intent upon pointing us to a mystery that will never fade away: the Mystery of the Triune God who has come near to us, and to the whole creation, in Jesus Christ. May many Christians read this book and allow it to lure them into a deeper awareness of that divine Mystery.

RICHARD MOUW

PREFACE

*P*refaces are awkward things. After all, a preface lies on top of a whole pile of pages called a book. It's the point at which we're still new to each other, you and I, reader and writer. I want to break that thin coat of ice that forms on the surface of a preface, so I'll try to be informal as I explain why I'm anxious to speak to you in the first place.

Perhaps at some point in your life you have talked to someone who just got out of jail. Someone close to me has done time, more than once, for drug-related offenses. When I see him after his release, I always feel a degree of guilt, however illogical, for not being able to communicate with him. After all, I love the guy. We were kids together. I want to be able to take on some little part of the pain I know he feels. I want to tear through, if I can, that filmy veil of knowing initiation—initiation into something I can't share—that has settled over his eyes. But so far, I can't do it. That veil separates us from each other and from the kids we once were.

On my most recent visit to the USSR, I visited another friend with a prison record. This friend, however, is a vital and vocal Christian thinker. And that, essentially, was the reason he'd been locked in prison. A kind of foreboding, then, settled over me a few months ago when I walked up the dark, gloomy staircase of a Moscow housing development to the apartment of Viktor Popkov.

Viktor is an Orthodox activist who now, thanks to *glasnost'* and a lot of prayers for his release, can once more be active. I am seized with awe of him—of his spirit, of his resolve, of his courage. And given what he's been through, I expected to feel some of the same distance that had pulled me away from the guy who'd shared my childhood. After all, I could never really cross the bridge of Viktor's experience. Although I shared his Orthodox faith with him and with all the others in the Soviet Union who had been through similar trials, I thought his suffering would ultimately separate us. The veil would descend over his eyes as well.

Russia, however, always defies my expectations. Once more I was wrong. Viktor Popkov's eyes—and those of his wife Tatyana Lebedeva—were full of invitation. Their sun-filled apartment, its shelves stuffed with books and its walls smoldering with deeply tinted icons, quenched the thirst for light that filled me after the dark walk up the stairwell. They both had the unadorned good looks that folksingers exhibit on their album covers. And, seizing upon our common Christianity and our common Orthodox identity, they were full of news and welcome.

Viktor did not rest content with the changes, so recently unthinkable, that *glasnost'* had brought to the church. "*Glasnost'* is great," he said simply. "But it's got to go further. It can't rest upon the goodwill of one man, Gorbachev. All our efforts now have to be focused on the repeal of the antireligious legislation of 1929, restricting our right to educate and publish. That's the real key." Tatyana filled me in on the health and developing thought of some other recently released Orthodox activists (some of whom you will hear from in these pages). Putting aside any resentment that the past might evoke, they both focused upon the future. Their apartment hummed with life. It was like the USSR itself in these days—a place without some of the conveniences of home, but surely a place where it is exciting to be with friends. It's a place where to be a Christian *means* something, something deep and profoundly interesting.

That conviction of meaning that pervades so much discourse in the USSR, among Christians and all other lovers of

ideas and values, can excite an American's envy. Christians in the USSR (from the Russian and Ukrainian Orthodox Church, celebrating its 1000th year, to the Orthodox Church of Soviet Georgia, celebrating its 1500th anniversary), are sure of who they are. They are a people without our American anxieties of identity. Many of us Orthodox in America spring from their religious tradition and their gene pool, but we enjoy no such certainties. Whereas other immigrants, we were taught, came here to pursue a dream, the assumption was that our parents or grandparents came here to *escape*. We settled among other ethnic groups, with whom many of us intermarried. Many of us were fast absorbed into larger religious communities, more "mainstream" by American standards. And in one way or another, even those of us secure in an ethnic community absorbed the lessons imparted by the long, inexorable cold war: if there was a Russian side to us, it was something our fellow Americans regarded like the dark side of the moon—hidden, mysterious, remote, dead.

For us Orthodox in America, coming to know Christianity in Russia is like an act of recognition: we feel like long-estranged relatives looking through a family album for the first time. I am a U.S. Army vet born on the west side of Detroit; I am as American as anyone. Yet all through my American education, in so many of its lessons about the USSR, I felt as a son might feel whose parents had told him lies about his grandparents. I'm afraid that I harbored a resentment against my own country for failing to recognize what was *good* in the Soviet Union. And that resentment, like the resentment of the oft-jailed sharer of my childhood, cast a film over my vision. Until Christians in the USSR taught me how to love my American identity most fully, it was difficult for me to talk to my fellow Christians in the United States about a crisis of identity all modern believers share—being a Christian in a secular culture.

I hope the ideas in this book challenge your presumptions. Christians in the USSR can teach you not only about themselves but about those who share their society. They taught me that not all Communists, for example, are mental automatons. I met Party members who acknowledged and de-

plored the abuses of the past, and who condemn existing anti-religious legislation. Christians in the USSR also urged me to talk to you, and to apply the theology of our Eastern tradition to the postmodern world shared by both East and West. Thus Christians in the USSR began to dissolve that resentment in me and gave me the hunger to write this book. They taught me to speak without shame as an Orthodox Christian.

A few years ago, before I began a process of contacts with Western Christians at the Ecumenical Institute in Collegeville, Minnesota, I spoke in the terms of discourse accepted in the West. This is a rather difficult task for an Orthodox Christian, something like asking a right wing in ice hockey to make a slap shot with a baseball bat. I am trained in literature and language, yet I was struck by the inadequacy of the classical Western treatment of Christianity and culture, like H. Richard Niebuhr's *Christ and Culture.* The handy paradigms, no matter how often graduate students took refuge in them, just didn't seem to work. Theology is immersed in the problems it must discuss: we cannot, like so many secular thinkers, presume to stand apart from culture as we discuss it. We risk ending up like Chaucer's Troilus—lovers who now stand aloof from their love, remote in the seventh sphere of the cosmos and enjoying only the cold laughter of dispassion.

The Christians in the USSR do not stand apart from their tragedy, and in this way they seek to follow Christ. Yet the laughter I have heard in Russia—above all the laughter—is something I would communicate to you. It is a laughter born of the human dilemma, the absurdity of contradiction. It is a laughter that presumes the solace of a God who shares our materiality with us. It is a laughter that invites you in. The Orthodox Christians in Russia have no illusions of separation from the culture or society within which they have been placed: they accept the fact that they have been victims. Yet, in accepting it, they live within their theology and make of it a vital force. That is the power of theology in the contemporary USSR—daily life, "lived culture," is its stage.

I started working on this book about five years back. These past five years have been some of the most significant

for the Russian church in this century, and things are happening faster than writers can document them. This book seeks to explain, in an American idiom, the way Russian Christians think. And their thought, their way of looking at the world, is in some part responsible for the new triumphs they enjoy. I have integrated recent events into the text that will allow you to see new developments. In an early draft of this book, I mourned as I described my visit to a former shrine, caves in which dead monks lay buried beneath atheist slogans. But in these revised pages I describe people near the same site as they struggle to pray through the din of churches being rebuilt and young monks moving into new quarters. But then again, whole cities of hundreds of thousands are still without a single church. And some of the insights I try to bring to this book have been given to me by people who grew up in such cities. This book, in truth, is about this latter kind of victory, the victory that keeps the spirit of the church alive even when it has no buildings called churches.

One thing about recent days in the USSR has made my task easier. Americans are now a little less likely to regard the Soviets as a people deprived of Christian life. In fact, Christianity has been the yeast for much of the current cultural ferment in the Soviet Union. I brought home sixteen record albums from my last trip—some of the most vital modern rock and lyric albums available, none of them imaginable in Soviet stores just a few short years back. One of the songs on one of the albums is a deft reworking, in heavy-metal style, of the Orthodox hymn celebrating the millennium of Christianity in the USSR. (The name of the group, in English, is "Black Coffee"; the song is "Vladimirskaya Rus'.")

Russians now show themselves to us more openly, and many times the face we see is a portrait of our own. My contact with Soviet veterans of the Afghan war was a poignant reawakening of the bittersweet communion in my own Post 30 of the Vietnam Veterans of America in Lancaster, Pennsylvania. I sat on a curb with Russian vets of Afghanistan until dawn bleached the night sky, and still we could not tear ourselves away from each other. They were fellow Orthodox believers. We were lost in the fascination of mirrored experi-

ences—the shared torment of Soviet vets and American vets of my generation—and together we felt the horrible fascination a kid feels when he's trapped in a seemingly infinite hall of reflections. Late into that night, it felt like our world was the grim funhouse, and we had only ourselves to hang onto. Clearly, the Russians have become more accessible as people, and this cannot help but make them more accessible as Christians as well.

I do not write about Soviet Baptists and Protestant Christians in the USSR. I know some of them and I know something of their religious life, but they comprise a small part of the Christian community in the Soviet Union. What is more, because of natural affinities they already tend to attract a good deal of American attention. Nor do I write here about the even smaller community of Jews in the Soviet Union, upon whom the American media have concentrated and who already receive a good deal of deserved concern. I concentrate instead upon the largest and least understood of Christian traditions—the Orthodox. I know them, and, as one of them, I can take upon myself the burden of interpreting their complexity.

I must apologize for occasionally giving only cryptic identification of the ordinary Soviet Christians I cite. Their past, of course, has made them shy of publicity in the West. As a rule, I identify only those who have given me permission to use their names. The rest have requested that I not name them; in a very few instances I have been asked to change place names as well where location would reveal a source. God speed the day when such caution no longer comes so naturally to any Soviet citizen.

So if a preface is to give you insight into why a book was written, the premise from which it springs, I must divert your attention from me to them, to the Orthodox Christians who inspired it. I want you to meet some of them and come to know how they think. I want this book to show you as much of the richness of modern Orthodox theology in the USSR as I am capable of conveying. I want it to combat the lies and half-truths that have distorted the inner moral life of the USSR, of believers and unbelievers alike. In what follows

I hope to capture some of the spirit of Viktor and Tatyana and their fellow Christians; I want this book to feel just a bit like their apartment felt to me. Perhaps, at times, the entry will seem dark and a little forbidding. You must expect the inside to be a little different, simply because Eastern Christians view the world so much differently. But once you come in, I hope it seems warm and hospitable. I want you to feel welcome in it. I hope it's a place that invites you back.

ACKNOWLEDGMENTS

A book that critiques individualism and promotes a communal vision of identity should provide a lot of acknowledgments.

First of all, of course, I owe the greatest debt to my wife, Elaine Georges Ugolnik. To borrow a phrase from my own discussion, marriage is the most "reciprocal of definitions." Together we have shared a passion for Christianity in Russia; and through her discussion, criticism, and patient listening, my wife is woven throughout this work. I thank my children— Adam, Marya, and Zachary—for putting up with my involvement in this manuscript and with my long and frequent absences occasioned by my trips to the USSR. (If you read this when you grow up, kids, I hope you will understand why your dad's work sometimes seemed to swallow him up.)

Families come in concentric circles: I've got to thank my parents, and my extended family, for giving me the sense of allegiance without which I would have had no perspective from which to write this book. I also owe a great debt to my parish family—the Annunciation Greek Orthodox Church in Lancaster, Pennsylvania—for keeping me charged with love and support. To its pastor and "co-pastor," Father Alexander and Presvytera Pearl Veronis, I give my love and thanks in return.

There are monastic families, too, without which I could

not have completed this work. To my spiritual father—Father Lawrence, Abbot of the Orthodox Monastery of New Skete in Cambridge, New York—and to our brothers and sisters in Christ who live there, I owe many thanks for reading and responding to the draft of this manuscript and for encouraging me in its writing. I would also like to thank the Benedictine monastery at St. John's in Collegeville, Minnesota, for its mission in hosting the Ecumenical Institute, which was central to this work, and for sustaining a theological and a monastic manuscript library, both of which were of great help to me. I offer my own thanks and those of many thousands of Christians in the Soviet Union to Holy Trinity Russian Orthodox Monastery in Jordanville, New York. The monastery's Russian-language press has provided traditional Orthodox prayerbooks, service books, and theological books to so many who cherish them, and many long for them still. I thank Holy Trinity Monastery for its generosity to me and to others. I would also like to acknowledge my debt to the monastery of New Valamo in Finland for the use of its library and facilities; I would like especially to thank Father Ambrose for his insightful Finnish perspective on Orthodoxy, and Pente Leiman and Dan Sandel of Helsinki for their advice and warm hospitality.

I owe many thanks to the institution where I teach and sustain my scholarly life, Franklin and Marshall College, for supporting the work of this project in a host of ways. For funding and facilitating two research trips to the USSR and Finland, for sponsoring my travel courses to the Soviet Union, and for funding student research assistance for this project, I owe a succession of deans—Bradley Dewey, John Vanderzell, and Gordon Douglass—thanks and appreciation. I am grateful to my colleagues, and especially my own English Department, for their patience in supporting someone who won't stay put in a single discipline. I thank them for accepting my commitment to theology as well as to literature.

For firsthand scholarly assistance and support, I owe most to the Institute of Ecumenical and Cultural Research at Collegeville, Minnesota. Its former director, Robert S. Bilheimer, became both a scholarly and a spiritual guide in the

ecumenical process that underlies this project. He and all my distinguished fellows in our magnificent year there together helped me conceive of the structure of this work. His successor, Patrick Henry, and his assistant director, Sister Dolores Schuh, have during my repeated returns continued to offer me all the resources of the institute and its unique methods of theological inquiry. To them, and to the supporters of the institute's work, I owe my thanks.

For a part of this project I relied heavily upon the resources of the University of Minnesota's Center for Immigration History, which offers a treasure house of materials on the cultural experience of so many ethnic groups in America. For supportive cooperation and help in using the center's archives, I thank Dr. Rudolph J. Vecoli, Director of the center, and his excellent staff. I also am indebted to the National Institute for the Humanities for funding seminars on immigration history and sociolinguistics, which assisted me in completing this work.

At many points in the writing of this book (particularly in approaching the work of Dumitru Staniloae, Pavel Florensky, and Mikhail Bakhtin), I received the help of students and staff at the Theological Academy in Leningrad. I am grateful for their thoughtful response to my ideas and their generosity in sharing their insights.

As an Orthodox Christian, I rely upon my bishop to "rightly guide me in the word of God's truth." The Greek Orthodox diocese of Pittsburgh, where I serve as a deacon, has been blessed with acute theological insight and spiritual sensitivity in Bishop Maximos. I thank him for his theological acumen, his guidance, and his openness to Orthodoxy in its American manifestation.

Over the years embracing this project, I received the unfailing support and frequent correspondence of Dr. John Meyendorff, Dean of St. Vladimir's Orthodox Theological Seminary in Crestwood, New York. I am also indebted to Holy Cross Greek Orthodox Theological Seminary for its summer Greek program and the support of the dean of the seminary, Father Alkiviadis Calivas. My colleagues in the Orthodox Theological Society of America have provided stimulation and a

sounding board for ideas. In particular, Father Lawrence Barriger and Father James Dutko of the Carpatho-Russian Orthodox Diocese in America gave me assistance in researching the history of their community and our common ethnic experience. To all of these I give my thanks.

In the everyday scrabble of writing and research, I of course owe most to our department secretary, Ms. Cookie Faust, with her unfailing efficiency and her steady sense of humor. I also have had the good fortune to find excellent student help. Tim Gray, now a graduate student in Boston, was more a colleague than an assistant. With a nose for research and a real sense of the library, he was able to chase down concrete evidence when he was given but hints and ephemeral hunches. Lori Essig, with her growing command of Russian and a real Soviet sense, helped me a great deal in proofreading and conveying some Russian notions in an American idiom; she is now in Russian studies at Columbia. Gita Baliga, with good cheer and good sense, did a lot of work for me with film and checking of detail. Sean Cassidy, another nascent student of Russian, did some very hard research for me on some material related to this book. Ralph Haines, now an officer in the Marines, performed many good and difficult offices for me on one important trip to the USSR. To these individuals, and to all the many students who responded to and helped me shape ideas in the classroom before they met the page, I extend my appreciation.

Any writer appreciates a publisher for accepting his work. I owe a special debt to William B. Eerdmans Publishing Company, because I wanted most of all to reach their audience. They believed in this project and encouraged me in completing it. They also assigned me the most helpful of editors, Mary Hietbrink. Although I still know her only as a kind, humor-filled voice on the phone (and as a surgeon of the page), I am very grateful to her for her help in operating on the manuscript.

A project like this one relies upon contacts as well as research. And for assistance in making and maintaining some of the Soviet contacts that helped me in this work, I would like to thank Bridges for Peace, a grass-roots organization

based in Norwich, Vermont, that began promoting and sponsoring Soviet-American contacts long before they were quite so acceptable. Richard Hough-Ross, Director of Bridges for Peace, has made it possible for me to assist in leading several "Bridges" delegations, and this in turn has helped me reach those at the official level of Peace Committees and church organization in the USSR. Good luck to him, and best wishes for the continued success of the organization in these hopeful and crucial times.

For a place to go sometimes, when I needed it, I thank my Post 30 of the Vietnam Veterans of America in Lancaster, Pennsylvania, and the Veterans' Outreach Center in Harrisburg. To George Worthington, past post commander, and to past member Jerry Gibson I owe special thanks for their acceptance and their ability to help out a friend.

I want to thank a lot of rock artists—especially Bruce Springsteen, the group U2, and a sheet of heavy-metal bands, from Def Leppard through Stryper to the newest, Guns and Roses—for a lot of things. I owe them many thanks from my Soviet friends who love Western rock—when the casettes can reach them. And I thank them for prodding me awake and giving me some needed perspective when my enthusiasm was flagging.

Not least, I am grateful to one tightly forged wedge of humanity—the ice-hockey team at Franklin and Marshall College. During my work on this manuscript, they constantly reinforced one principle to which this book is dedicated—that is to be human is, in the deepest sense, a team effort. I thank them for that, for making me laugh, and for keeping the juices flowing.

Above all, of course, I am in debt to the generosity of so many people in the USSR—in parishes, in peace organizations, in youth groups, and in Christian networks throughout the Soviet Union. I have met them at vespers, at liturgy, on the subway, at concerts, in the churches and monasteries, and in the theatres, gyms, weight rooms, and stadiums across the whole Soviet nation. To those who spoke to me at length, who kept in contact with me on successive visits, and especially to those to whom I am now bound by the deepest

ties of Christian friendship, I extend my thanks here in English, with the profound hope that somehow, sometime, this printed word will reach them in Russian as well.

On behalf of all Orthodox and all Christians in the West, I extend my thanks to those like Viktor Popkov, Irina Ratushinskaya, Father Gleb Yakunin, and Vladimir Poresh, who suffered for all of us and who thereby inspired us and gave us strength.

To the friends and acquaintances I have made both among the philosophically uncommitted and among those committed to the Communist Party, I express my special gratitude for openness and warmth where I am afraid I did not expect it. Many of these contacts, with believers and nonbelievers alike, were made in times when contact and conversation with foreigners about Christian commitment were rarer and more suspect than at present. The risk, of course, was always more theirs than mine. For taking that risk, and for sharing the love of God or the love of truth (a love with a common source), I am grateful to them and to the Holy Spirit.

Finally I extend my appreciation to the Orthodox Church of Russia for welcoming me as their own spiritual child. I offer this work to His Holiness Pimen, Patriarch of Moscow and All Russia. I hope its intention—to introduce Americans to the spiritual wealth of the Russian church—is plain to him and to his flock. I ask him to accept my prayers for the holy Russian patriarchate, and I humbly ask for his blessing upon this work.

THE
ILLUMINATING ICON

Chapter One
THE GODLESSNESS WITHIN

Christians in a "Post-Christian" World

We live in an era that styles itself "post-Christian." In their own company, in parishes and church communities, Christians can find emotional and spiritual sustenance in each other. But thinking Christians who live and work in the greater secular society cling to faith as individuals. Christians worship together, but they endure alone. They must assume, with such regularity that it ceases to be conscious, that their contemporaries act according to a different set of assumptions. In our era Christianity has become at best a matter of individual choice rather than collective conscience.

This has become a condition of Christian existence throughout the contemporary world. Christendom is no more. With it go a host of abuses, but also a place where the Christian mind could range and explore without segmenting itself as a sectarian entity. The Christian mind in America is hard to find outside a specific confession, and the Christian intellect expressing itself outside the rigidly confined areas of confessional dogma finds it harder and harder to find a home. Our contemporary world has become a vast land of exile, for those who share the world with us no longer grant Christians a real place. Even when others respect our views, they honor them as "traditional" in the dead, historical sense.

In secular terms, Christianity is based on values embedded in the past or in a biblical text. Thus Christians as Christians can easily find acceptance as clergy, church historians, theologians, or textual commentators. Here they are safely segmented from the assumptions of the greater society; here they can thrive as "servitors to the cult." It is as artists, teachers, merchants, and "civil servants" in the broadest sense, however, that Christians discover a painful problem. Here their Christianity is no longer regarded as central to their identity.

There is enough relief from the dilemma to allow us Christians to accept or even grow comfortable in our exile. Occasionally, in a scholar's essay or a physician's counsel, a friend's request or a client's question, a Christian may be invited to share reflections "from a religious perspective." Even the terms of the request, however, betray our isolation. We are asked to don our Christianity as if it were an occasional vestment, not as much a part of us as our own skin. This is a moment at which Psalm 137 takes on a sharp poignancy. When captors require songs, and tormentors mirth, then the exiles weep when they sing the songs of Zion. And in fact Christians in great numbers have been hanging up their lyres by the rivers of Babylon. The tone of condescension Christians so often hear from secular intellectuals is rarely personal; it is institutional. As a result, the American Christian intellect grows more and more muted. Even those who lament the collapse of a theist worldview take little note of those who still champion the cause. Indeed, Allan Bloom, in his best-selling dirge *The Closing of the American Mind,* sees something self-annihilating in the Christian response to modernity:

> Man, who loved and needed God, has lost his Father and Savior without possibility of resurrection. The joy of liberation one finds in Marx has been turned into terror at man's unprotectedness. *Honesty* compels serious men, on examination of their consciences, to admit that the old faith is no longer compelling. It is the very peak of Christian virtue that demands the sacrifice of Christianity, the greatest sacrifice a Christian can make. Enlightenment killed God; but like Macbeth, the men of the Enlightenment did not know that the

cosmos would rebel at the deed, and the world become "a tale told by an idiot, full of sound and fury, signifying nothing."[1]

The terms of Bloom's discussion show how little Christians have mattered to him in the life of the modern American intellect. Marx and Nietzsche, to whom Bloom so often refers, may not have shaped the American Christian soul, but they have done a great deal to shape the crisis of the Christian's intellectual exile. Christians themselves feel marginalized, sometimes even in their own company. Clergy complain of the secular, corporate models that increasingly shape the models of the pastorate. The minister often complains that he or she has become the ultimate manager, and aspects of the divinity degree resemble the rites of earning a Master's in business administration. Laity suffer from their isolation in the world, and such surveys as the "Faith and Ferment" studies in Minnesota use the tools of social science to reveal that vast numbers of Christians themselves now view the world through the lens of social science rather than the theology they profess in church.[2]

American Christians, good at nothing if not self-criticism, are well aware of these problems. It is not the purpose of this discussion to analyze American Christian dilemmas; there are a host of sermons and books that approach these problems within the framework of the American religious mainstream. A Protestant scholar like Martin Marty (*Righteous Empire: The Protestant Experience in America*) can reach out with a broad and rich eclecticism to illuminate the history of American Christianity. A Catholic theologian like David Tracy (*The Analogical Imagination: Christian Theology and the Culture of Pluralism*) can probe deeply into the ambiguities of our modern consciousness. Yet those who see prob-

1. Bloom, *The Closing of the American Mind: How Higher Education Has Failed Democracy and Impoverished the Souls of Today's Students* (New York: Simon & Schuster, 1987), pp. 195-96.
2. Joan D. Chittister and Martin E. Marty, *Faith and Ferment: An Interdisciplinary Study of Christian Beliefs and Practices*, ed. Robert S. Bilheimer (Minneapolis: Augsburg Publishing House, 1983).

lems from a different perspective can also be helpful in lending their insights to solutions.

I am an American Christian with another perspective. I am now a teacher at an excellent, tough-minded little liberal arts college. That college was once proud to be Christian, but now it is even more proud of the secular identity that has brought it greater prestige. Like the character in Bruce Springsteen's song, I was "born in the U.S.A." into the working class. I too wore the uniform, however reluctantly, of a U.S. army draftee. From my first days in grade school I was taught to hate communism and love the freedom my country represented. As a soldier I did not serve in Vietnam or in combat, but as a medic I treated those whose flesh had been burned, often to the very bone, at the behest of the law of the land. Like the combat vets, or perhaps with them, I endured the long American silence about and indifference to their suffering. My mind has been shaped by the joy and agony of our American contradictions. In short, I have lived the postmodern dilemma with you, my Christian audience.

Yet Michael Cimino, as well as Bruce Springsteen, has pierced the core of my identity. I have danced at scores of weddings like the one in Cimino's *The Deerhunter*. Like the soldiers in that film, I have an Eastern Orthodox, "Russian" religious and ethnic identity. When my wife and I married, we wore ritual crowns; when my children were baptized, they plunged into the water and emerged to join their Orthodox Christian people in a new life in Christ. We embrace a church that holds to its bosom hosts of those Russian people most Americans have been conditioned to view as the enemy. I speak to you not only as an American but also as an Orthodox Christian who genuinely loves the Russian soul and who identifies with Russians. I worship in and serve as deacon of the Orthodox Church to which most of them belong. And while most of my compatriots fear Russians, or at best pity the Christians who live among them, I know and love the Russian Christian mind. I can share its insights into the modern dilemma. My American identity, then, is a complement to my Orthodoxy. It is as an American that I interpret modern Russian religious thought in its profound tri-

umph over "post-Christian" assumptions—assumptions that oppress not only them but all Christians in the contemporary secular world.

I write, then, as an American nurtured by the Russian soul. In the discussion to follow I will first examine American Christian attitudes toward Russia and its Orthodox Church. These attitudes persist even through the perennial thaws in the long cold war between us: they survive and are reclaimed when the springtime summit euphorias subside. One of my underlying presumptions will always be that, as the hymn goes, "in Christ there is no east or west." I take that presumption seriously not only as a sentiment but as a matter of the intellect. In this age both the church in the East and the church in the West face a similar problem. Whatever the degree of resistance or persecution in a given system, the Christian mind in America or Russia must constantly mediate a body of assumptions essentially removed from the Christian worldview. Since the Bolshevik Revolution in 1917, the Christian mind in Russia has endured an exile more severe than that of its American counterpart. But the American church endures a similar exile nonetheless.

I will go on, then, to discuss in some depth the perspectives that the Russian Orthodox mind since 1917 can offer to the American church. The Russian church has incubated some profoundly stirring theological insights in its suffering over the past three generations. That church is now emerging with solutions to offer Christians living in the contemporary world. Thus it is not a romantic elegy that I offer to the once-glorious church of Russia—there are many such elegies already, and that old czarist church often shone with a false glitter. Nor will this be a dirge to an integrating Christian vision that once bound Americans as one—that thesis is surely questionable. The sufferings of the Russian church have too often been used to merely "inspire," as in some remote epic tale, those Christians who look at it from afar. But the church in Russia is not so remote as Americans might think. It is a church that has been nailed to the postmodern world and its cross of war, revolution, persecution, and utter marginality. The Russian church is a church of great wisdom, and Russians are a people

of deep thought. If we look and listen with care, we can learn from them.

Politics and the Unity of the Church

To draw a connection between the Russian and the American church involves the overcoming of both theological and civil divisions. It is no secret that Christians, despite the reputation they so briefly enjoyed for loving one another, have become a cliché for division and even mutual nastiness. American Christians are divided among themselves. But secular critics, knowing less about the church than they think they do, see ruptures in the wrong places. They mistakenly see Christian division as embodied in the American church's disconcerting assortment of various denominations and sects. In fact, attitudes toward Russia formulate a far better barometer of religious hostilities than do attitudes toward matters of faith and doctrine.

This is not to say that the commitment among Christians to established traditions is weak, yet (if I may borrow an analogy from well outside the evangelical frame) no longer do we tend to shuffle ourselves into mutually exclusive decks. Our sets match along new and variegated lines—on a normal Sunday, we may worship "in suit," with other Baptists or Reformed or Catholics. Yet we meet as well according to number and kind. We recognize the gospel as it manifests itself in others. Our Bible studies, our discussion groups, our voluntary associations bring us together, jacks with jacks and kings with kings, no matter what the suit.

I have been to a discussion of the book of Romans where stolid Lancaster County Mennonites met with members of my current Eastern Orthodox congregation. A native Greek woman from my parish discussed her understanding of the term *dikaiosune,* and her access to the language of the text allowed the entire group, Mennonites and Orthodox alike, to more fully understand the concept of "righteousness." When she confessed, a moment later, to keeping a relic of Saint Nectarios in her home, the Mennonites were merely a bit taken

aback. But when she then went on to relate a story from her childhood about how the monks in a neighboring village had had to remove the seaweed from the slippers of the saint every morning after he had visited the poor souls wrecked at sea, there was something in them that was horrified. Every knit eyebrow in the room belonged to a Mennonite and revealed generations of Anabaptist history. Yet they did not condemn. What resulted was a long conversation about the nature of holiness and the value of "story" that left both Orthodox and Mennonites the richer for the experience. No, these divisions are not the source of Christian bitterness.

The tragedy of Christian divisions in America is that they have been imposed from without. Although Christians may worship together in the same faith community, or agree with other Christians upon the basic doctrines that bind them in Christ, the dishes the world brings to the table taste of a hatred that sickens the soul. Christians can easily assume grounds of agreement sufficient to bring a group together for a common Bible study. Every day in America, Christians of different traditions meet and agree that Jesus Christ is the Son of God. Born of a virgin, he came into this world to save humankind from sin. He died to redeem humanity and rose from the dead. He will come again in glory. But the subject of Russia or Central America or the budget deficit can in an evening destroy our common allegiance.

Centuries struggled to preserve the Book that embodies the sacred text of the Christian communion. Ages labored through councils and dissent to produce the basic doctrinal consensus we enjoy. Angels might envy the shared life in Christ that even this much agreement could produce. Yet political allegiance can in an instant threaten the very grounds of the love by which each Christian can contribute to the mutual well-being of his or her cohorts in the faith. In our country, among our people, we Christians are most divided among ourselves not on religious but on political grounds.

John Garvey, the award-winning columnist for *Commonweal*, expresses a certain skepticism about the current Christian willingness to put aside doctrinal differences. There is an intellectual and spiritual softness, he suspects, in Christian

willingness to discount dogma. The proof that Christians have not suddenly arrayed themselves in robes of charity lies in their willingness to rip at each other's garments when it comes to civil issues. Intelligent Christians barely notice each other's positions on the Trinity, but a position on the wrong candidate can scorch a lover of Christ with hellfire. Good, tough-thinking theology in the church can give way to sloppy politics. Perhaps at bottom, suggests Garvey, politics has become more important even to Christians.

We can easily test this hypothesis. Imagine that we Christians hooked ourselves up to sphygmometers, sweat detectors, electrocardiographs, and all the other mysterious paraphernalia of biofeedback, then sat in chairs to watch TV—to watch evangelical testimony to the saving power of Christ. What, then, would most excite us? The message, I fear, would hold a distant second to the person who delivered it. Surging blood, prickling sweat, and zigzagging brain waves would register our annoyance and our passions, not our common commitments. Nothing can annoy a "left"-handed lover of Christ more than a sermon by Jerry Falwell, even if it be on the nature of Christ's peace. And nothing can set a "right"-handed champion of the Lord more on edge than the preaching of the evangelical peace activist Jim Wallis of *Sojourners,* even if it be on the need to commit ourselves to conservative family values. The politics that divide us take precedence over the gospel that binds us as one.

Engaged in common pursuits, Christians can set aside confessional differences as they pray, perhaps zealously, with our Lord, "that they may all be one; even as thou, Father, art in me, and I in thee, that they also may be in us" (John 17:21). How conveniently abstract the prayer when the divisions are imagined to be doctrinal alone. Through much work on Christian unity, I have come to believe that the real challenges of ecumenism are those political estrangements imposed on us from without. Here too we can pray for a change of heart, and with prayer we can recognize that each of us, on each "hand" of the mystical body of which we are a part, is at a common purpose. Each of us seeks to serve God.

We cannot intuit, precisely, the full range of political di-

visions in the early church. My wife is of Greek background, and I worship with the people from whom she springs. If Greeks haven't changed much over the centuries (and only a glance at Paul's warnings against the divisions in the churches shows they haven't), no doubt they loved to disagree. They left no minutes of their parish council meetings. But I can well imagine that Christians at the outer edges of the empire had strong ideas about the emperor. Perhaps they wanted a stronger line on national defense. And the Christians at Corinth may have been concerned over tax policies. Many early Christians were slaves. No matter how obedient to their masters, they probably hoped for policies that could more easily lead to their freedom.

Little is left to us of their hopes and dreams—little except the profound legacy of their faith in Christ and their hope in him. Yet we can be sure that they spent many an hour talking about these issues, and that they became animated over them. Perhaps they, like us, couldn't stand each other when it came to civil law. It took strong preachers and strong testimony to bring them back again to common purpose, to common will.

Tatiana Goricheva, a Russian philosopher and Christian believer, spent her training immersed in Nietzche and Kant and the other figures whose influence on the American spirit Allan Bloom discusses in his treatise on American education; Goricheva even corresponded with Heidegger. And once she became a Christian, she did not cease to take seriously the intellectual challenge of those figures who had brought her "to the verge of despair at which faith begins." Yet Goricheva, having emigrated, has focused upon spiritual authority as the issue most important to her new culture: "Since I've been living in the West, it has become clear to me that the crisis of faith here for the most part rests on the fact that there are no true clergy, or almost none; there are no true pastors who can really heal and give good advice and say 'Yes' or 'No' with authority."[3] Christians need traditional, authoritative voices to bring them back to common purpose and common will. The

3. Goricheva, *Talking about God Is Dangerous: The Diary of a Russian Dissident* (New York: Crossroad, 1987), p. 28.

tendency is to focus upon a world in crisis, but first comes the problem of a church in crisis. And that crisis exists precisely because the church in the West has accepted the terms of conflict set by the world.

Land of the Godless

When Christian leaders or Christian groups articulate the problems that face our world, they often focus upon the issue of international hostility. Humanity stands, on both sides of the world, with the capacity to utterly destroy itself. A theme of urgency has pervaded much Christian discourse in the past decade. Among one faction in the Christian community, the bomb itself constitutes the greatest terror; among another faction, that godless enemy which wields the bomb is the greatest threat to those who hold the Christian legacy. Insofar as the bomb can undo creation, it is the most terrible of sins. And insofar as the Russian Communists threaten the capacity of the church to function, they are themselves the most fearsome of enemies. From whatever Christian perspective, and whatever the Christian position on the just war, the Russians lie at the center of an American Christian dilemma. We can expect that conservative Christians will be among those least impressed with General Secretary Gorbachev. The injunction to "love our enemies," whatever we make of it, is posed against fear and what we regard as common sense.

The church in America, then, experiences real divisions over its attitudes toward Russia and, to some degree, Russia's church. For it is inevitable that Christians there will love Russia, their own land. But Russia is also the land that Americans have so long feared and that American popular culture has taught them to fear. The Christian difficulty over this issue in America is but a microcosm of the problem on an international scale. Each Christian faction, "left" hand and "right" hand, sees itself as mutually exclusive of the other. Each hand seeks to do without the other in work and in prayer. And each faction is encouraged, even nurtured in its divisive attitudes by those in the world whose primary interests are clearly not those of

the church. After all, the church receives most of its attention in the media and in secular intellectual circles only insofar as it has a political impact. Thus the grounds for our divisions are constantly reinforced.

I grew up on the west side of Detroit. Like most American children, I was made constantly aware of the Russian threat. Yet unlike most American children, I had the enemy's blood running in my veins. Although many American Slavs could exempt themselves from these connections with the designation of "Polish" or "Ukrainian," my family's roots were too far north and east, and my grandparents' affinities too transparent, for me to achieve that transformation successfully. My faith and my ethnicity identify me in some vital way with the Russians my country fears.

I bristled in the classroom when the subject was the Russian threat, even in the fourth grade when Mrs. Nelson warned us of Russian spies (lurking near the drinking fountain down the hall?), and certainly in the seventh grade when Sputnik (finally people began to spell my family's last name without a "c" before the "k") seemed to beam insults down on our science teachers in junior high school. I was taught then to fear the spectre of a "Russian invasion," when army tanks would roll communism down our city streets. Yet the only army tanks I saw on American streets were driven by Michigan's National Guard in the riot of 1967: I crouched on the roof of my apartment near Wayne State's uptown campus and watched Detroit's streets become ribbons of fire. The first person I saw shot fell here, on my street, a hell away from the Moscow my teachers spent so much time worrying about.

Shortly afterward, I served as a reluctant draftee in the U.S. army during the Vietnam years. I had struggled as a Christian to become a pacifist, but ultimately I could not abandon the principle of defense of loved ones and country. My father and his father before him came from a long line of conscript soldiers, regardless of the conscriptor. There is that within me which loves the image of Ollie North, jaunty and scrubbed, wearing medals the cost of which only a vet knows, professing his love of God with his hatred of America's ene-

mies (though I'd never send him a supporting telegram). But there is also that within me which knows and loves a complex Russian spirit that Ollie North and most Americans know so little about.

As both an American and a lover of the Russian faith and the Russian soul, I hope I can convey to my fellow American Christians something of the modern Orthodox spirit in Russia. When the "Soviet dissidents" of my faith like Solzhenitsyn and Goricheva speak, they speak with intimate knowledge of the suffering Christian spirit in Russia. Yet Russian dust still clings to their shoes; they speak with Russian voices. I am of their Orthodox tradition—yet I am also one of you. Of their faith, I share your spirit. It is your world that I address.

For this reason you will sometimes discern a certain confusion of voice in my discussion. That confusion is a function of my identity. Such confusions are built into the thousands of Slavic Orthodox Americans like me. Where is the "we" in "us"? As an American and a Westerner, I am one of you, yet in my "Eastern" Orthodox Christianity and in my ethnicity I am one of them as well. To me, onion domes look best in the factory landscapes you saw in Cimino's *The Deerhunter* (how that film captures the voice of us), but they are no less "my own" when they glitter off Red Square. The names of the best friends of my youth stare back at me from the polished black walls of the Vietnam Veterans' Memorial. Yet the huge monument at Volgograd, which recalls the millions of Russians who died in World War II, commemorates my relatives and co-religionists. Where is the "us" in me? Russian and Orthodox Christian roots hold together the chunk of American soil upon which I grew.

It is from the unique perspective of a complex Christian identity, then, that I offer what insights I can and shed some borrowed light upon our American Christian soul. Does the official atheism of the Soviet system confirm that nation in godlessness—or is there a godliness and morality within the Soviet Union that exists at some level, even in harmony with a Soviet identity? Each position has a political implication as well as a religious one. Little wonder, then, that massively, in

the entire Christian community of the West, we have done without the mind and insights, the heart and will of those who touch upon our greatest fears and suspicions.

It is not, surely, that Americans have been uninterested. Our religious publications argue incessantly about the nature of the enemy. Do the Russians have good will or bad will? Are they a godless nation or do they have a church? Some American Christians see Christians in the USSR as an enslaved remnant, a tiny minority within a vast and unbelieving sea. Some Protestants raise money to send them Bibles; others raise money to help those imprisoned by Russian authorities. Some Christians think they need evangelism and attempt to smuggle simplified, comic-book versions of the *Life of Christ* past the Soviet customs. Others think the answer lies in the immaculate heart of Mary, and as "missionaries of the rosary" count down their beads in rhythm with the arms race to pray for the conversion of Russia. Yet the Russians themselves exist as a mere abstraction among us. One seldom finds an attempt to understand the way Russians—especially Russian Christians—think about the world.

It is surprising how little has changed since my childhood. When my children see the cruel characterizations of Russians that people the TV commercials and sitcoms, they look up at me, and I see my old hurts and questions mirrored in their eyes. In some ways, during the last spasm of cold war, things got worse. Once, Greta Garbo in *Ninotchka* and Hedy Lamarr in *Comrade X* could be converted from drab sexlessness to instant womanhood with capitalist stockings and a little chocolate; more recently, perpetually thick, subhuman Russian women sold hamburgers for Wendy's. (Sure, it was a funny commercial, and my family and I laugh whenever we eat hamburgers—somewhere else.) Once, in *The Russians Are Coming, the Russians Are Coming,* the arrival of the Russians on American soil led to a saccharine but good-humored reconciliation. Then "Amerika" showed, in mini-series splendor, the ruin of a Soviet-American landscape. No wonder, when I welcomed a delegation of priests and bishops from the Soviet Union to my home, a busload of "Christian" demonstrators set upon us shouting, "The Or-

thodox Church in Russia is the arm of Satan!" Once, when I was in fifth grade, Freddie Cybulski joked about bombing the Russians. "Shush, Freddie," said Miss Elvira P. Gill, with considerable anger. "We never joke about things like that." More recently, speaking to an audience of Christians, the president of the United States (speaking as a "civil theologian") confidently placed the source of metaphysical evil firmly in Red Square, and his listeners applauded. No matter that, at his last summit in Moscow, he no longer held the same creed. In this decade even a president, like Freddie, has been very, very naughty. And the nation has scolded him with a half-concealed smile.

This mean spirit invades the most hallowed sanctuary of American fair play—sports. I grew up near the Canadian border, in an ice-hockey-crazed Detroit and in the awesome shadow of the Detroit Red Wings. I am even now the advisor and occasional coach of our college ice-hockey team, and the crunch of skates on a breakaway or the crack of a puck against the boards still awakens the youth in me. I understand loyalty to a team: my college players are my pride. When the American team won its heart-thumping victory at Lake Placid in 1980, I was lost with America in the delirium of the win. The elation of victory, however, resides in its evanescence: the poet William Blake admonished us that "he who kisses the joy as it flies / Lives in eternity's sunrise." Instead of following this wisdom, we hoard our wins against the Soviets and cherish them like a miser. Now, years and honest defeats later, bumper stickers still sport the message "Lake Placid— U.S. 4, U.S.S.R. 3." Thus the ethic of the sport can degenerate into a stale, cheap one-upsmanship. Although there is now talk of the unimaginable—of Russians playing in the NHL— my own adopted champs, the Philadelphia Flyers, still won't even play the Soviets. Matches against the Russians have been marred by a surliness of spirit as American fans project into the players the image of the "Ugly Russian."

Vladislav Tretyak, the Russian goalie and Olympic medal winner, is a giant in international ice-hockey lore. One day just a few months ago, the mayor of my town called me with a cheerful proposition. A Soviet delegation was coming to

Lancaster. Would I help by hosting one of the guests? You can guess that Tretyak was one of the guests, but only a hard-core hockey fan can understand the altitude of my elation when I was assigned as his guide. I took him to an Amish farm. I had a drink with him. We talked about religion in America, Russia's love affair with old women, and—of course—ice hockey. His bright, eager curiosity and his quick wit complement a ham-sized handshake. (Those huge hands left a lasting impression on my awestruck college team.) But most impressive was Tretyak's ethos of sport: sports most perfectly expressed his moral vision. For Tretyak, as for many Soviets, sports is a moral paradigm, the embodiment of commitment and sacrifice. Generous and gracious to his opponent, delighted with Americans, Tretyak is the antithesis of his archetypal foil, the crypto-bionic Russian athlete without a soul who threatens to savage our great American hero in *Rocky IV.*

Christians in America participate in popular culture, and it is no wonder that they absorb its precepts. But Russian Christians, too, participate in a culture. For Orthodox Christians in the USSR, the concept of "Russia" evokes an image diametrically opposed to that projected for us in the United States. Perhaps one of the best expressions of that image is embodied in the main character of Solzhenitsyn's novella entitled *Matryona's House.* The real Russia is an old woman, simple in her beliefs and unflagging in her labor for the common good. Solzhenitsyn portrays his character in homely, maternal terms. (*Mat'* is the Russian root for "mother.") Matryona is probably as thick and certainly as badly dressed as the women who invite ridicule in the Wendy's commercial. She is a model collective worker: unasked, she labors to dig potatoes out of sheer respect for the bounty of the soil. Matryona is nonetheless the expression of Holy Russia, Mother Russia. In a Russian text resonant with Psalms and Proverbs, Solzhenitsyn delivers her elegy:

> We all lived near her and didn't comprehend that she was in fact that same "righteous person" without whom, as the proverb goes, the village cannot stand.

Nor the city.
Nor our entire land.[4]

Contrast this image with that projected in a film by the most well-meaning of American Christians, a group in Wheaton, Illinois, dedicated to the furtherance of the gospel in Russia. They have produced a documentary entitled "Russia—Land of the Godless." It is haunted by an image that appears so often in American television—that of Russian soldiers marching beneath a red flag. The grand irony is that so many of those soldiers are likely to have been baptized. Although that may not affect the nature of the fear that underlies the film's emphasis, it certainly should challenge the presumption implicit in the title of the film. As a Russian woman once said to me after liturgy in a church in Moscow, when I was trying to explain to her the doctrine of deterrence, "All the same, your missiles are pointing at me and at my children." A Russian can see America, too, as "ungodly." And in the shadow of our missiles, the Russians would be right.

"Love Thy Enemies"

The cold war, whatever its political motivations, has distorted theology. Even worse, it has helped to make American theology the handmaiden of politics. A "civil theology" has developed in which the metaphysical parameters of evil have a physical incarnation. The symbolic "Iron Curtain," after all, has not of itself veiled from our eyes the churches of Eastern Europe. The existence of a church and especially of a viable theology under Marxist government threatens the cosmography of American civil theology. Seen from this side, the domain of the enemy extinguishes good. The survival and especially the development of a Christian mind in the realm of the enemy is inadmissible in a cosmography that places the source of good in one's own political (no longer theological) system. Michael Novak is a political-theological Catholic writer

4. "Matryonii Dvor," in M. Zoshchenko's *Izobrannoe*, ed. M. Slonim (Chicago: Russian Language Specialties, 1965), p. 122.

who has championed Russian prisoners of conscience; none-
theless, he once let it slip in an anecdote about Russian bish-
ops that they were "all KGB." And Cal Thomas, once of the
Moral Majority, dismisses the Russian church as utterly com-
promised. Novak and Thomas—indeed, many American re-
ligious thinkers—allow the church in Russia to be subsumed
by, rendered subordinate to, the system that can be the first,
the primary, and frequently the only object of their analysis.

The Christian analyst must grant that, should we fight a
war, the Soviet Union might well become the enemy. Chris-
tian tradition, even through the centuries in which Christians
have been slaughtering each other in wars that honest theo-
logians have deemed "just," has given us biblical guides in
this dilemma of "the Enemy." Christ has, in his Sermon on
the Mount, given us incredibly tough counsel. First, we can
never remove our gaze from those whom we count as our
enemy. Even the Christian who fights must not objectify the
other combatant. To pray for our enemies is to take them fully
into our consciousness. Even to turn the other cheek is not
to run away: in passive or active resistance one must look,
steadily, upon the face of the one who has caused injury. Sec-
ond, in a conflict we can never rest comfortably in the con-
viction of our own virtue. "You hypocrite," says Christ to each
one of us in all our conflicts. "First take the log out of your
own eye, and then you will see clearly to take the speck out
of your brother's eye" (Matt. 7:5). Jesus wrote no articles on
political ethics, but he has unquestionably given us a moral
equivalency, each with the other. This moral *equivalency*—to
be distinguished from the moral judgment that may have led
to the conflict—is the bedrock of any Christian theory of con-
flict. An intellectual in secular terms can (and usually does)
assume a superior intelligence, but a Christian moralist must
always be conscious of the communality of human sin.

But how often nations allow themselves to indulge in
practices that they would deny their individual members.
Christians, too, can adopt that same indulgence toward their
collective, national behavior. Christian believers possess
moral convictions that would never allow them to refer to a
neighbor as absolutely and irredeemably evil. Even the death

penalty allows for repentance before execution. Yet in times of war or hostility, Christians can tolerate characterizations of an entire people, an entire culture, as morally tainted. In the middle of the Reagan presidency, political commentators like George Will, Jeane Kirkpatrick, and Alexander Haig ventured into precisely the area of "moral equivalency." Transcending a moral judgment that distinguishes us from our enemy in specific areas of dispute, these commentators have taken civil theology a step further. In a neo-Manichean world of metaphysical dualities, the very nature of the enemy occupies a different moral category. The communality of human sin dissipates, replaced by a systemic distinction between self and other.

Jeane Kirkpatrick, in a polished lecture before the Royal Institute for International Affairs, attacked with alarm the suggestion that the United States and the Soviet Union should be judged as morally analogical: "The suggestion that the United States and the Soviet Union are morally equivalent, that with regard to methods and policies there is a rough moral symmetry, is now common enough among our closest allies that its expression no longer causes shock in Europe. Obviously, this is a serious matter."[5] Dr. Kirkpatrick focused upon specific policy issues of Grenada, Afghanistan, and Central America. Underlying her analysis was the conviction that American actions are to be judged in the light of her purer motives. Her clear assumption was that those motives are purer than Russian motives by virtue of the American system that nurtures them. This repudiation of moral symmetry is hospitable to those Christians at the rightmost end of the political spectrum. In this view America becomes in itself a kind of ecclesial entity, a "mega-church." And any interests, even domestic ones, that frustrate the identity of church with state become "Communistic" and, presumably, associated with Russia. The Moral Majority Report defends its view of public policy in this way:

5. Kirkpatrick, "Doctrine of Moral Equivalence," *Department of State Bulletin,* Aug. 1984, p. 58.

It is time to reject the godless, Communistic definition of separation of church and state that says there is no place for biblical moral law in public policy. We must honor the God who rules over the nations and said, "Whether therefore ye eat or drink or whatsoever you do, do all to the glory of God." Let us never forget that "the wicked shall be turned into hell, and all the nations that forget God."[6]

Most Christians are not willing to carry through this identification of national with divine interests. Even Reverend Jerry Falwell has denied that divine love applies more specifically to America than to any other nation. American Christians in the mainstream would certainly grant that Russians and Americans have "equal access" to the saving grace of God. However, American Christians can tolerate a metaphysical frame of reference within which America denotes an absolute good and Russia denotes an absolute evil. Heresy—once an appropriate designation for so radically different a mode of distinction—has become an unfashionable and embarrassing word. Yet phyletism—the identification of the universal church with a single nation, its values, or its interests—has been regarded as heretical by the traditional church.

Christ shaped his followers into morally reflexive beings. The gospel and Christian tradition call upon Christian citizens to reflect upon their own state even as they direct criticism against an enemy. American Christians are acutely aware of Russia's gross and undeniable sins, yet at the same time they can, as patriots, be remarkably indulgent regarding their own. Europeans often comment upon the friendliness of individual Americans as it contrasts with their collective pride. Those Americans who, as individual Christians, might tremble before God in reflecting upon a lack of charity, an insensitivity to others, or self-indulgence can express an overwhelming national arrogance that as individuals they would never express. American culture has been acutely sensitive to the outrage of Russia's slave labor. Yet in the rosy aura of *Gone with the Wind* or in the plumes of dust rising from the

6. *Moral Majority Report*, 1 May 1980, p. 10.

wagon train, American popular literature and film have disguised the ugliness of the Gulags neither our religion nor our civil system spared us. There have indeed been beams in America's eye.

"Praying Indians"

This reminder of American sins is not to preach or even to condemn. Phyletism is just as heretical in reverse; Christians on the left who see Washington as the focus for evil in the world adopt the same neo-Manichean vision as the conservatives they condemn. America is human and fallible, and as we look to Russian Christians that is precisely the point. Christians, whether Russian or American, are to be morally reflexive. But it is hard for us to see parallels in behavior—to see East European hegemony as parallel with our policies in Latin America, for example—precisely because the metaphysics of our "civil theology" has been so pervasive. In any case, analogies are weak, and moral analogies between America and Russia defy the sharp moral distinction that American thinkers make between themselves and the Soviets. Yet we Americans can look to our own past for the roots of this distinction. We live, after all, upon expropriated land. In the religious dimensions of our Manifest Destiny, we had to deal with that fact.

The narrative of early American settlers shows the articulation of a civil theology that relegated the enemy to a different moral category. Long before Jeane Kirkpatrick, Americans resisted a moral equivalency between themselves and those whom they supplanted. When we look at Christian narratives in early American history, we see the settler-authors dealing with the Indian question in a way similar to the way in which modern civil theology deals with the Soviet Union. For even in the seventeenth century, honest and believing Christians formulated a metaphysics that assured the enemy—even the Christian enemy—of a permanent moral exile.

One narrative among many can stand as an emblem. The elaborate title tells the author's intent: "The Sovereignty

and Goodness of God, Together with the Faithfulness of His Promises Displayed; Being a Narrative of the Captivity and Restoration of Mrs. Mary Rowlandson."[7] Mary Rowlandson (c. 1636?-1678?) was a minister's wife in the garrisoned town of Lancaster, Massachusetts, in 1675. She was taken captive in an Indian raid by the Wampanoag tribe, a people who had first been friendly to the settlers but who later retaliated against them for their acquisition of Indian lands. It is important to remember that these Indians had become evangelized, and that many of them regarded themselves as Christians. Scholars assert that 20 percent of the Native Indian population in New England was Christian by 1675; in Massachusetts the percentage was much higher.[8]

Mary Rowlandson's tale is a sample of a popular genre in colonial literature whose influence continues through to the modern western. But Rowlandson's moral dilemma is more acute than that of her successors, who daub the Indians with heathenism as well as war paint. Rowlandson thematically identifies herself with Job, and Massachusetts with the Promised Land. Yet many of her captors were Christians who called upon the same Savior as did she, and who discussed Bible verses in detail. (Surprisingly, an Indian in her narrative used 2 Kings 6:25 to justify the eating of horseflesh in times of famine.)[9]

Rowlandson had lost loved ones to these Indians. She did not confront the ambiguities of an enemy who is also a Christian. The persona of her narrative is a "reformed" Mary Rowlandson who interprets her affliction in a distinctly personal way. She has experienced deprivation that she may know what is of true value: "The Lord hath shewed me the vanity of these outward things. That they are the Vanity of

7. Rowlandson, "The Sovereignty and Goodness of God," in *Puritans among the Indians: Accounts of Captivity and Redemption 1676-1724*, ed. Alden T. Vaughan and Edward W. Clark (Cambridge: Belknap Press, 1981), pp. 29-76.

8. See Alden T. Vaughan, *New England Frontier: Indians and Puritans 1620-1675*, rev. ed. (New York: Norton, 1979), p. 303.

9. Rowlandson, "The Sovereignty and Goodness of God," p. 62.

vanities, and vexation of spirit, that they are but a shadow, a blast, a bubble, and things of no continuance."[10] The Indians are a part of her affliction. They exist as evil in order that she may know the good. Significantly, when she is long separated from home, she mistakes appearances for realities. The European garb that some Indians wear causes her some confusion: "but when they came near, there was a vast difference between the lovely faces of Christians, and the foul looks of those Heathens, which much damped my spirit again."[11] Far from winning her sympathy, those Indians who are Christians earn her greatest suspicion and contempt. She calls them "praying Indians," Indians who had taken on Christianity and who yet in wartime found a conscience "as large as hell, for the destruction of poor Christians."[12]

Mary Rowlandson is not different from most of us. Because she feels threatened by the Indians, her Puritan theology buckles under the weight of her fear. Their "national interest" is at odds with her own. She identifies her own interests as championed by God. Thus she loses the capacity to be morally reflexive, and she sees her enemy as morally depraved. The Christians among the enemy she alternately ignores or discounts. Similarly, the Christian presence in Russia and its Christian mind disappear in the frequent American fear and condemnation of the Soviet political system. The good, the humanity in the enemy is subsumed by fear. The gospel seeks to cancel out fear, but civil theology employs fear as the basis of its metaphysics.

Thus civil theology makes heavy demands of the traditional Christian. In some sense, the Russian-American conflict "converts" American Christianity to a Manichean vision in which the forces of Darkness hold part of the universe captive. Exiles in the "Land of the Godless," Russian Christians become parallel to the "praying Indians" in Mary Rowlandson's narrative. Their presence disturbs the cosmography.

10. Rowlandson, "The Sovereignty and Goodness of God," p. 75.
11. Rowlandson, "The Sovereignty and Goodness of God," pp. 58-59.
12. Rowlandson, "The Sovereignty and Goodness of God," p. 62.

And like Galileo, who once threatened the neat order of the Ptolemaic universe, those who too readily see God in Russia can find what Billy Graham found—repudiation and abuse. In this new Manicheism, we imagine Christians elsewhere to be reflections of ourselves, not only in faith but in political cosmography. If Christians do survive in the godless realm, we suspect that their spirit must be invisible, their thought without manifestation. A Christian who would march in the Soviet army can be but one of the "filthy heathens" Mary Rowlandson saw in her captivity.

Christians in a Wax Museum

Many dedicated leaders in mainstream Christianity have fought the heretical implications of this Manichean duality, and they have struggled to resist the trend. Such leaders worked to invite the persecuted Russian Orthodox Church onto the world scene. When that church became a member of the World Council of Churches in 1961, a larger number of Christians became aware of the existence of a Russian church. This awareness was not without a certain price: staid churchpeople have had to endure condemnation for allowing a "Communist presence" in the WCC. Nonetheless, the World Council and now the National Council have helped develop a wider awareness of the dilemma of the Russian church. Significantly, the "new" dissidents of the Orthodox repression beginning in 1976 and extending up to the implementation of Gorbachev's *glasnost'* policy have turned to the World Council as a body of appeal.[13]

Conscious of the Russian church, the major denominations have resisted the grossest expressions of American phyletism. With the celebration of the millennium of Christianity in Russia in 1988, thousands of American Christians have traveled to the USSR for a specific encounter with the Russian

13. See Jane Ellis, *The Russian Orthodox Church: A Contemporary History* (Bloomington: Indiana University Press, 1986), pp. 355-69, 382-88, 450-51.

church, and this too will be a profoundly significant move-
ment. With this massive pilgrimage of mainstream Christians
will come a better awareness of Christian thought and ex-
pression in Russia and a theological awakening to the East-
ern church that can extend into the new generation. One prob-
lem with theology in America has been its confinement to
academic specialists. Now that President Reagan has met
monks in a restored monastery, and now that streams of
American Christians will be showing their slides and telling
the stories of their visits, more Americans will be able to see
Orthodox theology expressed in Orthodox life.

Jesus Christ has enjoined Christians to love their ene-
mies, and this means that even in the midst of hostilities they
must seek to know those enemies. The mainstream churches,
through their offices of evangelism and mission, have
awakened—especially in this decade—to the task of knowing
the Russian church. Yet they must continually battle the mis-
placed trust that American Christians—both on the left and
the right of the political spectrum—have in their own politi-
cal institutions.

Government serves political and social ends born of
the moment. To commit oneself to Christ involves a radical
re-altering of loyalties, for Americans no less than for the cit-
izens of any other nation. Orthodox Christians sing in every
liturgy that verse from Psalm 146: "Put not your trust in
princes, in sons of men, in whom there is no salvation." When
this child of the sixties, given to social causes and political
passions still, attended a liturgy at the cathedral of Alexander
Nevsky in Leningrad, I heard those words as if for the first
time. In my insistence upon certain political positions as a
function of my Christianity, I have placed my trust in princes.
So also have those who stand to the right of me, and from
whom I was so long separated in dialogue. The first loyal-
ties of the Christian must be to the church, the *ecclesia,* who
cannot be confined to a single nation and whose only prince
is the Lamb of Revelation. That church includes of necessity
the Russians and particularly those whose faith makes them
one with Americans within the church. But the abandonment
of passions, particularly political passions, is a hard and

sweaty struggle. We American Christians can at least under-
stand our country's princes. But we confront a natural diffi-
culty in discovering the mind of a people who have for so
long been separated from us by a chasm of suspicion and
hatred.

It often surprises Americans to discover that they have
easy and domestic access to the mind of the Christian East—
the same mind that nurtured Russia for centuries and that
still lies nestled within the modern Soviet Union. Onion
domes rise up not only in Moscow—if you look hard enough,
you can see them just off the expressway as you wait through
the traffic jams in cities like Cleveland. Immigration has
placed Orthodox churches throughout the United States, and
American Christians need not travel to Zagorsk to experi-
ence the heart of the Russian believer. They can feel it beat
here.

To find that heart and listen to it, however, requires a
great deal of attention and sensitivity. The Orthodox in
America, no less than Presbyterians or Reformed, have been
affected by the civil theology that pervades America with its
phyletism. But their dilemma has been more acute. "Slavs"
comprise a broad ethnic category that holds many cultural
and linguistic features in common. These features alone set
Slavs apart from mainstream American Christianity. Most
Orthodox Christian Slavs in America—even those who call
themselves "Russian" Orthodox—are not, strictly speaking,
"Russian" at all in ethnic origin. (Few immigrants to the
United States came from what is now the Russian republic
of the USSR.) Their origins lie in other smaller but related
ethnic groups. Some of them, like the Ukrainian Orthodox
community, sharply distinguish themselves from the Rus-
sians. Others, like some among the Carpatho-Russians and
my own Byelorussian people further north, have not resisted
the "Russian" label. (The last chapter of this book will help
explain why.) But whatever their specific origin, Orthodox
Christian Slavs in America are people whose very faith
strikes deep into the consciousness of Christian Russia. Our
fellow Americans are often not aware of the distinctions
among us. And even given those distinctions, we do reflect

a common bond: ours is a Slavic identity, and ours is an Orthodox spirit. To cling to that Orthodox identity and yet to fit somehow within the framework of a nation that fears the land of its source involves some profound problems.

The problems were so severe for the first working-class immigrants that they felt isolated from the world to which they had come. They built their churches with lay initiative and under a congregational control unusual in the Orthodox tradition, and they built their churches as havens from the alien society in which they lived. As an Eastern priest said early in this century about his congregation, who were mostly coal miners, "My people do not live in America. They live *under* America. America goes on over their heads."[14]

America was not receptive to these early immigrants on their own terms. Their ethnic identity was something most Americans found confusing. In addition, they were working-class people, and their fierce loyalty to unionization efforts and their hospitality to radical causes alarmed their employers and the society in which they lived. After the Russian Revolution of 1917, the popular mind tainted immigrant Slavs in America with a Red brush. In the "Red scares" that followed, these Orthodox settlers became extremely cautious. Isolated from the turmoil of politics in Europe, they retreated also from involvement with their fellow Christians in the United States. Their mind and their culture swam beneath the surface of this country, preserved now only through the efforts of ethnic study centers like the immigration history archives at the University of Minnesota and scholars like Paul Magocsi, chair of Ukrainian studies at the University of Toronto. Orthodox immigrants have not been a resource upon which the American mainstream could draw to discover the strains of the Orthodox mind.

"America," as one of my relatives used to say, "likes its Russians white." Popular culture in America allowed one manifestation of Russia to survive and even prosper: the voice of the old "white Russian" or monarchist emigration. Greta

14. Quoted by Emily Greene Balch in *Our Slavic Fellow Citizens* (1910; rpt. New York: Arno Press, 1969), p. 419.

Garbo's Ninotchka was wined and dined into a new awakening by a trio of Russian emigres. Through the Hollywood of the thirties and forties danced a procession of czarist princesses and princes, countesses and dukes, most of whom happily drove taxis or ran restaurants and spoke in an amusing array of accents. Nor was that condescension confined to the golden age of the movies. In Robin Williams' character in *Moscow on the Hudson* and in the collective self-deprecation of the new emigre comedian Yakov Smirnoff, America has fantasized its liberating effects upon the consciousness of Soviets. When even the Soviets themselves joke, "What is a Soviet duet?—A Soviet quartet after a visit to the West!" it is hard for an American to imagine that the Russian mind has much to offer a modern Christian. In this framework, the Orthodox Church is a relic of a glorious past. Beautiful, exotic, rarified like some delicate and ancient porcelain bird, it is a church in a state of suspension—a church in a wax museum.

The new dissident immigration makes it possible for thoughtful Christians to see the effects of the Orthodox mind. Writers and thinkers like Alexander Solzhenitsyn, Tatiana Goricheva, and the poet Irina Ratushinskaya inspire American Christians with the vitality and power of Christian thought in the profoundly a-religious environment of the Soviet Union. Yet, as these dissidents themselves sometimes complain, America wishes to deal with them on its own terms. Solzhenitsyn's self-imposed exile in Vermont is an emblem of their fate. They are easily digested as "dissidents," as critics of the regime from which they come. In this role they can even be slid within the frames of our civil theology: despite the fact that Russia nurtured and formed them, they are used to prove the neo-Manichean thesis. Thus the "evil of the Soviet system" confirms a phyletist presumption: America is the embodiment of good. These Russians display a consciousness too rich and complex to be easily absorbed by the media. Comfortable in dealing with them as "dissidents," the press processes each of them in turn, eliminating all but their critique of the American political enemy. In turn, the dissidents, as unaware of America's complex identity as America is of Russia's, find themselves used and exploited by one or

another party in our political struggles. And, like Americans who don't understand the Russian church, they cannot fully find their way to the heart of the American church.

The Orthodox mind, in its richness and complexity, challenges the simplistic and absolutist presumptions of civil theology. Nor is this absolutism confined to America. I have often taken groups of college students to the USSR to confront Soviet culture on its own terms. Just four years back, before Americans knew who Gorbachev was or what *glasnost'* meant, my class learned in Leningrad how badly a new openness and flexibility was needed. One of my students engaged in a verbal wrestle with a young member of the officially sanctioned Soviet Peace Committee, assembled to greet foreigners. All of my students were shocked when the young man quite readily asserted, "In the matter of pursuing peace, my country has never made any mistakes." Given a chance to recant, he of course failed to do so. The Russians themselves call such people "ideological mules," braying their consistent agreement with predetermined policy. My own congressman, loud in his suspicion of the Russians, quite proudly displays that he rarely reads the opinions of his less anti-Soviet critics. "It depends on who you believe," he proclaims—and relies exclusively on the analysis of those who agree with him. Political mules on both sides pull in opposite directions. Oversimplification has become a political virtue, yet moral strength resides in our ability to perceive the many sides of an issue before we come to a conclusion.

Moral complexities are painful things to bear. As the old Norse sagas can show, they are painful unto death. The old Icelanders faced a world of violence which rivals that of prime time. Yet, in the grand patience of their narrative, they delighted in showing how each separate choice made by any of the hundreds of characters implicated, in a never-ending chain, the fates and choices of others. Although their lives so often ended with the thunk of a spear in the chest or a sword blade sliced through the neck bone, they did not allow themselves the luxury of moral simplicity. And when conversion to Christ came, as it did in the midst of the slaughter of *Njal's Saga*, it did not make things any easier. Far from it. Christ

sharpens the poignancy of life as we live it, for our own ineptitude is constantly contrasted with the grandness of his possibilities. American Christians can learn much from the sagas. The "post-Christian" era has destroyed for us a host of certainties. What is left is the one stark certainty from which even our Lord once begged to be free—the cross. To lose the conviction that one's enemy is evil can be its own cross.

In some sense, thousands of Orthodox Christians in this country love Russia and America at the same time. That dual love can involve a host of moral ambiguities. I remember so vividly the fervor with which I absorbed the patriotic lessons of a fifties' childhood. We Americans were "free." I never stopped to contemplate the limits of that freedom, even when my mother went in the backyard one evening during the worst of the McCarthy days in order to burn some books and political pamphlets printed in Russian and collected by my grandfather and one of my great uncles during the "first Russian revolution" of 1905. I remember the smell of books burning still, yet at the time I sensed only the fear of my very American mother, lest someone discover the Russian core of our hearts. I was too young to realize that as she was burning books, a Russian bishop in New York was being dispossessed of his cathedral, St. Nicholas. The reason hinged upon the loyalty of his American flock to a canonical patriarch in Moscow.

It was only last year, as I was doing some research on the subject, that I saw a *Newsweek* caption of 1954, beneath a photo of the Russian Orthodox patriarch, which captured the spirit of the times. The caption reads simply, "Puppet with Red Strings."[15] No doubt the editors of *Newsweek* in the fifties were certain enough of the moral compromise of the Russian church to allow such a caption within their own compromised article. Such "certainties" are impossible to counter. Recently a devout Christian man assured me that Russian Orthodoxy in the United States was a tool of worldwide communism. His evidence? A retired air force colonel had informed him of the

15. "The Christian in the Soviet Union: A Rising Faith under Kremlin Fire," *Newsweek,* 18 Oct. 1954, p. 59.

fact. Although my fellow Christian was good enough to grant me at least good will, he accepted the civil, political testimony of a military officer over that of another Christian.

This kind of pervasive suspicion is one reason that the Orthodox mind in America has had difficulty conveying its counterpart in Russia. I now belong to a Greek Orthodox community, identical in faith with the Russian Orthodox but different in ethnicity. There is no conflict for Greek Orthodox in asserting their simultaneous love for Greece and the United States. But to assert a simultaneous love for modern Russia and America can involve problems of a unique kind.

A dual love for America and Russia also suspends the lover in the chasm between the Eastern and the Western minds of Christianity. Despite their concern for combatting racism and sexism, Western Christians to the left of the political spectrum have either ignored Christians in Russia or remained ignorant of the Christianity that they espouse. Patrick Henry, director of the Institute for Ecumenical Research in Collegeville, Minnesota, claims with confidence, "Ignorance of Eastern Orthodoxy is the scandal of the western Church." America's intellectuals tend to obscure the Christian East in clouds of incense and an aura of romanticism. Many rank-and-file Christians, if they are not completely unaware of us Orthodox in their midst, regard us as living actors in a museum display. Despite the fact that we obviously live in this modern age and experience it as fully as others do, we are yet regarded as "those who once were," as the living evidence of the Christian life as it once was lived.

Portrayed at best as quaint and antiquated, we Orthodox in the West have lived at the edges of American religious consciousness for so long that some of us have become comfortable with the role. In Europe we were profoundly involved in the intellectual and aesthetic issues of any age in which we lived. In America, Orthodox theologians labor valiantly merely to gain some notice. Like a goose incubating the golden egg of tradition, many an Orthodox congregation struggles to sit perfectly still. We will be true to our past, some of us argue, if only we do not move. Given the need of American Christianity to know the Russian and Orthodox soul, this is

not an enviable role. Like the young boy who stands deathly still in a wax museum, many of us Orthodox today are just aching for someone to come along and look at us closely, just so we can leap and say "Boo!" Exotic to you, perhaps, in our origins—Russian or Greek, Ukrainian or Serbian, "Eastern rite" or Orthodox—we live in your midst. Our religious presumptions are not identical with yours, but they are shared by a good portion of the Christian world, including those Christians in a country whose power now haunts America's inmost fears. In this Orthodox Church now sifted into America's soil, America can begin to know the enemy she must love.

The Distorted Icon

I have relatives up north in Canada. (They were refugees who settled there.) As a boy I used to sit by the Canadian lakeshore and watch the loggers leap nimbly from one bobbing trunk to another. One of the lumberjacks, jumping like a lithe frog, told me once that to leap from one log to the next was the easiest part. The hardest part came when a logroller wanted stability. Then he had to straddle two logs, and there was always the danger that one would pull away from the other. A logger could fall into the crack, and the two logs could come together and crush him.

Like most American Orthodox, I have been doing the splits all my life. Nowhere else in the world do I feel matters of the Spirit taken more seriously than they are in Russia. Even my students have remarked that in the United States it is rare to have conversations as deep as those they have in Russia. Nor are such morally laden encounters confined to exchanges with dissidents. Recently one of my classes met a journalist in Kiev. After a long exchange, this young member of the Communist Party lamented to my students, "But you're so materialistic! Are there any spiritual values left in America?" Each time I return from the Soviet Union, I feel renewed for a struggle with the torpor of our age. Critically we Orthodox in America think like the Westerners we are, yet in

religious terms we have an Eastern mind. In the Orthodox world, we employ an alien methodology of critique; in the Western Christian world, we cling steadfastly to our trust in tradition. Such a balancing act has its dangers, and many times one can take a fall. Yet when ideas move so quickly between Americans and Russians, when, slick-wet and dangerous, they must be grasped before we all plunge into a maelstrom, it is only by straddling the two identities that one can achieve stability. To straddle but one log is to be swept downstream.

It is tough to endure ambiguities. It is difficult to surrender the absolute conviction of one's own virtue, individual or collective. I learned that lesson in good American company, among the brave men and women who served the United States in Vietnam. Because of my insistence that Russia holds a people whom we must love, I have been called "un-American" by a few rightist groups. But I was American enough to get drafted.

As a medic, I saw the cross in the tormented bodies of those American soldiers who had bathed in napalm's fire. The American forces had intended that fire for the "enemy," of course. Yet, as is always the case when we turn our hatred outward, we ourselves also bore its rage. In the confusion of combat, with missed coordinates called in by radio and the accidents of haste and pressure, Americans often dumped it on themselves instead. It is not a sight that one easily forgets. My torment was and is still in the realm of the imagination: to this day, I cannot rest easy before a fireplace. But *they* bore our collective torment in the flesh. It was through them—through the wounded and burned and through the many friends whom I lost in that war—that I learned the real nature of ambiguity.

Was the cause noble? In all truth, throughout my hitch in the army, I can honestly say that no one asked. The answers offered now are too glib, too easy, too "natural." It is interesting, as a matter of fact, that some of those most adamant in asserting the absolute virtue of the vets in their *cause* are the very ones who never served. Many a current neo-conservative spent those days conveniently out of uniform. (Sylvester Stallone, "Rambo" himself, spent those years sequestered in the

Swiss Alps as a teacher in a posh girls' school.) Yet my friends, the guys whose names still stare back at me from the mirrored granite of the memorial in Washington, never once asserted the righteousness of their cause. They were, if anything, skeptical of those civilians who did. They can surely teach us a lesson in embracing ambiguities.

There is a "Rambo" side in many of us called sin, the lust for revenge. This blood lust can be intimately connected with what we hold most sacred. If you have ever seen an Orthodox church service, you know that we pray surrounded by the images of Christ, his mother, and his saints. We use incense in our worship. The unaccompanied sound of human voices in chorus shapes the melody of our prayer. In stark contrast, my first encounter with the aftermath of war was with the smell of burnt flesh, the sounds of screamed pain. The human face, once napalm has touched it, mocks the images we use to portray the sacred. It becomes a distorted icon—the very image of what we, in our depravity, intend for our enemy but what we instead do to ourselves. War is a diabolic liturgy.

No conviction of our own rightness, our own virtue, can take away the tragedy of what we do to our own flesh through our hatred, however justified our feelings may appear. Fresh from a burn ward, shortly after I first wrestled with those impressions, I was in a crowded airport. I've tried to remember why. I can't reshape the circumstances. But how clearly I remember what I felt. Lulled by Muzak, swathed in prosperity, the rest of my countrymen walked by in the indifference of self-preoccupation. I still can't forget the faces: an older woman in a navy-blue hat, her gray hair carefully crisped in tight curls; a young guy in a new suit, on his way "up" before "yuppie" was a word imagined; a middle-aged man with long, Tim O'Leary-type hair, his wrinkling neck oddly decked with beads. My fantasies put *First Blood: Part One* to shame, and I broke out in a sweat. I wanted to sear the face of America with a flamethrower. I wanted to send a cascade of fire down the concourse of that airport and watch those smug, indifferent masses writhe. I wanted to rub their noses in napalm.

My fellow vets will understand those feelings. God has

forgiven me for them. Lest they seem too shocking, think for a moment how indulgent we have become of such feelings when they are directed against those whom we see as the enemy. Communists, apparently, are fitting objects for our hatred— even our "Christian indignation." If we look closely enough, we can find within our very selves that evil we fix with such certainty in Moscow, or Hanoi, or Havana. We have resurrected the Vietnam vet, made him almost fashionable. Yet on what terms? I am heading an archive project that brings together the testimony of men and women who served in that war. Very few of the people whose testimony I have collected came home with a bag full of certainties. They came home confused and seared with doubt. They had to rebuild themselves.

If you could crawl within my own unburned skin, you too could see napalm as the emblem of our blind and sanctioned hatred. There, in the scars of our own wounded, you could see that whatever we invent to punish the enemy torments us as well. You can learn that lesson even from those who do not understand it. Sylvester "Will-they-let-us-win-this-time" Stallone, even though he spent the war in Switzerland, now becomes for the third time reborn in celluloid as Rambo. When we first met him, Rambo was most honest. What does he do at the climax of the first film? He blows up downtown. He rubs our noses in napalm.

I am an American and a veteran who rejects the resurrection of the Vietnam vet in the terms of civil theology. The friends I lost and the wounded who died were not sacrificed on an altar of certainty. They took upon their shoulders the cross of our countrymen's ambiguity; they took up the burden of their country and discovered what others were afraid to face. "We know that we are of God, and the whole world"— Russia, America, Vietnam, and the rest—"is in the power of the evil one" (1 John 5:19). My veteran comrades saw the worst face of this country and still loved it. Now I have come to know Soviet veterans of the Afghanistan conflict. They, too, feel alienated from their countrymen but at the same time deeply love their country. The love of these Soviet and American veterans, like the love of Christ, is an authentic love.

The Vietnam veteran can teach us how alienation, in a

Christian context, can be redemptive. The Russian Christian has learned the same lesson. Some Christians in the United States have just learned what the vets knew a long time ago—that one's country is not always faithful to one's hopes and ideals. Yet the alarm at this idea in Christian circles, the profound sense of betrayal and even the longing for halcyon days gone by, should be the object of examination. On the left and on the right, Christians expect too much of our country. For we have looked, falsely, to our state for a validation we should seek only in God. Our foundation, *themelios,* is in him alone. "But God's firm foundation stands," says Timothy, "bearing this seal: 'The Lord knows those who are his,' and 'Let every one who names the name of the Lord depart from iniquity'" (2 Tim. 2:19).

The world, unable to process the paradox of victory in defeat, seeks to "overcome Vietnam" and regard the experience of a generation as a syndrome. But the church can learn what so few Americans have understood—the real virtue of the veterans. Their virtue was of a tough and wiry kind. It rested in their willingness to take upon themselves the moral ambiguities that their nation thrust upon them. Those young kids from Kentucky and the draftees from New York, ducking bullets in the filmed interviews, confounded all the various commentators and analysts who beset them on all sides. The soldiers understood, instinctively, that the claims for the cause had nothing to do with them. But the people themselves, their fellow Americans, had everything to do with them. These young men and women committed themselves to each other, understanding full well that the morality of the conflict was a conundrum within an enigma, a morass within which self-interest and self-justification afflicted its supporters and opponents alike. At their best, they were selfless within a cause beset by selfishness.

Causes rooted in this world are beset by ambiguities. As Christians we have allowed ourselves to lose contact with that one sure hope Who binds us as one. This hope binds us together as Christians of the same nation. Should Jerry Falwell read this—and I choose him only because the media (a secular agent, after all) has dubbed him a "spokesperson for the Christian right"—at the deepest level I claim him in Christian

fellowship. Should the Catholic activist Dan Berrigan read this, I make the same claim, believing that the Christian left shares full responsibility for our mutual estrangement. To come to know the Christian mind of Russia is an enterprise that can challenge presumptions of both right and left, and pull them together in a fellowship that transcends nationality and political allegiance. For our fellowship in Christ is greater than the loyalty that binds us to any state.

"Christian Gothic"

Christian ethics is an ethics of possibility. Rules exist not to bind but to free. We Christians know from childhood what we are enjoined to do: "Love your enemies, and do good to those who hate you" (Luke 6:27). Yet, like the children we were, we still imagine that the enemy whom we are to love is indeed what the Greek text describes: *echthros*—"one who evokes our hate." We imagine (to borrow from the rock opera *Tommy*, which so many vets listened to in the late sixties) that our enemy will be the perfect incarnation of Tommy's wicked cousin—"the school bully, the classroom cheat," one whom we despise. Yet here we see the grand irony on which rests the moral brilliance of the gospel. For the injunction of Christ "implodes." It is self-fulfilling. In loving our enemy, we come to know him. In knowing our enemy, we come to understand her. Thus we see why knowledge of the enemy is a threat as long as we struggle to maintain the category itself. If we love that which inspired hatred, we cast out the hatred that first distorted our perception. Of course, our consciousness of wrongdoing, of hostility remains. But in coming to know what we hate, never again can we harbor the hatred that itself first twisted our souls. In loving "he-or-she-who-evokes-hatred," we no longer hate. The enemy, too, is transfigured.

It is one of God's grand plans that in trying to destroy that which we hate, we often destroy ourselves. The aftermath among us, in division and war, is but one example. Yet in coming to know that which we hate, we often find enrichment and even salvation. The good and evil within a nation,

like the good and evil within a person, often intertwine in a complex and tortuous maze. Christians in Russia are not, despite popular mythology, a ragged remnant cowering in the hidden forests of the Soviet Union. Using the statistical surveys of William C. Fletcher, whose exhaustive work is the most complete available on the subject, one can estimate that the number of believers in the USSR is easily 115 million, 70 million of whom are Orthodox Christians.[16] A leading layman of the Orthodox Church has stated that among educated youth who have passed through the system of Soviet higher education, 15 percent are believers.[17] Those Christians of all classes are intertwined throughout the tapestry of that nation. They ride the subway. They eat Sunday dinner with their relatives, many of whom are the Communists and unbelievers whom we most fear. Their mothers and fathers may be Communists. They give witness. Although we know little about them, they are as much our brothers and sisters in Christ as are the members of our local congregation. Although we never hear their voice, in the wisdom of their tradition we can encounter their spirit.

The classic portrait of Christians in Russia, that image of a tiny remnant, simply bears no relationship to reality. Russian Christians have suffered and continue to suffer from repressive policies, and American Christians must call attention to those policies and also to any relaxation of them. Yet Americans cannot deny that most Christians in the USSR have achieved a restless accommodation with the state. True, there are many national groups who long for religious self-determination. The Ukrainians, the very architects of Orthodoxy among the Slavs, have found themselves repeatedly absorbed within the Russian church structure, both under the czars and under the Soviets. And many Ukrainians long for an autonomous church. (Ukrainians are, all the same, a chief source of

16. Fletcher, *Soviet Believers: The Religious Sector of the Population* (Laurence, Kans.: Regents Press of Kansas, 1981).

17. Sir John Lawrence, introduction to the Keston Books Modern Russian Spirituality Series, in *An Early Soviet Saint: The Life of Father Zachariah,* trans. Jane Ellis (Springfield, Ill.: Templegate Publishers, 1977), p. x.

vocations for the priesthood in the "Russian" Orthodox Church: many a member of the Ukrainian minority has drawn an adult Russian convert to Orthodoxy.) Yet most Orthodox Christians in the USSR profess some sense of a "Soviet identity" and take pride in their country's achievements. It would be a mistake to see them as utterly segregated from those nonbelievers whom they love, even within the system that persecutes them. And even among the most unlikely atheists there is a certain pride in the church's existence. On one of my arrivals in the USSR early in the morning, a sharp-eyed customs officer spotted a few paper-printed icons I had brought as souvenirs for fellow Orthodox believers. He took them away and sifted through my luggage for more contraband religious materials. All the time he chatted cheerfully. "So you're a believer, are you? Well and good. My wife is a believer. I can't wait until Easter—you should taste her *Pascha.*"

My purpose is not to sanctify the Russians as a people or to excuse the legislation that allows a customs officer to confiscate religious materials from a visitor's luggage. But American Christians must acknowledge some parallels between themselves and Russian believers. Surely most American Christians, like their Russian counterparts, count non-Christians among the people they love. It is true that many Russian young people are not aware of the most basic Christian dogma. It is also true that in teaching Milton's *Paradise Lost,* I must routinely give a simplistic synopsis of the opening chapters of Genesis just to explain to my American college class the mysteries of Adam and Eve in the Garden. Our commercialized media preaches materialism far more effectively than does Russia's state-controlled communications system. The fact is that Russian Christians, like us, live and work, pray and suffer in this world. We face a common dilemma. Whatever the positions of our political systems, we are no more "Christian" as a people than they. As a matter of fact, as most Russians readily sense, we are very like each other as a people. While the nations that lie between us leave the churches empty on a Sunday morning, in Russia and America people begin once more to look to theology for meaning.

Unlike the cowed and ragged masses that our popular culture imagines, the Christians in Russia are a stalwart, strong community. I have seen them face the difficulty of living a lay Christian life in a manifestly secular society, and I have seen lessons that they can teach American Christians as we struggle to do the same thing. I have seen them worship God in a world that is at best disdainful of his existence. And in the most stirring sign of all, I have seen the Christian mind, sleeping throughout the Christian world, wake up and think in Russia.

One day a professor who teaches at the University of Moscow was crying on my American shoulder. "You don't understand," he complained. "Of the people I teach with, so few are believers."

"How many?" I asked, curious.

"No more than 30 percent," he asserted.

I teach in a formerly "Christian" college once affiliated with the United Church of Christ. Among my colleagues and friends, few are self-proclaimed believers. Fewer yet attempt to apply that belief creatively in their intellectual work or in their teaching. I know professors at Catholic colleges who count fewer believers in their departments than did my friend at the University of Moscow.

"When you're done with your lament," I replied, "give me equal time."

I, with all the Orthodox in your midst, am of the same religious tradition as millions of Christians in the Soviet Union. I have visited their country, taken sacraments and worshiped in their churches, and made close friends among them. I have visited their seminaries, monasteries, convents, and non-Orthodox churches. I am convinced that the church in Russia will usher in a new school of Christian thought. Russian Christians have explored the so-called "post-Christian era" and emerged leaner, but with a profound inner strength. Institutionally they have endured difficulties that our own institutions can anticipate. We can no longer afford to be ignorant of them. We must take Soviet Christians on their own terms.

Too often we make the mistake of regarding the Russians as possessing an existence only in relationship to our-

selves. Solzhenitsyn and other dissidents do not exist to vali-
date our own presumptions. The Christians in Russia do not
exist to "make us grateful" for our own freedom and pros-
perity. Nor do Communists exist as a divine foil for us to
prove our own virtue. In order to learn from the Christian
mind in Russia, we who approach the Russian church must
not allow a kind of condescension to infect our concern or
interest.

There is a genre of horror story cataloguing persecution
of Christians in Russia that I will call "Christian Gothic." The
covers of the books in this genre are sensationalized, with
bloody crosses superimposed over hammers and sickles, or
vice versa. The genre permeates all kinds of serial newslet-
ters in which tales of persecution and abuse accompany ap-
peals for funds to assist Russian Christians in ways often
vaguely described. What distinguishes the genre is that in the
lurid descriptions of suffering, the narrative seldom gives a
real portrait of the one who suffers. And never have I seen
the persecutors emerge as characters; Communists and un-
believers in these narratives are flat and devoid of personal-
ity, much like the evil Indians in the Puritan tales.

"Christian Gothic," like the Gothic genre from which
it springs, exists more to satisfy the reader than to describe
an object. It exists not to illuminate the *Russian* soul but to
reverberate with "civil theology" and thrill the Christian
psyche with terrors that Americans can only imagine. Such
tales provide entertainment and self-purging catharsis. But
they are devoid of *people.* On the other hand, in Russian sto-
ries that emerge from the civil war, the Stalinist Terror, or
the Gulag, the believers themselves can be portrayed as
flawed and sinning. The suffering victim confronts his or
her persecutors directly, unflinchingly, and with great com-
passion for the great trial that only the godless can bear—
their own unbelief.

In Russia there is a secretly circulated *samizdat* (self-pub-
lished) document, a hagiography of Father Zachariah (c. 1850-
1936), a monk who was forced to leave the disbanded monas-
tery of St. Sergius and who suffered many trials. The accounts
of his preaching are instructive:

Sometimes the elder would say to unbelievers: "Why have you forgotten, don't you know God, don't you see God? Believers see God much more brightly than you see the sun and the sky. But they see with their hearts. Well, you all know and see me, sinful Zosima, so at least be mindful of me and my love for God, and I will prostrate myself before the Lord and beseech him for you. O poor people, people who have taken leave of your senses, who has done you this harm? I think it is those who, bearing the outward image of a Christian, have spurned its powers; those who, calling themselves Christians, do not fulfil the fundamental commandment of love to one's neighbor. You see, the aim of the Christian life consists of possessing the Holy Spirit within oneself, so that the nature of man, changed by this Spirit, as though all enlightened and strengthened, may serve its neighbors in a feat of pure love in models of the loftiest wisdom and beauty."[18]

The elder confronts his antagonists as people, not as an impersonal force. The narrative is filled with anecdotes and portraits illuminating personality; it is not filled with the exquisite conventions of the Gothic romance.

The monk conveys a profound confidence, the kind of confidence inconsistent with "dirges for the Christian intellect." The Russian Christian mind can teach all Christians how to use their powers of intellect and sensibility to confront the "post-Christian" world in which we all live. It is not that the Christian mind must analyze the powers of the Spirit, but that Christians can be confident that the Spirit affects the process of analysis itself. The Orthodox mind in Russia can illuminate the deficiencies in the post-Enlightenment modes of thought most Western Christians have unconsciously adopted. In "categorical implosion," the injunction of Jesus initiates a process by which the "enemy" is itself destroyed. As a gift of grace, God can let our "enemy" help us to *think* once more as Christians.

18. *An Early Soviet Saint*, p. 51.

Chapter Two
IMAGE AND WORD

Icon or Idol?

Most Orthodox Christians, at one point or another in their lives, have the experience of taking a non-Orthodox friend to church. At no other point in American Orthodox life does the gap between the religious sensibilities of East and West appear more vividly. The more "homegrown" the Christian friend, the greater the chasm. I want to stress that this gap is one in *sensibility*, not necessarily in faith. Orthodox Christians with non-Orthodox friends will already be aware of some distance in doctrine. The Orthodox regard a common faith as a mark of their unity and hence do not "intercommune" with other Christians. Yet this does not prevent them, in most instances, from bearing goodwill toward other Christians. Friends in the mainstream churches are apt to be tolerant of differences in Christian expression, and evangelical or fundamentalist friends soon discover that we Orthodox too are, after all, profoundly "conservative" in dogma. Our theology is suffused with the sense of Christ's divinity. And, in the secular arena, we Christian laypeople find mutual allies in each other as Christians. This often leads to an invitation: "Hey, why don't you come and visit our church sometime?"

Back in the sixties, before Orthodoxy was even minimally known to most laypeople, I made friends with an evan-

gelical couple. Both had graduated from a solid, Christian college. Well read in C. S. Lewis and his circle, they were intrigued by my religious tradition, especially its Russian antecedents.

I enjoyed their company when they invited me to their apartment for dinner. Soon our conversation drifted to Christianity. They explained their mistrust of ritual and their membership in a "Bible-centered" local church.

"Yeah. We like the Bible too," I joked. I explained that the Orthodox see liturgy as a symphony of Scripture—a long, lyrical celebration of the Word.

"Would it be all right if we came to a service sometime?" they asked.

I paused for a moment. The only local parish here was very Russian—a small, emigré community made up of our "church in exile," a group dedicated to preserving the pre-Revolutionary czarist church intact. No English was sung in the liturgy. And there were no pews; the congregation stood, as they do in Russia, for the long liturgy.

"Sure—come this Sunday," I said. I hope it's not a disaster, I thought to myself. I hope they can understand.

A few days later we walked into the church, a little wooden structure with its bell ringing to announce the beginning of the liturgy. Some old ladies were already arriving. In those days our churches were filled with a certain kind of old lady—crinkle-eyed, smiling, capped with a babushka and wearing, usually, a dark coat or dress, whatever the weather. Russia is still filled with them—armies of them. Those who still had husbands (don't forget that our old ladies tended to lose their men in war) would bring them along. The old men usually had white mustaches.

These old ladies smiled at us and greeted my friend and her husband warmly outside the church. Good, I thought to myself. You can always count on our old ladies.

"I think I'm going to like this," said my friend's wife.

I hope so, I thought.

We entered the church. The first thing that is likely to strike a visitor to one of our churches are the icons: ranks of religious pictures—usually portraits of Christ, his mother, and

the saints—all arranged on a screen that separates the sanctuary from the rest of the church. Visitors wouldn't realize, until they had been to a number of our churches, that all over the world these pictures are arranged in a prescribed order. In this little church, they were all there reassuring me, from the smaller icons arranged on stands with lit candles being placed around them, to the large icon of Christ the Judge, the *Pantocrator*, looking down with admonishment from the ceiling. "What are you worrying about?" he said to me. "I'm here. They'll love it."

The liturgy was already underway. The choir was singing the Beatitudes, which begin every Slavonic liturgy. Russians especially like the Beatitudes: they articulate the acceptance of suffering that pervades the Slavic spirit. I notice in Russia especially that when the choir finally comes, in beautiful polyphony, to the last beatitude—"Blessed are you when men revile you and persecute you and utter all kinds of evil against you falsely on my account. Rejoice and be glad, for your reward is great in heaven" (Matt. 5:11-12)—there's a palpable stirring in the church. People "do their cross," or make the sign of the cross, when it is sung.

"When do you do that?" asked my friend's wife as she sidled up next to me. (This coziness is one of the many advantages of a pew-free church.)

"What?"

"Make that sign."

"Oh," I answered. "Mostly when we feel like it, I guess. It's kind of a 'body-prayer.'" Both of my friends were struggling to be comfortable, but I could sense the alienation. I didn't blame them for it. Obviously they had not had much experience of even Catholic or Episcopal worship.

"What is that woman doing?" one of my friends whispered. A young mother with two small children had just entered the church. Shepherding her boys toward the center of the church, she lit three candles off the flames of the others burning near a central icon on a stand. The icon was of Saint Seraphim, a kind of Russian Saint Francis.

"It's a sort of symbol of her prayer," I answered. I thought even as I spoke that the word "symbol" is so inadequate to

describe ritual. "Symbol" implies that a thing is *other* than itself; Orthodox Christian "symbols," however, *participate* in the reality they convey. But how could I express that? "She's probably lighting candles to represent her and the kids," I said, inadequately. At this point it struck me that in trying to explain these things, I was rediscovering them.

"What's she doing *now?*" The whisper was louder, and I sensed a feeling of near panic.

"Well, she's kissing it."

"Kissing a *picture?*"

"No," I said. "Kissing an icon. There's a difference."

The woman lifted her children to the image of the saint and they too, utterly without self-consciousness, gave it a kiss. Suddenly I was uncomfortable.

"Excuse me," I said.

In hosting my friends, I myself had neglected to perform the introductory act with which Orthodox begin a liturgy. I too made the sign of the cross and lit my candle and placed it near the central icon, and I too reverenced it with a kiss.

This act, which comes so naturally to Orthodox Christians, is emblematic of an estrangement between us and that vague entity that Orthodox conveniently refer to as "the West." We take images seriously. It is not, as many people think, that we are primitive in our practices, like unto idolaters who hold before them graven images. It is that we see the image itself as an emblem of Incarnation. Christ took upon himself flesh, the "stuff" of this world, and thereby redeemed us. He called upon us, as we see it, to take the flesh, the "stuff" of this world, and sanctify it for his service. The icon is fashioned, in a prescribed way, of wood and paint. It is an "incarnation" of Christ's image and that of his saints. It is a sanctification of materiality, meant to remind us of its Prototype, "the image of the invisible God, the first-born of all creation" (Col. 1:15). Icons "image forth" the majesty of God, just as we are called to "image forth," in turn, Christ our Savior.

Unfortunately, I didn't have time to go into all that. By the time I returned to our place in church, my friends smiled back at me politely. But I knew I had lost them. Clearly writ-

ten on their Western faces was the conviction that, however beautiful the services of the Orthodox might be, we were all profoundly "foreign." ("I thought you said she'd like it," I said to the icons. But they looked back, impassively, as icons should. The dilemma was mine to unravel.)

Years later a Christian Reformed friend went through a similar experience when he visited my church. He too asked a lot of questions. By this time I had been through graduate school—perhaps too recently through graduate school. If I had nothing else, I had words. Lots of words. I quoted lyric phrases from one of the best short books on liturgy, Alexander Schmemann's *For the Life of the World*. I lifted chunks of discourse from John Meyendorff, a historian-theologian whose revival of Byzantine thought had helped me make it through the meaninglessness of Vietnam. But words made no impact on my friend. "I don't care *what* you say," he finally responded in all frankness. "To me, it looks like idolatry."

The answer to this gap between the Christian East and the Christian West lies not in words, for words themselves but "image forth" or express an understanding that is already there. It lies in the act of understanding itself. Each Christian must encounter the Word of God in the garb and shape of his or her own distinct language, with its own nuance and shading. The meaning of words is necessarily invested with the images that those words suggest.

I have been trained in and teach the history of the English language. In the various versions of our gospel—from the Old English glosses through the Wycliffe version, the King James, and onwards—we can perceive hints and colorations of insight, each different from those contained in the last. When I read a translation in semicolloquial modern English, I can hear echoes of modern American discourse. When I read the gospel in Russian, I see the "Slavic stamp" upon the Word. For this reason, of course, scholars return in study to the original Greek and Hebrew, but their own culture is visible in the commentaries they write thereafter. There too they knead and ply the Word until they sculpt it back into terms that a specific audience can understand. Language is not, of itself, an absolute medium. Nor is the culture within which

we receive it. Orthodox sensitivity to images creates a "context" within which the Orthodox understand the Word.

On one level, Eastern and Western Christians experience God's presence in different ways. The "contexts" or surroundings within which they worship him differ as well. If Orthodox churches look ornate and peculiar to Western Christians, so also do Western churches look stark and peculiar to the Orthodox. When I first showed my five-year-old son a Baptist church, he was impressed. "Wow!" he said. "Is this where they play basketball?" My son hadn't yet, in his own mind, seen the *church*.

Christians of different perspectives, if they both accept the same premise, can discuss an issue together. However, between Orthodox and non-Orthodox, and between the American and the Russian Christian, the premises are different. Before an analysis can deal with the issues the two minds hold in common, we must first come to perceive how those issues are understood. For it is through two different "avenues of understanding" that the minds of East and West, of Russia and America, come to religious consciousness. Attitudes toward the icon, and toward the broader issue of imagery in general, are central to that difference.

"Take Up and Read!"

If Russians and Americans approach Christian imagery differently, that does not mean that the American Christian world is devoid of images. A simple stroll through the spreading institution of the Christian bookstore reveals a multitude of symbols. Scripture passages, in innovative print and in bold graphics, can now be stuck into books, hung on the wall, stickered on a window, or magnetized to the refrigerator. In this form Scripture is more an emblem than a "text." Bibles themselves, which contain the Word, come bound in denim or moroccan leather, and can be "personalized" with the name of the purchaser's choice in gold leaf on the cover. One can even buy a cross to jingle with the change in a Protestant pocket (or even to hang around the Protestant neck).

And there is usually another interesting image available near the cash register: an American flag for the lapel. And indeed, none of us is adverse to raising, saluting, folding, draping, and reverencing the American flag, amid great ceremony, as a symbol of our love for our country, even in a manifestly religious context. (Shortly after the October Revolution of 1917, some well-meaning Orthodox parishioners in the United States placed the red Soviet flag in the sanctuary right next to the red, white, and blue. They did not fully understand the offense they caused.) Americans are like any other cultural group in that they exempt their own image-making from suspicion because they understand its context. But they, like the friends I took to church, are apt to react against the images of others, whether they be portraits of Lenin or icons that old ladies kiss.

The Western mind is just as "image-producing" as the mind of any other culture, yet Westerners think differently about the images they produce. The act of understanding in the West has tended to be bound within the context of the book. From the earliest days of Christian reflection, we see an established Western paradigm in the *Confessions* of Saint Augustine. The story of Augustine's conversion creates a model that, consciously or not, his successors in the Western church tended to follow. His mind was drawn to Christ; nonetheless, Augustine long resisted the attraction. His attitude toward faith was parallel to his attitude toward sex: "O God, give me purity—but not yet, not yet!" But there came a day when, sequestered alone in his garden, he had Saint Paul's Epistle to the Romans at hand, and he had one of the most famous self-confrontations in literary history:

> Suddenly I heard a voice from some nearby house, a boy's voice or a girl's voice, I do not know: but it was a sort of sing-song, repeated again and again, "Take and read, take and read [*Tolle lege, tolle lege*]." I ceased weeping and immediately began to search my mind most carefully as to whether children were accustomed to chant these words in any kind of game, and I could not remember that I had ever heard any such thing. Damming back the flood of my tears I arose, interpreting the incident as quite certainly a divine command

to open my book of Scripture and read the passage at which I should open.[1]

When Augustine took up that book and opened it to Romans 13:13, he created a primary epistemological model, a blueprint for understanding. In the Western encounter with the Word of God, Christians relate to a text. The central quest is to wrestle meaning from the Book.

This Augustinian model had a powerful influence on the way people envisioned the process of meaning. The Middle Ages, for example, had its own counterpart to what we might call "psychological insight." Medieval literature abounds in "dream narratives," in which a dreamer falls asleep and discovers a rich interior world that conveys somehow the *real* nature of things. Significantly, the dreamer typically falls asleep with an open book in his or her lap. For example, in the opening passage of *The Book of the Duchess,* which launched his literary career, Geoffrey Chaucer employed a scenario well known to his audience:

> So whan I saw I might not slepe
> Til now later this other night,
> Upon my bed I sat upright
> And bad oon reche me a book,
> A romaunce, and he it me tok
> To rede and drive the night away.[2]

In short, Chaucer liked to read in bed. And reading becomes the act by which he most makes sense of the world—the reader becomes a dreamer, and the terms of the text reshape the inner landscape of consciousness. When educators now lament our loss of a common body of classics and complain that teachers can no longer assume that their classes have read the same (or any) texts, they prove how central the text is to meaning. They fear meaning itself will be lost, just as some educators fear that the spreading ignorance of Scrip-

1. *Confessions of St. Augustine,* trans. F. J. Sheed (New York: Sheed & Ward, 1943), p. 178.
2. *The Riverside Chaucer,* 3rd ed., ed. Larry D. Benson (Boston: Houghton Mifflin, 1987), p. 331, ll. 44-49.

ture will undermine cultural as well as religious meaning. This problem constitutes an intellectual crisis precisely because it erodes the foundation of meaning as the West has perceived it.

From the earliest medieval romances to the great Reformation works like Spenser's *Faerie Queene* and Bunyan's *Pilgrim's Progess,* the reader learns through the text how to approach the phenomena of this world. Truth comes through the book, and so also does deception. When Spenser's Red Cross Knight, the champion of truth and the true church, battles the monster Error, it is significant that she vomits forth gobbets of undigested books and pamphlets. The book begets illumination or perdition; we can "read" experience, like we "read" the book, in order to discern meaning. And the greatest meaning of all, the Word of God, comes to us bound between two covers. The Protestant mind, whether or not it approaches the Word of God through the filter of "inerrancy," imagines the Word as embodied within a text, a book, a bible. This is a cultural inheritance.

The Orthodox mind also gives primacy to the canonical, duly "handed-down" and biblical Word. If Westerners bind their Word in denim or morocco, the Orthodox lift theirs—clad in gold and, of course, icons—before the assembly of worshipers. Their priests then chant a single word: *Sophia* in Greek, *Premudrost* in Slavonic—in English, "Wisdom." But that wisdom comes in the context of the liturgy, the Word communally celebrated rather than individually encountered in the text. The Book is the repository of meaning, yet the Book is regarded and treated as if it were itself an image begetting images. The Book not only reveals but is itself "image-producing," transforming dead matter into the reflected image of Jesus Christ.

If the Orthodox kiss icons, they kiss the Bible as well. (They also kiss each other. One Mennonite visitor to my church announced, "I haven't been kissed so often by my own mother!") In Orthodox cultures the encounter with God and the flash of insight that conveys religious meaning occur not so often in private reflection as in encounter with another. That encounter is sometimes expressed in dialogue with a

spiritual elder or holy individual who has "absorbed" the Word and can now reflect it. But often the encounter is silent, like the icon itself. It emerges through the act of embrace. To embrace another, even a sinner, is to encounter directly the image of Christ. In Dostoyevsky's *Crime and Punishment*, the bloated drunkard Marmeladov describes his wife's conflict with his daughter Sonia. In a starving and miserable household, the woman hurls an insult at her stepdaughter: "Just look at her . . . eating and drinking, and keeping warm, the lazy slut!" But after the innocent girl walks out into the night, selling herself for thirty rubles in order to feed the family, she silently hands her earnings to the stepmother who had wronged her. The drunkard describes his wife's act of repentance:

> And it was then, young man, that I saw my wife, also without uttering a word, walk up to Sonia's bed, go down on her knees, and kiss Sonia's feet. And the whole evening she was on her knees, kissing Sonia's feet and refusing to get up. And eventually they both fell asleep in each other's arms— the two of them. Yes, sir, the two of them, and me lying there drunk as a lord![3]

Sonia, even in her sin, becomes an icon of the Christ whose selflessness she reflects. Similarly, in *The Brothers Karamazov* Christ himself responds to the long and cruelly intelligent discourse of the Grand Inquisitor silently, with a single act of embrace. Humanity itself is an image of the Creator, and the human in loving, Christ-like action is an icon of the Christ he or she reflects.

These are the terms in which the Orthodox Russian mind is apt to "translate," imagistically, the Word of God. The East and the West clothe the Word in different manifestations. When a Western Protestant Christian like Francis Schaeffer, for example, takes up the passage "Take the helmet of salvation, and the sword of the Spirit, which is the word of God" (Eph. 6:17), he automatically envisions the Bible as that

3. Dostoyevsky, *Crime and Punishment*, trans. David Magarshack (New York: Greenwich House, 1982), p. 35.

"Word." Of course, when Paul wrote the passage he envisioned neither the black-bound, dog-eared King James edition nor the golden, gem-encrusted text we Orthodox carry in procession before we read. "Word," *rhema* in Greek, has the distinct sense of "utterance," "meaning-as-it-is-proclaimed." There is nothing at all static or established in the term: the *rhema* unfolds in the process of revelation. This is the "word" Paul used to convey his sense of "Word." Christians color the term with their own understandings of meaning.

Biblical meaning takes shape in our minds, Orthodox and Reformed, in different ways. The Protestant mind concentrates on the message itself, the concrete word that is the utterance. The Orthodox mind takes into account a more peripheral vision: the Orthodox embrace the surroundings as well, the context within which this utterance is proclaimed. And for the Orthodox, the context includes the full range of the senses that shape meaning—sight, sound, smell, taste, and touch. In liturgy, which employs all these senses, the Word emerges dialogically rather than in individual, private encounter. The community within which the Russian Christians live and the tradition which passed that Word on to them are the vessels wherein they receive and within which they understand that Word.

The American Protestant mind is culturally and literarily disposed to envision the Word in terms of a book, the "text" of creation. The Russian Orthodox mind, through the veil of its own culture, interprets that Word in the light of the images that reflect it. American Christians obey the Augustinian injunction "Take up and read!" Their Russian counterparts are apt to concentrate upon the insight that follows the imperative "Look up and see!"

The Mind's Eye

Moderns imagine the cold war to be no older than a generation. Yet the distance between Russia and the United States can be too easily assigned to recent political differences. The

secular intellect, when it excludes theological categories, is as limited in its perception of politics as it is in its analysis of culture. The estrangement of the Eastern from the Western mind has gone on for centuries, and insofar as each culture has partaken in its religious sensibilities, the estrangement between America and Russia still emerges even in the attitudes of each toward the religious expression of the other.

Russians and Americans differ profoundly in the way they view the imagination. These differences emerge in almost every aspect of Russian-American relations, but they began long ago in an East-West dispute over the role of the image in worship. If these differences seem esoteric or even academic, it is only because the role of religion in shaping the imagination has been reduced by a secular culture that no longer feels its influence. Christians, however, can encounter these differences at their roots.

Most Americans can appreciate the architectural and artistic splendor of Russian churches, but many harbor natural reservations about Russian reverence for the image. "Humbug," says the skeptic. "Trust in the Word is well and good. But look at all the superstition these Orthodox tolerate. People bowing and scraping all over Russia and lining up for bottles of holy water. . . . Let's get rid of all the nonsense. Why can't they just chuck all the pictures and blessings and other accretions and stick to the basics?"

This attitude, though simplistic, is not trivial. It has a venerable history, and it has been present in the West ever since, 1300 years ago, the Eastern Church declared its doctrine on icons. After a protracted civil war in which the Byzantine emperors themselves often warred against religious images, the Second Council of Nicea (the seventh ecumenical council) met in 787 to proclaim the mind of the church on the issue. The text of the council's declaration makes it plain that to the Eastern mind, the text and the image, the idea and its material expression, are profoundly interrelated:

> In summary, we preserve all the traditions of the Church, which for our sake have been decreed in written or unwritten form, without introducing an innovation. One of these

traditions is the making of iconographic representations—
being in accordance with the narrative of the proclamation
of the gospel—for the purpose of ascertaining the incarna-
tion of God the Word, which was real, not imaginary, and
for being of an equal benefit to us as the gospel narrative.
For those which point to each other undoubtedly mutually
signify each other.[4]

The strength of the declaration should be seen in its
assertion of equivalency. Images—a material expression of
what the narrative contains—are of "equal benefit" only be-
cause they signify the gospel.

Christianity did not have to wait for a Reformation to
find objections to this perspective. Suspicion of the East has
a long vintage, and it was the Western emperor Charlemagne
who in the eighth century found the defense of icons as ob-
jectionable as any modern Western skeptic would. Char-
lemagne was already irritated with the East for his own politi-
cal reasons. (The Byzantine empress had apparently jilted
him.) But he reserved his irritation for this issue, and a
phalanx of his court scholars wrote up grounds for his ob-
jections. In this treatise, known as the *Libri Carolini*, we find
a fascinating insight into the Western attitudes toward East-
ern religious thought. Most of these objections resonate with
issues still important in contemporary encounters with the
Russian mind.

The *Libri Carolini* displays a great deal of skepticism
about the importance of the image in the Eastern empire. Like
many misunderstandings between East and West, this one
was assisted by a bad translation of council proceedings. But
the translation merely confirmed suspicions that already ex-
isted. To begin the document's argument against the East,
Charlemagne's scholars made a distinction between the facul-
ties of the "interior" and the "exterior" person. Clearly, said
these scholars, it is the "interior person" who is made in the

4. "Definition of the Holy, Great, and Ecumenical Council, the
Second in Nicea," translation found in Daniel J. Sohas, *Icon and Logos:
Sources in Eighth-Century Iconoclasm* (Toronto: University of Toronto
Press, 1986), pp. 178-79.

image of the Triune God. To confuse this spiritual quality with the gross, bodily "exterior person" is to make the same mistake the East did. To give too much attention to the outward image is to confuse the corrupt Adam with the redeemed Christ.[5] Right-thinking Christians must employ the *oculus mentis*, the "mind's eye," as opposed to the fleshly eye of carnal materiality, to keep the two worlds distinct and separate. The "mind's eye" is the equivalent of our modern concept of "common sense."

Thus this eighth-century text began a refrain that often recurs in the relations between East and West. According to this view, the Eastern mind confused the material with the spiritual. The East had seen the artist as one who "incarnates" the Word of God in culture. Whereas the Byzantines cast the artist in a priestly light, the *Libri Carolini* insisted on sharp (and sometimes artificial) distinctions. No artist, who was in effect but a craftsman, could occupy the place held by a priest:

> The mind's eye cannot discern how much distances the sacrament of the Lord's body and blood from the images depicted by the iconographer's art: while the one is effected invisibly through the work of the Spirit of God, the other is visibly produced by the hand of the artisan; the former is consecrated by the priest invoking the Divine Name, the other is painted by the artistry of a human agent. (II.xxvii)

The Western authors thought, then, that the East had invested art and the world of the imagination that it tapped with an unwarranted sacramentality. Religious art might be useful; it might have didactic function. Essentially, however, creating such art was no different from other human activities. Encounter with God was, through the "mind's eye," basically intellectual and spiritual in nature. The images belonged to the corporeal world of humans; what is more, the respect that the Byzantines paid them was of a kind inappropriate for God.

5. English translation of *Libri Carolini*, Patrologiae cursus completus series Latina, 221 vols., ed. Jacques Paul Migne (Paris: Garnier, 1841-1864), vol. 2 of *Carolus Magnus* (vol. 98 in the series), 941-1246 (I.vii). Subsequent references in the text cite chapter and heading of this Latin edition.

"God is to be adored," concluded the text, "but he is not to be embraced" (IV.xxiii). Apparently Charlemagne was just as disapproving of the kissing of an icon as any Southern Baptist would be.

And there is indeed a continuity between this ancient controversy and the world that Americans and Russians share. John Calvin encountered an edition of the *Libri Carolini* when he was composing his *Institutes of the Christian Religion.* Not only did he approve of the terms of the argument he found in the treatise, but there is evidence that he shaped his *Institutes* in accordance with it. According to Calvin, the text can have no equivalency with the image in imparting meaning. Even the world itself, in Calvin's eyes, conveys itself not as an image but as a text: "There is no part of the world or its creatures so small, so apparently insignificant, that it does not contain some perspicuous mark of divine nature."[6] As Thomas Luxon observes in his discussion of Calvin, Calvin sees God as having inscribed himself upon the cosmos.[7] Reading is a central metaphor for discerning meaning in Calvin's world.

This thread of iconoclasm running through Western history has affected attitudes toward the religious image but not the secular. The "mind's eye" that carefully contains the religious image within its proper sphere can surrender the image to the secular world. The Byzantine emperors who fought against images had the murals of Christ painted over with images of themselves. Charlemagne viewed the cross as a kind of "civic-religious" symbol. "It is no compagination of colors which our troops follow into battle," declared the *Libri Carolini,* "but the cross is the standard of our king, and upon it our armies cast their eyes" (II.xxviii). The unadorned cross superimposed upon the American flag, then—a symbol which I have seen in the Christian bookstore, and which was imposed upon the flyleafs of the New Testaments given to all inductees in Detroit on that day in February 1969 when I took

6. *Institutes of the Christian Religion,* 6th ed., trans. John Allen (Philadelphia: Presbyterian Board of Christian Education, 1930), 1.5.1.

7. Luxon, "Calvin and Bunyan on Word and Image: Is There a Text in the Interpreter's House?" in a forthcoming issue of the journal *English Literary Renaissance.*

my oath to defend the United States—is compatible with Carolingian theology. Our monuments in Washington, in the shape of Greek temples, commemorate our civic heroes with images. And in the funerals of fellow veterans who died in the war, I have seen parents who would never embrace an icon hold and kiss the folded flags that draped the coffins of their sons.

These parallels are meant not to critique the West but to show that the materiality of the image does indeed find its way into the American consciousness. But that consciousness rather sharply delimits the material from the spiritual frame of reference. Like the authors of the *Libri Carolini*, the American religious mind imposes a separation between the spiritual and the material, the "interior" and the "exterior" person, and the realms of church and state. Americans exhibit a tolerance for imagery and the realm of the "cult" in secular and civil-secular symbols like the flag and the "cross and flag" with which they might not feel entirely comfortable in a religious sphere. Thus, in a world replete with the images that shower down upon us from billboards, pour from the television screen, adorn our cities and public parks, and inhabit our entire interior landscape, the religious image has little power of itself to claim its own dominion over the imagination.

The history of the Russian Orthodox Church has given it a solution to this problem. Easterners, and Russian Christians as well, have been labeled the "dreamy mystics" of the Christian world. Americans have criticized the Russian church for its susceptibility to state control. Yet in acknowledging the relationship between spirit and matter, between spirituality and materiality, the Russian Orthodox mind can make an encompassing claim upon the imagination. To segment one part of the mind or of experience as "religious" and another part as "secular" is impossible in a system that admits of no imaginative separation between the two. Thus Orthodoxy in Russia spawned a culture and a vast array of art and also a way of looking at the world that continually confront even the modern, secular mind with the image of God. The church need not claim dominion over the mind when the imagination will draw the mind, of its own will, to the vision that will

liberate. The church need not deny or escape the realm of materiality when the gospel can *transfigure* materiality and free it to reveal the Creator.

When the church confines its territory to the heavenly realm alone, it surrenders the material world totally to the secular powers. Those powers, of course, have legitimate claims: they can govern and legislate, and within limits they can command obedience and loyalty. Christians would agree, however, that the church has a claim upon the mind as well as the soul. And the mind, resident in the head of flesh and bone that encases it, must deal with the material world that it interprets and shapes. Russian Christian thought, like the Orthodoxy of which it is a part, has a profound respect for the material world, and that respect is a part of its power.

John of Damascus was an Orthodox theologian belonging to the era of iconoclasm. Residing among those Muslims who were absolutely opposed to imagery, he had to come to special terms with the issue. No doubt his debate with the Muslim scholars of his day honed his arguments for those Orthodox who faced the iconoclasts. Confronting the issue of the uniquely "spiritual" nature of textual interpretation, John asked a pertinent question: "Is not the ink in the Most Holy Gospel Book matter?" In John's view, materiality calls forth the Incarnation of Christ. The Bible, written in human language, is itself "enclothed" in a material frame of reference: human speech. In creating and then redeeming this world, Christ has charged it with meaning. And meaning, according to John, is far too rich a phenomenon to be confined to the text: "For just as words edify the ear, so also the image stimulates the eye. What the book is to the literate, the image is to the illiterate. Just as words speak to the ear, so the image speaks to the sight. It brings us to understanding."[8]

To give this parallel place to sight in the process of coming to know God grants a special role to that material world that the eye sees. Thus the "mind's eye" need not retreat alone into the confines of private consciousness: it can look out into

8. John of Damascus, Apology I:15, in *On the Divine Images: Three Apologies against Those Who Attack the Divine Images,* trans. David Anderson (Crestwood, N.Y.: St. Vladimir's Seminary Press, 1980), p. 25.

the world, discover the manifestations of God in materiality, and thereby assist in the *transfiguration* of this world into the kingdom of the Father.

The Kinetic Icon

In modern film there are two powerful examples of the difference in religious sensibility between Russia and the United States. The first is *Martin Luther*, a film produced in 1953, which frequently finds its way into many Sunday schools during the celebration of "Reformation Week." In it the young actor Niall MacGinnis, smoldering with zeal as a young Martin Luther, sparks an image that still exerts its power in the mind of young Protestants. In a film replete with images of the "closed book," Luther walks forward to touch, tentatively, a chained Bible. Soon the Book is liberated as Luther mounts a pulpit and stands before the open Bible, proclaiming its message in his (the actor's) polished voice. Luther emblematically breaks those chains, and in the minds of succeeding generations they clatter to the floor forever.

In truth Luther was no iconoclast: he saw images as perfectly in accord with the teaching mission of the church. Nor was he given to encasing the Word within a "text." He saw his mission as one of liberation through proclaiming the gospel in oral speech. In fact, as the Reformer himself professed, he wanted to "free" the gospel from its textual form precisely to launch the Word of God within a community:

> And the gospel should really not be something written, but a spoken word which brought forth the Scriptures, as Christ and the Apostles have done. This is why Christ himself did not write anything but only spoke. He called his teaching not Scripture, but gospel, meaning good news or a proclamation that is spread not by pen but by word of mouth.[9]

9. "A Brief Instruction on What to Look For and Expect in the Gospels," in *Word and Sacrament I*, vol. 35 of *Luther's Works*, ed. E. Theodore Bachmann and Helmut T. Lehmann (Philadelphia: Muhlenberg Press, 1960), p. 123.

Luther's task, then, was as social as was Calvin's in a sanctified Geneva. Luther saw "the Book" itself as a confining entity; the proclaimed word has life and resonance within the community that hears it and puts it into practice. Yet in the way the modern post-Enlightenment audience so often receives and interprets the Reformation, it is precisely the opposite that occurs. The film *Martin Luther*, discriminating in its discourse, nevertheless projects a book-centered, popular image. The Book, once chained within a cathedral, is now placed instead into the hands of thousands of "interpreting selves." In Christianity's popular culture, Luther mounts the pulpit not so much to unchain the Bible and proclaim the Scriptures as to pass out Bibles to the crowd. As a result, even for those who believe, faith can become a matter of "personal choice," of individual rather than communal conscience.

A Soviet film directed by Andrei Tarkovsky creates an interesting parallel to *Martin Luther*. Produced in 1966, *Andrei Rublev* portrays a famous medieval Russian iconographer who created many of those icons most beloved by the Russian people, believers and nonbelievers alike. The film celebrates his life, using a masterful technique—employing dark, "icon-like" concentration on single figures and group tableaus—to portray a Rublev who absorbs the sufferings of his people. The film focuses on the sorrows of Russia under the Tartar-Mongol yoke, and as the story progresses Rublev broods more and more deeply over Russia's pain. The actor Anatoli Solonitze portrays the iconographer as an acutely sensitive but passive recorder of events. He emerges in the foreground of those mass scenes we see in so many Soviet films, or appears as a shadowy figure lurking within them. In the elongated, pain-etched lines of his face emerges the collective suffering of his people, and in the drawn, spiritualized outlines of his icons emerges the tale of Russia itself. In the idiom of the Russian Orthodox, Rublev's mission is to write (*pisat'*) his icons in testimony to the people who inspire him.

This Soviet film, not released in the USSR until 1971, is a favorite of Russian believers, not only because it deals with a religious subject but because it makes a theological asser-

tion: The people of God suffer in communion with their Creator. Official Soviet critics attacked the film because it failed to show Rublev's "commanding genius." Yet Tarkovsky grasped an Orthodox theological insight. The iconographer is but a candle, allowing the believer to see what is already there.

The theology of the icon, which seeks to "illumine" the senses and thereby the imagination, can also prepare the believer to look outward, even into the secular world, to find the image of the Creator. This claim on the imagination will allow the very act of interpretation, the structures of meaning that the Christian assigns to the world and experience, to transfigure the culture of his or her people. Russia's church may seem weak indeed to the Western Christian because its external mission has been severely limited by the state under which it has lived. But its developed theology, with the primacy it gives to the image, has allowed the Russian Orthodox Church to exert a tremendous power over the Russian imagination.

In czarist and Soviet times, the state has attempted to tap this power. Americans are well aware of the cruelty and arrogance with which Soviet officials have sought to eliminate religion. They are less aware of the fantastic lengths to which the czars went in seeking to put religion at the service of the state. Yet when the secular realm became enmeshed with the religious, when czars attempted to assume control over the religious imagination, the results tended to undermine the purpose.

Peter the Great, for example (though the American TV mini-series lionized him), sought to place the church at his disposal. In building the cathedral at St. Peter and Paul Fortress to celebrate his own power and glory, the czar commissioned the famous icon on the central icon-screen. Yet Peter was forced to borrow Christ as a metaphor for his own power: on that screen Christ himself reigns, although adorned and arrayed as emperor and czar. Peter was "absolute," of course, only in his own deluded imagination. Long after he and his successors have been tucked into their elaborate sepulchres, Christ continues to reign, czar-like, in the heart of the Russian believer. Christian power over the image, over the imagination, has continually preserved the mind of the

Orthodox believer, if not his body, from the absolute power of the state.

The form of the placid icon is but a prototype for the transfiguring power of the illumined image over the mind. The icon's form is static and unchanging, faithful to a body of convention that preserves the mind of the church but that discourages too much interpretive "individuality" on the part of the artist. But if the form is static, the effect is not. The icon's intent is not static but kinetic, moving and prodding the Christian imagination to shape and interpret the world anew. The icon, material expression of an immaterial truth, moves the Christian to enter into energetic dialogue with the material, physical world. The kinetic icon of Christ exerts its dominion over the Christian imagination, moving it to engage the culture of which it is a part and transfigure it.

The entire history of the contemporary Christian movement in Russia is a testimony to the power of the image in the Russian mind. A wide range of Christian activists began their journeys as secular people who at first sought merely to probe more deeply into the heart of Russian culture. Yevgenii Barabanov was a young art historian; the icon-begotten art of Russia relentlessly made its claim upon him. It "converted" his imagination. Tatiana Goricheva was a student of philosophy. Her simple appetite for meaning beyond the self-enclosing limits of dialectical materialism led her to the roots of faith in her own people. Vladimir Poresh was a student of film at the University of Leningrad. His viewing of Roberto Pasolini's *Gospel of St. Matthew* led him from the screen to the kinetic icon of Jesus Christ.

These three figures are but emblems of an entire movement throughout Russia made up of those who rediscovered their church. They see an intellectual landscape devoid of belief contrasting sharply against a Russian skyline still crowded with crosses and onion domes. Thus an artistic tradition so resonant with faith but serves to highlight an emptiness within. The result, as some describe it, is a sharp sense of guilt at the loss. The poet Irina Ratushinskaya, writing with all the sharpness of her generation's conscience, captures the feeling. In one of her poems, a group of Russians enters an

abandoned church near Moscow, "door wide open, cupola smashed." There they confront a defaced icon of the mother of God, shielding her son in her arms:

> And we stand before him, as clay
> created in his likeness, cursed,
> on our temples: hammering,
> sensation of collective guilt.
> How long must we—on crosses,
> executioner's blocks—
> through fire of maternal alarms—
> cleanse His image of shame
> of ashes, scourged within us?
> How long wash this earth
> of force, falsehood?[10]

The liberation from falsehood, from a sense of lies (in Russian, *ot lzhi*), is a pervasive quest among these young seekers, just as it is a pervasive theme in the current movement toward *glasnost'*, of which they were the precursors.

This awakening of the Christian mind in Russia did not occur in the past several months or years. It was nurtured, often in secret, by meetings and assemblies of people like Goricheva, Poresh, and many others—people who sensed a sleeping presence in those images that their culture had preserved for them. Since the mid-1960s, such discussion groups had been meeting throughout Russian cities and towns. In 1974 the believer Alexander Ogorodnikov, working with many others, founded one such group called the Christian Seminar. According to several participants with whom I have spoken, many who attended the Christian seminars described themselves as seekers rather than believers, people who were

10. Untitled poem in dual-language edition entitled *Beyond the Limit: Vnye Limita* by Ratushinskaya, trans. Frances Padorr Brent and Carol J. Avins (Evanston, Ill.: Northwestern University Press, 1987), pp. 20-23. The author, in prison for her Christian activism, was denied writing materials. Ratushinskaya preserved the original lines of many of these poems by etching them in a bar of soap in her prison cell, committing the lines to memory, and then washing them away to prepare the way for the lines that would succeed them. See the foreword of this edition for a discussion of Ratushinskaya's work.

culturally attracted to the richness of Orthodoxy but not themselves Christians. This interest, however, was the catalyst for a faith that had to sustain its members when, beginning in the summer of 1976 and ending only recently, participants were singled out for ruthless repression.[11]

It is impossible, of course, to document the numbers of these Christian intellectuals. Foreigners encounter them only in major cities; I have met some Christian activists from the provinces, a few from deepest Siberia, who made brief sojourns to the city only to assemble what Christian literature they could for groups back home. What distinguishes the entire process of this seminar movement, however, is its inherently domestic nature. Frequently labeled with the negative, reactive term "dissidents," in reality these individuals affirm rather than negate. They affirm religious idealism, traditional moral values, the deepest love of their country and its people. Dissatisfied with the limits of a narrowly defined materialism, they find themselves exploring faith as they explore more deeply their own Slavic literature, art, and music. For them the church has become a spiritual necessity because in the church they find a liberation of imagination and the culmination of culture.

The new openness in the Soviet Union, in recent days somewhat uncritically celebrated in the American press, did not spontaneously appear. Its way was cut through a thicket of resistance by the sharpness of human longing. Leaders in that quest have been young Christians with a relentless appetite of the imagination. This hunger and enthusiasm for culture marks the new Christian activism in the USSR. The best films, those that penetrate the external forms of socialist realism with flashes of religious analogy or insight, attract believers. Bookstores are the haunts of Christian intellectuals, who scan the shelves for the newest studies of Byzantine history

11. For a discussion of the Christian Seminar, see Jane Ellis, *The Russian Orthodox Church: A Contemporary History* (Bloomington: Indiana University Press, 1986), pp. 381-91. For a general discussion of young Soviet believers, see Anatoli Levitin, "Religion and Soviet Youth," *Religion in Communist Lands* 7 (1979), pp. 232-37.

and Russian culture. Music, art, and poetry draw believers and those hungry for belief.

Scholars who illuminate the Christian mind are the celebrities not only of believers: long before *glasnost'* they also earned the respect of the broader Soviet community. Dmitry Likhachev, a venerable Russian medievalist, recently published a bold attack on the state's policy toward religion in the cultural journal *Literaturnaya Gazeta.* S. S. Averintsev, a Byzantinist who explores religious consciousness, has been given permission on occasion to attend meetings and deliver lectures abroad. When either Christian scholar gives a lecture exploring the religious mind in Russia, people pack the halls. The faces of listeners, like the audience of a stirring play, strain and then relax with emotive participation; the air is alive with an excitement that so seldom enters the American academy. The cultural activists in the Russian church believe that their evangelical mission is not simply to spread the knowledge of Christ but to convey the imaginative vision that Christ inspires. No censor yet invented in any culture can touch the act of interpretation itself.

The new Russian Christians have been engaged in a cultural mission. This is what disturbed the authorities about the Christian Seminar, and this is why they repressed it. Now, perhaps, the quest for freedom from imaginative constraints has entered the Soviet mainstream. The extent of the new liberation has yet to be seen. Yet it is to the credit of so many young Christian thinkers that they anticipated the trend—indeed, in many cases, they led it. They fulfilled their Christian mission within their own culture. Vladimir Poresh (recently released from confinement) conveyed his sense of cultural mission at the trial that condemned him to imprisonment. He spoke of his fellowship with other believers as "a new religious community." "This new spiritual reality," he declared, "this communal Christian view of the world, is being created everywhere, even here in this courtroom."[12] The prog-

12. English extracts of the trial transcript (evidence of Oleg Okhapkin, a witness, and a final word by Poresh) in *Religion in Communist Lands* 10 (1980): 26.

ress of the Christian Seminar shows that it relied in part upon the traditional Slavophil suspicion of "enlightenment." Secular critics treat this Orthodox skepticism of Western rationalism as reactionary and anti-intellectual, yet it signifies not an indictment of the intellect but a different perspective on how the intellect functions.

This suspicion of modernist rationalism in Russia troubles Americans. However, it is endemic to Orthodoxy itself, precisely because "enlightenment" encloses the single, inquiring mind within an isolated, interpreting self separated not only from a creator but from the social framework of other minds. The Christian Seminar reached outward to the West to build a new Christian "communal understanding" in solidarity—not, as Poresh made plain at his trial, as a political entity but as a league of the Christian imagination. What little writing Poresh was able to accomplish stresses the obligation of the Christian mind, in every society, to assert its creative influence. He and Viktor Popkov made an appeal in a letter to American young people written before *glasnost'* was a word known to Americans:

> The time has come for us, living as we do on different continents and raised in different historical traditions, to open our hearts to each other and unite our efforts in creative searching. . . . We are grateful to you for the spirit of liberation which has filtered through the customs barriers. . . . We turn to other people with our souls laid open. Open your hearts to us, as we are opening our own to you.[13]

If Poresh appeals to the West for "openness" and acknowledges a debt to the West, the West can also look to the kinetic icon for assistance in the creative enterprise of which Poresh speaks. The West will not abandon the Book as a model for meaning: the Bible as Book will maintain its centrality in the Western church. But freeing the Christian imagination from its constraints can assist Western Christians in their own mission, no less important than that of the Christian Seminar in the USSR. Believers in the West

13. This letter, a copy of which is in the Keston College Archive, is quoted by Ellis in *The Russian Orthodox Church*, p. 390.

have adopted the idiom and the style of the secular, "post-Christian" world that they share with nonbelievers. Theology no longer colors any enterprise in which a Christian engages; socially and academically it has become a mere specialty, a separate language in which one speaks. The Christian movement in Russia, with energy and assertiveness, restores theology to the imaginative center of the Christian mind. In thrusting theology to the periphery of the arts, in resigning academics and education to secular perspectives alone, in living life in a "segmented" way, with the religious and secular dimensions of experience sundered from each other, Western Christians place themselves in danger. Humans are material beings. They are creatures, inevitably, of image and symbol. To qualify or constrain the role of the image in the religious sphere leaves the arts open to secular control and secular interpretation. Christians thus resign their imagination to the control of others.

With the death of "Christendom," Christians have abandoned many of the occasions of sin, especially those sins that spring from power and arrogance. But they have also entered an age, East and West, in which the secular powers have an unparalleled power over the images that crowd the mind. In Russia, the secular image of "Father Frost" charms children with candy and gifts. Here, television and the schools immerse us in the image of Santa Claus. The birth of Christ is hidden, as if behind a screen, from public view. American thought picks through a junkyard of cola commercials and deodorant ads; Russian minds duck and weave through a thicket of political slogans. Lenin's omnipresent portrait has become a cliché for propaganda—a term that the Soviets, fully familiar with the power of the image, take completely for granted. ("The difference between us and you," said one Russian friend of mine, "is that we recognize propaganda when we see it. It's labeled for us. Americans, it seems to me, can too easily mistake propaganda for truth.") Although Americans react negatively especially to the cultic, religious dimensions of Lenin's portrait, they accept the lapel pin superimposing the cross over the American flag. Sacred symbols have been, in effect, "desacralized." Those in the West can look to Christians in

the East to see how they, more sensitive to the image and its role in shaping the imagination, respond to our common dilemma.

There is no question that Christians in the USSR are far more confined in their action than Christians in the United States. Yet Christians in America, as well as in the Soviet Union, have been complaining of their position. Major university departments in the United States act as havens for specific ideologies and positions. Indeed, departments engage in long searches for scholars of a specific ideological cast. State schools with a range of specialties can be known for Marxist scholars or feminist scholars; few if any such faculties seek to strengthen their departments in "Christian scholarship." On the contrary, in many academic circles—even in nominally Christian schools—Christian scholarship is considered to be in bad taste.

The practical effect on the American academy is, for Christians, similar to the active repression we condemn in the USSR. Christian artists, scholars, and writers have been increasingly confined to their own circles. As the influence of the Christian mind wanes in the broader world, it is only common sense to assume that those circles will grow smaller. The Christian mind itself becomes littered with the flotsam and jetsam of the commercial, political, and social world that surrounds it. Thus the intellectual mission of Christians in the West can follow the model of their Eastern counterparts. To restore the primacy of the gospel in the world, Christians must restore the power of the image. They must free their imaginations of secular control. They must confront the charged "kinetic icon" of Christ and interpret the world in the light of their own Christian imagination.

"Be Ye Perfect"

The genre of the "Christian Gothic," which consoles American Christians with stories of the incomparably worse condition of Soviet believers, blinds Americans to the vital, kinetic icon projected through the Christian mind in Russia. The tales

do not reveal the heart and mind of the Christian believer in Russia. They create the misconception that Russia is a nation practically devoid of Christianity rather than the repository of insights that can assist Christians in the West. The "Christian Gothic" mode penetrates the consciousness of the American people and their leaders. When President Reagan, in condemning Soviet policies, urges, "Let us pray for the salvation of all those who live in that totalitarian darkness—pray that they will discover the joy of knowing God,"[14] he ignores the faith and the creative power of those millions who already have discovered the joy of knowing God. We must not assume that President Reagan's (and the media's) recent discovery of Christianity in Russia means that it has only recently emerged from hiding. ("We were Christians," said one rather sour old Orthodox lady now living in the District of Columbia, "when Washington was a swamp.") Given his perspective, the president cannot admit that these Russian Christians could inform American Christians about darknesses that they too endure. President Reagan characterizes America as having been "set apart in a special way" to be discovered by people "who came not for gold but mainly in search of God." This insight needs some qualification. The Pilgrims were fine people, but they after all were the ones who had a hard time with "praying Indians." Orthodox Christian Americans came here much more recently, and for very different reasons. Our Slavic families knew God fairly well when they came (I should be so devout). What they needed was a little ready cash. Political rhetoric, East and West, can obscure the Christian consciousness of other Christians.

The "freedom" of religious assemblies in the West cannot conceal the crisis of Christianity in a "post-Christian" culture. Some American Christians have sought political power as a remedy for the world's estrangement from the church. The Russian example proves the illusory nature of that goal. To desire power to promote virtue is a laudable aim. Yet, as the Orthodox Church has learned through its history, to seek and to find power can of itself turn Christians from their orig-

14. Quoted in *Christianity Today*, 7 Oct. 1983, p. 44.

inal goal. Through successive ages and empires, the Orthodox were beguiled into believing that the princes were wielding their power for the sake of the church. Many princes, of course, sought only to use the church to preserve their own power. "Official" atheism radically severs the state from the church and does not pretend to serve the church's interest. The state—whatever state—seeks its own earthly security. And there is an innate danger that the earthly security that the state seeks will be opposed to the heavenly, spiritual welfare that is the province of the church. Christians in Russia exude a spirit of meekness that their spirituality seems to promote. Yet Americans must examine the nature of that apparent "meekness" to discover whether or not the meek will in fact inherit the earth.

The activism of the Russian church is of a subtle kind. "The church in the west," said a Russian Orthodox theologian, "strives for breadth. It seeks to influence as many as it can. The church in the east, however, strives for depth. It seeks to steep its members in the Spirit. Those two movements," he says, with a broad gesture, "make up a vast and saving cross." Americans note the political accommodations of Russian church officials. I have drawn attention to the deep cultural involvement of young Russian Christians in the artistic and intellectual life of their country: they do not seek to separate or isolate themselves culturally from the people of which they are a part. They do, however, make a radical commitment to the "depth" of which the Russian theologian spoke. Their mode of life—the standards by which they eat, dress, and conduct their personal relationships—is profoundly different from that of the world. They are a disciplined people.

Americans can easily obscure the lessons of Russian Christianity beneath a cloud of pity. "I don't know how you can take it," I once said to a friend—a bright, educated, and totally committed Christian in a large Soviet city. "The school system, the newspapers, the statements of public officials all around you are so blatantly biased against you."

"Ah, Anton," he said with a dismissive smile. "And I feel sorry for you. For me, the oppositions to religion are so easily recognized. Whereas you Americans, if you will pardon my

frankness, are constantly suffering from the illusion that your own system has no such contradictions. Materialism among you is so pervasive, it must be hard to extricate yourselves from it."

The believers in Russia possess a theology that has profoundly respected the potential for divine manifestation in the material world. Yet they are inclined to see American Christians as somewhat "materialistic." The Soviet Union permits freedom of religious observance but a "corresponding" freedom of anti-religious propaganda. In other words, the dice are loaded against believers. The only witness they have left is their way of life. Christians in Russia must through their lives renounce the terms of the world. Many Christians in the United States, on the other hand, are tempted to see their worldly prosperity as the evidence of their Christian commitment. "Self-help" books on the Christian circuit celebrate the gospel not in itself but as the means to psychological integrity, bodily health, financial security, and even business success. Intellectually and spiritually, we Christians in America may feel isolated from the world in which we participate, but economically we are fully integrated into the system. We are like the rich young man in the gospel. The act of renunciation is hard for us.

American Christians have access to material success. Most Russian Christians, even if they wanted such prosperity, do not have easy access to it. Not only is Christian commitment more common among less affluent rural people, but those successful urban types who do embrace it have a harder time gaining access to the jobs and promotions that bring affluence. They do not, then, have precisely the same problem that afflicts American Christians: a great ambivalence about their own prosperity. On the one hand, we Americans accept our material blessings and even sometimes assume that they are the product of our "Christian values." Yet, on the other hand, we are aware of the radical injunction of the gospel. "If you would be perfect," Jesus says to the rich young man, "go, sell what you possess and give to the poor, and you will have treasure in heaven; and come, follow me" (Matt. 19:21). The exegetical problems involving wealth are the most troubling

for Americans, and we have given much attention to examining and qualifying passages that seem self-evident to Russian believers.

In this instance the word "perfect" allows us all too easily to dismiss the passage, along with the camels passing through needles' eyes and other vexing problems. *Teleios* is the word in Greek: "complete," "in fullness," applicable to a work undertaken or to mental and moral growth. And *teleios* is what the Spirit calls upon us to be: "You, therefore, must be perfect *(teleios)*, as your heavenly Father is perfect" (Matt. 5:48). Paul uses the same word to describe those who are ready to receive the Word: "Yet among the mature *(teleios)* we do impart wisdom, although it is not a wisdom of this age or of the rulers of this age, who are doomed to pass away" (1 Cor. 2:6). Among average Russians with little access to foreigners, American wealth is exaggerated legend. Most of them envy it—when I visit Russia, the teenagers I meet commonly request American catalogs (Sears and Penney's), "dream books" for those who aspire to acquisitiveness. But Russian believers find nothing about American Christians more puzzling than our apparent insistence that our prosperity is in some way the proof of our virtue. To their minds, discipline demands that we let go of the standards of this world: not that we be "a-material" beings but that we engage the material world to turn it to God's service. To be *teleios* demands that we be disciplined to shape ourselves and the world in his image. The danger in wealth is that it affects the imagination: it allows mail-order catalogs to shape our heart's desire.

Christians in the USSR, then, are more uncompromising in dealing with consumerist materialism than we are. I have seen this quality in the way they contrast with their fellow Orthodox in the West. We American Orthodox are not the products of a Western theology, yet our willingness to compromise our tradition in the service of wealth shows our own acculturation. Greek Americans are proud of their economic success, yet as Orthodox they are also troubled by it. When we American Orthodox visit Russia, we, like many Americans, take some comfort in the Russian pursuit of blue jeans and Sony Walkmans: it gives us some confirmation of

the inevitability of our own consumerist values. The Soviets who ape Western ways and Western dress may testify to the power of the marketplace and contribute to a certain American smugness, but these are hardly the believers. Believing Russians are singularly unimpressed by Western technology and Western prosperity. They find heretical the position that the most prosperous society is the most moral. "Westerners— even the Christians—pity the strangest things about my life," laughed a devout young woman believer whose work sometimes brings her in contact with foreigners. "They feel sorry for me because I don't have the same *things* they do. What kind of Christian position is that? Do you think the young people who trade for Western goods on the street admire your *values?*"

This is a fundamental irony in our relationship with the Russians. We American Christians first seem to hold over them our prosperity as proof of our freedom. And they, living in a "materialist" society, respond that they pursue fundamentally spiritual values. Even Communists find my American students "too materialistic." The young American family who attends church faithfully every week but whose resources are primarily invested in maintaining itself in a "competitive" mode of life is hardly "free" in the Christian sense. The Christian family in Leningrad, rejecting the atheist principles that surround it, drinks deeply of the gospel's liberation. I know a couple with four children (a lot of kids for an urban Russian couple) who choose a crowded life in a smaller apartment simply so that they can remain close to a "working church" in the center of the city. They are a truly loving family whose relationship reflects their bond in the Spirit. They are an icon: they "image forth" for other believers the values they cherish. If we choose the standard of *teleios,* the model of perfection offered by the gospel, we see that the Christian in the Soviet Union can teach the Christian in the United States how to make the radical choice for the gospel.

Many of our own mainstream religious groups are trying to recover a lost sense of simplicity. The Mennonites and the Amish in my own Lancaster region have become an emblem for others as they give excellent witness to this quality

(and not primarily through their cookbooks and the way in which they evoke in us a certain nostalgia). The tourists who travel here for a glimpse of their lives see a people who mock American consumerism. My Mennonite friends not far away, farmers with three sons, live what their church preaches. Ike has chosen to work his farm simply, contenting himself with less profit, to be sure, but at the same time securing his land against debt. His wife, without adopting distinct Mennonite garb, chooses to reject the worldly standards of the society around them. Many might tend to measure their lives, like the lives of Soviet Christians, in terms of what they do *without*—without TV, without contemporary styles, without two bathrooms. Yet Ike and Faye, like my Christian friends in the Soviet Union, place their priorities elsewhere. They are happy in the same way that the Christian family in Leningrad is happy—but not according to the standard of merely material gratification.

Ike and Faye have the support of an entire subculture in maintaining a simple Christian way of life. Most Christians in America do not—nor do Soviet Christians. They must continue to live and work in this world, with all its manifestly materialist, "humanist," anti-Christian presumptions. They must look at the kind of contentment the world offers them and decide if it is compatible with their beliefs. Christians, too, after all, seek to make each other "happy" in some sense. Yet the kind of happiness the gospel promises is of a different sort from that "pursuit of happiness" in which citizens of this world usually engage. *Makarios,* meaning "happy" or "blessed," is the word the gospel uses to convey our desired state of mind, and we experience that state only when we act upon the lesson of humility taught when Christ washed the feet of his disciples: "If you know these things, blessed (*makarios,* "happy") are you if you do them" (John 13:17).

Happiness comes to believers in precisely the opposite way in which it is typically pursued. Alexander Solzhenitsyn uses a common Russian word, *schast'ya,* to describe the kind of happiness that the secular world identifies as the object of its usual quest. This kind of happiness involves physical well-being and the assurance of its continuance: the kind of secu-

rity afforded by our goods. Assuring material well-being is the goal of the "free market." This is also the goal of communism as many Soviets see it—a fair and equitable society in which all can live with security. But Christians must have the courage to understand that these are the world's promises in which we do not place our trust. Economics professes, as a discipline, to be "values free." Christians are not. Those who place their hope in an economic system must understand their values as, in the main, economically derived. Christians do not.

Christians in any economic order must protect their values from the system that controls their commerce. The aims of the system, capitalist or communist, are not those of the Christian community. Russian Christians love their country with great passion; they also reject the purely materialist economic premises of those who guide their state. American Christians can be no less discriminating. We need not assume, with many of our leaders, that our system has derived a magical formula for reconciling God and mammon.

Among Christians there is a renewed intellectual interest in "the founders" who established our nation. Like Allan Bloom in his critique of American education, Christian intellectuals have tried to restore the founders to prominence. Among some mainstream Christians, and among several influential sects, there is a tendency to identify these eighteenth-century Deists with the "Christian roots" of our republic. The founders presumably established a means to make the "natural" pursuit of wealth consistent with a pursuit of spiritual well-being. In that relationship between the pursuit of wealth and the pursuit of "happiness" resides the liberty upon which our republic is built.

The most superficial reading, of course, reveals that the distant, benevolently vague God of Federalist Deism is quite different from our own God of power and might. Nor did the Deist system allow for sin and redemption as Christians understand it. Much as they may admire such figures as Washington, Jefferson, and Franklin in their political insight, most Christians in America, were they to examine their theology, would find it utterly befuddled. The avuncular, indulgent

Deist God is the one in whom so many place their trust on the dollar bill. He requires little and provides much.

This is not the God who has sustained American Christians through revolution, war, and civil chaos. A search for America's real Christian roots reveals a relentlessly involved theology, a testimony that the God of American Christianity is not a bemused master technician of his universe but a God of wonders who dives deep into his creation. This is the part of the earlier American religious tradition that scholars like Harry Stout at Yale are rescuing from obscurity. In his work on the sermons that inspired the American Revolution,[15] Stout reveals a traditional Christian imagination rejecting the naturalist theology of the Enlightenment and calling for repentance, commitment, and sacrifice. If today's American Christians were to follow the example of their Russian counterparts in rejecting the purely secular vision of well-being, they would find it easier to recover their own Christian identity. As Christians we are neither capitalists nor communists. Our role lies not in the blind endorsement of the civil and economic systems we inherit but in our forging of a distinct Christian identity within them. Only then can our theology act to interpret our culture and our world.

This separation of Christianity from economic ideology does not threaten patriotism or a Christian role within national culture: there need be no contradiction between national and Christian identity. The contemporary Russian Orthodox, after all, share an underlying identity with the culture of which they are a part. They assert a passionate love of country; younger Orthodox have acquired a distinctly "Soviet" identity and take pride in what their country has been able to accomplish. They can even confess to a sympathy with the "revolutionary consciousness" that colors Soviet history and the Soviet curriculum. The Aurora is a boat that helped initiate the Bolshevik Revolution. It is preserved as a monument in Leningrad. "I still get a thrill when I visit the Aurora," said a

15. See Harry Stout, *The New England Soul: Preaching and Religious Culture in Colonial New England* (New York: Oxford University Press, 1986); see also "Colonial Sermons Laid Groundwork for the Revolution," *Christian Science Monitor*, 3 July 1987.

devout young Christian man to me. "And I certainly don't want to return to the days when civil servants had to show a 'church-card' proving that they had received communion in order to be paid their salaries." Yet the nation in which these Christians live professes atheism openly. Their government—local representatives whom many of them know as well as you might know your city councilman—strictly limits the function of the churches to worship. They can hold no Sunday schools, no religious discussion groups in private homes. They cannot even assemble for charitable purposes. And the very people who limit their freedom are those they know and often love—children, parents, cousins.

There is that in both our cultures, Russian and American, which defines happiness as Christians cannot accept it, and which places happiness where Christians cannot find it. Russian Christians have not only resisted the limitations of materialism and modern rationalism; in some heroic figures they have shown a distinct triumph over them. Their involvement in culture and the image offers a way to reject materialism and yet embrace materiality. Their iconographic mentality looses the Christian intellect upon the world in engagement with "other." All that is "other" is, to use the term of the Russian literary philosopher Mikhail Bakhtin, "alterity." Unlike Marx's "alienation," the term "alterity" is a friendly one. Alterity, all that has not yet been drawn into the Christian consciousness, offers the Christian mind an opportunity to engage, transform, and be transformed. Christians must not segment themselves from society and the world; they must embrace it and engage it.

The Thrice-Holy Hymn

Holiness is a theme that pervades the Russian Orthodox mind. "Holiness" is an attribute assigned to the Godhead in every daily prayer, in every liturgy. The "thrice-holy hymn" is a theme that pervades the Orthodox liturgy. Three times believers pray, "Holy God, Holy Mighty, Holy and Immortal, have mercy on us." And repeatedly throughout the liturgical cele-

bration, at moments of great solemnity, this theme of holiness is evoked. The "thrice-holy" is a structural element embedded in Orthodox worship and prayer. And if holiness is that quality which is proper to God, a part of God's very essence, then holiness must also be a quality proper to the Christian. God is holy by his very nature; humans, however, must sweat and labor and struggle, through God's grace, to be drawn to holiness. The Russian Christian mind, as has been previously noted, has an insatiable appetite for "wholeness," for unity, and this holiness is an expression of the unity all creation finds in God.[16] Holiness pervades creation; it is potentially present in all that emerges from God. Humans "image forth" their Creator, and in that process they become icons of Christ, conveyors of the "sacred image."

This consciousness of the holy image of God that is potentially present in all humans and this holiness with which all creation is charged creates a strategy by which Christians can assert their intellectual and creative power. Orthodox believers, through their ritual of worship and their respect for the image, are prepared for the "image-producing" capabilities of the world in an effective way. The sacred arts and the sacredness of liturgy and worship *sanctify* or "render holy" a space in one's life and a part of one's mind. When Soviet Christians walk into the church off the street, their minds and even their attitudes, no doubt, are still full of the presumptions of the world outside. They are still in the grip of its images. Yet there is something holy about the space they have entered, and that holiness is conveyed as well by images or "signs." Candles flicker before icons and holy images. Believers, in bows and ritual actions, convey that sense of holiness. Soviets who enter the church merely for the sake of curiosity sense that quality; they may be made uneasy by it at first, because they are aware of an influence that is different and hence suspicious. Yet many return to experience it again. Americans who have visited Orthodox churches in Russia

16. For a discussion of this theme through modern Russian philosophical thought, see Katerina Clark and Michael Holquist, *Mikhail Bakhtin* (Cambridge: Harvard University Press, 1984), pp. 35-62.

note this sense of the "sacred space." According to the Russian writer Nikolai Gogol, the mind enters this space like a sanctuary; the imagination is affected by it and "blesses" the world from which it has come, ready to return and encounter it, to see it anew.

There is a certain discipline that enables the Christian to focus the mind and open the imagination to God's grace. Over centuries, Christians in Russia have developed ways to train the mind not to reject materiality but to interpret the material world according to Christian structures of thought. Ritual practice—a way to seal the image of Christ and stamp it firmly in one's daily life—gives the Christian a "habit of intellection," assisting a continually God-centered perspective on experience. Daily prayer at regular times, before icons and in a "sanctified space" within the home, accompanied by the lighting of a candle or even the burning of incense, establishes a custodial rhythm over an Orthodox Christian's life. Carried over into the home, the rituals of sacred holidays—with specified dietary fasts for certain seasons and customs in the church—carry that imaginative power through to the rhythms of family and communal life. Rituals of birth, maturation, and death—if they are distinct celebrations and more than casual events—also assert a power over Christian life that consecrates it and renders it "holy." Christian ritual gives Russian Christians an important base from which they can engage the secular world around them. This engagement becomes a process, then, of continual commendation of a fragmented, "autonomous" world to the integration of God. The Christian mind participates in the transfiguration of the world it encounters.

That sense of "sanctification" is evident in the Russian intellect—even secular scholars grow rapt over the beauty of the Russian icon and the stillness and spirituality that it can convey. Intellectuals create aesthetic terms and blend them with the theological in order to convey the spiritual truth that an icon can express. Thus theology is not an abstract discourse removed from the realm of the material. Through expression in literature, art, or any other form of materiality, theology can have a point of access, a point of "in-carnation" or en-

fleshment in the perception of the Christian believer. It is not through gospel tracts or even preaching that the new Christian believers in the Soviet Union are drawn to God, but rather through thought and culture itself. Christians in their art, their thought, and their work convey their Christianity through their very perspective, their worldview. A Soviet believer described the process whereby his conversion occurred: "At first I entered church only as a curiosity. I found it interesting from a historical point of view. Then its music, its beauty drew me back. It was a special place, a sacred place. I saw and heard and felt long before I listened to what was said."

For the sense of holiness to embrace the world, it must first reside in a sanctuary. This is a retreat, in a sense—it is a sacred space in one's life from which one can review and sort all the multiplicity of images over which one has no control. It is an evangelical source as well: it is a base from which the mind, refreshed and converted, can extend its influence outward and *transfigure* the world and culture in which one lives. No Christian can empty his or her mind of what has been collected there, nor is this consistent with the sense of mission. But the Christian can sanctify the images and impressions he or she has gathered in the realm of the world and turn them to God's service.

I fully realize that no mainstream Protestant, without doing violence to his or her own cultural base, could adopt candles, incense, and icons any more than we Orthodox could strip our churches down and order Methodist hymnals. (I once joked with a Reformed friend of mine that if we Orthodox had tracts, the kind that some Christians pass out in the shopping malls, ours would be of the "scratch and sniff" variety.) Yet the Orthodox tradition has existed for centuries, under persecution and domination by Christian and non-Christian princes alike. And during this time it has collected much wisdom. Western Crusaders once plundered Byzantium of wealth. This is a time to plunder it of ideas. Believers in the West can glean these ideas from the daily practice of Orthodox Christians, and apply these concepts as the means whereby all Christians in this "post-Christian" world can live within the non-Christian culture around them and yet remain partici-

pants in it. This is a process of "restoring the image," of converting the Christian imagination and liberating it to interpret the world according to that light which it has been given.

I once spoke at length to a mother and her young son, who was just old enough to join Komsomol, a political-social organization for young people. The children of believers quite regularly join the Young Pioneers, a red-scarfed version of the Cub Scouts and Brownies; Komsomol, however, actively discourages religious practice. Consequently, young people often face a crucial decision by the time they're fourteen. This boy was like any American teen—active, alive, intensely interested in sports and social life. His mother, who was a teacher, wanted the best for him. But it was time for a hard choice. And much as her son wanted to take advantage of the rich social life offered by Komsomol, this woman felt he couldn't do so and remain a Christian. It was a tough decision—one that twisted the boy's face in perplexity and called upon him to "break" in some way with his own best friends.

The boy didn't join Komsomol. Americans cannot imagine that God calls upon only those in so-called godless societies to make such choices. Americans face tough choices of a different kind. We American Christians have the opportunity to create models of our own. Christian scholarship, for example, could work creatively with new methodologies to integrate the dimension of moral values into discourse. Most often, as Christian scholars themselves complain, they adopt the methodologies of their secular colleagues. Christian evangelism can, at its best, leap into imaginative engagement with the new, image-begetting medium of television. Instead, Christian critics see that the television ministry has adopted the commercial, managerial, stultifyingly consumerist models of the secular medium. We Christians are obligated to turn ourselves loose upon the world. We believe that baptism in Christ allows one to "see anew," to interpret the world wherever one finds it according to new structures of thought. The American Christian mind has been timid in expressing its own imaginative vision.

Russian Christians can help us realize our own power. Their sense of "hallowed space" can help Americans strug-

gling to sustain the Christian imagination. If our consumerist materialism blurs the edges of our Christian vision, we are not alone. The Soviets face a daily landscape quite different from ours, but its effects are similar. In place of commercials and neon, they face political slogans and monuments. Their art and architecture stress the social over the individual, the collective over the private. Believers do not find the secular vision devoid of value; the social emphasis is consistent with their theology. (Even in exhibits of modern Soviet art, it is a joy to see the shape and sensibility of the icon continually peeking through.) Yet it is fair to say that the Soviet world-view is consistently purged of the religious: belief is a dimension of life that the Soviet Union barely acknowledges and officially only tolerates.

Nevertheless, the believing mind in Russia embraces its afflicted culture and blesses it. When Orthodox people "bless" an object or have it blessed, that act of blessing singles out the object, whether it be food or drink or apparel, and "frees" it, liberates it from the autonomy of the secular and places it in "context," that interdependent context whereby we are all God's and each other's. The mind pours out from that sacred space and sanctifies what it encounters.

This Christian mind has seen its motherland as a "holy Russia." America no less than Russia is suffused with the holy. A secular vision of our history and culture has stressed the material, individualist aspirations of our nature. *Habits of the Heart*, the best-selling study of American aspirations, tells another story: it reveals that Americans long for a social, collective vision that their vocabulary has not given them the words to express.[17] Churches give Americans a way to "get involved" with others and their community, and in this social role Christians can engage easily in secular frames of reference. Yet the aspirations for the holy, for a place suffused with the sacred, have often emerged in the history of American faith.

17. Robert N. Bellah et al., *Habits of the Heart: Individualism and Commitment in American Life* (San Francisco: Harper & Row, 1986), especially pp. 20-26.

Just as Russian Christians find Christ embedded in their culture, so American Christians must look for him hidden beneath the veneer of secular "objectivity." American churches are more than social halls. Opposite our Lancaster row house is a stained-glass window in Emmanuel Lutheran Church. Lit from within, at twilight, an image of the Good Shepherd rinses our neighborhood with a clean and holy light. Baptist and Methodist hymns can soften even an agnostic ear. I don't know Protestant piety very well, yet I would be surprised if there were not a rhythm of ritual—prayer, Bible-reading, an "ordering" of daily and family life—that could create a sanctuary from which the Christian could engage his or her culture.

Americans, however, are not ones to linger in the sanctuary. Accordingly, once the Christian imagination has asserted itself in a "post-Christian" world, and once it has claimed a sacred space from which to launch its act of interpretation, the Christian mind must move outward to restore a sense of holiness and "wholeness" to the world. The era of the "secular city" in American religion is past. Its force has been spent, and its continuation deadens the sense of the sacred. Americans need to revive the sense of the sacred not only in their churches but also in their culture. It is this awareness of "the holy" embedded in one's people that brings young believers back to the church in Russia, and I believe it is this sense that has been lost to our own youth in the United States. Allan Bloom and others apply secular, post-Enlightenment methods in efforts to restore or lament the loss of the integration of belief and faith. Such efforts are hopeless and lead, inevitably, to the overwhelming pessimism and bitterness that they express.

We Christians hold within ourselves the antidote to that bitter poison. Only believers can sanctify the sense of place and time because only among believers does the sense of the holy endure. Believers in America and Russia have a vital mission, because even the secular mind itself cries out in anguish at its own entrapment. Believers need not "convert" only through the rhetoric of persuasion; they have at their disposal the means of conferring an integrated intellectual vision and

a wholeness upon the world. The Christian imagination can color the world in such a way that others can see its compelling, irrepressible beauty.

Christians need to stress that sense of the sanctified world and strengthen it. We Americans are an informal people, and "blue-jean Bible studies" (from the denim-covered edition of the gospel, no doubt) have their place among our young people. But so also does orderly, liturgical worship, worship that conveys the beauty, calm, and structure of the Christian worldview. Informal "Christian fellowship" is good, but so also are the hymn and the kind of prayer that does not allow for slouching or the "I just wanna say, Lord" prefix. Christians "image forth" the Lord. We have preached and spoken a great deal; perhaps it's time for the rich silence of prayer. If we can call a blessing upon our food, we can call a blessing upon our work, upon a room, upon a book. A Christian imagination allows Christians to seize control over the objects and images that surround them.

The radical choices that Orthodox Christians have made in Russia allow them to see the world itself "evangelically." The mind of the believer can sift through the rubble of the world and find treasures within it. "It was strange, after I came to Christ and received baptism," said a young Orthodox man. "I started to see everything else with new eyes. I thought my father was a dull, unspiritual man. I discovered sensitivity in him. I began to re-read the poems and stories I had read before and see new meaning in them. The world began to take on color and meaning." Soviet Christians do not reject the world from which they come. Far from it; they see it anew. They are voracious readers of Soviet poetry and stories, avid music fans, intensely involved in their world. The segment of their lives that is "sanctified," that capacity they have for hallowing the image, spreads outward and embraces the whole of their society. They become the mirrors through which others, devoid of meaning not only in their own lives but in the society around them, perceive the glimpse of unity in God.

A sense of fear pervades American Christianity—a fear of its own impending extinction. The fear of the Russians is but one face of the fear of ourselves: their "godlessness" be-

comes an incarnation of a similar quality in us. Yet the gospel does not enjoin our minds to fear. The world around us is suffused with God. Once we sensitize ourselves to his presence, we will perceive him in the the films around us, the music, the literature. Nor is that presence confined to the conventional procession of "great works." For example, the wings of the Spirit can beat in rhythm with the music of our popular culture. Social critics may lament the effects of contemporary music, but Christians who fear the negative influence of rock music have not listened to groups like U2 and Talking Heads. In fact, many modern rock groups strain to hear the heartbeat of God. I have found the anguish of profound insight—what Tatiana Goricheva calls "the verge of despair at which faith begins"—in a rock group called "the Damned." In their music, even "the Damned" can be saved. In a newly marketed Soviet album, the Russian rock group called Chernii Kofe ("Black Coffee") celebrates the conversion of Russia. Rock is just one of a hundred avenues open to those in America and Russia who seek and reject what is false, what is meaningless, what cannot satisfy. "Even if the textbook says God does not exist," said one believing Russian teacher, "God exists in the reading of the text." The simplest handiwork of any human in some sense reflects the great act of creation that is God's.

Christians need not fear the world in all the forms of its expression. Ultimately Christians are called upon to engage the world, to embrace it. In the ritual of baptism the Orthodox intone a hymn three times in a ceremonial procession around the baptismal font. The procession signifies the journey through all of life's experience, and the hymn declares, "Those who have been baptized into Christ have put on Christ. Alleluia!" The Image, as the Orthodox see it, is the perfect complement to the Word. Neither contradicts the other. Christians are "clad" in Christ. The Christian imagination, thus robed with a new vision, can interpret even a "godless," even a "post-Christian" world in the light of Christ's unifying holiness. The Russian Christian mind offers us that insight not on its own terms, as a possession, but rather as a shared gift.

Chapter Three
TRINITY AND AUTONOMY

"The Profound Reality Called the Church"

To attend the Easter liturgy in an Orthodox church in the Soviet Union (or in any Orthodox parish in the world, for that matter) is to come closest to the religious consciousness of those believers who celebrate it. It is our churches' most crowded day. In America it brings parishioners to church an hour early to claim "their" place. In Russia the people come many hours early, because there are too few "working" churches to hold the swell of believers, and the churches fill to a dangerous capacity. Inside the churches the early comers camp at a favorite spot by an icon or near the central altar. Outside the churches the local police take over crowd control, since many curious onlookers gather around the churches to join those many believers who can no longer find a place inside.

The special civic events and extravagant TV offerings that the authorities schedule for this night cannot keep the masses away. Each church is a magnet, and between the poles of belief and nonbelief, the air crackles. People arrive in clusters and join the groups pressing near the churches. On workdays, in subways and on the streets, Russians huddle in orderly impassivity. Yet on this night the deepest of feelings rise to the surface. Self-consciously carnival-like among some

clusters of observers who speak with an almost exaggerated loudness, profoundly devout among others who stand nursing candle-flames in the late-night breeze, the atmosphere testifies to a profound importance. The restiveness of the crowd promises either an accident or a miracle.

In Easter the "sensuality" of Orthodox religious life reaches its fullness. The long prayer and fasting, which devout Orthodox take seriously, come to a close. During Holy Week the church has lamented with Christ, held watch with him, seen him crucified, and, in solemn procession, buried him and waited at the tomb. The Orthodox, the people of the image, do not simply proclaim these things; they do them. They build a tomb-like structure in the midst of the church. On Holy Friday, a usually stoic people weep through the lamentations for a dying God and then place a shroud bearing his image within the tomb. It is a real enactment of Christ's death. And on this night, as crowds all over Russia fill and surround her churches, the Orthodox genuinely anticipate Christ's resurrection.

Those who explain Orthodox services often say that they do all this "symbolically," but the word does not grasp the completeness of the experience. In the West "symbol" is of course understood in a Western way. Let us go back to the book as the usual Western model of understanding. The way in which Western Christians see the term "symbol" begins here, for their grasp of the symbol is primarily textual in character. Augustine again can act as an originator and example. In his treatise *On Christian Doctrine,* Augustine developed the very model of *allegoresis,* the allegorical model as understood in the West. In allegory one set of terms "stands for" another set, much as Augustine saw Christ foreshadowed throughout the Old Testament. Just as Christ was announced by Isaiah and the prophets, so also he was prefigured in incidents throughout the Hebrew Scriptures. The juxtaposition of the two great "Books," Old and New Testament, creates the terms of allegory and symbol. And these two books are in a real sense the "home" of religious symbol among American Protestants: their tradition of interpretation imparts the distinct sense that symbol belongs there.

The rich tradition of allegory in the West, for example, is seated firmly in the text. Edmund Spenser, John Milton, and John Bunyan all developed rich and elaborate models of the Christian life based upon the adventures of the soul within a textual frame of reference. And the early forebears of the Reformation, when they wanted to divine symbolic meaning, exercised their capacity for symbol there, within the adventures of a reader seeing himself or herself replicated in a struggling Virtue battling an array of the Seven Deadly Sins. Even within the memory of many a pastor's grandparents, Sunday school lessons were punctuated with the adventures of Bunyan's Christian as he plodded his way through *Pilgrim's Progress* to gain salvation. Horatio Alger took the same form and transmuted it into the secular-moral tales in which Industry prevailed over Sloth and brought many a bright-eyed American boy to the salvation of wealth and "happiness." Symbol, for Protestant America, is locked within the page for discernment.

But "symbol" for the Orthodox and for most Catholics as well occurs within a dramatic rather than a textual context. Just as the Western critic tends to define his or her standard within a textual frame (the honest Western conviction is that one must "read the right books correctly"), so the Orthodox most frequently identifies worship as the central standard (the honest Orthodox conviction is that one must praise God as he should be praised). The Orthodox "act out" their understanding. The Russian word for the Orthodox faith is *Pravoslavie,* or "right-praising." Russians are convinced that they *worship* the Lord in the right way, and all the physical senses fully participate in the dramatic ground of that worship. "Liturgy," the word for communal worship, evokes a dramatic concelebration of the Word. The Orthodox sensibility does not deal with "symbol" as an act of intellection, an understanding gained through interior reflection. What the Western critic sees as "symbol" is for the Orthodox an act of dramatic perception, an understanding gained in communal celebration.

Very few Westerners understand how deeply liturgy, religious or secular, affects the perception of meaning. Liturgy

is at the core of an understanding that permeates the masses of Russians gathered at Red Square on May Day—and the masses of Russians who stand restive and expectant on the eve of Easter, the feast of feasts. Since Westerners see meaning as analytically derived, it is difficult for them to comprehend this most basic of processes in the Russian mind. The political columnist Charles Krauthammer, approaching the issue of meaning as an act of pure intellection, sees the funeral of Chernenko and writes "A Case against Atheism." To Krauthammer, the masses who surround the pudgy body of a head of state bespeak a certain banality. He sees this exaggerated focus on the body as itself the act of a cramped atheist imagination. Yet Krauthammer's imagination, too, is limited, suffering the constraints imposed by an unfamiliarity with Slavic tradition. Far back in medieval times, in King Alfred's *Orosius*, Western travelers among the Slavs complained of long-delayed burials. And to this day corpses lie in Russian churches with the mourners massed around them in testimony to the common life they shared together and in Christian hope of a resurrection. A common understanding, an act shared in common, can thus convey meaning despite the fact that an individual, rational analyst can perceive none.

Thus Orthodox people are surrounded by objects with "symbolic" import. Icons portray their religious images; vestments and candles of various sorts enrich their worship. During Epiphany, the winter feast of the baptism of Christ, Russia's churches are crowded with people who bring huge jars and bottles in order to take home some of the blessed water and engage in a ritual rinsing or re-enactment of baptism. The plates that hold the bread prepared for Eucharist, the knives that cut it, even the cloths that cover it are encrusted with significance. An Orthodox home is likely as well to be interpenetrated with "symbol." Greek Orthodox couples often hang the ritual blossom crowns that they wore on their wedding day in their homes, amid the icons. Food is invested with symbolism as well, with certain meals prepared for certain religious holidays and feasts. There is a fusion between the object and what it signifies. And Easter, as the greatest feast, is invested with the greatest significance.

What strikes me most about Easter liturgy in Russia is not so much who is *there*—those believers who, prepared by faith and discipline, attend in expectation of the dramatic enactment of Christ's resurrection and our own resurrection from sin and death. I am fascinated by those who "attend"— those who, while not fully participating, hover somewhat uncomfortably at the edges of the experience. Who are those masses of people who come merely to witness the act? My Russian friends tell me that the days when young hoods used to come and loudly "make trouble" are over. That would now be in bad taste even in Communist circles. But people still come. They are probably not believers, most of them. Maybe they have relatives who are. Somewhere lurking in their memory is an experience from the past, perhaps, or an episode in a novel. At any rate, they come in such numbers as to crush round the church, holding candles, and for that one night a year to press close, to watch curiously, perhaps to join, however tentatively, in the hymn of the procession.

Once when I, as a privileged foreigner, oddly distinguished by virtue of my Orthodoxy, joined in the procession around the Cathedral of Saint Nicholas during the Easter vigil and sang the hymns, I looked at the faces which ringed that huge church and wondered. Beforehand I had worried that believers unable to get into the church would resent the fact that I, a foreigner, had been shown to a prominent place. But most of these people outside had come too late to get in— "regular" believers would know enough to come early. They held candles and pressed close, but most of them, unlike the thousands crammed inside the cathedral itself, looked more curious than devout. I could pick out a lot of comments and questions as they spoke to each other, and the questions were naive, the voices tense with inexperience. I wondered why they were there. Suddenly I recalled the truth in a passage by Evgenii Barabanov, one of the most insightful of contemporary Russian believers:

> They wait patiently for midnight, when they will hear the distant singing from inside the church, when the worshippers will come out in procession, and the cry "Christ is

risen!" will resound over the crowd. They wait for the ac-
complishment of the shining mystery which—who
knows?—might draw them as well into the profound real-
ity called the Church, admit them to it, unfold its secret and
unite it with their own spiritual life.[1]

These people around me had something in common with the
students I teach, with the people in the States who also visit
our churches on this one day of the year. Each year in Amer-
ica, too, the Orthodox welcome visitors to their churches. If
we American Orthodox do justice to our tradition, we too can
convey in celebration and hymns, in embraces and "symbols"
the same sense of joy. We want to offer it to others, just as
the believers in Russia offer it to those who wait. There are
those in America and Russia who are hungry for mystery.
And in hopes of satisfying that hunger, they come to the "pro-
found reality called the Church."

A Pendulum in the Sanctuary

Orthodox are often described as belonging to a "mystic" tradi-
tion. I do not object to the word so much as to its common
interpretation. The Western mind has little tolerance for mys-
tery, and it often casts in vaguely condescending terms those
who do. The shaman, the guru, and the priest who acknowl-
edge mystery are in many circles but a step away from the
charlatan. If rationalists hold at a distance those who acknowl-
edge mystery, surely they are genuinely threatened by those
who would assert that the recognition of mystery confers a
clearer understanding. Even those academic minds, anthro-
pological or literary, who take an interest in the role of mys-
tery in society act upon the tacit presumption that they, as ra-
tional analysts, of course "eclipse" or control the process they
analyze. This is also the dilemma of some specialists in re-
ligious studies. By subscribing to the rationalist, empirical pre-

1. Barabanov, "The Schism between the Church and the World,"
in *From under the Rubble* by Alexander Solzhenitsyn et al., trans. Mi-
chael Scammell (Boston: Little, Brown, 1975), p. 172.

sumptions of the greater academy, they enter a realm in some sense alien from that in which they attempt to specialize. Go to one of their conventions and you will find people not precisely sure of what they are.

Partly because the history of the intellect in the West has Christian roots, and partly because Christians wish to remain in dialogue with the secular mind, we in the West fail to satisfy the hunger of those who come and stare at the feast. Living among those utilitarian rationalists who control the world and with whom we seek to communicate, we Christians can forget the nature of Christian perception. We confess to doctrines profoundly mysterious by their nature—that a man should be God, that one God should be at the same time three persons, that we of corruptible flesh should also be temples of the living God. So we believe, but so we cannot comfortably *think*. For as "thoughts," these are in essence mystery. Mystery is what many contemporary minds are hungry for; it is what they seek far afield, in the non-Christian realms and such Eastern, Asiatic sources as the Bhagavad Gita and the Tibetan Book of the Dead. We Christians in the West have not shared what we possess. We have mystery in plenty, yet our discourse averts it, avoids it as if in embarrassment. For mystery is what we have been taught through our education to relentlessly extinguish.

Alexis de Tocqueville visited America in the 1830s, and already it was clear that Americans were a people who relied upon individual judgment and individual analysis in deriving meaning from the world. Tocqueville also noted that there was a price to pay for such a divorce from community: "Each man is forever thrown back upon himself alone, and there is a danger that he may be shut up in the solitude of his own heart."[2] In the eyes of the Russian Orthodox, this self-imprisonment is a feature of Western rationalism, a disease that Dostoyevsky probes in *Notes from the Underground* and that Western post-Enlightenment thought imported wholesale to Russia. From the perspective of Russian believers as well as

2. Tocqueville, *Democracy in America*, trans. George Lawrence, ed. J. P. Mayer (Garden City, N.Y.: Doubleday-Anchor, 1969), p. 508.

Russian Communists, the Western mind exists in solitary confinement. And Americans themselves can feel this isolation. *The Lonely Crowd*, the classic sociological study produced by David Riesman in 1950, became a description of the American dilemma. Ogden Nash, in a chilling little poem he wrote in 1945, touched on the isolation that he saw as implicit in thought itself:

> There is a knocking in the skull,
> An endless silent shout
> Of something beating on a wall,
> And crying, Let me out.[3]

Thus Westerners, too, feel themselves to be alone as they think. Rodin's *Thinker* is a concise icon for this Western vision of the process. Thought segregates the thinker from others. Laws assure the ownership of the "products" of our thought. It is as individuals that Westerners think (or at least *think* they think), it is as individuals that they come to understand the questions that concern them, and it is as individuals that they come to a decision. All of this is, as Tocqueville foresaw, a part of the legacy of a post-Enlightenment democracy. Yet in their identity as Christians, American believers acknowledge as well an intense communality in the body of Christ. Both secular and religious works in America have dwelt upon this persistent tension between individualism and community. Any real alarm about the problem, however, is relatively recent. Americans in particular have prided themselves on their ability to rely on the sanctum of private perception. No matter how much community may act as a support for the individual, Ralph Waldo Emerson's theme of "self-reliance" runs strong in the American Christian temper. Here again there is a profound contrast between American Christians and their Russian counterparts. Just as Russian Christians incorporate a sense of mystery into their worldview, so also through their reliance upon tradition do

3. Nash, "Listen . . . ,"in *Introduction to Literature: Poems*, 3rd ed., ed. Lynn Altenbernd and Leslie Lewis (New York: Macmillan, 1975), p. 745.

they see the community as necessary to understanding. For the Orthodox mind, mystery and community are interdependent concepts.

The American's intellectual world is guided by empirical analysis, the "scientific" method of thought that distinguishes those living in the present from those in the ages preceding them. The critical theorist Michel Foucault, in somewhat convoluted prose, touches upon the progress of thought in empirical terms:

> Whatever it [thought] touches it immediately causes to move: it cannot discover the unthought, or at least move towards it, without immediately bringing the unthought nearer to itself—or even, perhaps, without pushing it further away, and in any case without causing man's own being to undergo a change by that very fact, since it is deployed in the distance between them.[4]

Now Foucault in translation is not always noted for crystalline clarity, so let me offer an analogy based on a familiar cartoon. In summary, the French academician makes thought into the Coyote and the unthought into the Roadrunner. We, the thinkers, are like the arena for the chase. The Coyote cannot ignore the Roadrunner, just as the modern mind cannot ignore mystery. Yet the Coyote does not pursue the Roadrunner as a roadrunner but as a tasty blue-plate special: thought chases the unthought down not to consider it, not to respect it, but to eat it up. Thus if we wade through Foucault's passage we achieve an insight even more frustrating than the nature of the sentences. Our continual impulse is not to "apprehend" mystery but to render it extinct. The *primum movens* of the modern mind, its very reason for being, is to move ever outward and embrace the unthought. I remember sitting in a darkened grade-school classroom and watching the science documentaries produced by Bell Telephone. The warm tones of the narrator reassured me with the same message Soviet children received in their classrooms a world away: knowl-

4. Foucault, *The Order of Things: An Archaeology of the Human Sciences* (New York: Vintage Books, 1970), p. 327.

edge marches on, and in the light of rational knowledge all mystery and perplexity will vanish like the wind.

For Christians this is not only a false faith but a faith that in its outworkings destroys true knowledge. Belief in God is not merely a comfort on a cold winter's evening or a refuge from the utilitarian demands of the marketplace. It is in the grand intellectual tradition of Christianity that belief in God assists understanding: it helps people to know not only themselves but their world. Thus our belief is our intellectual asset. One image borrowed from modern Russia illustrates the extent to which we Christians, both East and West, are faced with the relentless pressure to put aside our own intellectual presumptions in favor of those proposed by the secular intellect.

In the center of Leningrad, not far from the church of St. Nicholas, where unbelievers crowd to see an Easter procession, there stands one of the great cathedrals of the world— St. Isaac's. It is now a museum. It spreads its rounded domes like great, golden half-moons setting into the city landscape. For anyone with the slightest glimmer of imagination, the wonder of the place speaks for itself. Nevertheless, the cathedral guides, not trusting in the imagination, continually pound statistical distinctions into the stunned mind of visitors: the number of meters in the span of the domes, the number of pieces in the mosaics, the number of steps to the top of the belfry. Enormous pillars of intensely colored semiprecious stones soar into the vaulted ceiling. Mosaic icons in semi-Western style dwarf the visitors who flock in groups, like geese, across the vast floor. And oddly, in a grand incongruity, the very center of the cathedral is occupied by one of the great emblems of modernity. A Foucault pendulum, suspended from the midst of the central dome, swings in grand arcs across the floor of the cathedral-turned-museum. Guides place small wooden blocks at points marking the degrees of axis, and at intervals the great, relentless pendulum will drop one, with a tiny clatter, to the flagstone floor.

The pendulum first seems utterly sacrilegious to the Orthodox mind. After all, that central space before the stripped altar is where deacons with great booming voices proclaimed

in bass chants the Word of God. Now the huge pendulum dumbly, inexorably slices the air. And indeed, it was certainly an atheist hauteur which first placed that pendulum there to "disprove," in its scientific demonstration of the earth's roundness, naive religious notions about the nature of the world. That same hauteur infiltrates the tone of the Russian nonbelievers, relentlessly lecturing all those who resist the so-obvious-to-them Great Nonbeing. But I have often heard the same arrogant assumption dominate the conversation over my very American lunch. To the peasant grandmother who thought God made the world flat, the pendulum would be but an affront. To the contemporary Christian who lives quite comfortably (if precariously) on an orb of a world, the pendulum is a somewhat amusing annoyance. Only a fool, after all, could see that shining pendulum as a proof against God's existence. And in fact it has long since taken on a different function.

The pendulum is an emblem of the modern mind in the midst of the sanctuary. Bent over the altar of St. Isaac's when it was a functioning church, the celebrating priest used to say a prayer heard in all Orthodox churches just before the Sanctus prayer, the "thrice-holy" hymn. Behind the huge doors of the icon screen, with a vast brocade curtain pulled behind the doors to emphasize the intense nature of mystery, bearded deacons would fan the gifts of bread and wine as priests would repeat the following:

> It is fitting and right to sing to You, to bless You, to praise You, to give thanks to You, to worship You in every place of your dominion: for You are God, beyond description, beyond understanding, invisible, incomprehensible, always existing, always the same; You and your only-begotten Son and your Holy Spirit.[5]

Before that spot, where worshipers once stood in rapt awe before the mystery of the Trinity and the fact of God's absolute and utter incomprehensibility, the great pendulum

5. From the liturgy of St. John Chrysostom, in *Byzantine Daily Worship*, ed. Joseph Raya and Jose de Vinck (Allendale, N.J.: Alleluia Press, 1969), p. 282.

now swings. Where mystery once reigned over the mind in worship, the pendulum now gives daily testimony to pure, unadorned fact, as its inventor, Jean-Bernard-Léon Foucault, intended. The same kind of pendulum swings in the United Nations building in New York. And the pendulum in silence says with much greater clarity what Michel Foucault the critic tried to say. As we think, we stretch our dominion over the unthought. We see thinking as antithetical to mystery.

As an Orthodox Christian, I should feel a certain violation, I suppose, in the presence of the pendulum. Yet sacrilege is possible only when God's dominion is violated in some way. To me the sacrilege does not exist so much in the space of the building. It is now a museum, and if we look at its structure and imagery, it is clear that it was meant to be a monument to the czar who constructed it. The cathedral was the medium of the message, but its lavishness was clearly intended to proclaim the glory of that earthly prince who built it. He wished his name to survive, and, pharaoh-like, he instructed his minions to insure the fact. The chattering guides have given the ugly details in a dozen languages: workers by the dozens died of chemical poisoning in gold-leafing the magnificent domes; stonemasons were driven and abused. The cathedral, then, was consecrated only by the worship that once took place there. The pendulum is a violation not in its sacrilege against the building but in its proclamation of the hubris of modernity. In asserting its finite ability to know, the modern mind declares its ability to negate mystery—what is not and can never be known.

Thomas Edison once said, as if in frustration, "We do not know one-millionth of one percent about anything." And Edison, of course, as many of us learned admiringly in school, did his best to increase that percentage. So did many of the other intellectual models processed before us in grade school. Yet no matter how well the model may serve us in a secular and technological environment, its religious effect is far different. Like Tantalus in the Greek myth, Christians are ever taunted and "tantalized" to taste that which we do not and cannot know. We insist on *assurance.* We want *proof* in the text.

We long for *verifiability*. In a religious context as well, Christians take on the presumptions of the age.

Christians too try to hang the pendulum in the sanctuary and allow it to ascertain the "truth" of religious convictions. From an Orthodox perspective, American Christians of both the right and the left show a common suspicion of mystery. Indeed, the doctrine of "inerrancy" at times is an unconscious manifestation of this mentality. Orthodox Christians feel they must approach the "Sacred Book" with a "sacred mind." The Book is suffused with the mystery that informs it. To read it too insistently as if it were, indeed, a science text is to limit the wonder and majesty of God. Likewise, a corresponding abandonment of the religious mind in favor of the secular is the more conscious, deliberate endorsement of a mind destructive of mystery. Many contemporary "liberal" theologians regard the rationalist Western mind as itself an inevitability, a prism through which the gospel must be read; many conservative theologians sense this profound problem, yet use the very empirical terms of Western rationalism to combat its effects. Both groups neglect wholesale the mind of the Christian East in our common dilemma—a dilemma that even the seculars themselves recognize. As Michel Foucault himself asserts, it is its hostility to the realm of mystery that gives the modern mind its most pressing handicap: "Modern thought has never, in fact, been able to propose a morality."[6]

The Crucified Mind

We Christians, of course, do not "propose" a morality. We embrace a morality, and there is a profound difference. A morality is a way of life based upon a commonly held premise. We subscribe to behavior commanded by God and adjudicated by a Christian community. The strength of the Christian intellect rests in its honest acceptance of its individual inadequacy. Yet the civil vocabulary and secular presump-

6. Foucault, *The Order of Things*, p. 328.

tions, like Foucault's, imagine morality as a thing capable of "proposition." Our very legal system and our ways of defining our freedoms place individual "right" and "choice" in a central position.

The Orthodox in Russia do not accept that presumption, nor do many Christians who seek to reinterpret the notion of a "civil right" in a more communal framework. For example, now that many Western Christians wrestle with their own opposition to abortion (a position they share with Orthodox Christians), they recognize the troubling limits to "choice." There is a continuity in *values* between those who would permit abortion on moral grounds and those who adopt a "pro-choice" position in the case of civil law. Orthodox Christians, and most certainly Christians in the Soviet Union, see morality as flowing primarily from the consensus of the Christian community to which they belong, and only secondarily from any individual act of assent. If there is no consensus, then Christians must expend efforts to build one.

The Orthodox, like all Christians, make the fundamental Christian assent of faith: "I believe." Yet when they perform that act of faith, they perform it in concert, chanting together in harmony the creed and consensus that binds them together as a believing community. To be human, to be whole, means to belong to a community centered in God—not to a community that one "chooses" but to one that binds through commitment and conscience. Russian Orthodox Christians adopt a fundamentally different model of "personhood"—not isolated and individualist but Trinitarian, mysterious, and communal in origin.

Americans and Russians too often act as if their behavior is based upon the same set of assumptions. It is difficult for us Americans to escape from the "private" model of personhood because it is everywhere present around us. American sports figures and musicians, rock stars and poets all tend to emerge as heroic individuals. As an avid hockey fan who works with a college club team, I marvel at the different coaching strategies favored by Americans and Russians. The Russians feature precision, in-concert teamwork, skating with blades flashing in synchrony on the ice, while Americans try

to set up scenarios within which an individual player, darting out into an opportunity, can flash forth to a goal.

We Americans imagine our scientists as well to be single crusaders making discoveries alone rather than compilers who rely upon the data painstakingly provided for them by their colleagues. Our "great thinkers," whether Thomas Jefferson or Henry David Thoreau, also emerge for us as "pioneers," "innovators," "bold seers," carved heroically in the Mount Rushmore of the imagination. This monolithic model of the intellect is etched in our culture. Yet that model of individualism has never taken hold in the Christian East. It is interesting to me that my Orthodox Christian friends in the Soviet Union puzzle over the Western mind in precisely the same way the Communists do. "You are such individualists," said a young Russian woman to a group of my students, "as if alone you could decide everything. We instinctively seek to express the mind of the community to which we belong."

When we look to the theological roots of this difference in perspective, we can discover an overwhelming emphasis upon the Trinity in Orthodox consciousness. Orthodox worship and speculative thought have returned again and again to the Trinity as a model for unity in multiplicity. God manifests himself as Trinity, three-in-one. Similarly, humans themselves are full "persons" only in the context of the community of love. Just as, in the words of the Orthodox American theologian Thomas Hopko, "God alone is not God," so also the "individual" Orthodox, apart from all others, cannot see himself or herself as complete, as a "self." Russian Christians offer their Western counterparts a renewed Trinitarian consciousness, one that can relieve the pain of intellectual exile and reawaken a communal model of personhood.

This Trinitarian theme pervades Christian consciousness in Russia. The Orthodox liturgy is filled with the celebration of the Trinity, of God as "one in essence and undivided." Of course, the Russian Orthodox share the Trinity as a point of doctrine with their Western Christian brothers and sisters, but as Western Christians themselves often acknowledge, the Orthodox have retained the Trinity as a central element in their prayer and devotional life.

The Trinity in the West often emerges as an intellectual category, the subject of doctoral dissertations in Christian philosophy and panels at theological society meetings. As one pastor in the United Church of Christ confided, if the Trinity as a concept appeared at the parish level, it would be confined to the three-leaf clover on a Sunday school blackboard. The U.C.C. pastor may not be a typical example, but he testifies that Trinity is not the center of American Protestant emphasis. In an Orthodox context, however, the Trinity is a central manifestation of divine life. God manifests himself as divine community; Jesus himself is incomprehensible except within the context of the Trinity. Each complete Person of that divine wholeness gives of himself unto each other Person in total love. Thus the very manifestation of God among us is the perfect exemplar of that Love which God is. The very thematic structure of the liturgy, with its "thrice-holy" theme, continually reinforces that realization for the Russian Orthodox, and the Trinity as a concept resonates with the communal vision of personhood.

This Trinitarian emphasis brings a multitude of reactions. Non-Christian secular thinkers tend to be uncomprehending or even hostile. One anti-Marxist scholar has even compared the devotion of intellectuals to Marx with all the "wasted centuries" of intellectual activity expended upon the illogic of the Trinity. Even some religious scholars regard Orthodoxy as if it were a frozen epoch in history, as if it manifested Trinitarian concerns that once were vital but that now resolve themselves into more purely Christological and "Jesus-centered" concerns. There is still the tendency even in ecumenical circles to see the Orthodox insistence upon Trinitarian matters as an insistence upon "non-essentials." Most theologians in the West are aware, for example, that the Orthodox object to the Western insertion of the Latin word *filioque* into the Nicene Creed, a single word that has left centuries of Western Christians confessing to the procession of the Holy Spirit from the Father *"and the Son."* Yet in Orthodox countries, many simple people as well know about the dispute, whether or not they understand the subtler dimensions of it. ("The Catholics are good people, better than most of us

Orthodox," said one old Byelorussian man. But then he raised a gnarled finger of warning and added, "But the Holy Spirit proceeds from the Father just the same.") Western Christians must understand that the Orthodox concentration upon the Trinity is basic to their process of thought.

Different ways of envisioning God result in different portraits of the human. Typically, early Byzantine and Russian artists were anonymous creators, and in religious works they tended to remain nameless as they expressed a perception common to all the community. In the East the self-portrait is rare. Yet on the edges of certain Western illuminated manuscripts, miniature figures appear; the artists began to portray themselves—tiny, wizened figures at first—prostrate before the images they had drawn. "Cynewulf" is not a name known to many English-speakers, but Cynewulf was the first English poet who, in the eighth century, wove his name with runes into the conclusions of his poems. In courses dubbed "surveys of literature" I teach a procession of "the greats," each single figure succeeded by the next, like classic carved busts in niches down a hallway. The Western concentration upon the individual intellect and the critical faculty causes Westerners, and Americans in particular, to emphasize the attributed achievement. Philosophers and even theologians become heroes of the intellect, and teachers seek to produce the "independent mind." Recently there is one point on which the feminists, the Marxists, and the Christians have found some agreement: that our structures of thought in the West have stressed autonomy and dominion.

Russian Christians are weaker in terms of critical faculty, but they are more sensitive to comprehensiveness and integration. The Orthodox artist or theologian seeks not so much self-expression as expression of the community. The long conversations in the novels of Tolstoy and Dostoyevsky are reflected today in the strong emphasis upon dialogue in the work of modern Soviet writers like Valentin Rasputin and Vladimir Soloukhin. As the Orthodox critic Mikhail Bakhtin has indicated, the novel is the dialogic form. Its genius resides in its ability to express minds in interplay, in mutual interdevelopment and shaping. Russians recognize that there

are some goals that the individual, inquiring intellect can never reach—as a matter of fact, in some vital matters the trust in the individual intellect alone may prevent rather than assist understanding.

In looking at the structure of the Orthodox Church from without, it is possible for Westerners, with their emphasis upon individuality, to stress the merely hierarchical quality that is first apparent to them. Doctrine and theology seem to flow, like authority, from the top down. But there is an inner, dialogic quality to the Russians' concept of their own church. *Sobornost'*, which is defined as "conciliarity" but which has a much fuller meaning than that weak English word, is a term often used to describe this quality. It is a kind of "co-being," a concord that at its deepest level unites all Orthodox churches but also all Orthodox Christians. The bishop, like the artist, expresses the communality of the church. So also does the Orthodox thinker, the Orthodox worshiper. Bishops may be autocrats and theologians egotists, but this is the product of sin rather than of structural design. Liturgy is a supremely dialogic form, and in the light of tradition, so also is theology. The Trinity is a paradigm, the archetype for the "co-being," the "concord" and *sobornost'* that inform thought and nourish life in the church.

Thus, through a concentration upon the Trinity, Russian Christians keep communality and mystery as a necessary foundation of Christian thought. This may help to explain why Russian Christians are naturally estranged from Western rationalism and individualism. As "thinking Christians," as Christians who live a life of the mind, the Russian Orthodox cannot subscribe to the model of the autonomous intellect. The Trinity is not merely "mystery" in the sense that the mind cannot confront it: rather, the Trinity is a mystery that confronts the mind, tries it, and in some sense must shape it. "The Trinity," says a Russian Orthodox theologian, "is the cross upon which the mind is crucified." Like the cross, the Trinity confers an immense power as well. The ever-repeating conundrum of the Trinity is also ever renewing in its insights. In our individuality, we Americans stress the "subjective" aspects of our insights. Just an evening's conversation with a Russian

Christian would reveal the intense "inter-subjective" emphasis in Orthodox thought in Russia. We Orthodox are interdependent upon each other for our perceptions, for our images, for our own "self-image," the interior icon that shapes the model of our identity. We all must encounter the other as a complement to the self. In the other, in those with whom we interact, we continually destroy the illusion that we are in fact autonomous.

In the sacrament of marriage and its sacramental sexuality, the place where humans discover most deeply the extent to which we lose all autonomy, Russian thinkers see most fully their complete interdependence. Russians in the West like Pavel Evdokimov and John Meyendorff have developed Orthodox insights into this sacrament, but they reflect earlier Russian insights like those of Vladimir Solovyov and later treatments unpublished in the Soviet Union. Marriage is the first sacrifice of the rational, utilitarian, and individualist view of human relationships, and in the Soviet Union no less than in the United States, marriage is an embattled institution. Most Soviet priests I have interviewed list marriage as the most serious pastoral concern, and all of them confirm the scant available data that even as baptisms in the church rise, marriages in the church have fallen off. They seek to restore the Orthodox emphasis upon marriage as that relationship that expresses the model for our loving relationship to the rest of the community of the church. The beloved whom the lover loves most fully is simultaneously an expression of great mystery. In sacramental marriage each partner finds mystery always renewed in the other. It is in community that we come to fully understand. "That which I am," the person who I am, becomes revealed most fully in "that which I am not," he or she whom I love most fully. Marriage is "mystery" in the sense that the "self" is paradoxically revealed most fully in the person of another "non-self." These Trinitarian echoes recur whenever Russian Christians discuss personal relationships, and they reveal a fundamental feature of the Russian Christian mind. Christians in the Soviet Union see mystery as a function of community and mystery as necessary to knowledge.

When one of my graduating seniors was discussing his

own education, he said a very revealing thing. "Here I am," he said, "almost at the end of a lifetime of education. And yet when I go over my classes and courses through my whole life, there's one subject that I can never remember focusing on or taking seriously. We don't have any vocabulary for talking about love."

"And what is love's vocabulary?" I asked. "Where do you hear it spoken?"

"I don't know," said the student, his brow knit as he searched, like a humming word processor, for relevant data. "I hear some good stuff in rock music, but most of that speaks of love as if it were a stimulus. I don't think I hear it spoken anywhere in the classroom. I don't know if many of us believe in it any more, at least in the way Christians here seem to."

"Did you ever go to church?" I finally asked him.

"Gee," he said, surprised. "Once in a while. Not much. But they never really talked about *love*—just about God."

This intellectual capacity to speak about love is the great strength that the Russian Christian community can impart to us in the West. Love as a binding principle has little real power in Western secular society. Our sociological studies show that in public and commercial life, in politics and at work, the utilitarian principle dominates. We do not really expect our employer to love us, and it is hard for us to believe that our politicians do. Thus love is a domestic refuge, a "personal matter." It is certainly not a principle that has much intellectual clout. Insofar as love is "mystery" and hence unquantifiable or indefinable, our academic discourse does not devote much attention to it. Even in literature and the humanities, the one refuge for this embarrassing entity, teachers tend to concentrate on love when it rears its troublesome head in a given character in a novel or play or poem. Most instructors leave it to the students to "make the connection," if there is one, to their own experience.

Even Christians, who are by now veterans of the secular world, have an impoverished vocabulary for love. Love is vital, central to the Christian worldview, yet the words used to describe it seem so weak, so sentimental—and they are, because love as it is portrayed in the world around us is indeed

a privatist and sentimental matter. The language of analysis also fails. In fact, the analysis of love is antithetical to love as a subject. Love is "inter-individual," communal and binding in its nature. The Western models of mind and discourse are individual and privatist. The inter-individual, inter-subjective realm of love—a realm wherein mystery is always renewed—is a threat to the very nature of self as we see it. And yet of all subjects, which is most important to our common life?

Is it not profoundly disturbing that in our American society, which we in our own consensus acknowledge to be "free," we are so little engaged with questions of love? A look at contemporary novels and films will reveal an era of profound retrenchment. A new nihilism afflicts our young. I have been teaching college students for twelve years, and nothing has struck me more than the failure of belief—not belief in God (that may be present, in some merely confessional form), but belief in love. The characters who represent the young in the insightful films of John Hughes express a longing for belonging, a longing to escape the cocoon of subjectivity, but they also express a cynicism about the possibilities of love. Those once foolish enough to believe that their love could in some way affect the world end up dead or disillusioned; the wise "survivors" fall back upon the small, tight inner circle. A look at contemporary song lyrics frequently reveals the same spasms of longing piercing a foreground of consistent cynicism. One of the greatest present dangers to young life around us is suicide, the greatest, most hopeless act of longing possible to express. Suicide does not spring from the presence of anything: it springs from its absence. The secular mind does not have the vocabulary to deal with what is missing, and Christians have suffered a failure of the imagination to do so.

Like the crowds in the Soviet Union who crush in a vast circle around the church to feel some small puff of its breath, to hear a tiny snatch of its hymns, vast crowds in America long for a new evangelization. They also long to be released from the prison of self in which modernity has enclosed them. The church, of course, can offer that release. Yet those creative people among us who could most broaden the possibilities of the church are disillusioned with it. The church in the

West has in large measure failed to present to them what the gospel offers: the saving love of Christ, the mystery of the Spirit among us. What the church too often champions instead is the weak, pale, and subjective treacle that love has become in a "post-Christian" world. The real, objective power of love, for the mind as well as the soul, emerges most fully in its Trinitarian context.

The "Personal Savior"

The Trinity teaches that love is a state of being rather than a state of feeling. There is no question that serving God and committing ourselves to him can make Christians "feel good." In America there is a palpable sense of well-being in our congregations on Sunday morning. As the sun streams in through the windows, and we swell together in a good old hymn with our families around us and other families, equally pleased, singing along, we can and well should bless God for our good fortune. Yet there is also no question that serving God and committing ourselves to him can make us feel very bad indeed. Spectres of war and famine on the TV screen overwhelm us with the images of those who demand our concern. We in America have good reason to sing "God Bless America," for the space from our mountains to our prairies and the oceans white with foam has been filled, by and large, with good fortune for us and our children.

But Russia, too, blesses God. This nation that has endured famine and invasion, the loss of twenty million loved ones (in World War II), revolution, and civil war also raises its voice to bless him. A parish priest in a country church in the Ukraine told me, "If you ask one of our believers why we have suffered so much, and others in the world so little, you are apt to get one answer: because God loves us so much. He too suffered much, and he knows we can endure it." Ukrainians have had a special fullness of suffering, and they, like other Slavs, have made their suffering a special mission. Tatiana Goricheva, the dissident Christian feminist, has found much comfort in the conviction that the suffering of the

Russian believer has been redemptive in some way for the whole church. Like the Vietnam vet whose suffering is eased when he discovers that he and others can at last find some *meaning* in their suffering, the Orthodox believer in the USSR dissociates genuine love from the gratification of feeling.

Recently the press has given much attention to those Christians who have abused the TV ministry, often by offering sentiment or "good feeling" in the place of that genuine love that is "integral being." My own concern is with those who long for a cohesive, integral worldview that will allow them to "fit" somehow in the scheme of creation. People with such compelling needs do not usually respond to the TV ministry. These people hover at the edges of the church, curious about what goes on inside but unwilling to come in. They aren't much lured by the promise of "feeling good." There are plenty of mere products, after all, which promise that in our culture—and besides, nonbelievers too seem to feel pretty good much of the time. But real seekers have had enough of self-sufficiency and "lifestyle." What they long for is not an emotional high but a focus to their being, a wholeness to replace the segmentation that the secular world has imposed upon them.

Believers in the Soviet Union have experienced a similar segmentation. They too have seen the economic parts of themselves sundered from their spiritual and intellectual desires. What draws seekers to the church in the USSR is not the promise of good feeling but the promise of a wholeness of being. The church offers what it calls God's "inheritance," a deep and abiding sense of belonging. No sermon or homily I have heard in the USSR offers a sense of "good feeling" or any emotional afterglow resulting from service to God. Rather, the preaching is tough and uncompromising. The way of love is strewn with sacrifice and demands a certain stoicism. It can be followed only through serving others. (Whoever would lose his soul shall save it.)

When the theological emphasis strays from the Trinity, as Russians see it, the result is a failed understanding of Jesus Christ. In the Orthodox vision, Jesus alone, apart from the Persons with whom he is one God, does not relate to the

Christian alone. This violates the social dimension of God's being and our being. Russian Christians, for example, are puzzled by the terminology that identifies Christ as "personal Savior." I have tried to explain that phrase to them, and they are somewhat baffled by the word "personal." "Like a wallet?" one of them asked with smile. "Or a toothbrush?" In their cosmology, Jesus is that divine agent by which all creation is related to divinity. Jesus is a Savior so great that he defies the personalist category.

The gap in sensibility between Russian and American Christians is interesting, because Christians in the USSR do not place the primary agency of theological apprehension in the mind in isolation. The social being of the church is in some ways parallel to the social being of God in the Trinity. Through the agency of others in the church, the individual Christian receives the enlightenment of the gospel. Christians in the church cooperate with God in bringing each other to be saved: thus "salvation" is collective as well as personal. "O God, save thy people," goes the Orthodox hymn, "and bless thine inheritance." When we remove the primary agency of faith and understanding from the solitary mind, we place it where the Russians believe it properly belongs—in the Spirit that binds us as one. Christ is animate and filled with life through the Spirit. Christ is intelligible only through the Spirit.

Russians are deeply sensitive to the social dimensions of life. It would be a foolish mistake to attribute that emphasis to the current ideology or form of government. In fact, the difference between the Communist and the Christian in the Soviet Union rests in the perspective of each upon the source of humanity's "common life." The Communist, like the capitalist, sees the social life of humankind as resting primarily in the economic relations among humans. In the dominant secular mind, the marketplace creates the model for human relations. American Christians on both the right and the left can, in their weaker moments, borrow from the same set of priorities when they become apologists for the systems they prefer. Christians in the USSR, however, draw upon Cappadocian and Byzantine thinkers. Moving economics from primary to secondary focus, they place the social life of humankind in

the context of the "social life" of God. In this view the Holy Spirit is not simply the Enlightener, the Comforter of us as individual Christians. The Spirit is the Quickener of social life in the church.

Dumitru Staniloae, a contemporary Romanian Orthodox theologian who is much respected in the Soviet Union, expresses the relationship between the Spirit and Christian understanding. "We might say," says Staniloae, "that the Church was founded precisely through the infusion into all Believers of a common understanding, an understanding which was shared by faithful and Apostles alike."[7] Staniloae structures the life of the Christian mind in communal principles rather than in the isolating models prevalent in the West. When Trinitarian questions are confined to the treatises of theologians and scholars, not only do they lose pastoral life, but they also become a function of the single, inquiring mind that ponders them. But the "inner life" of the Trinity plays an important role in popular Russian piety, and that piety stresses the "communality of understanding" that Staniloae develops in his work on the Spirit.

At this point it may be best to look to the image rather than to the text. The icon by Andrei Rublev entitled *Old Testament Trinity* is a perfect example of this "relational" principle of common understanding. This tremendously popular Russian icon reveals the three angelic visitors whom Abraham and Sarah host, and who bring the Lord's promise of a son to Sarah (Gen. 18). The three angels, of course, are emblematic of the Trinity, and the composition of the icon seeks to defy the "individualist" categories according to which we portray personality. There is no "center" here; each angel inclines gently to the other. The effort is to portray not the individual angel but the common life inherent in them all. And that communal center draws the figures of Abraham and Sarah forward, as if they too are drawn into the angels' accord. The structure defies autonomy. Trinity here is a model

7. Staniloae, "The Holy Spirit and the Sobornicity of the Church," in his *Theology and the Church,* trans. Robert Barringer (Crestwood, N.Y.: St. Vladimir's Seminary Press, 1980), p. 53.

for social life and for the way in which Christians come to understand creation.

Staniloae articulates a principle at the center of Christian consciousness in Russia when he seeks to portray the life of the Spirit. The Holy Spirit is a mighty presence in Russian Orthodox piety, but it is a presence in itself "self-effacing." It is the peculiarity of the Spirit that to concentrate upon the Spirit in prayer is to find the mind always drawn not to the Person itself but to the relationship between that Person and another. Staniloae concentrates upon this relational aspect of divine life, and in doing so he touches upon a need we have in our own Western Christian consciousness: "Perhaps it is because He [the Spirit] is the Person who sustains relationships that He is the Person who gives life. For a person comes alive always and only 'within a relationship.' The Holy Spirit can under no circumstances be possessed in individual isolation."[8]

In Staniloae's synthesis of Orthodox sources, Trinitarian procession acts as a model in envisioning human interrelationships: "We might say that each human being in some measure 'comes forth' from every other human being when he enters into relation," says Staniloae.[9] This vision of mutual procession is a recurrent theme in modern Russian thought. Human beings shed all pretense of autonomy when they are viewed as shaping each other in a kind of "co-being." Humans are, in effect, *reciprocally defined* by each other in a model that draws directly on the Trinity.

In the West, Methodist hymns can express beautifully the "common life" inherent in liturgy, and, indeed, John Wesley drew the roots of his social piety from the Orthodox fathers whom he studied. Occasionally, however, a hymn will startle me with its sense of private possession of the Godhead. "He walks with me and he talks with me, he tells me I am his own." Piety in the Soviet Union clearly stresses communal apprehension: the life of the Spirit demands that

8. Staniloae, "The Holy Spirit and the Sobornicity of the Church," p. 62.

9. Staniloae, "Trinitarian Relations in the Life of the Church," in his *Theology and the Church,* p. 35.

humans "interrelate," that together they live the life of God. Look to the ceiling of the worshiping churches in Russia and you will find a majestic icon of Jesus spread across the dome, looking down upon all gathered in his kingdom. Divine life comes to us in community. No Russian Orthodox believer would think to call this Jesus "personal." He is a cosmic Savior—he does not belong to me alone.

The "Self-Made" Christian

In each age the church tries to meet the special needs of her people there gathered. The church in Russia offers the church in America new insights based on community and the Trinity, yet those insights cannot change the social conditions under which all of us, Russians and Americans, live. The relational principles within the Russian Christian vision must be applicable to both our societies. In the "Palaces of Economic Achievement" that mark so many cities in the USSR, the Soviets accept the technological criteria by which so many Americans judge them inferior. In both America and Russia, Christians live with the "public" and "private" roles in their lives split from each other, and with their identity as Christians carefully segmented from their relationship with others. It is against these obstacles that the communal, tradition-based perspective offered by the Russian Christians must assert itself.

The Russian vision has an even more difficult access to the American mind, marked as it is by profound individualism. *Habits of the Heart*, with its sensitive commentary on the directions of American society, aptly identifies the problem. America has hosted many tradition-based peoples, but in this culture they face a crucible of individualism:

> The American understanding of the autonomy of the self places the burden of one's own deepest self-definitions on one's own individual choice. For some Americans, even 150 years after Emerson wrote "Self-Reliance," tradition and a tradition-bearing community still exist. But the notion that one discovers one's deepest beliefs in, and through, tradi-

tion and community is not very congenial to Americans. Most of us imagine an autonomous self existing independently, entirely outside any tradition and community, and then perhaps choosing one.[10]

Americans have been taught to prize what used to be called the "self-made man." Sociologists doing surveys have remarked upon those individuals who identify themselves as having "made it on their own," yet who in reality work in a family-based and inherited business. A vivid scene comes to my own mind: one of my students (who drove a Porsche) had never worked except in his father's flourishing business, and he anticipated taking over that business. A Russian student asked him whether he felt any responsibility toward his father's employees. "No," responded my student hastily, "I've worked for every penny I have, and so will they." The categories of American thought simply classify the self according to the standard of autonomy. Even in the choice of a local church, Americans are apt to stress private criteria rather than the generations of tradition that have shaped their "new" Methodist or Reformed or Presbyterian community.

Although Western thought since the eighteenth century has tended to see this kind of self-interest as a function of natural law, the Russian tradition has not defined the human being in the same way. Orthodox thought conceives of personal identity in a distinct way. Trinitarian theology provides a paradigm for personality: the Trinity is perfect society united in love. It is a model for our own relationships with each other. The doctrine of the Trinity dignifies distinct "personhood," just as each Person within the Godhead is manifestly individual. Yet the Trinity discourages any reliance upon purely individualist subjectivity. Son and Spirit "require" the Father; they "come forth" or "process" through him. Each of us likewise is a "self" only by virtue of our having been in relationship with "another." Orthodox Christians see themselves as "reciprocally defined" by each other.

10. "Finding Oneself," in *Habits of the Heart: Individualism and Commitment in American Life* by Robert N. Bellah et al. (San Francisco: Harper & Row, 1986), p. 65.

This consciousness of "reciprocal definition" is strong in the mind of the Russian believer. There is a mutuality in the self-concept of Russian Christians, and an examination of that quality may help American Christians to deal with the conflicts that result from the struggle between their radical individualism and their Christianity. The intellectual roots of Russian communalism lie far back in the Byzantine origins of Russian Orthodoxy, particularly in the way in which the Byzantines developed the doctrine of Trinity. Concerned about the interrelationship or "procession" of the three Persons in the Godhead, the Byzantines generated a strong philosophical and psychological emphasis upon interdependence. In 1422 Joseph Byrennios gave a series of lectures on the procession of the Holy Spirit. Dumitru Staniloae draws from those lectures to articulate an Orthodox perspective upon personhood:

> Every person "passes through" the other or others in order to manifest as fully as possible what belongs to him in his very being by virtue of his coming into existence. This "passage" is precisely the relation he has to one or another group of persons, and the result of this passage is the manifestation or the "shining forth" of that person in a new light.[11]

Staniloae's application of the inner life of the Trinity to the psychological and anthropological model of human identity follows in a Russian tradition. Staniloae acknowledges and cites the work of Pavel Florensky, a modern Russian priest-scientist and a casualty of the Gulag who, like Staniloae, has had a great influence on modern Christian thought in Russia. (We will discuss Florensky's thought in more detail in Chapter Five.) Florensky sees humans, in a pale reflection of the Trinity, as "co-substantial" each with the other.

Theology is far more important in reflecting and in shaping popular consciousness than secular scholars in Russia or America will acknowledge. The "Jesus-centered" consciousness of popular American Christianity reflects the individual-

11. Staniloae, "Trinitarian Relations in the Life of the Church," p. 36.

ism of the American mind. The Trinitarian emphasis of the Orthodox, on the other hand, reflects the communalist, relational mind-set of Russians. Once again let me take refuge in a sports analogy. Hockey fans in the United States cheer for individual players—for Wayne Gretzky or, in my own Flyers, the brilliant goalie Ron Hextall. (Yes, despite their refusal to even play the Russians, I am loyal to the Flyers.) The North American "hockey press" emphasizes biography and individual initiative. In the ritual following victory, chants focus upon a single name. In the USSR the tradition of "reciprocal definition" expresses itself in a focus upon the team: individual players, even when they excel, credit their success to group strategy, and sports coverage in the popular Soviet sports journals features that strategy. Thus the Russian fan foregrounds team strategy; the American fan foregrounds a key player. Likewise, the veneration of certain saints in Russia such as Seraphim of Sarov and even the growing devotion to the new Russian martyrs seem suspect theologically to an American whose models of autonomy see Jesus thereby "threatened." Yet the Russian sees the saint, just as the Russian sees identity itself, as a function of constant and reflective interrelationship with a Triune God.

Americans, whatever their vision of ice hockey or saints, need to borrow some measure of this Trinitarian vision of communalism. Christians who seek fellowship with each other must place limits on a doctrine of self-reliance; the great tradition of Christian theology proves hostile to the model of a "self-made Christian." And if we Christians are defined by each other, so also are we defined in relation to those who do not share our beliefs. In the social structure of a "post-Christian" world, we daily engage in relationships with non-believing, non-Christian people. What is more, we do so in an environment that places limits upon rhetorical, overt modes of confession. Thus far, much of the work in evangelism has applied technological tools to an old, outmoded vision: the show may appear on a wide-screen projection TV, but it's still called "The Old-Time Gospel Hour." Television evangelism in the USSR, of course, would be unthinkable. Although we in the United States have greater latitude, our basic

situation can be compared with that of our Russian counter-parts. We Christians can no longer assume that the world around us recognizes or accepts the terms in which we speak. Not only the techniques but also the vision of evangelism must change to acknowledge Christians' interdependence with non-Christians.

Believers in the USSR provide a practical model for a Christian's intellectual and social relationship with nonbeliev-ers. The genre of "Christian Gothic" discussed in Chapter One projects an image of utter separation between Russian atheists and Russian Christians, yet there are in fact cordial, even loving relationships between believers and nonbelieving counterparts. I have met American Christians who wish to pass tracts on Russian street corners. They want to "give wit-ness" to Christ through the overt, rhetorical means common in the American tradition. Christian rhetoric was never strong in Russia, and believers in the USSR give witness in a differ-ent way, through the purity and principle they seek to make apparent in their lives. Of the many sermons I have heard in Russian churches, this theme most often prevails: "Live in peace, live in purity, and others will profit by your example." Believers see themselves as possessing precisely that social role: it is through the lived Christian life that others will be brought to perceive the gospel.

Russian Christians take a profoundly evangelical stance toward nonbelievers, yet they seek to integrate Christ into the society of which they are a part rather than to impose him, as an intellectual proposition, upon the minds of others. "You can-not," said a woman living as a nun in the Soviet Union, "thrust Christ into the intellect of another. You must first bring him to another's heart, to their soul. Only then can another freely ac-cept the love within which Christ lives." Here love is conceived of not as a sentiment but as a mode of interpreting the world. If Christians are "reciprocally defined," then they shape and are shaped in their relationships with nonbelievers. Christians must seek not to alter or change the other but to relate to the other so that both they and the other can be manifest, can "shine forth" in a new way. Evangelism is an imaginative act.

As Americans look from afar at the Soviet Union, they

tend to portray nonbelievers in that country as an undifferentiated, unredeemed mass. But believers in the Soviet Union show love and respect toward those who do not share their commitment to Christ. We cannot forget, after all, that Christians in the contemporary USSR are likely to have close family members—mothers or husbands or children—who do not share the faith. (And don't Americans as well?) At times they even come to the defense of those principled Communists whom they admire. For example, Anatoli Levitin, an Orthodox activist now living in Switzerland, wrote an eloquent defense of a Communist general when he felt the officer had been unjustly treated in the press. And Levitin continually engaged in brisk and loving dialogue with his Communist friends.[12] I once asked some Soviet seminarians if they were not troubled by their love of a country in which nonbelievers were in charge of public policy. "Russia is our mother," said their young spokesman. "What if a mother's children are no longer believers. Does she cease to love them? Does she love her believing children any more than those who are not? Of course not!" It was clear that in the mind of the seminarian, "Mother Russia" is herself a believer, no matter what the ideology of her sons and daughters.

The evangelical imperative, as Christians in the Soviet Union tend to interpret it, depends upon an organic principle. If each of us is reciprocally defined by the other, and if love admits believer and nonbeliever alike into relationship, then each is in some sense shaped by the other. There is less "anxiety of influence" that so often marks the American vision of creativity—a desperate desire to be utterly one's own. Believers in the USSR leave the process of influence to the Holy Spirit. They believe that if they are faithful to the gospel and live a life of prayer, they will help to shape and define those nonbelievers with whom they come into contact. This is not to say that they accept the restrictions that have been

12. One friendly argument about atheist and Christian beliefs is contained in an article by Levitin entitled "Correspondence with a Communist Friend," in *Dialog s tserkovnoi Rossiei (Dialogue with Ecclesiastical Russia)* (Paris: Ichthus, 1967), pp. 71-86.

placed upon them; they resist those restrictions strongly, as we should on their behalf. But what they seek is not the rhetorical voice to proselytize but rather the social presence to teach and heal and comfort. Russian believers seek not to convince nonbelievers but merely to engage them. Christians, in their view, need not exert intellectual dominion over unbelievers; dominion is the way of the world.

American Christians, much more active as a force in the political process than their Russian counterparts, are more comfortable with the ambiguities of power. In the political arena, on both the right and the left, Christians in America find themselves split not on the issue of dominion precisely, but on the question of which perspective should be dominant. American Christians of a conservative political bent openly yearn for the days when law reflected a Christian view of private ethics. Likewise, those on the left seek to express a Christian vision of social justice in matters of public and foreign policy. One of the personal lessons I have learned through my contact with Russian believers is that as an American I have identified political power too closely with service to the gospel—a shortcoming they consistently critique. "What of those who disagree with you?" asked a fellow teacher in the USSR. "Do you exclude them from the love of Christ? Don't you shape each other, bring each other to God?" I have tried (with tremendous, daily difficulty) to put aside my own temptations to impose judgment upon and dominion over those who do not share my political perspective. What I have seen in Russian Christians of "reciprocal definition," the confidence that each of us is the hand that sculpts our neighbor, has led me to long for a purer form of Christian thought and witness.

Earthly power and dominion are starkly contrasted against service to God in the teachings of Jesus Christ. The mother of the sons of Zebedee was anxious over such things, and our Lord reacted with a clear comparison: "You know that the rulers of the Gentiles lord it over them, and their great men exercise authority over them" (Matt. 20:25). Among his followers, Jesus clearly indicated, it should not be so. Theirs is to be a different model of service and love. It is not, of course, that Christians do not wish to have any social *ef-*

fects: the problem arises when Christians consider the way in which they hope to achieve them.

Russian Christians often react with some shame to the way in which the church participated in civil abuse prior to what even they now call the "Great October Revolution." A friend of mine at the Leningrad Theological Academy, raised a nonbeliever, reacted strongly against those who romanticized the "Christian" days of pre-Revolutionary Russia. "What do the monarchist emigrés in the West want us to return to?" he asked. "To the days in which the civil authorities used compulsion to make religion a function of citizenship?" Christians in Russia, removed from the arena of public power, have arrived at a new way of giving witness. They all have a civil role in the social order, defined by the work they do and their place in the community. Christians seek, in peace, to exercise that role in full accordance with the gospel. My friend at the academy explained the dimensions of the role: "The gospel too has given us the powerful metaphors of salt and leaven to indicate our role. But neither substance remains apart from the substances they affect. We are of one people with those who do not share the faith. Like leaven and salt, we seek to blend with them. Our effects will be felt."

Again, the Trinitarian theology of the Russian church offers a model for the new, more constrained relationship of Christians with their non-Christian society. As believers enter a new age together in both East and West, an age in which the church no longer has an active role in civil administration, Christians must necessarily expect a "secular" administration of power. This is happening even in such "Orthodox" nations as Greece, where the secular government is in the process of taking over church property. Yet the exertion of secular power over the empirical, institutional church does not change the interdependence of Christians and non-Christians as *persons.* Believers and unbelievers "enter into relationship" with one another, affect each other, regardless of faith commitment. Christians "evangelize" in and through those social relationships, by their very actions, in accordance with their faith commitment.

Christians are to love one another, and from that very

love emerge the effects of our social role. Love is not a "feel-ing" but an acknowledgment of and a commitment to complete interdependence. Whereas the direct quest for political power alienates Christians of different political per-spectives from each other, love involves a unity of commit-ment. "Let us love one another," enjoins the Orthodox litur-gy, "that with one mind we may confess Father, Son, and Holy Spirit, one in essence and undivided." The common confes-sion of faith among Christians proceeds *through* the love they express toward others. This love itself "empowers" them to help define the social conditions of which they are a part.

Christians everywhere find that their efforts to affect public policy as a function of their religion are increasingly frustrated. Even when they receive concessions, on the left or the right, the secular conditions under which those conces-sions are granted insure that Christians will be used as a mere base to broaden political power. Similarly and more severely, Christians in the USSR find the czarist abuses of the church-state relationship intensified in severe Communist restrictions upon church activity. The *glasnost'* policies initiated under Gorbachev are hopeful, yet it remains to be seen whether any real structural changes will integrate believers more fully into civic life. Christianity, however, has proven its durability. Christians can through the very structures of their thought give witness to the gospel.

No matter how much tradition-based Christians in the United States may feel constrained by secular society, and no matter how much Christians in the USSR might lament the fact that many churches are closed and that they are not free to instruct and assemble and educate in the faith, the process by which humans are "reciprocally defined" is irrepressible. I have a Communist friend in Kiev—an intense young journal-ist whose commitment is strong and whose ideals are as yet uncompromised by age or expediency. My Christianity, which he only vaguely understands, frustrates him. When I complain that the state should have no fear of the church, he responds with impatience, "But you don't see the point—the sole exis-tence of the church is to serve the needs of believers! It has no other role." Recently the church in Russia has been granted

the status of "legal person," the basis for church rights in the United States. Yet in the United States as well, the church from a secular perspective exists for the same reason: only to meet the needs of believers. Such limitations are a mere construct, an illusion. So long as believers assert the intellectual and social power of love, they will shape others in interaction.

"Christ Is Risen!"

In a "post-Christian" era, believers can no longer rely on institutions to witness for them. Russian Christians have had to deepen their own spirituality in order to fill their new and much harder role. This is a mission that is antithetical to political power as it is usually exercised. The mission now is to exercise the power of love, not in a sentimental way but in a way that profoundly challenges the mind to reinterpret experience. This love demands a shift in Christian attitude: the abandonment of "proprietary" attitudes toward other people.

Where there is consciousness, there is "other." That which "I" think, that which "my" consciousness contains, implies something that is different from "me" yet connected to "me." When we love, we engage one another as fully as we can in our "co-being," and we discover an "alliance of subjectivity," a sense in which "we" experience and know the world more fully than the "I" alone does. (We feel that alliance profoundly when we grieve, for in death the one we love has been torn from us—indeed, a part of our very being has been torn from us.) It is this "alliance of subjectivity," a way of knowing the world, that Christians share. Yet love is not shared if it is not also imparted, conveyed to others. Just as a single "I," a solitary subjectivity, can distort experience with egotism and self-enclosure, so also even an alliance of two persons born in love can become limiting, distorting, and self-enclosing if it does not engage a third party—the other. The "I-Thou" relationship demands a third entity in order to fulfill itself, for the alliance in subjectivity that begins the process of love must flow out and embrace, must include "the other"

in the world in order to fulfill it. Thus the fullness of human love acts in feeble but genuine imitation of that profound love which exists in the Trinity.

In the very Persons of the Godhead, "proceeding" in perfect love from their interrelationship, we experience a vortex of love that pulls us as well into its power. The God of power and might has dominion over the earth; the God of love "invites us in" to experience the love that is his very being. Love has been understood, even among Christians, in terms of sentiment. "Jesus loves you" is a profoundly true statement, yet it has taken on the same quality as the expression "Have a nice day," complete with smiley-face sticker.

In the context of the Trinity, Jesus' love imparts a way of knowing the world, a mode of interpreting experience. Love does not impose dominion: love, to be love, must be freely given and freely received. Christian love, then, cannot presume to require the imposition of "my" will upon another. Love is absolutely antithetical to the "autonomy" in terms of which secular thought deals with human relationships. In popular culture and the popular mind, love is a state that is narrowly confined. It is romantically limited to two, or at most domestically extended to the decreasing number in the nuclear family. Love is even described as if it belonged to the lover. Yet clearly, love does not belong only to the lover: by its very nature, it also belongs to the beloved as well. Love is "trans-subjective."

So, then, is Christianity "trans-subjective." It does not belong merely to Christians, to those who are believers. Insofar as believers truly engage nonbelievers, Christianity also "belongs" to those with whom we enter into relationship. The Christian Seminar movement in the USSR in the 1970s brought together all those interested in religion and culture. In one sense the atheist and agnostic members of the Christian Seminar were at one with Christians before they became believers; they were drawn into belief as they became shaped in love. Russian culture, as the Russian monk Archimandrite Platon Igumenov illustrated in a paper presented in the United States, is itself a repository of belief.

Russians and Americans, believers and unbelievers, are "reciprocally defined." Like leaven and salt, Christians impart

something to others and receive something in return. In and of ourselves, we Christians are not worth all that much—yeast and salt taken by themselves, after all, would curl the tongue. In order to become palatable, we must escape from the self and engage in relationship with the other. Nor should we become obsessed with the "salvation" of those with whom we engage in daily interrelationships. We must leave that state to God. If we give witness to the gospel through our faith and practice, God acts through us. That is one thing we can be sure of.

If we return to the Easter liturgy with which I began this chapter, we can find there an emblem of the church's role in postmodern society. To proclaim, again and again, as those assembled worshipers proclaimed by the thousands that Easter night in Leningrad, that "Christ has risen! Indeed, he has risen!" is of course an assertion of faith. But is it an "individual assertion," a "private act"? This is neither a Russian nor an Orthodox perception. Acts of faith in the USSR tend to be communally proclaimed and communally understood. "Let us love one another, that *we* may confess," says the liturgy. The proclamation itself is dialogic.

The white-bearded bishop, his vestments and countenance reflecting the icons of his saintly predecessors that flash out like mirrors throughout the church, makes the assertion, "Christ is risen!" And after a long Lent of fasting and penance for sin, the masses of believers, responding as a community, shout back in unison, "Indeed, he is risen!" They embrace. The church bells ring. As a testimony the confession is a dialogic act. All the believers assembled make it together. All the believers when departed echo it in spirit, reflect it in icons. And in the common proclamation, as Evgenii Barabanov asserts, all duplicity, all concealment, all hypocrisy is driven back and extinguished. Not only do we proclaim the truth of the historical event, but in this common declaration the risen Christ is indeed manifest among his faithful. Unbelief is vanquished.

And what of the ring of people surrounding the church outside? Drawn in by the drama of the moment, they too raise their candles. They too respond, however tentatively, "Indeed, he is risen!" They have come close for a moment in hopes of touching the mystery, feeling its power. How do we Chris-

tians best serve those masses on the edge of our fellowship? After all, only yesterday many of them probably were indifferent to the feast we celebrate. They may have come only out of curiosity; tomorrow, in fact, they may speak lightly of their presence or even repudiate those who were there. "What did you do for Easter?" somebody might ask, as one of my students asked his colleague in class. "Oh, we did the church thing—you know," he said, with a faint note of satiric apology. "I got saved." The unbelievers are not drawn in by testimony or rhetoric. They are drawn in relationally, through the power and the mind that are conveyed through love.

We American Christians, too, see a ring of people pressing close to the feast. At times they may define themselves against us, but we live and work with them. They are one with us as well. At this point in our history we may best fulfill the evangelical and intellectual duty before us as the Russians fulfill it—by partaking in the feast as joyously as we know how. For there are many in our society who are isolated and cut off from each other by the structures of self-definition that prevail in the American mind. We see in cultic movements and in sporadic enthusiasms that sweep over our country a desire for belonging, a desire to escape the limits of autonomy and the self. The promise of mystery, like the greatness of the Trinity itself, lies in the ability to transcend the limits imposed by one's own being. Christians must be faithful to that sense of mystery in their own tradition and recognize its source in Trinitarian thought. Despite the severe limitations placed upon public witness to faith in Russia, Soviet Christians have drawn many inside, into the church, where they too can fully proclaim Christ's resurrection. The church in America, if it could only feel its own power, could host a mighty feast. In escaping the limits of their individualism and in sensing the way in which they are interrelated and reciprocally defined, American Christians too could offer mystery and holiness to those who desire a more "profound reality."

Chapter Four

GOSPEL AND LITURGY

A Living Memory

In the Old English poem *Beowulf*, the monster Grendel suffers his greatest torment when, isolated and alone, he hears from afar the songs and the laughter of feasting in the great hall of the king. In the isolation and cynicism of modernity, many Soviets see the Russian Orthodox liturgy as the great feast that still sends its echoes through contemporary life. Although liturgy has always been central to Orthodox life and thought, in this century Orthodox thinkers have given special attention to its role. In the United States, the late theologian Alexander Schmemann, an American emigré via the Russian community in Paris, has shaped the popular consciousness of liturgy through his work.[1] Father Schmemann's insights complement those that emerge on native Russian soil, and his lectures and books are influential even among Soviets who would identify themselves as nonbelievers. The influence of liturgy cannot be limited to that single segment of ex-

1. The best-known text in the USSR is Alexander Schmemann's *For the Life of the World* (1963; rpt. Crestwood, N.Y.: St. Vladimir's Seminary Press, 1984). The core of Schmemann's scholarly canon is *Introduction to Liturgical Theology*, trans. Asheleigh Moorhouse (Crestwood, N.Y.: St. Vladimir's Seminary Press, 1966). Father Schmemann also broadcast a series of lectures in the USSR through the "Voice of America."

perience we dub "religious." Through the Orthodox tradition, liturgy has exercised a special power in shaping the Russian consciousness.

American Christians, by and large, do not see themselves as a "liturgical" people. Those who identify strongly with liturgy generally see themselves as an embattled group, even within their own churches. In order to appreciate Russian Christianity, however, Americans must try to see the world and the gospel through the eyes of those sensitive to liturgy. Liturgy is not simply an "event" punctuated by candles and brilliant robes; liturgy profoundly affects the understanding of the Word. Having seen that the Russians are "sensual" in their worship, and that they are corporate rather than individual in their emphasis, one can then begin to see how they receive and understand the "text" of the gospel.

The "new wave" of American Christianity definitely features the evangelical spirit, with its emphasis upon text and oral witness. This quality has come to pervade the mainstream denominations as well, virtually all of whom now have seasoned their congregations with the zest of American evangelicalism. Sunday services in Protestant America, with all their careful flower arrangements, Scripture reading, and hymn singing, nonetheless tend to feature the sermon. Structurally the sermon is at the center of the Sunday program; even architecturally our churches place the speaker in a dominant, compelling position. Thrust above the congregation on a pulpit, or poised in the church's center upon a platform before the altar, the speaker seeks to instruct, to move and compel. The sermons, even when they explicate a text, feature psychological insight and personal application of the gospel.

In Orthodox churches in the Soviet Union, the sermon-giver takes on a very different role. Ordinarily he (and, indeed, it is a "he"; women do not preach) does not speak until the service itself is complete, the choir has ceased its singing, and the congregation has been finally blessed. Before he takes his place, people are milling about, and there is the distinct sense that the "liturgy," the sacred "work" of the people, is now done. The stance and demeanor of the people show a notable relaxation, as if some voice had just shouted, "At ease!" The

priest who is to deliver the message takes his place on a lower step before the altar. Everyone who had claimed a bit of floor space in the pewless church draws near to him, exhibiting the "huddling instinct" that so many Americans note about the Russian people. Feet shuffle across the floor, and the bodies press forward, sheep-like, toward the speaker.

The criteria for a "good sermon" in the USSR are different from those in the States. Russian Orthodox preachers emphasize life within the community rather than personal fulfillment. The nature of the subject, of course, differs with the preacher, just as it does in America, yet there are some general characteristics that sharply distinguish the Russian preacher from his American counterpart. Some preachers in the Soviet Union do gain personal notoriety: a famous example is the unfortunate Father Dmitrii Dudko,[2] who was so successful in his aggressive posture against atheism that he was effectively silenced. There are also some passionately articulate priests among less controversial clergy, like the protopresbyter Michael Yelagin in Novgorod, a priest who moves his audience to tears with appeals not only to religious fervor but also to staunch Soviet patriotism. Yet individual preachers in Russia seldom gain anything like the phenomenon of "a following" that can claim a separate congregation or a movement.

Russian sermons do not strive to "convert" in quite the same way American sermons do: the examples given and the models evoked are common and accessible rather than distinct or unique. Father Yelagin, for example, frequently relies upon the experience of suffering in World War II (known to Russians as "The Great Patriotic War"), remembered by the older members of his congregation; younger priests allude to the virtues of perseverance needed by those younger Orthodox who resist the unbelief of their peers. The "born-again" experience of "conversion" is, in popular American Christianity, radically specific: when I received a New Testament

2. Samples of Father Dudko's "dialogue sermons," given in response to questions submitted by the congregation, are available in his book entitled *Our Hope*, trans. Paul D. Garrett (Crestwood, N.Y.: St. Vladimir's Seminary Press, 1977).

upon my induction into the U.S. Army, the flyleaf had a space for me to mark the day and the hour in which I first committed myself to Jesus Christ. (To this day, one of the criteria in adjudicating a conscientious objector's appeal to selective service is the nature of the "crystallizing experience" that drew him to nonviolence.) Russian Christians, however, rely more extensively upon the common life inherent in faith—imagery in sermons stresses the way in which the believer joins the "inner spirit" of the Christian people as a whole. Salvation emerges through the labor and struggle of a long process rather than through the catalyst of a moment's insight.

Sermons, like everything else, exist in a context. And faith in America has relied consistently upon images of renovation and renewal. The emphasis upon simplicity and starkness in American church architecture can serve as an emblem of a life laid bare before God. Theologically, of course, all Christians accept the fact that they are "born again" in the Spirit, but the focus upon that image in American evangelicalism stresses the fresh insight, the radical new affiliation that baptism imparts. The "born-again" emphasis acts as a challenge to the vague formalism of a mere "institutional" baptism. And in the plain, simplified icon of the American church, the prominent place of the pulpit offers the constant challenge of the preached word to a congregation that can allow the gospel to fade into triteness. Challenge and critique reside in the spoken word.

In the Orthodox Church, however, the liturgy itself offers that alternate vision which always exists in tension with the world. To be born (*rodit'sa* in Russian) means to "join a people who live on the land" (*rodina*); to be "born again," then, means to join the people of the kingdom, "God's land." Beginning with the intoned phrase "Blessed is the kingdom of the Father, and of the Son, and of the Holy Spirit," the liturgy creates its own divine context. The people who attend that liturgy strive to place themselves within that kingdom for the space and the time of the liturgy. The long services of the Russian church are not scheduled to fit within a fixed time-span; people know when a service begins, but when it will end is a matter of guesswork and experience. An Orthodox American once asked an old Russian grandmother what time

the service would end. Her response was a bemused shrug. Liturgy creates its own unhurried sense of time. The church building, with its abundance of images, is meant to mirror that kingdom on earth.

Lutherans see the believer as *simul justus et peccator*, "justified, and yet simultaneously a sinner." The Orthodox apply a similar *simultaneity* to their own liturgical life of prayer. The liturgy creates a context within which the worshiper can stand as resurrected in a fallen world. Liturgy in effect "brings into being" for worshipers the kingdom of the Father. In any framework—whether Soviet or American—in which a secular mind-set excludes those terms by which God can be apprehended, liturgy recreates the context within which God assumes his importance. Christians come to liturgy not as a "refuge" but as a remedy.

This is the perspective of the Russian church. Liturgy, the common worship of the people of God, sustains the kingdom of God among them. Liturgy is work—*leit-ergos* in Greek, "the work of the people." In Russian the service is referred to as *sluzhba*, "task." It upholds the faith. In harmony with the patristic sources that are so central to Orthodox Christianity, liturgy becomes an expression of a common will. When Basil the Great describes the dialogic, antiphonal liturgical structures of the fourth-century church (essentially the same as those used in contemporary Orthodoxy), he says simply, "The practices that have obtained today in all the Churches of God are concordant and in mutual harmony."[3] This harmony characterizes the Russian vision of God's *social* presence in his people, especially manifest in worship. The American church, on the other hand, emphasizes the *psychological* manifestation of God's presence in the individual Christian. The preached word of the gospel in an American church seeks to convert, renew, and confirm the individual soul; the mind of the Christian will express itself in all its distinct dependence upon Jesus Christ. In the Russian liturgy the "celebrated" word of the

3. Basil the Great, Letter 207, "To the Clerics of Neo-Caesarea," in *The Fathers Speak: St. Basil the Great, St. Gregory of Nazianzus, St. Gregory of Nyssa*, ed. George A. Barrois (Crestwood, N.Y.: St. Vladimir's Seminary Press, 1986), p. 57.

gospel seeks to draw the worshiper into harmony with all believers and into the social life of the Godhead.

The Orthodox consciousness of God's being among humans, then, is anthropologically rather than psychologically centered. The Orthodox perceive prayer as a collective, communal enterprise, the outflowing of the church. The emphasis of many an American sermon is upon the individual and his or her commitment to Christ. The vocabulary of "the personal relationship," drawing the individual believer into a private, psychological communion with the personality of Jesus Christ, pervades the new American evangelical language. In Orthodox worship, however, the liturgy emphasizes the communal interaction of all believers as children of God. The strong Trinitarian awareness of Russians also has its effect upon their concept of "relationship." In the fourth century, Gregory of Nyssa cautioned against relating to God too readily as a "single subject": "We advise those who are to work out their own salvation not to depart from the simplicity of the first principle of the faith, but to receive in their soul the Father, the Son, and the Holy Spirit, and not to imagine that these are just three different names for a single subject [hypostasis]."[4] Orthodox Christians, who even in private prayer routinely address the "three Persons" of the Trinity separately, are less likely to conceive of a "relationship" with God in terms analogous to those of private human psychology. And Russian Christians follow in the patristic "anthropological" tradition in that they see themselves in continuity with the history, identity, and culture of an entire Christian people. Their Christian expression does not feature the psychologically based language of relationship so much as a kinship-based language of *inter*relationship.

Russian believers have retained some patterns of language from the folkways that preceded modern technology. They still have a habit of referring to each other, for example, by familial relationships. An old woman will be called "grandmother," a man "brother" or "uncle." This occurs even in a

4. Gregory of Nyssa, Letter 24, "To Heraklianos," in *The Fathers Speak*, p. 125.

secular context, especially in rural areas. But the habit retains a special strength among believers, and interactions among believers in church have an especially "familiar" context. Baptized Orthodox babies are given communion and enter into the full sacramental life of the church. In a Russian church it is common for strangers to approach the parents of a child after communion to offer greetings, congratulations, a kiss on the forehead, a small gift on the child's behalf. The "liturgical fellowship" of believers brings them together within the reign of the kingdom; the material "symbolism" of the liturgy underscores the tangible nature of God's kingship. American Christians frequently concentrate upon family issues, perhaps in an effort to retain those structures that appear to be slipping away. But Christian rhetoric in America portrays the "family" in nuclear terms, as a haven against the pressures of the world. Russian believers, drawing from the extended family tradition in Russian folk culture, tend to spread that image of family outward into the broader network of church and even secular relationships.

Since the "relational languages" that American and Russian Christians use are different, so also are the ways in which the gospel comes to have meaning for these two groups. Poised between them, the Orthodox in America have experienced both perspectives.

Seeing themselves as individualists, American Christians are a people of reform, of critique. In taking up the gospel, they seek to "apply" it to a world and a life that has essentially abandoned it. Their hymns and popular spirituality reflect an emphasis upon personal renewal: "Amazing grace! (how sweet the sound!) that saved a wretch like me!" Communally they seek to "bring us back" and restore the dominion of the Word over a society that has strayed from first principles: "Give me that old-time religion. . . . It was good enough for Moses, and it's good enough for me." They clearly emphasize the imagery of restoration, reform, and revival. The primacy of the preached word in mainstream American Protestantism continues that tradition. And in Western scholarship as well, the effort has been a hermeneutical one—*hermineia*, the "restoration of meaning" to the gospel.

In Orthodoxy the emphasis is on continuity rather than on restoration. That mainstream Protestants continually stress Reformation as a principle presumes an "estrangement," some period of time through which one passes before one achieves, once more, a purity that had been lost. That is what "reform," after all, means. Orthodox Christians, however, see themselves in unbroken rather than "restored" continuity with the early church. When Russian Orthodox believers stand in church to pray, they do not presume any historical lapse over which they have somehow made a leap. As a matter of fact, they take distinct comfort in the perception that they are praying as many generations did before them. And although the Orthodox are surely surrounded with artifacts that seem ancient, they do not view tradition as merely a principle of preservation. As Georges Florovsky, an emigré theologian, has pointed out, "Tradition is the constant abiding of the Spirit, and not only the memory of words." The "memory" implicit in tradition is collective, and it must be reconstructed in each successive age. Tradition, then, is life as it *is* lived, not a reenactment of life as it once was. It is a profoundly charismatic principle.

This charisma of tradition is something that American Christians must grasp in order to appreciate the nature of Russian Christianity. Tradition does not involve an estrangement from the present and an abiding exclusively in the past. Nor does tradition in Russia manifest itself as "traditional" movements do in the United States, as efforts to "restore" or "recover" some aspect of a lost past. Tradition involves an abiding "incarnation" of past teaching in the present. Of course, each Russian Orthodox is conscious of the rich history that for a thousand years has placed the gospel in Russia. Russian believers feel themselves to be entrusted with the witness of those who came before them. Confident that they, too, will witness to those who come after them, the Orthodox see themselves as a "living legacy" to succeeding generations. In other words, Orthodox Christians see themselves as the full inheritance of their own past, and the pledge of their own future. Thus Russian Christians believe themselves to be a "living memory" of the church.

The "Anxiety of Influence"

This vision, though it may lead to an understanding of Russian Christian thought, may also produce a certain discomfort in Americans who have been taught to value uniqueness and originality above so much else. One book by the American literary critic Harold Bloom (not to be confused with the political philosopher Allan Bloom) helps to illustrate this profound difference in worldview between Russians and Americans. Bloom concisely describes his vision of the poetic process in the title of his book: *The Anxiety of Influence.* For Bloom as for many secular critics, Christianity is a historical relic, so the terms of his discussion rely upon Nietzsche and Freud much more extensively than upon the theological concepts that shaped the poets he focuses upon. In a kind of Darwinism of the Muse, Bloom selects "strong poets, major poets" who in his mind fulfill his thesis: that great poets wrest places for themselves in history "by misreading one another, so as to clear imaginative space for themselves."[5] In Bloom's system, idealism is the province of the weaker mind, which passively receives its ideals; the "stronger mind" appropriates and seizes. Bloom sees even God himself as an enemy to the creative mind:

> British and American poetry, at least since Milton, has been a severely displaced Protestantism, and the overtly devotional poetry of the last three hundred years has been therefore mostly a failure. The Protestant God, insofar as He was a Person, yielded His paternal role for poets to the blocking figure of the Precursor. . . . Poetry whose hidden subject is the anxiety of influence is naturally of a Protestant temper, for the Protestant God always seems to isolate His children in the terrible double bind of two great injunctions: "Be like Me" and "Do not presume to be too like Me."[6]

Of course, Bloom utterly neglects the abundant manifestations of Incarnation and the presence of the Trinity in Protestant thought; he also limits his definition of "overtly devotional

5. Bloom, *The Anxiety of Influence: A Theory of Poetry* (New York: Oxford University Press, 1973), p. 5.
6. Bloom, *The Anxiety of Influence*, p. 152.

poetry" to bad poetry and thus assures the truth of his prop-
osition. But the crux of his misunderstanding, in the Orthodox
mind, lies in his vision of the poetic process itself.

Bloom's grasp of Christianity is weak—even weaker
than that of many Soviet critics—but his reverence for poetry
is profound. Poetry and the arts are also profoundly impor-
tant to the Russian Christian mind, so Bloom's thesis is use-
ful in pointing to a crucial difference between American and
Russian approaches to tradition. Bloom sees poetry as the ut-
most in "original expression," the literal outgrowth of a pri-
vate psychological process upon which Freud sheds his light.
I once shared Bloom's book with a Soviet artist. After read-
ing it, she was restless until she shared her reactions with me.
She claimed that among Russians the process of creativity
could not be understood in the way Bloom sought to codify
it. "Such a notion is strange to the Russian mind," she said.
"We simply assume that in our very being the past will re-
veal itself. Each person is by nature the product of 'influence.'
I am not my own construct; my people have 'brought me
forth.' My art is the product of the interrelationship I have
had with others."

The Russian "anxiety," if we wish to see one, is quite the
reverse: the "new" and "original" is fast interpreted in the
light of what is traditional and received. Even the "Great Oc-
tober Socialist Revolution," radical in its innovations, is now
treated and presented as an act initiating a new set of "tradi-
tions." Similarly, the way in which the Orthodox mind "brings
the gospel to meaning" has a great deal to do with the way
in which the Orthodox view themselves. They rely quite nat-
urally upon assumptions of continuity. Like the villagers in
Nikos Kazantzakis's novel *The Greek Passion,* they bear the
bones of their ancestors upon their shoulders as they con-
tinue their pilgrimage. "I am not here to save myself alone,"
says the worshiper in the liturgy. "In allowing God to save
me, I cooperate with God in saving others." A vision of com-
munal continuity contrasts with the "anxiety of influence" so
important to Bloom.

In order to understand this principle of continuity, let
us look for a moment at the phenomenon of language in

American and Russian Christian life. Although English-speaking Christians have been some of the most radical in proclaiming the "literal truth" of Scripture, they display their own "anxiety of influence" in their relationship with the gospel. For the language in which most Christians encounter Scripture is, of course, different from that of Scripture's original incarnation. This is not a matter for scholars alone: every Christian who claims to gain "understanding" from the Scriptures must acknowledge that this understanding is mediated through language. And since Americans read the Scriptures in modern English, the "language" and the understanding that it generates are different from those that informed the original text.

If Christians assert the "truth" of the gospel, then, they must of course simply assume some correlation between the Word as they hear it and the Word as it was originally proclaimed in Hebrew or Greek. Christians know intellectually that there must be a certain estrangement, however slight, between their own reading of the text and that language within which it was written. Even if the text itself be perceived as "literally true," the translation surely can be but an "icon" of that truth. Ordinarily they can discount that estrangement between the original word and the text as they perceive it because they do not know the original tongue: the distance, then, is invisible. Christians can feel an acute anxiety, however, when they adopt in their congregations a biblical text in a new form of the vernacular. Then a kind of estrangement becomes visible indeed.

The revered King James Version has taken on a special authority because it has shaped the mind and feelings of many generations. When that version is put aside in favor of another, the members of any English-speaking congregation feel an "estrangement," even between two translated texts. Each subsequent version of Scripture, then, must be measured not only against the original tongues but also against its predecessors, for that earlier version shaped minds and attitudes. At times those versions are altered to reflect or even cause a shift in sensibilities: the controversy over "sexist language" in the Scriptures is a case in point. At times those versions can fea-

ture a special truth. "Baptism," for example, was translated in Old English as *fulwihtes baeth*, the "bath of full being." What a wonderful theological insight that conveys! A look at some of the Old English poems and homilies proves that the term as these people understood it produced a rich perspective on the act of baptism. (The later replacement of that term with "baptism" did not enrich but rather confined its meaning.) The medium through which the sacred comes to us is marked with a linguistic "strangeness" for which there must always be some allowance and compensation. The controversy over "literal truth" in Scripture is shaped in part by this anxiety. Both liberal and conservative seekers must restore with precision the meaning of that ancient, estranged Greek or Hebrew tongue in which the "literalness" is most perfectly locked.

Thus, in the West and among Americans, the act of interpretation is a distinctly personal one. The popular value placed upon private reading of the Bible and personal interpretation of it presumes the same mind-set as does the emphasis upon restoration and renewal. The English-speaking mind confronts the translated text, and in the act leaps back over the centuries to encounter the insights within the writings of an ancient Judeo-Hellenistic world. There may be a few mediators in a Calvin, a Luther, or a Wesley, but Bible reading is essentially a quest. The Western mind has "doubled back" upon the text, and it has sought to move forward again through the encounter. In the "figurative knot" of meaning that results, American Christians can much more easily bypass the centuries of interpretation and "tradition" that lie between. The American mind explores the text like the vast, unexplored land that early Americans settled.

When the Orthodox encounter the text, however, they confront a peopled landscape. For them the language of the Scriptures is a testimony to the communal life, because language itself is in a real sense a "tradition"—a handed-down complex of meaning-bearing signs. Language itself is a communal act. Popular Orthodox commentary often claims that the Orthodox tradition has always chosen the vernacular, the language of the people, for liturgical expression. This is only

partially true, for in most cases that language is actually an ancient form of the native tongue. The Greeks, who are the nation and the people from whom the Russians received the gospel, continue to worship and proclaim the gospel in precisely the same language in which it was first inscribed. On any Sunday in my Greek Orthodox parish, the Scriptures are read first in that ancient form. The Greeks who listen do not understand every word, but they recognize the meaning through familiarity. Likewise, Russians worship in Old Church Slavonic, the medieval incarnation of their language. It is not so strange to the modern ear as, say, Tibetan might be, nor is it as familiar as Shakespeare. It, like *koine* Greek to the modern Greek Orthodox, contains intimations of the sacred that continually illuminate daily speech. Even when the liturgical language is modern, the context of liturgy can "de-familiarize" and hence renew it. The Orthodox Church in Finland, for example, celebrates the liturgy in modern Finnish. The Finnish psychotherapist Pennte Leiman, when he first heard the liturgy in his own tongue, wrote that the sacred context of the utterance lent both a remoteness and a renewal to his own language, as if he were hearing it for the first time.

There is some desire in the Soviet Union to celebrate the liturgy in modern Russian, yet that desire is resisted (for different reasons) both by the state and by the strong conservative bent of the church as a whole. Laypeople who grow zealous in the faith frequently study Old Church Slavonic. I know one young man, an engineering student, who interrupts his already demanding academic work to pore over the gospel in his old, pre-Revolutionary Slavonic text. "It's not as if I'm translating," he says. "It's as if I'm recognizing the skeleton, the simplicity of the gospel once more." In their liturgies, of course, the Orthodox most frequently hear the gospel rather than read it. Its context is dramatic. The act of *interpretation*, then, takes on a different character among these people. It is not so much the application of a new, original insight as it is the restoration of some long-neglected, hidden gem in the common storeroom. The language of the "celebrated gospel" in the liturgy can uncover a long-hidden treasure of a word or insight buried in the cluttered closet of everyday speech.

The original intention of the canons, of course, was to present the liturgy in the language of the people. In practice, however, liturgy has elevated the more ancient forms of those languages, and the result has been a constant, sacred reminder of the continuity implicit in language itself.

Jesus as Story

Although different attitudes toward language and different "traditions" distinguish the Christian temperaments in the East and the West, there is a way in which Russian Orthodox perspectives can help to prod awake liberating ideas engendered in the West. The liturgy has proven a durable means of survival in the Orthodox world. The liturgy preserved the Orthodox through centuries of Muslim rule; likewise, the liturgy has conveyed the Word through the constraints and censorship of Soviet policy. The church in Russia continues to evangelize and attract Christians through the liturgy, while an entire modern Soviet bureaucracy exists, complete with publications and a public relations budget, merely to critique and propagandize against Christianity. The liturgy has kept alive the sense of "story" in Christianity. It has placed the text within a *context* and liberated the saving story of Jesus Christ, so that people can continue to organize their lives around it.

The popular sermons of that archetypal reformer Martin Luther show a desire to do precisely the same thing. He sought to release the Word to the common folk, to relieve Scripture of its textual "weight," to place the gospel firmly in the context of community. To Luther the act of interpretation was not at all a private phenomenon; it was the act of a community bound by the same vision. In his own work and writing he sought to relieve the gospel from its confinement to "text." For Luther chose the medium of *discourse*, "story," as his central image for the gospel:

> The gospel is a story about Christ, God's and David's Son, who died and was raised and is established as Lord. This is the gospel in a nutshell. Just as there is no more than one

Christ, so there is and may be no more than one gospel. Since Paul and Peter too teach nothing but Christ, in the way we have just described, so their epistles can be nothing but the gospel.[7]

Luther moves away from the written "text," the meaning of which must be penetrated through various layers, to the orally proclaimed "story," which emerges in various forms. The distinction is an important one, for in a communal context the text exists but to nurture the story. The Bible is the Book of the people of God, written by their spiritual leaders under the inspiration of his Spirit. Likewise inspired by the Spirit, the people of God selected the most sacred among many separate books, those that most completely served the one and sacred story of salvation, and they preserved these books through the ages.

The Orthodox mind in Russia can help bring back this realization that Luther and the Reformers reawakened. The controversy over "literal truth," so destructive in many denominations, suffers from a misplaced emphasis. Christians take their intellectual criteria from the secular, rationalist mind when they make objective, verifiable "truth" their primary focus in approaching the gospel. "Story," a term embraced by Luther and many other Christians, has become something of a scandal among us in this rationalist age. "To tell a story" is to lose touch, somehow, with the "literal truth" that the world demands. To engage the gospel as a dramatic, moving tale, a tale that has the capability to stun the soul of anyone who can *surrender* himself or herself to it, might fill some with discomfort. What an irony it is that Christian anxieties over rigid historical scrutiny of contemporary biblical scholarship have produced constant disputes over "literal truth." The Jesus of the gospel tale is bold and manifest; the "historical Jesus" has become a cipher within a conundrum.

7. Luther, "A Brief Instruction on What to Look For and Expect in the Gospels," in *Word and Sacrament I*, vol. 35 of *Luther's Works*, ed. E. Theodore Bachmann and Helmut T. Lehmann (Philadelphia: Muhlenberg Press, 1960), p. 118.

Rationalist inquiry can illuminate the gospel, but such inquiry cannot give it life. The gospel is more than a record, and Luther calls the attention of his Christian world to some simple truths we so often neglect. Stories are to be told; stories bind their audience into a community; stories constitute a shared experience and convey a body of assumptions to all who share them. All we need do is remember our childhood, or think of the ritual by which we draw our own children around us and, together, lift one of our favorite stories off the page by recounting it aloud. In the "telling," the passing of a tale among us, we preserve the community, the family of faith.

It seems to the Orthodox that their Western counterparts—whether conservative fundamentalists or liberal scholars—miss something in focusing so relentlessly upon the "literal nature" and empirical character of the truth contained in the text. They shift emphasis from what the story contains to the manner in which it is perceived. The gospel can thereby become a chart, a textbook, a dead and "objective" thing. This is precisely the way in which the atheist publications in the USSR approach the biblical text. It thereby loses its mystery, its communal dimension. Georges Florovsky, in reaction to the way in which American scholars approach Scripture, sees the text as an "icon" of truth: "We cannot assert that Scripture is self-sufficient; and this not because it is incomplete, or inexact, or has any defects, but because Scripture in its very essence does not lay claim to self-sufficiency. We can say that Scripture is a God-inspired scheme or image *(eikon)* of truth, but not truth itself."[8] Indeed, I would go further than Florovsky. Scripture is *more* true than truth as the rationalists envision it.

Professors of New Testament in the Soviet Union, generally more proficient in reading German than English, find the approach of Westerners like Gerhard Ebeling and Ernst Fuchs compatible with the Orthodox perspective. These writers focus upon the nature of the "language community," and in doing so they are sensitive to the value Russians place on

8. Florovsky, *Bible, Church, Tradition: An Eastern Orthodox View,* in *Collected Works,* vol. 1 (Belmont, Mass.: Nordland, 1972), p. 48.

sobornost', "conciliarity." In the Russian view, an emphasis upon the communal, binding mortar of language features our "interbeing" or "co-humanity," our state as communicating beings. The "critical" emphasis of both American liberals and American conservatives, in what Russians see as an unseemly battle to possess critical power over the act of interpretation, seems to neglect that dimension of our humanity. "I don't get to read many of the arguments of American Scripture scholars, of course," said one Orthodox professor of Scripture. "But those I do read seem devoid of any sense of tradition, as if the critic alone can determine divine truth."

A brief look at Gerhard Ebeling's approach shows why a Russian Christian whose religious sensitivity grows out of communal, liturgical worship might find his perspective attractive. Ebeling shows a "dialogic" sensitivity, an awareness of our interrelationship:

> The fact, that man precisely in his linguisticality is not essentially self-sufficient, is illustrated by his dependence on his fellow man. No one can speak independently. And no one can be content to speak alone. Man speaks because he has received the gift of language as taught to him by others, and because he longs to hear in turn an echo, an answer to his own speaking.[9]

From this perspective, no Christian can in fact "interpret" alone. Although critical education in the West sharpens the sense of that singular *persona* within each interpreter, the Christian cannot rely exclusively upon it in a religious context. Theology, like language, is a communal act. The theologian cannot work in a white lab coat, nor can he or she make a scientific treatise of the gospel. A theologian who does not speak from or for a community has forgotten the reason for speaking.

This difference between the nature of religion and the nature of science begets a profound difference in methods of approach. It is as individuals that inquirers methodically test

9. Ebeling, *God and Word,* trans. James W. Leitch (Philadelphia: Fortress Press, 1967), p. 29.

"objective truth," striving not to be unduly influenced by the perceptions of those who have preceded them. It is as a community, however, that an audience listens to a story. The insights begotten of the two methods may, of course, coincide. No Russian Orthodox would call into question the objective, factual resurrection of Christ. Yet in assembling together for the great and holy liturgy of Easter, they do not gather to affirm a historical event. They come to *celebrate* it. This common celebration overcomes the isolating individualism implicit in the rationalist approach to the world. It involves a surrender to the community and the tale that defines their experience. This is the dimension of the gospel that the celebration of liturgy fully embraces.

In common celebration and worship, the gospel leaves its "text" and becomes good news openly and orally proclaimed. Its narrative centers upon a Lord who is hero-in-the-flesh in a salvific mythos, a great and marvelous story. Christians celebrate this story together, and wherever they gather they create structures that help to define their relationship to each other and to the world. The gospel as *story* thus builds structures that pattern the common life of Christians. In the Orthodox churches throughout Russia, the liturgy, a carefully constructed communal and dialogic dramatic act, is the gathering within which those structures are generated.

Incarnation proved a scandal to some of Jesus' followers, and incarnation is manifestly a scandal to the modern mind. Nor is that scandal limited to the flesh of Jesus alone. Jesus, who became man for us, becomes *story* for us as well. As man, he took on all the vulnerability of the flesh: as story, he takes on all the vulnerability of language and human understanding. Christians in modernity have probed and tested the gospel text much as, in a far less crucial endeavor, scientists have snipped and dipped and X-rayed fragments of the Shroud of Turin. No measure of analytic rationalism, however, can turn the gospel into what it is not: an objective, scientific proof text of verifiable reality. The now-discredited shroud is an emblem of the problem. That piece of cloth began as a Byzantine *relic,* a category that the rationalist, empirical mind rejected long before it could carbon-date the rags of time. The life of the

relic resides in the significance of the story or biography to which it belongs (and "story" to the empirical mind smacks of "legend"). But once the shroud ceased to be a mere relic, it lost its context in "story" and became instead a potential "proof": it held out the false promise of a "verifiability" that neither a relic nor the gospel ever offers.

Jesus became flesh within history. He becomes *story* in ever-present continuity. It is that realization which touches any Christian as he or she stands in the midst of the thousands of Russian worshipers on Easter morning. We can affirm objective fact as isolated inquirers, but as individuals we cannot fully realize the meaning of what we say. The meaning of the gospel story emerges in a social, "inter-individual" context, not in isolation. In fact, liturgy creates a ritual dialogue in which the worshipers and the celebrant together affirm and relate the drama of salvation. Christ as "the image of the invisible God, the first-born of all creation" (Col. 1:15) becomes incarnate among us, is materially realized, within the sacramental and social life of the church. "Literal truth" is too limiting, too secular a criterion, for it is to limit the Incarnation to that historical flesh of Jesus' person in the historical era of his human life. The whole of the gospel teaches us otherwise. The truth of Jesus' life and resurrection *begets* truth as it is received among us in the church. He is with the church, present among us, in his Spirit. We are his body. He has become incarnate in *us* as well. As the Russians sing, again and again, in the Easter hymn that was sung at their baptism, "Those who have been baptized into Christ have put on Christ. Alleluia!"

To shift the terms of Christian analysis from "literal truth" to true and saving story, then, can capture some of that powerful insight of contemporary Russian spirituality. The secular mind in Russia and in the United States constantly prods at religious understanding; it always predicates the illusion of its own critical autonomy. If we take up its terms of argument, we too become subject to its illusion. "Scientific truth" may of course coincide with the truth asserted in faith, but the two terms do not convey the same thing. Christians must not fear the categories "story" and "myth" as applied to

the gospel, for our faith gives us the unique capability to put them to intellectual use. Christians possess a gift of understanding. Through story, the Christian understanding can penetrate to a greater awareness of truth than that of which the secular mind is capable. The mind of rational modernity is dead to imaginative *possibility*. In the great capacity Christians have to believe in and surrender to the truth of the myth they celebrate, Christians both East and West have a gift that the secular mind longs to possess but cannot. In restoring the celebration of story in the West, American Christians can follow the Russian Orthodox model and assert this power of intellect and imagination in the postmodern world.

As we have seen, the mind's mission in modernity is to extinguish mystery, to make the unknown "known," and to make such knowledge the condition of belief. Yet the very critical mind that extinguishes mystery at the same time longs for it. The anthropologist and structuralist scholar Claude Lévi-Strauss, for example, pursues what he calls the "Savage Mind" with a scholarly passion. He admires possibilities inherent in its workings—its more accurate images of time, its ability to discern pattern and to see expressions of truth in invariant properties or "structures." He recognizes that the mind which can accept myth as its organizing principle is given greater capacities of understanding. Yet, though he would like the modern, scientific mind to use these capacities as a complement to itself, Lévi-Strauss cannot do so. He is himself trapped in the limitations of modern rationalism. "Myth," he claims, "gives man, very importantly, the illusion that he can understand the universe and *does* understand the universe. It is, of course, only an illusion."[10]

"*Of course*, only an illusion." In that devastating qualification one can read both the arrogance and the tragedy of modern rationalism. The arrogance implicit in the "of course," dismissing all the belief inherent in the vision of a risen Christ, is a daily experience for the Russian believer. I have felt its touch when nonbelieving Russian acquaintances have said to

10. Lévi-Strauss, *Myth and Meaning* (New York: Schocken Books, 1979), p. 17.

me, "You don't really believe that stuff, do you?" In their as-
surance, they were oblivious not only to me but to all those
Russians who may themselves believe. Nor is that arrogance
confined in any way to the USSR. It is a daily facet of the
American Christian experience as well—ask the Christian col-
lege student subjected to the so-called objectivity of the secu-
lar classroom, or the reader of the polished review essay that
is laced with the dogmatic assurance of the urban agnostic.
Most Americans know that atheism is the "established creed"
in the USSR. But a kind of "High Agnosticism" has also be-
come the established religion of the American academy,
complete with its own creed, its own social ritual, and struc-
tures to assure its continuance.

The arrogance of the secular mind resides in its control
over the terms of intellectual discussion, but its tragedy re-
sides in its admission of profound defeat. Lévi-Strauss, after
all, regrets that he must see mythic understanding as "illu-
sion." The critical, empirical mind seeks to understand every-
thing, yet its very methodology prevents it from under-
standing the process of communion or accepting the
inevitability of mystery. Its imperative is to assert the "con-
trol" of knowledge over everything it touches—it is, after all,
the presumption of "knowledge" that allows the Soviet critic
and the American skeptic to assume a certain arrogance. Yet
Lévi-Strauss, who recognizes the possibilities inherent in
myth, cannot "understand" myth. He cannot surrender him-
self to those possibilities. Orthodox Christianity in the USSR,
as well as in so secular a culture as Finland's, exerts a vital in-
tellectual attraction precisely because the communal, *liturgical*
mind can grasp the intellect's possibilities, unlock the imagi-
nation's potential. It is our belief in Christ our Savior that
gives us Christians the confidence that, indeed, in some sense
we can and do understand the universe. Christ pours himself
into creation, and he is the hero of our tale. We Christians
indeed possess this "mythic understanding."

There are many concrete representations of the arro-
gance and tragedy of secular rationalism in both the United
States and the USSR, but one that is most vivid is present in
the modern Ukraine. The city of Kiev, host to the millennial

celebration of Christianity in Russia, has many great Christian monuments. Among the greatest of them is the Monastery of the Caves. Here, in the winding catacombs that penetrate the steep riverbanks, lie the mummified bodies of the monks who nurtured the gospel for the Slavic people. Mummified bodies may in themselves seem a travesty to any mind touched by rationalism (ironically, just as Soviet reverence for Chernenko's body, with Lenin's mummified remains in Red Square, offended Charles Krauthammer's theist sensibilities). But Russian Orthodox believers revere both the caves and the bodies that they hold. The care that they lavished on the catacombs, the opulent architecture, the iconography that decorates every possible surface—all bespeak the sacredness that they believe resides there.

The Monastery of the Caves is now, like numerous churches, a "museum." Many churches in the USSR are thereby preserved, at least as monuments, for posterity. In honor of the millennium of Christianity in Kiev and in response to the prayers and demands of believers, a part of the monastery complex is being restored to the church. Yet the "museum" was long organized in a way that offered a particular affront to believers. In contrast to the rich icons that stud the monastery complex, the most simplistic of atheist slogans adorned the walls of the entrance building where visitors gathered. The guided cave "tours," especially those conducted in Russian, began with a crude preamble ridiculing the naiveté of believers who felt that the monk's bodies, mummified in the dry soil, were "miraculously" preserved. The entire atmosphere breathed the deliberation of insult. And thus the rational mind sought to turn the Monastery of the Caves into its own shrine.

As an Orthodox believer, even one who is ready at every opportunity to look for the best in the Soviet mind, I ground my teeth in anger at this travesty when I first took the tour. Hearing the Russian guide speak in a dreadful, matter-of-fact monotone replete with a shrill arrogance, I longed for a chance at an insulting rejoinder. Admittedly, it was hardly a Christian response, and it betrayed my lapse of faith that belief would triumph. (I never imagined that day that the shrine

would so soon be returned to believers, or that in a corner of the monastery the chatter of the guides would give way to the silence of prayer.)

The guide's listeners that day seemed untroubled; they nodded agreeably, even jotting down notes as she spoke. Unable to break free of my sense of outrage, I followed them through the catacombs. And there I witnessed one of the great victories of the believing mind. As the guide droned on at the head of the group as it made its way through the long, tortuous maze, she was rapidly lost to view in the curves. Her voice became a vague echo, and the glass-covered coffins of the monks presided in the near-silence. I noted to the person ahead of me in line that the faces of the dead monks were covered. "Oh yes," she replied. "The believers demanded it—for the sake of respect." And one by one, I saw most of the nodding, agreeable Russian tourists who were with me at the end of the line cross themselves and stuff their sheets of notepaper, filled with prayerful petitions, into the nooks and crannies of the caves. Thus had pilgrims left their prayers for centuries. And thus these Russian believers made fools of both me in my anger and the guide in her insults.

I never visited the caves again after that. The guides were respectful of the wishes of foreign believers who did not wish to be exposed to the secularization of the shrine. So even if I took others, I sat out the tour myself. Just weeks ago I returned there to worship as an Orthodox Christian in the monastery. I stood in a makeshift chapel placed on the porch of the church now being restored. Young monks unloaded trucks, moving themselves into the building complex. And as the pilgrims lit candles and prayed in a clear atmosphere of triumph, I smiled, realizing that those patient Soviet believers have prevailed. All my outrage accomplished nothing.

Americans should not grow too self-righteously indignant at the many "museum churches" in the USSR. I have passed many a former "working" American church now transformed. The more picturesque ones, usually in villages-turned-suburb, have been yuppified into exquisite *nouvelle cuisine* restaurants. In at least one of them, waiters in monks' garb serve appetizers to well-heeled patrons. Some of them

have been converted into apartments, and their stained-glass windows (only the geometric ones, of course) now shed a soft light on the off-white furnishings of the interiors. Icons are traffic at artsy flea-markets in the States, and it is perfectly acceptable, even among Christians, to purchase them as "investments" even in Russia itself. Although the affronts in America are not the products of state policy, they are achieved nonetheless with the central "sanctity" of our legal system—that of private property. The secular mind seeks to extinguish holiness wherever it may be found. The Christian mind, however, is too powerful to waste itself in anger. As the believers in Finland and the USSR make clear, wherever holiness has been extinguished, it can be in a moment restored.

Russian Christians use that sense of holiness very effectively in their triumphant enactment of the saving story of Jesus Christ in the liturgy. The whole of Russian Orthodox practice continually stresses a sense of the profound "holiness" of God. The Orthodox liturgy repeatedly resounds with the strains of the "holy." Before the Epistle, again in the Great Procession, and then again before the Consecration of the Gifts, the people of God engage in the "thrice-holy" hymn, attributing holiness to the Persons of the Trinity: "Holy God, holy mighty, holy and immortal" is a common refrain in Orthodox prayer. Before receiving communion, the people are invited to partake of the sacrament, "the holy, immortal, and life-giving mysteries." The response summarizes the thematic concentration throughout the liturgy: "You alone are holy, you alone are Lord, you alone, O Jesus Christ, are most high." Here, in the grand irony of which only the "mythic mind" is capable, the very terms of surrender become reversed. For the celebrant announces that the holiness attributed to God has also been granted to those who worship him—"holy gifts for the holy people of God." Those people who have attributed holiness unto God now receive it in return, dialogically, from him.

The sense of reverence, the sense of profound awe that pervades the Russian church witnesses to the power of this believing mind. For in attributing holiness, the mind engages in an act of complete surrender. It acknowledges its utter in-

sufficiency before God; it empties itself before the mystery of our divine parent. And in the response the mind becomes invested with its greatest powers of perception. For in complete surrender it receives all the awareness of which it is capable. It receives precisely those powers that Lévi-Strauss recognizes as inherent in the "mythic mind." It overcomes exactly that anxiety which Harold Bloom sees as endemic to the "severely displaced Protestantism" of the American poetic imagination. When Christians try to combat the secular mind on its own terms, they undermine the very strength of the Christian intellect. It is in surrender to God that God conveys the greatest possibilities. It is the secular mind, not the religious mind, that experiences the greatest sense of crisis.

I know a Russian monk. Although he looks the part when he is in church, and might in fact evoke some romantic images from one's vague memories of Dostoyevsky, he is in fact a very modern man who became a Christian when he got a job as a night watchman near a church. He was, like many believers, "a good Soviet kid." He was, like his family, an avowed atheist. His father, with whom he is now reconciled, disowned him when he became a monk. "The only answer to the unbeliever," he said to me, "is prayer." Not only is prayer the ultimate act of trust, but it also acknowledges the sense of the holy that is forever closed to the secular mind. The praying Christian engages in an inner dialogue with the Trinity. That dialogic act awakens a sense of holiness within the one who prays, a holiness that extends outward to embrace the one who prays and those whom he or she commends in prayer. Prayer is the most powerful interpretive act.

Awe and Yearning

The gospel, when it is perceived as "literal truth" alone, becomes the "object of knowledge." In reading or hearing the Word, our understanding "embraces" it. But the gospel as tale, as saving story, as central divine comedy of the believing community makes the gospel our *subject* as well. It then embraces

and encompasses *us* instead of the other way around. What Russian Christians have managed to do, as if their intellectual history were a vast act of preparation for one of the greatest Bible shortages in the Christian world, is to free the gospel from mere text and restore it to the people. J. R. R. Tolkien, well-known author of Christian fantasy, manages to blend the two models of the gospel as text and as story, as book and as image, when he sees the gospel as both myth and art:

> The Gospels contain a fairy-story, or a story of a larger kind which embraces all the essence of fairy-stories. They contain many marvels—peculiarly artistic, beautiful, and moving: "mythical" in their perfect, self-contained significance. . . . There is no tale ever told that men would rather find was true, and none which so many sceptical men have accepted as true on its own merits. For the Art of it has the supremely convincing tone of Primary Art, that is, of Creation.[11]

In the contrast between Lévi-Strauss and Tolkien we see the power of the believing mind. As believers we are endowed with the capacity to make *meaning* of the world as no others can. The universe—no longer a cold, dead thing—is charged with significance that involves us directly.

Russian Christians teach their American counterparts that they must not surrender any of the powers of the Christian mind. The agenda for American Christians has been too persistently set by an empirical and rationalist frame of mind. Having accepted and admired the successes of the secular intellect, the "liberal" Christian thinkers among us have transmuted Christian thought into purely secular categories. The "Secular City" model has captured its champions and dulled their sense of the holy; a textual formalism has captured many of its scholars. The "conservative" Christian thinkers among us, on the other hand, have attempted to preserve the truth of our propositions by regarding the gospel itself as we would a secular text—a document that "scientifically" demonstrates

11. Tolkien, "On Fairy-Stories," in *Essays Presented to Charles Williams*, ed. C. S. Lewis (Grand Rapids: Eerdmans, 1966), pp. 83-84.

the truth in its assertions. Yet our intellectual strength, our power of mind, rests precisely in the gospel's "perfect, self-contained significance." To make the gospel a "scientific" text is to reduce, not expand, its capabilities. The gospel is not to be applied to the secular world and its consciousness from without, but to "unfold" its truth, as a myth does, from within.

Unbelievers in Russia surely have recognized this unique power. In recent years Serge Schmemann, son of the late Russian Orthodox theologian Alexander Schmemann, has served as Moscow correspondent for the *New York Times.* His reports have shown a sensitivity to the role of the church in Soviet life that is unusual in the work of his colleagues. (A few years ago in Moscow I lunched with a correspondent from a major U.S. daily who, like the ideal catechumen of atheist propaganda, barely knew that there still existed a Russian Orthodox Church; needless to say, he was completely unaware of many Orthodox thinkers and of those in the church who were already predicting *glasnost'.*) Schmemann's reports from the USSR, like those of the *Christian Science Monitor,* document an increasing awareness among Soviet officials of religion's growing influence. Indeed, proponents of General Secretary Gorbachev's reforms now appear to be enlisting the direct support of the church in their cause.[12]

Even more interesting than these political developments is the growing philosophical interest in religious thought among the official intelligentsia. Materialist philosophers in the USSR have distinguished themselves with the dreary predictability of their dogmatic opposition to religion. Their critiques are still, by and large, dull and unimaginative reflections of an arrogance of power. But recently Communist academics have shown a willingness to take up mysticism and theology on their own terms. There is an excitement and a respect for their adversaries even among the materialist opposition. Thus the writing and thought within Soviet Marxist circles shows a new vitality. Religion has sharpened the edge of Soviet ethics.

12. For a recent Schmemann report, see "Gorbachev and Church: Soviet Leader's New Tolerance Recognizes That 1,000 Year Grip Is Not Easily Broken," *New York Times,* 16 June 1988, p. 1, col. 1.

Dr. Vladimir Provatorov edits the popular Soviet journal *Nauka i Religia (Science and Religion)*. Although it is doggedly anti-religious in nature, its basic mission is to provide "scientific" rationalist explanations for phenomena often identified as religious. Thus its articles can provide information of value to believers as well. (One Russian Orthodox bishop, in the presence of a Soviet official, heard the petition of three Siberian applicants to the seminary. These three Soviets, from a remote village with no church close by, testified that they got their basic information about the church, including substantial chunks of Scripture and the Fathers, from such "anti-religious" publications as *Nauka i Religia*.) Editor Provatorov condemns polemical attacks on faith. In fact, in an interview he lauds religious thinkers for their ability to identify "unsolved problems" in sociology, epistemology, and philosophy. Frequently condescending to religion in his tone, Dr. Provatorov nonetheless acknowledges that believers make a contribution to a socialist society: "In one sense," he admits somewhat grudgingly, "it is a paradox that religion can demonstrate something to us."[13]

As to what that elusive "something" is, Soviet intellectuals most often remain silent. True, there are signs of change. Raisa Gorbachev, a scholar on materialist thought in her own right, has spoken with insight on the contributions of religion to Russian culture, and she sits on a national cultural commission with at least one Russian Orthodox archbishop. But in the contemporary USSR, "culture" is a more acceptable medium for Christian influence than "thought." Artists and writers frequently show, quite unapologetically, the influence of Christianity in their art. Intellectuals and academics, however, have more difficulty showing "Christian influence" lest they be perceived openly as believers. Any Christian contribution to the academy is institutionally discouraged. The "censor of

13. See "Interview with Dr. Vladimir Feodorovich Provatorov," in Howard L. Parsons, *Christianity Today in the U.S.S.R.* (New York: International Publishers, 1987), p. 85. In Chapter Three, "Soviet Scientists on Christianity and Religion," this volume provides interesting short interviws with contemporary Soviet academics and a brief bibliography of their work.

sanction" muffles that voice to such an extent that even American scholars are deaf to Christian elements in Soviet practitioners of "Marxist thought" and "Marxist theory"—though some of those Soviet Marxist thinkers may simultaneously be practicing Christians.

In the USSR, believing academics and intellectuals have been very cautious in professing their allegiances. The church has assisted them in their discretion: I know one Soviet intellectual, in a media position, who before *glasnost'* attended liturgy each week behind the altar screen, invisible to the congregation. Recently Marxist-Leninist thinkers, in their articulation of theory at least, show that the intellectual wall between themselves and believers is beginning to crumble. In the field of ethics in particular, there has been the recognition of a common ground. Dr. A. A. Guseinov of the Department of Marxist-Leninist Ethics at Moscow State University speaks encouragingly of his official dialogues with theological ethicists. (It is revealing that this talented scholar has met only with foreign delegations—not with the Russian Orthodox in his own society.) Dr. Guseinov acknowledges that in his dialogues both Marxist and religious ethicists employed a common mode of ethical interpretation. He goes so far as to make this claim: "Our approach was so common that I would call myself a theological ethicist, because in the human content and the real moral evaluations they were identical with us. In the negative evaluation of consumerist morality we shared the same opinion."[14] Dr. Vladimir N. Sherdakov, an insightful and prolific ethicist at the Institute of Philosophy in Moscow, researches the traditional moral values upheld by religious tradition, particularly Christianity. Dr. Sherdakov is critical of the zeal employed by antireligious officials, and he asserts without qualification, "You see, the thesis of the incompatibility of religion and socialism is untrue. Those who hold this thesis are trying to threaten religion."[15]

14. "Interview with Dr. A. A. Guseinov," in *Christianity Today in the U.S.S.R.*, p. 113.
15. "Interview with Dr. Vladimir N. Sherdakov," in *Christianity Today in the U.S.S.R.*, p. 136.

Outside the academy, Soviets have become direct and un-ashamed to ask questions laden with theological meaning. In the mid-1980s, when I was visiting the central Russian city of Voronezh with a group of American clergy and laity, we were interviewed by a group of local correspondents. Like many Russian cities, Voronezh suffered terribly during World War II. We were impressed by the way in which the monuments of that war moved both believing and nonbelieving Russians to a profound silence. I was not surprised, then, to be asked a question relating to the war, but I was surprised to hear it framed in this way: "You are a religious believer and an Orthodox Christian. You have observed both the churches in our city and the great suffering we have experienced in the war. Christ was a man who himself suffered to save the innocent from suffer-ing—yet you have seen how terribly we have within our own memory endured such pain and death. How do you explain such suffering to your own people, to your children?"

The question was a sensitive one, and it acknowledged the claim of belief, at least, to forge meaning from pain. As I answered, I admitted to my own incapacity to "assign" mean-ing, automatically, to suffering. I too, after all, have seen the face of death, and I cannot confront the Vietnam War Memorial without feeling myself sucked up into the great black hole of an enigma. To imply that I could find meaning in their suffering or that of a child would be a loathesome dis-honesty. I am aware that Russia has felt its share of pain and suffering—some of it self-inflicted, but some of it also endured to absorb the fury of a Nazi reich and to divert that evil from the West. I only know that my tradition teaches me that we can fuse our pain with that of Christ, and through Christ em-pathize with all others who endure suffering. I know that many believers in Russia feel that expressing this militant em-pathy is Russia's special Christian mission.

Later, in private, the correspondent who asked me the question discussed my answer—and, in fact, he well knew what my answer would be. The Christian tradition in Russia is suffused with this consciousness—the mute question before the pain of the innocent. "I myself am not a believer," he said. "I cannot bring myself to believe. Yet I believe in the power

of us all to make meaning of our past—I believe in the future." I, like any other Christian, saw a certain misplaced hope in his argument. Yet he underscored a truth of which so many Americans are unaware. The Russians, believers and nonbelievers alike, can be a profoundly idealistic people. I believe, of course, that what Russia has endured at the hands of her own tyrants bespeaks a terrible betrayal, but I also believe that the betrayal resides precisely in atheist rationalism, not in socialist economic policy. What Russia has been able to impart to her people—a profound and genuine love for their country, a spirit of endurance, and the ability to see property as a communal resource—springs from the successes of her Christian legacy. Suppression of the church deprives the Soviet Union of her greatest strength. Soviets at their best can grasp the spirit of interdependency, of "reciprocal definition," with which a thousand years of Christian history has imbued them.

The native idealism of the Russians, which their authors celebrate and which is consciously nurtured within both the church and the party, suffers the assaults of skepticism. Russians, like Americans, now worry over the hopelessness and cynicism of some young people. Once dismissed in the Soviet press as a problem of the West, the collapse of faith in the system—any system—now pervades Eastern Europe as well. Skepticism produces a profound isolation. It may be used creatively, of course, in testing the propositions of any creed, but it cannot be used as the medium through which we receive those propositions. And skepticism, the aura of doubt with which every proposition is suffused in rationalist inquiry, has led to an empty cynicism and the lack of belief in any constructive proposal. When I last took a group of my students to the USSR, they were fascinated by the "Russian punks" they saw on the streets of Soviet cities; like the British punks who spawned them, they wore their hopelessness with bravado.

The Soviets have themselves helped to create this phenomenon, even though it defies the usual conformism of the Russian temper. The atheism of the Russian school system takes a "propositional" approach to religion. Systematically,

the methodology of rationalist inquiry seeks to undermine the proposals of assent within the gospel—that a God created the world, that a man has risen from the dead. A relative of mine recalls one of the cruder examples of indoctrination used in his grade school before the war: "The lecturer asked us all to say, 'God, God, give us a piece of pie' [*Bog, bog, dai pirog.*] Dutifully, we chanted the ditty. Of course, there was no pie. Then he said, 'O.K., kids, now try this: 'Soviet, Soviet, give us a piece of candy' [*Sovet, sovet, dai confet.*] Of course, we chanted what he said, and immediately he reached into his pocket and showered us with candy." Laughing while he tells the story, my relative denies that it had much effect—and nowadays the methods are much less crude. Nonetheless, the systematic denial of religious knowledge has had various effects, and among them has been a pervasive atmosphere of cynicism. Ultimately, it was as much a mistake for the teacher to provide the candy as it was to undermine the false promise of pie. For no belief, no ideal, no American *or* Soviet dream can ever deliver constant and unlimited gratification. Cynicism is the natural result of misplaced faith.

American cynics, too, can approach belief in a similar way. Rather than a true and saving story, the gospel becomes a series of propositions and promises that fail to deliver. Many a student with whom I've discussed Christian values focuses exclusively upon so-called Christians who fail to live by the standards. Defining Christian standards with an overwhelming idealism, many young people express their disillusionment with those who cannot achieve them. These honest young critics don't expect God to deliver anything so simple as pie: they expect instead a world free of hypocrisy, suffering, and pain. When secularized American students see the fervor in Russian churches, it provokes a certain agnostic defensiveness. One of the most frustrating discussions I had during one of my travel courses in the USSR was with an American student from an Orthodox family who now proclaims himself to be a social Darwinist. He maintained that Christianity, like communism, was an impossible ideal. Capitalism was preferable to them both. What is more, he asserted, he had seen bishops in the United States enjoy a lifestyle that

any rich capitalist would envy. He would rather pursue the same lifestyle, he said, without the hypocrisy of proclaiming that the poor would inherit the earth.

This is, of course, a convenient argument to justify an unprincipled pursuit of wealth, yet it is also humbling. It focuses upon the failures of Christians, and thereby it also often leaves Christians in guilty silence. Yet that "argument from failure" is also a false one, fed by a false, rationalist approach to the gospel. It makes law of the gospel, and Paul preached with vehemence against that error. Christians live under the presumption of failure. The gospel in its essence constitutes not a body of propositions to which Christians must assent or a set of rules by which believers must abide. The gospel is the story of our true and saving God who became man. Our first response to that story is awe and yearning. Awestruck by the God who has entered creation, we yearn for his coming. The sins and failures of Christians do not deny the story's truth; rather, they indicate the waning of our awe and the weakness of our yearning. Sin is as much a failure of the imagination as of the will.

The gospel as tale, as story, is all-engaging. It demands something more than mere assent. Awe and yearning are much more joyous, much more infectious than mere acceptance; they are also antithetical to the cynicism of a misplaced faith. The structure of worship among Orthodox Christians in the USSR does not stress the "propositional assent" that is so central to Western expressions of faith. It does, however, express an awe and a yearning that is related to its intense dramatic structure. Awe and yearning recognize the "absolute sufficiency" of God and the "absolute insufficiency" of the individual mind in worshiping him. "He alone is worthy to be glorified," says John of Damascus, "but no one can of himself glorify him." Corporate, orchestrated prayer unites believers into the audience for the tale. Liturgy defies the "individualization" of faith; it does not allow the worshiper to make of the gospel a simple private standard. Liturgy demands *company*; it is not a private but a communal experience of the gospel. It restores that element of "self-insufficiency" which the "self-conscious" critical mind of modernity is, by definition, denied.

Dialogic Life

The influence of this collective act, this liturgical experience of the gospel, is central to understanding the Russian Christian mind. In his study entitled *The Origin of Russian Communism*, Nikolai Berdyaev has traced the way in which the modern Russian mind has flowed directly from its antecedents.[16] Unlike the authors of Western Christian treatises, many of which deal with communism in the neo-Manichean mode (as antithesis to good), Berdyaev often sees Soviet sensibilities as having arisen from philosophical flaws or immoderate passions in the pursuit of the good. There are "Orthodox" elements in the making of the secular Russian mind, just as Christianity has had a hand in producing the secular mind of the West. Both Russian and American Christians have acknowledged a debt to the technological and social advances brought by secular rationalism. Less often, however, do we American Christians employ the power and freedom of the believing mind to liberate this secular thought from its limitations.

The Christians in the Soviet Union—so often cut off from the public expression of faith in their work and their writing—experience a kind of "displacement of voice." They cannot easily express their belief openly. Yet all their communication is nonetheless "Christian"; they are informed by a Christian worldview and interpret the world according to a Christian frame of reference. The gospel is "their story," and in the liturgy they express their awe and yearning for its completion. Although Russian Christians experience constrictions more severe than our own, American Christians also live and work in a secular world, and these Christians in the USSR can teach us how to successfully express fundamentally Christian ideas through a secular medium.

Orthodox emphasis on mutuality and reciprocal definition has shaped the thought of Christian Russian intellectuals. We can see an example of a Christian working through a

16. Berdyaev, *The Origin of Russian Communism*, trans. R. W. French (Ann Arbor: University of Michigan, 1960).

secular idiom in the critical work of the Soviet literary scholar Mikhail Bakhtin (1895-1975). Bakhtin's work is well received in the United States by the secular academy, particularly by scholars of a Marxist bent. And Bakhtin did indeed work within the Marxist idiom in his writings; in fact, until the emergence of a scholarly biography about him by Katerina Clark and Michael Holquist,[17] the extent of Bakhtin's Christian identity was virtually unknown in the West. I have met with and interviewed many of Bakhtin's colleagues and contemporaries within the Orthodox Christian community in the Soviet Union, and my conversations with them revealed that to the end of his life Bakhtin was a confirmed socialist, yet also a believer.

The absolute separation between the Christian and the secular mind is evident in the response to Bakhtin's work. In the Soviet Union, of course, as a matter of policy there is no allowance for "Christian thought" in the academy; those scholars who are Christian do not openly profess their belief in their writings. In Russia there is no outlet for the publication of Christian academic materials outside of the "pure theology" produced in the theological academies, and even this material is not distributed. Thus Bakhtin's Christianity is not a subject for discussion. In America, though there is surely Christian expression, scholars are being forced into two distinct academies, theist and nontheist. Here, too, theological discourse does not readily penetrate other disciplines. "Christian perspectives" on scholarly subjects do not often emerge outside Christian journals. As a result, in America as well as Russia there has been but a painfully slow acknowledgment of the relationship between Bakhtin's Christianity and his critical thought. Indeed, to admit that Bakhtin had a theology

17. Clark and Holquist, *Mikhail Bakhtin* (Cambridge: Belknap Press, 1984). See this volume for an extensive bibliography. Of particular Christian interest are three volumes by Bakhtin: V. N. Volosinov (a pseudonym for Bakhtin), *Marxism and the Philosophy of Language*, trans. Ladislav Matejka and I. R. Titunik (New York: Seminar Press, 1973); *Problems of Dostoevsky's Poetics*, trans. R. W. Rotsel (Ann Arbor: Ardis, 1973); and *The Dialogic Imagination: Four Essays*, ed. Michael Holquist, trans. Caryl Emerson (Austin: University of Texas Press, 1981).

would threaten many a Western scholar's construct of Bakhtin's theory. Since Bakhtin is already one of the most influential minds to have emerged from the Soviet Union in this generation, and is emerging as one of the major thinkers of this century, it is crucial that Christians in America read and understand him.

Clark and Holquist, both acute scholars of the Russian intellect, have done a brilliant job in their biography of pointing out these connections and their implication. But modern secular scholars are seldom conversant even with Western theological sources, and they are even less often familiar with Russian Orthodoxy. Consequently, scholars taken with Bakhtin's theory feel unfamiliar with or even threatened by his Christianity. On the other hand, because Bakhtin is so strongly identified with a Marxist critical perspective, few Christian scholars have attempted to wrestle with his thought. Although attempts to integrate Christianity with socialism and even communism have been common in Slavic intellectual history, such attempts meet with controversy and some intimidation in the United States. Thus the two dimensions of this great critic's identity seldom meet. Yet nowhere in contemporary Russia has the power of the Orthodox Christian intellect emerged more strongly.

In the literary and philosophical tradition of Russian lay theology, Bakhtin managed to transmit many Eastern Christian presumptions into his Soviet environment. This was a task that cost him a great deal. An active, writing Christian in the early days of his professional activity in Nevel, Vitebsk, and Leningrad, he was arrested and later imprisoned. As a consequence, throughout his professional life he wrote with that persistent awareness shared by all who deal in the terms of Christian thought in the USSR: the awareness that the censor is a partner in the dialogue. Fascinated by differences and oppositions, Bakhtin ultimately made of that censor an ally, and the entire wealth of his work focuses on the ever-emerging, never-complete process of "becoming" that each of us experiences through our human interaction. Bakhtin's Orthodox spirituality is manifestly communal and social in nature, as Clark and Holquist point out:

Bakhtin sought God not in what John of the Cross called "the flight of the alone to the alone" but in the exact opposite, the space between men that can be bridged by the word, by utterance. Instead of seeking God's place in stasis and silence, Bakhtin sought it in energy and communication. In seeking a connection between God and men, Bakhtin concentrated on the forces enabling connections, in society and in language, between men.[18]

The term "God," of course, did not appear in Bakhtin's writings after his imprisonment. But Bakhtin's understanding of God—especially in the social, dialogic manifestations of God's presence already permeating Russian Orthodox thought—shaped his vision of human interaction. Writing diligently, often under pseudonyms, he impressed a young audience of academics with the vitality in his writing. I spoke with someone who was one of a party of young Soviet academics who traveled to see Bakhtin, years after his imprisonment, when he was writing and teaching at a remote provincial university. When Bakhtin met this delegation from Moscow, they told him how much they admired his ability to express Marxist thought in new and stirring terms. "Gentlemen," he said to them immediately, without hesitation, "I must first inform you that I am no Marxist." Bakhtin resisted categorizing himself ideologically; categories are hostile to the openness of constant encounter.

Shaped by his Orthodox, Christian culture and his dialogue with other Christian thinkers, Bakhtin expressed himself in materialist categories of thought. The material, incarnational vision of Orthodoxy provided him with a natural point of entry into Marxist theory. Intellectually he was convinced that language itself is a material entity. He was consistently annoyed at the tendency of Western, bourgeois thinkers to "individualize" the consciousness, to make it appear as if each person's thought were a separate possession, a psychological entity. "The only possible objective definition of consciousness," he maintained, "is a sociological

18. Clark and Holquist, *Mikhail Bakhtin*, p. 62.

one."[19] The individual mind continually reflects its interaction with other minds.

Bakhtin's emphasis upon materiality, however, must be balanced with his insistence upon the "value-bearing" capacity of a material work of art. His close friends report that throughout his life he was a great devotee of icons, and in religious terms he compared the material form of the icon to the material frame of reference of human speech. "He had an eccentricity. He used to insist upon a peasant practice," said one of his colleagues. "Dogs were forbidden in the presence of any icon—he thought of dogs as representative of the bestial. Cats, however, of which he was very fond, could be seen as spiritual and hence acceptable in the presence of an icon." Thus in Bakhtin's way of thought even common animals became, as they are in the peasant mind, semiotic signs, "value-bearing" entities. And the icon became, as it is in the frame of Russian perception, an expression of the "materiality" of the idea. Just as the icon is not an independent entity—just as it reflects the entire body of assumptions upon which the Christian worldview is based—so also no work, no "sign" is independent and autonomous. "No work, then—no painting, no statue, no reading of a book, exists autonomously," said Bakhtin. "The work is alive and meaningful in a world also both alive and meaningful—cognitively, socially, politically, economically, spiritually."[20]

Bakhtin was perfectly comfortable with—and intellectually honest in—grounding his discourse in firmly material terms. It is important to understand that this approach was one he shared with other Marxist thinkers and with the material, incarnational emphasis in Orthodox thought. Sensitive to the element of mystery, the Orthodox tradition also has the capability to center its discourse in material terms. "Incarnation" is a principle as well as a historical act; its power depends upon the conviction that humans are "enfleshed," mate-

19. Volosinov (Bakhtin), *Marxism and the Philosophy of Language*, p. 10.
20. Bakhtin, "Toward the Aesthetics of the Word," *Dispositio* IV, 11-12, p. 306.

rial creatures. For Bakhtin, the "word," the means for our communication, is a *material* sign.

This uncompromising "linguistic materialism" may seem problematic for Western Christians. The word as an arbitrary set of sounds, an emblem with a pure, material frame of reference, seems sharply opposed to the Word as Western Christians understand it. "In the beginning was the Word, and the Word was with God, and the Word was God" (John 1:1). Yet the Word of God in the Christian framework is not a static, quiescent principle. The Word of God is "dialogic"; it is directed to its hearers. As Bakhtin noted, "Word is a *two-sided act*. It is determined equally by *whose* word it is and *for whom* it is meant."[21] If we go back to the way in which Paul characterizes the Word of God—as *rhema* or "utterance"—we too can acknowledge the carnate, material grounding of the gospel in human discourse. The Eternal Word issues *for us* in a carnate, material Jesus Christ and directs itself to a carnate, material audience. As we confess in the Apostles' Creed, he became flesh *for us and for our salvation*. Discourse is a communal engagement; God's Word is oriented to us.

The "Never-Found Self"

As we have seen in Chapter Three, questions of the Trinity in Orthodox writing concentrate on the interior discourse of God. God's love, the dynamic principle of mutual engagement, emerges through his Trinitarian, "dialogic" being. God is Three-in-One; God in his own being is in "interaction." Bakhtin, like many Orthodox, was taken with the questions of the Trinity. Significantly, Bakhtin engaged the secular mind by exploring the phenomenon of dialogue. The "plurality of consciousness" emerging in dialogue has its theological roots in the Trinitarian context of the Word. In the privatist individualism of modern rationalist thought, not only the "word" but consciousness itself become "individual products,"

21. Volosinov (Bakhtin), *Marxism and the Philosophy of Language*, p. 86.

defined in and through the individual. In short, in Western terms consciousness itself reflects a kind of autonomy. In his writing Bakhtin attacked this perception as an outgrowth of Western psychologism. He released the modern mind from its privatist prison. In a challenge to the presumptions of secular, post-Enlightenment thought, he grounded consciousness firmly in the material, social world. No individual, no idea exists autonomously. "Signs can arise only on interindividual territory," he asserted.[22] Many regard this assertion as philosophically "Marxist"; in reality it is completely in harmony with Orthodox Christian thought.

This realization is crucial in understanding the Russians' relationship to the gospel. Western, post-Reformation Christians tend to presume a private, individual "self" that encounters the gospel. "Consciousness," the phenomenon locked within the individual mind, thus in effect adopts the Christian vision through an individual encounter. For the Russian Christian, consciousness is a communal product. The self is not owned; it is the product of interaction. The self is never complete; it is always in interrelationship and ever-becoming. Russians, in effect, do not conceive of a "self" in the Western, American sense. Vladimir Solovyov, the Russian Orthodox philosopher, speaks of consciousness in broad, cosmic terms as the "momentum of the eternal all-unity," the "development of the idea of God" in humankind.[23] Bakhtin confined his discussion of consciousness to our understanding of the word. Understanding is grounded in language. Thus "consciousness can arise and become a viable fact only in the material embodiment of signs," Bakhtin claimed.[24] Yet the word or sign derives its power and meaning only from the fact that it is shared. Language is "inter-individual." Two individuals must be organized socially, must comprise some kind of a social

22. Volosinov (Bakhtin), *Marxism and the Philosophy of Language*, p. 12.
23. Solovyov, Lecture Ten, in *Lectures on Godmanhood* (London: Dobson, 1948), p. 181.
24. Volosinov (Bakhtin), *Marxism and the Philosophy of Language*, p. 86.

unit, before the medium of signs we call dialogue can take place between them.

Humans, then, are profoundly dialogic beings. Bakhtin's goal of reconciling philosophy and theology was centered in this vision. Bakhtin philosophically expressed an insight native to his Russian Orthodox tradition: our materiality as enfleshed beings ensures that our very consciousness is "communal" rather than autonomous in nature. Clark and Holquist explore the etymological roots of this important Russian term in Bakhtin's vision:

> Every thought is connected to other thoughts and, what is more, to the thoughts of others. Thus the world has "being" *(bytie)*, but consciousness is always co-consciousness (the normal Russian word for consciousness in any aspect of awareness is *soznanie*, "co-knowing"). Being is therefore the activity of "being with" *(sobytie bytija)* . . . so that an alternative rendering of the two-word term is the "co-being of being." This emphasis on simultaneity and sharing characterizes all Bakhtin's work.[25]

This difficult but revealing insight indicates the extent to which Bakhtin's work reflects the "communal personhood" endemic to the Orthodox mind. The individualism of the Western religious consciousness often leads to an American emphasis upon religious rebirth as a private experience or salvation as an individual enterprise. But the very language of Russian religious discourse expresses renewal and resurrection in a different light. Bakhtin expressed a vision of resurrection, that concept at the center of Russian Christology, in communal and material terms: "The body shall rise from the dead not for its own sake, but for the sake of those who love us, who knew and loved the countenance [the flesh] that was ours and ours alone."[26]

Thus, in looking at the way in which American Christian and Russian Christian minds relate to the gospel, we can see that there are different models of the *audience* for the Word. Given their cultural emphasis upon the individual encounter-

25. Clark and Holquist, *Mikhail Bakhtin*, p. 77.
26. Bakhtin, quoted by Clark and Holquist in *Mikhail Bakhtin*, p. 87.

ing the Word through the text, Americans tend to envision a
"soul in communion with God" according to a psychological
model of relationship. The "preached gospel" or the "read
gospel" is the natural medium for encounter with the Word.
Bakhtin spent a good part of his career challenging psycholog-
ical—and in particular Freudian—notions of dialogue. In the
Orthodox perspective we humans are, by the very nature of
our understanding, social beings. For Bakhtin understanding
was in no sense a private apprehension: it constituted a join-
ing of sign with sign, a chain thereby linking speaker to speaker.
Thus we can project a linguistic and anthropological model of
relationship. The "chain" that constitutes understanding
stretches from individual to individual as they engage in com-
munication and interaction, binding them together as *interde-
pendent* units. The "self" (that which is "I") is in a perpetual
state of becoming, in constant interrelationship with other
"selves" (the "not-me"). Thus, for this communal, Slavic sensi-
bility, the appropriate medium for the gospel is the dialogic
form of the "celebrated Word" in liturgy.

I do not intend to place these two models in unalterable
conflict; that in itself would be unfaithful to the "dialogic model"
that I am describing. The religious consciousness of the East
and that of the West also exist in "co-being," and they can bring
each other to fuller communion in the gospel. Yet American
and Russian encounters with the Word can be most fully com-
plementary if they are placed in creative tension. The gospel is
not a single voice: it is a complex of authors, inspired through
a Triune God, reaching an audience of complex inter-
relationships. The linguistic "medium" for the gospel involves
the culture of the audience, defined through all its conflicts and
tensions. Our task is to allow our "Christian consciousness" to
penetrate the world in which we participate—not only because
it is our duty but because the world *needs* the mind we possess.

The Divine Irony

Bakhtin developed in linguistic and critical terms the prin-
ciple of "reciprocal definition" already defined and articu-

lated in 1422 by the Byzantine theologian Joseph Byrennios (see Chapter Three). But Bakhtin's emphasis upon "dialogic process" expresses a contemporary Russian interpretation of a traditional Orthodox principle. "Dialogism" has a vital theological dynamic and offers productive insight into the realization of the gospel among us. Michael Holquist, the foremost Bakhtinian scholar, expresses that insight in his stirring lectures on modern Russian thought. "The Bakhtinian self is *never whole*," says Holquist in an unpublished paper. "It exists dialogically: not as substance or essence in its own right, but only in a tensile relationship of all that is other." Secular scholars have already used Bakhtin's ideas in their critical attempts to escape the limits of an autonomous "self." Christians living in this "post-Christian" world can use his insights even more creatively in the restless outreach that Bakhtin himself initiated. Christians are not meant to be "self-contained." Yet the perpetual Christian temptation is to become "hoarders of the Word," to see a commitment to Christ as a means to "self-fulfillment." The Christian task, the *human* task, is to engage the world intellectually and socially as well as spiritually. In his work on Dostoyevsky, Bakhtin revealed the core of his own Christian vision:

> To be means to communicate dialogically. When the dialog is finished, all is finished. Therefore the dialog, in essence, cannot and must not come to an end. On the level of his religious-utopian *Weltanschauung* Dostoevsky carries the dialog over into eternity, thinking of it as an eternal co-rejoicing, co-admiration, con-cord. . . . One voice alone concludes nothing or decides nothing. Two voices is the minimum for life, for existence.[27]

Dostoyevsky's work, with its religious and philosophical preoccupations, has been of tremendous theological significance among the Russian Orthodox. Bakhtin's profound involvement with the rich dialogue in Dostoyevsky's work also led him to a concern with genre and form. And, in fact, the contrast between American and Russian visions of the Word can emerge in the light of form: the single voice of "God's

27. Bakhtin, *Problems of Dostoevsky's Poetics*, p. 213.

proclamation" and the multiple voice of a dialogic response. Bakhtin was taken with the novel as a form emblematic of modernity. The "epic voice" of the past reflected a world of linguistic singularity. It represented a world that envisioned an "absolute past," a world that saw itself in terms of "epic distance" from the deeds and times of the hero who was celebrated. To Bakhtin modernity represented a world of linguistic and ideological complexity. "The world has become multi-languaged, once and for all and irreversibly," he noted. "The period of national languages, closed and deaf to each other, has come to an end."[28] The novel, with its multiplicity of characters and perspectives, expresses the rich tension and interplay of ideas that characterize our era. The epic voice is "monovocal"; it does not allow for the discordance or tension that begets irony. The novel, however, is a form that dissolves absolutes, a form that at its center nurtures and promotes a dialogue among voices.

The way we read or encounter one form is influenced by the way in which we read or encounter others. One could recognize among Western Christians an "epic reading" of the gospel, one which distances that text so far from us, renders its single voice so "absolute," that Jesus becomes a hero forever separated from us in his greatness, his significance. One could also see a "dialogic reading" of the text shaped by the narrative forms of our own age. Viewed dialogically, the gospel provides a series of dialogic encounters with Jesus and his Word, encounters that "bring into being" those who encountered him and that in turn bring us into fuller being. Christians, who are members of complex cultures, can no longer live within the comfort of a single voice. Americans live too comfortably in the linguistic isolation of a dominant English tongue, but that cannot be their model for the gospel. The fullness of the church involves different cultural encounters with the Word of God, encounters that will be variously expressed. Indeed, the fullness of the church demands that we hear, respect, and respond to those who do not hear the

28. Bakhtin, *Epos i Roman from Voprosy literatury i estetiki* (Moscow, 1975), p. 457.

Word of God at all—except, of course, through their en-
counter with us. A monk in a Finnish Orthodox monastery
said, "In our secular culture, we may be the only gospel many
people ever see." The fullness of God's Spirit sustains the
chain of understanding, linking our "co-consciousness" in the
gospel and our "inter-being" in the community of the church.

It is natural that the modern expression of this "dialog-
ic vision" should arise in a vision shaped by the profoundly
dialogic act of liturgy. Of course, Bakhtin was himself steeped
in a liturgical consciousness and immersed himself in the very
"material" shape and form of the Orthodox liturgy. I knew of
Bakhtin's Christian identity and had spoken to some of his
colleagues; nevertheless, I was surprised on one visit to the
USSR to see Bakhtin's portrait hanging in the residence of the
late Metropolitan Anthony of Leningrad. Although I had
known that the metropolitan was an intellectual, I did not
know of his interest in Bakhtin. The bishop smiled when I
mentioned the portrait. He admitted that Bakhtin had been a
friend. "Are you a student of dialogism?" I asked. "And what,"
he responded, "is the liturgy?"

When we look through a dialogic lens, we can see how
liturgy shapes the consciousness of Russian Orthodox Chris-
tians. Liturgy for Russians is the divine dialogue that is the
emblem of "reciprocal definition." Bakhtin's Orthodox col-
leagues report that he was immersed in liturgical life; in his
later years he most often attended liturgy at the church of the
Novodevitchii Monastery in Moscow. Bakhtin was a critic sen-
sitive to genre and form, and his lifelong immersion in this
central, archetypal "form" shaped his literary sensitivity. For
Russian Orthodox Christians, the liturgy is the central me-
dium for apprehension of the gospel. And indeed, many
themes implicit in the liturgy express themselves in Bakhtin's
own ideas of narrative.

The most productive insights are often the most unex-
pected. Western visitors who encounter the Russian Orthodox
liturgy perceive it according to a romanticized body of expec-
tations: beautiful and solemn, it seems expressive of a pro-
found seriousness and melancholy. Yet to be steeped in litur-
gy as a medium for the Word is to see as well its playful

restlessness, its constant shifts in frame of reference. Bakhtin, in his work on the Renaissance author Rabelais, developed the notion of "carnival," a concept now widely used in anthropology and literature. "Carnival" is that dialogic form by which rigid, tyrannical hierarchies become mirrored, distorted, and overthrown. And liturgy can indeed be seen as "carnival." Liturgy is, in effect, a celebration of the gospel whereby we partake in a divine carnival, a divine irony whereby we overthrow the kingdom of this world.

"Carnival" is a state of being that has engaged us all. Remember the exhilaration we felt as children on the last day of school? Do you remember the atmosphere of excitement, the ritual mockery by which we celebrated the overthrow of such tyrannies? Look at Mardi Gras, which originated in the Caribbean as a way in which the slave parodied his or her masters, and in so doing symbolically overthrew the structures by which he or she was enslaved. In ritual role-reversal, we often engage in a kind of "controlled anarchy" whereby we overcome our spiritual and physical oppressors. I once had friends who were "Cape-Colored," nonwhites who had been hounded from one neighborhood to another and deprived of virtually all political rights by the Afrikaans minority in South Africa. Their parody of Afrikaans speech and mannerisms was not only hilarious; it was also a way for them to "overthrow," in their own minds, the power of the tyrant. Satire flourishes in Russia especially when the repression is most severe.

"We are fools for Christ's sake" (1 Cor. 4:10). Tyranny cannot bear to be mocked; the folly of the gospel, then, will enrage the powerful but delight the poor in spirit. Bakhtin's sensitivity to "carnival" springs from his own Christian tradition. Russian Orthodoxy is replete with icons and services celebrating a certain kind of saint, the "holy fool," the fool for Christ's sake. The crazed, beautiful domes of St. Basil's on Red Square celebrate, in their riot of color and form, just such a sainted clown. Early Russian czars, by tradition, included in their retinue a fool who mocked the pretense of the worldly prince. Similarly, Russian literature is filled with the same kind of character, a character who in his or her "folly" forces an encounter between reality and pretense.

We in the West are also familiar with the image of Christ as clown. The "schlemiel" in the Yiddish tradition is a Jewish reflection of the "holy fool" so prevalent in Russia; in the popular play *Godspell* American Christians have seen their own incarnation of the "fool for Christ's sake." The holy fool refuses to accept the structures by which the world forms judgments. He reminds the people of God that the structures by which the princes of this world prevail are less than "transitory"—they are signs of liberation in God, showing us in the narrowness and cramped insistence of worldly power what God will never be. The gospel's clown is, like the monk or nun, "apophatic"— that is, he or she shows us not what God is, but rather what God is *not*. The holy fool mimics the standard by which the cross is seen as "tragic," for the gospel is the very antithesis of tragedy.

Liturgy in its structure is the very archetype of divine carnival. In proclaiming God's kingdom, it alters the way in which we see this world and forces us into perpetual re-evaluation. Intellectual tyranny and worldly power take themselves seriously. The gospel mocks that seriousness. Liturgical celebration of the gospel brings Christians together in community, where in a structure of "dialogue" they recreate the terms by which they interpret this world. In liturgical structure we see a majestic celebration of what Bakhtin calls alterity, of the "otherness" of God. In liturgy the Christian overthrows the kingdom of this world and celebrates the kingdom of the Trinity. It is the social and religious structure within which the poor are enriched, the meek made courageous, the oppressed made into monarchs. Thus it is hardly an empty "cultic" celebration, an "opera" that is removed from the terms of the lived world. It is indeed in its nature a "subversion" of the structures of tyranny. It demands that we see this flawed and blasted world anew, as renewed in Christ; that we sinners stand as the redeemed. Liturgy does not "announce," in monologue, the Good News. Liturgy dialogically "celebrates" the gospel; it *enacts* the plan of God.

Thus Western Christians must not see the liturgical dimensions of Russian Christianity as in any sense a "substitute for" the Word of God. Liturgy constitutes that dialogic arena

within which the Word "comes to mean." It creates a context. When Christians perform an act of faith, they do so in the first person: "I believe." It is what linguists call an "illocutionary act," a statement that brings itself into effect. Yet Russian Christians chant the creed in concert. Each "I believe" is sung in a chorus of "I believes"; each voice tends toward a hearer in its audience. Christians express the act of belief not only privately, to God, but also publicly, to each other. In our mutual belief, we help to *effect* each other's belief. Liturgy is a dialogic act, an expression of our mutuality as Christians.

One of Bakhtin's favorite sayings, the point of which was central to his vision, was the simple line "There is no alibi for being." Clark and Holquist, in an incisive commentary on the phrase, develop its philosophical implications.[29] Let me simply express its most basic meaning in this context: the Christian mind has no escape from encounter; our Christianity is not an "alibi" for a failure to confront each other and the secular world. In the church all followers of Christ are shaped by each other. Just as we Orthodox who live in the West have been enriched and shaped by our encounter with the Western and American sense of the biblical text, so also American Christians can find a fuller sense of "interbeing" in the Eastern Orthodox and Slavic awareness of the dialogic, liturgical sense of gospel. In the intellectual tradition of the Ukraine, for example, there is evident the rich interplay of Western and Eastern influences shaping a single religious and cultural identity. But even more important, in the Slavic Orthodox vision all Christians can find a model for our relationship to the secular mind. For each of us, the self is a gift of the other. Believers and nonbelievers are shaped and defined through their encounter. Mikhail Bakhtin is not only a Christian who can express, in completely secular language, the intellectual liberation of the Christian mind from an isolating "selfhood." He is also a reminder that in our world, so enriched by a multiplicity of languages and perspectives, we cannot confine the gospel within a single cultural frame.

Economic theorists rigidly isolate themselves from

29. Clark and Holquist, *Mikhail Bakhtin,* pp. 67-70.

"values"—those very values by which we live—in articulating the principles of the competitive marketplace. That does not prevent us American Christians from living within, and seeking to temper, a capitalist society. Similarly, many Christians in the Soviet Union live within and seek to temper the theoretical rigidities of a materialist Marxism. Such encounters have brought even the anguish of martyrdom. But in the light of a dialogic sensibility, Christians will most certainly have an effect only if they enter, vulnerable and stripped of baggage, into the country of the stranger. The traditional Eastern Orthodox concept of the "reciprocally defined" human means, ultimately, that American and Russian Christians (or Western and Eastern Christians) hold in their very tension, their opposition, the means to more fully define and enrich each other. Christians in Russia and America cannot fall back upon defensive and isolationist self-definition, for the believers in each nation are truly the only ones who can fully understand our mutual interdependence. We shape and are shaped by those among whom we live. Our Christianity takes on its life within dialogic process.

Chapter Five
BEAUTY AND THE BEAST

"The Beast among Nations"

*I*n these days I, like many Orthodox Christians, have rich ecumenical relationships with members of many denominations. Most of us Orthodox no longer live in those warm but isolating ethnic neighborhoods that once held us together like syrup binds a popcorn ball. In fact, recent statistics show that most of us now marry non-Orthodox Christians. Sacramentally, then, in the most intimate of "reciprocal definitions," the Orthodox bring themselves together with those other Christians whom they once barely knew.

And our distance from others could be vast. My grandmother, whose memory I revere, once sat me down at the table in her farmhouse kitchen and told me all I needed to know about Protestants. "They like roosters—absolutely crazy about birds," she said, stirring a spoonful of jam, Russian-style, into her tea. "I don't know, maybe it's some kind of an image of the Holy Spirit for them. But they place the image of the rooster before the cross of Christ himself." Now my grandmother was the very soul of graciousness to all her Protestant farmer neighbors. But she spoke so little English that as she served them meals and coffee, she communicated little but goodwill. She retained for her entire life this odd misconception about Protestant Christians.

The mystery was never fully unraveled for me until years later, when my grandfather explained to me that in the Old Country, the few Lutheran churches they ever saw—usually in market towns—were topped by weather vanes rather than crosses. And the vanes, of course, featured roosters. Being a profound people of the image, the Orthodox peasants of course attributed the prominence of the rooster to a theological cause.

In fact, they attributed virtually *everything* to a theological cause. My grandmother told me about a particular day in her girlhood. Everyone was working in the fields, taking in the harvest. Suddenly people began to look up, shouting and pointing in agitation. She lifted her eyes and saw the most amazing of miracles: a vast eagle, with two heads, its wings outspread, swooped down from the clouds. Its very shadow swept over the fields of rye. Her mother, frightened, gathered the children and hurried back to the village; the other women ran to see after their babies. Men dropped their scythes on the ground and took to the trees. As her elders rushed in every direction, shouting in near panic, my grandmother looked back again and again, only to see the vision confirmed as a reality. Each time she shut her eyes tight and opened them again, it was still there, drifting awesomely over the fields.

The church bells soon rang, and the agitated villagers gathered for prayers amid rumors that the Holy Spirit had indeed come—it was the end of the world, and all the injustices of the past were to be set right. There were a great many prayers said and candles lit before the icons that day. Nevertheless, some people returned, with a sense of caution, to the harvest. After all, it might rain at the end of the world, and it wouldn't do to spoil the grain. My grandmother's parents were among those who continued to harvest. "It would be a sin," they said, "to waste the crop." Only the next day did my grandmother's village of Stanovishcha learn from a traveling monk that what had passed over their remote settlement was a zeppelin, a huge balloon emblazoned with a great bird. And quickly, as the word spread, everyone returned to the harvest—even the village priest.

There is a certain familiar comfort in setting what one knows and loves against that which is strange and different,

like Lutheran weather vanes. There is also a thrilling comfort in the revolutionary threat of the Apocalyptic, like the Holy Spirit hovering over the Byelorussian village of Stanovishcha on a bright, late-summer morning in the first years of this century. Since that day, Stanovishcha has felt many a scourge of war and invasion that no doubt felt like the end of the world. Civil war and certainly the Nazis were far worse than any devils my peasant forebears could have imagined. But in the way my grandmother told that story, and in the way it made her sigh like a child, even after a hard day's work of harvesting a half-century later and an ocean away, I could tell one thing. The Holy Spirit had never felt quite so close.

Perhaps for this reason, even after a century in which humanity has experienced the horror of world war and the slaughter of the Holocaust—which should be sufficient unto themselves as objectified sin and evil—some American Christians can still court the Apocalypse. They can still tease their Christian imaginations with an enemy so beastly that he confirms their own humanity. They can still imagine a horror that not only would be worse but also would be welcomed in its very inevitability—a horror in which that beastly enemy plays a central role. Although the harbinger of the end times in Stanovishcha was an eagle of surpassing beauty, some American Christians see instead a monster poised to consume the world. Like the Byelorussian peasants, they gather to await the end. And like the Byelorussian peasants, they leave behind a rich harvest—the harvest that is gathered when you come to see God's image in another. The grain stands ready, neglected in the fields.

It takes most Orthodox Christians a long time to realize that the ghost of that beast haunts so many American churches. They can see it on the TV screen, even on Saturday morning kiddie shows. They can see it in politicians' speeches, in bumper-sticker slogans, and in hamburger commercials, and deal with it in one way or another. But they don't imagine that it exists in the church. My wife and I found it there, snug amidst the pews and hymnals, one Sunday morning. This happened years ago, before we had our children, but sometimes in my ecumenical discussions the

memory of that service can come back with a special sharp-
ness, a special poignancy.

We went to our usual Russian Orthodox church on Sun-
day morning only to discover that our old priest had sud-
denly taken ill. There would be no liturgy that morning, and
there we were, all dressed up with no place to pray. On the
way back home, we passed a nearby church—a small, con-
servative congregation that displayed an inviting "Welcome"
sign. Actually we went past the church a couple of times
before we finally overcame our misgivings and decided to
go in.

We were greeted with the same open, friendly smiles
with which my grandmother welcomed her "rooster-loving"
Protestant neighbors. The hymns that opened the service
were beautiful. One of the deprivations of being Orthodox in
the United States is that we miss so many of the great hymns
that lie close to the center of a Protestant liturgy. My wife and
I had a great time singing "Rock of Ages" and "Bringing in
the Sheaves," and our neighbors in the quaint white pews
showed us the right hymnal and coached us along. But then,
amid the rustling of pages, came the point at which a "guest
preacher" was introduced. Our own old priest preached only
in Russian. Since my wife is a Greek American, she didn't un-
derstand a word of the sermons—and wouldn't have under-
stood even if the priest had been silver-tongued (which he
was not). We gave each other a covert smile: this was bound
to be an improvement.

To say the sermon was a disappointment doesn't quite
capture the experience. The preacher chose as his subject the
book of Ezekiel. In what I have since come to recognize as an
American thread in biblical interpretation, he drew contem-
porary parallels to the apocalyptic imagery of the prophet.
Warming to his theme, he loosened his tie and unbuttoned
his collar as he drew the verses toward a crescendo of con-
clusion. (Our priests wear vestments when they preach; they
can't "loosen" anything.) Usually the Orthodox are not much
for penetrating the mysteries of the end times with any
specific precision, so the sermon was eluding me even though
I liked the preacher's oratory. Suddenly, however, with one

sharp stab of realization, I was struck by his point. He was preaching against the Russians.

He was unaware that he had "a Russian," of sorts, in the congregation. Nor would it have done him any credit, I suppose, if he had changed the theme to suit me. But what stunned me was the remarkable parallel between the negative portrayal of Russians that pervades the American media and the biblical imagery the preacher found in the apocalyptic texts. His glossing of the text indicated that Russia would invade southward, into Israel. There would be a great war. Blood would run "high as a horse's bridle." The preacher explained that laser technology would render tanks useless and that cavalry would take their place, a substitution that would render the verse literally true. (Having seen napalm burns as an army medic, I doubted that horses would fare any better than tanks against laser beams.) And Russia, "the beast among nations," would ultimately perish. The mode of perishing— especially grisly and complete with every death spasm—occupied the preacher for some time. He seemed to take some pleasure in it.

Glosses on Scripture or on prophecy are not my subjects here. Although I try to respect the perceptions of others, the "scientific" application of Scripture in this case did not impress me. Nor has it since. I have seen television preachers use Scripture as "a key" to everything from the structure of the Great Pyramid to a cure for a backache. Just last night, after the evening news, someone quite well-groomed promised to show me "scientific, biblical principles for success" that earned one devout couple their very own seven-story bank! "Literalist" interpretation of Scripture can be the modern equivalent of the medieval magic charm, which was also laced with references to Scripture.

Yet what struck me most about the sermon I heard that day was not its pretenses to interpret history. I had already studied long-dead languages and read medieval texts. Ancient commentators as close to the first millennium as we are to the second also saw the end times near. They too found references to their own nations hidden cryptically in the Word. Franks and Ostrogoths, Celtic kings and Viking warriors have heard

Scripture whisper their own names into eternity. This was nothing new. But now, in my own times, I encountered a central theme of American apocalyptic preaching—Russia as beast.

Among Russian Christians in the Soviet Union, their land and their "peoplehood" are salvific categories. To them Russia embodies good rather than evil; it brings to mind divine grace rather than beastly depravity. Believers in Russia still reveal a faith in "holy Russia," a land that endures its suffering as a mission not only for itself but also for the rest of humanity. In completely secular terms, the Russians see their suffering in World War II as affliction they bore on behalf of all the Allies fighting against the Nazis. The twenty million dead have become a hallowed memory of national sacrifice. Russian Christians concur in that vision, and perceive their endurance of persecution in the civil war and under Stalin as a further dimension of the same mission—to suffer for the whole church. Their "peoplehood," their "Russian-ness," is emblematic of their common vision. They are bound to their very soil in a mystic contract. Russia, to them, is an ideal of surpassing beauty.

What an irony it is that believing, confessing American Christians should identify as beast that very land which other believing, confessing Christians see as an embodiment of beauty. This misunderstanding can penetrate every relationship. Christians who are habituated to the image of Russia as beast quote in their defense Russian dissidents whose remarks are taken out of context, dissidents who themselves cherish the image of holy Russia, Russia as beauty. The apocalyptic interpreters of "Russia the beast" are oblivious to the Orthodox vision of transfiguration; in their own version of "historical necessity," they see obliteration of the beast as the only answer. War—even a "holy war"—will sear and punish that land which Russians revere as holy. And politics, usually radically conservative, will speed prophecy on its way. The land which to the preacher on that Sunday morning symbolized everything opposed to God, everything evil in nature, symbolizes to worshipers in the Soviet Union an ideal of faith, of endurance, of God's grace.

Years after hearing this sermon, I heard a shorter sermon

delivered by Michael Yelagin in Novgorod. That priest and a good proportion of his congregation at that weekday service were people who did not have to imagine apocalyptic images. They had seen them. One woman in that church, who stood next to me, had felt her children die in her arms during the war. Another man had felt the pangs of starvation as a child. In this sermon the priest spoke of the past that he and the people had endured together, and the evil that had afflicted them. As he spoke, the people—simple Christian people, not Soviet propagandists—wept. Their comfort, asserted the priest, was a God who would never abandon them, who would never abandon the Russian people. This was a God who, he said, "consoles us with his beauty and the beauty of his land and his people." The priest, in his purely Christian tradition, was saying something that recently even the *Izvestia* correspondent Alexander Vasinsky wrote about in June 1987: the enduring churches and monuments in Russia embody the dialogue of the present generation with its ancestors; they represent "a ceaseless dialogue of an immortal people with itself."[1] The Christian Orthodox, however, see the beauty expressed by that "immortal people" as the radiance of God.

In the midst of the congregation that day were Americans whom the priest introduced, part of a Vermont-based group called "Bridges for Peace." I was one of them. The priest acknowledged the hostility between his people and ours; his words, as a matter of fact, reflected those of the Russian press and indicted us Americans as being cavalier about the arms race. Yet transcending the secular rhetoric about "peace," which is usually ringing in its formal emptiness on both sides, he dug into Scripture for a peace grounded in our common identity. He demanded prayer. "And the peace of God, which passes all understanding, will keep your hearts and your minds in Christ Jesus" (Phil. 4:7). Although he indicted American leaders for neglecting earthly peace (and, incidentally, was silent about his

1. For a discussion of renewed Communist interest in churches and their preservation in the USSR, see "Soviet Officials Deplore Neglect of Historically Valuable Churches," *The Orthodox Church* 23 (Sept. 1987): 3.

own country's leaders), he did not heap upon us an image contrasting us with himself. He did not make a beast of us.

For this weekday service during Bright Week, the week after Easter, it is customary for Orthodox Christians to carry Easter eggs. They are carefully prepared, blessed by the priest, and taken home to be shared with loved ones. As the congregation left the church, we Americans among them received the spontaneous gift of eggs—hundreds of eggs—given as emblems of the feeling of Russian Christians. The eggs, dyed in the red of Christ's blood (and of the blood we could so easily spill in battle against each other), were pushed into our hands until we couldn't hold any more. The Russians embraced us as we fumbled with the eggs and struggled to move through the crowd. "Christ is risen!" the people said in the traditional Easter greeting. And there were other messages: "God forbid you should go to war as we have—tell your people that"; "Forgive us sinners." And there was one request whispered to me by a man near the back of the church: "Don't remember the sins of our unbelievers. Remember the beauty of our church!" Laden with eggs tucked into our pockets, held under our arms, cradled in our hands, we left the church, its bells ringing. It was a scene that would have enraged some critics as an exercise in propaganda. Yet to perceive it in such a way would be to condemn as ephemeral "propaganda" a thousand-year-old church and the spirit of an entire Christian tradition.

Salvific Beauty

Beauty is a central category in Russian theology. As a principle, as an idea, it has tremendous power over the Russian soul. That principle stands in stark contrast to the apocalyptic beast that some Western fundamentalists see in Russia. Yet the word "beauty," with the connotations it has taken on in the English language, is inadequate to describe the power the concept conveys to the Russian mind. "Beauty" among Americans takes on a "softness" in connotation, a vulnerable fragility. Surely it is not a category that "tough-minded," disciplined

theologians or rationalist scholars would want to waste much time talking about. The fact that for so long Westerners have seen beauty as a feminine element and an essentially womanly attribute is a sign of its subordination as a category. Some feminist thinkers shun the category still.

When we Americans examine the principle of beauty as it permeates Russian Christianity, we must abandon some of our own presumptions. In all the discussions of Christianity, in all the evangelization that takes place in the West, we seldom encounter beauty or aesthetics as central to the Christian experience. Beauty more often emerges as a theme of temptation, a force that can *distract* us somehow from the plain truth of the gospel. Such a notion is foreign to the Slavic sensibility. Among Russians beauty is a powerful constituent of theology and the culture of which religion is a part.

This Russian concern with beauty contrasts sharply with the portrait of Russians that Americans usually see. Again and again the snide remark of the columnist or the bitter aside of the political commentator fixes upon the "ugliness of the Socialist landscape." The beefy sturdiness of Russian women as they appear in movies and other products spawned by American popular culture manifests another dimension of the problem. Russian women, in a curious brand of sexist humor, emerge as huge-shouldered, laboring denizens of the working classes. Remember that in *Ninotchka*, Greta Garbo's transformation into the very emblem of beauty occurs only after she has left the dreary necessities of life in Moscow. She smiles only after she tastes Western champagne.

During the 1980s I made it a habit to count, in the newspapers, the pictures of Russians who laughed. There weren't many. Only lately have our media Russians begun to smile a bit. In the American imagination, Russia has indeed been tainted with the mark of "the beast," and the mark seems to prove by contrast an American comeliness. Two nights ago I parked behind a student's car and faced a pair of bumper stickers: next to "America the Beautiful" blazed a fluorescent "Ronnie says . . . RUSSIA SUCKS." Bumper stickers, it is true, outlast fickle public sentiment. But the recent TV reports from Moscow prove that Americans are still surprised that beauty could survive in

the "workers' state." If Americans reject moral equivalency with the Russians, they will reject aesthetic equivalency as well.

It is too easy to dismiss this problem with the old adage "Beauty is in the eye of the beholder." It would be hard to find any Russian who could see as beautiful what the Western media usually portrays as Russian. Yet it is true that Russians understand beauty quite differently than Americans do. We now tend to appropriate "the beautiful" in a privatist manner; it becomes something that expresses our individual tastes, preferences, and, in that omnipresent word, "styles." For many Americans "lifestyle" in some way expresses who they are. I gave an assignment to my college freshmen in which I asked them to describe their roommates. A full four-fifths of the class relied primarily upon what the roommates owned— clothes, shoes, and other possessions—to reveal who they were. To the reader the roommates were faceless, yet their personalities were conveyed through the objects of value that they, individually, had purchased. Brand names forged the key to a stranger's identity. For some, the material dimensions of our lifestyle can express our notions of the beautiful.

In Russia beauty is distributive rather than appropriative. It is less a matter of preference there than it is in America. In continuity with their own Platonic heritage, Russian believers see beauty as having a real existence, and even Russian nonbelievers see it as being firmly grounded in social realities. In the Slavic mind-set, the nature of a people or a class is revealed through what they collectively find to be beautiful: the objects that an individual prefers to purchase only reveal his or her allegiance to a larger aesthetic category. Since beauty expresses social ideals rather than private preferences, it is a pressing concern for both religious and secular thinkers in the USSR. Russian artists are more apt than American artists to argue in passionate terms about what constitutes beauty. Whereas American academics have tended to withdraw from aesthetics as an intellectual category, in Russia it is still an area of concern. "The beautiful" is not a matter of private taste but a matter of public affirmation.

American Christians, like American academics, have largely withdrawn from questions of aesthetics. This grieves

Christian artists in America, who have an even more difficult
time than their hard-pressed secular colleagues. The beauti-
ful is a private matter in which the church does not interfere.
And, in fact, beauty *must* become a privatist category when it
is defined by preference. That paltry term "preference" can
trivialize many precious things, from the deepest of faith com-
mitments to the greatest physical act of self-transcendence in
sexual love. A "social aesthetic," however, gives beauty a more
compelling role. The social role of beauty, once acknowl-
edged, gives Christianity an important aesthetic mission.

The recognition of beauty and its value is linked to the
perception of meaning. When my American student relates
to a text, the first reaction he or she has is invariably a per-
sonal one. It may, at the lowest level, be one of preference:
in saying "I liked the poem," the student may also be telling
me that he or she thinks it is in some sense beautiful. But
there is a problem. The student may also be completely toler-
ant of what others see in the work, despite the fact that these
insights may conflict utterly with the one the student has just
expressed. (This is a lesson in "reductive pluralism"—accep-
tance without discrimination.) It is at the level of the shared
insight, the communal vision, that the American student is
most at a loss to grasp meaning. This is precisely the insight—
the collective "aaah" of the gathered audience rather than the
private "aha!" of the individual reader—that the Eastern
Christian vision most values. The recognition of a common
beauty binds people into a community and a culture.

My students, like most of us in the West, have an iso-
lated, individualist model of readership. Like Augustine
sequestered in the garden, each student will hear the com-
mand to "take up and read," and each will derive an insight.
But this Augustinian model conflicts with the model of Saint
Basil, the Eastern church father. In Saint Basil's instructions
to the Christian reader, the object of the quest is the *mia har-
monia*, the "one harmony" that pervades both the text and its
readers. This harmony binds the audience into community,
and it reveals the presence of God in human culture. There
is a reason why so many poets in America, seen to be pur-
veyors of the private experience, struggle in oddly named,

obscure journals, while poets in Russia can pack a stadium with a public reading. Poets are Russia's conscience and her crown. In the aesthetic derived from the Eastern Christian vision, the recognition of beauty is seated in the "we" rather than in the "me."

American Christianity has the potential to liberate its own artists who struggle to reach their community. A few Christian poets like Denise Levertov already create in this confidently communal vein. Yet American Christians, like their secular counterparts, have essentially privatized the category of beauty. When an American congregation chooses to remodel its old church or, even more daunting, to build a new one, the matter can immediately divide a church council into various constituents, each with its own separate claims. Each party has its preferences. The debate becomes a battle among categories of taste, and faith does not seem to animate any agreement unless some communal vision of that congregation inspires a choice. In America beauty tends to be a neutral religious category. Questions of beauty are ancillary to our Christianity and our worship.

To some, the questions themselves seem trivial. One American pastor once told me that Russian Christians most probably were concerned with questions of beauty because they were deprived of more immediate concerns. "Beauty," to the pastor, was an ephemeral matter. And indeed, I can understand the suspicion. Aestheticism, when it is confined to the question of preference, can be ephemeral. This is what Simone de Beauvoir meant when she said, "Pluralism is the perfect ideology for the bourgeois mind." Beauty, deprived of its concrete social grounding, can seem but a consoling sprite sent to distract the mind or soothe it in moments of reflection. Thus the individualist is an easy victim of the neo-Romanticism to which we Americans so readily fall prey.

The Orthodox in America have often been victims of the beauty their own tradition conveys. When non-Orthodox Americans first experience an Orthodox service, they are sometimes attracted by the "dreamy, mystic" landscape it seems to offer. This romanticized perspective confuses the dynamic social role of beauty as the Orthodox see it with the

privatist vision fostered in secular culture. The Orthodox tradition, hostile in most ways to the very category of "the self" as understood in Western psychology, can seem to be an avenue to a Romantic "self-fulfillment" in religion, a haven that offers quiet rest from the demands of the secular world.

Orthodoxy, in the word-centered and Puritan-derived American consciousness, can even hold the attraction of the forbidden. There can be something exotic and "precious" about silken vestments and heady perfumes. Edward Said has convincingly argued in his book *Orientalism* that the West has invested the East and its symbols with decadence. Orthodoxy too can hold that Oriental savor for the American intellectual palate. No less important, the suspicion that "beauty" is a feminine or an effeminate concern plunges the issue into the swampy domain of American sexual identity. Focus on beauty or the arts seems to convey an ambiguous sexuality, and this too is a dimension of "Orientalism." When that part of our identity known as "the masculine" feels itself embattled, a new image begins to take hold in both religious and secular culture: Rambo has his counterpart in a tough-talking "muscular Christianity," which wields the Bible like an Uzi automatic to mow down its foes. No wonder that the popular mind has closed itself to "the aesthetic."

Beauty in the USSR, in both religious and secular terms, emerges most insistently in the public and not the private domain. Whereas in the United States our splendid homes and apartments enclose for us spaces that we can adorn to our liking, Russians invest less personal and public attention in the dwelling. Their monuments, czarist and Soviet, consume the landscape. They pour their energies into public space.

Our consumerism seems peculiar to Russians: although they envy us our goods, they make fun of the baroque care we lavish on such things as multiple brands of perfumed, softened, pastel toilet paper. And to Americans, private life in the USSR seems hopelessly Spartan and its public monuments, whether religious or secular, needlessly extravagant. Whether viewing a glittering czarist cathedral or the vast, haunting monument to the fallen at Volgograd, Americans tend to ask themselves the same question: Why didn't they spend all that

money on more immediate problems? Yet the investment of art and energy into that communal space is itself an expression of reverence, an act of worship. Russian theatres and public buildings, post-Revolutionary as well as pre-Revolutionary, articulate a beauty that contrasts with the aesthetics of the personal.

When we understand this issue in Orthodox terms, we see that beauty is not an ephemeral issue but a lasting one, not a peripheral concern but a central one. Nor does its service exclude the masculine. I met a huge, Olympic-class weightlifter in a gym in Kiev. This hulking Ukrainian reverences a particular icon of the mother of God "because it is so beautiful." Russian ice-hockey players, indisputably tough on the ice, liken their maneuvers to ballet. Strangers to the anxiety of sexual identity that links beauty to but one gender, Orthodox men in Russia and Finland embrace the aesthetic dimension of their being without fear of compromising their maleness. Although Orthodox men are no strangers to sexism, they are less likely to exile emotion and the category of the beautiful from the realm of male experience.

The works of the great philosopher-novelists Fyodor Dostoyevsky and Lev Tolstoy are examples of the role that the beautiful plays in the consciousness of Russian Christianity. Modern Soviet poets like Anna Akhmatova and Irina Ratushinskaya show the continuity of the tradition. The Orthodox mind believes in a "salvific beauty," a beauty that radiates from the Godhead itself and draws us in with its grace. In order to grasp the notion, it is necessary to abandon the presumption that beauty is a "product," an "achievement" of the great mind or the genius from Aeschylus through Shakespeare to the most compelling modern author. Western classicism has helped foster that notion, and even Christians are struggling to preserve it. All humans, from the most talented to the most lowly, but reflect and refract that uncreated light whose source is God. Salvific beauty is incompatible with the cult of genius. For in this perspective beauty is not a product but a kinetic *effect*. The effect is achieved through applying an unchanging principle of divine truth.

I touch the minds of students often enough to know that

among us Americans, too, beauty possesses power. There is little agreement about what beauty *is*, of course, and as a criterion it seems very slippery indeed. But Americans can agree on their response to beauty once they recognize it: in simple terms, they "like" it. It projects an attraction, instills awe. But our understanding of beauty has a tragic dimension as well. During a discussion about images of nature in American poetry, one of my best students once silenced my assertion that, unlike the goods that we so often seek, beauty is universally accessible. "You can say what you like, Professor," she said. "But money is the crucial issue. We live in a world where money can buy beauty." My students may not see the world as I wish they would, but they are no fools. There is a sense in which she was right. As private property extends its dominion over "nature," we grant parcels of seashore, acres of woods, and feet of lakefront property to those who can afford them. For that matter, even lectures and discussions about beauty are hard to come by without the money to pay some tuition. Insofar as we confine our apprehension of beauty to our power over the exterior product, the material artifact, Americans will be estranged from any ideas of salvific beauty. If beauty in any sense is implicit in the act of *possession*, it no longer saves.

For beauty to be in any way salvific, it must be accessible. If we see beauty as in some way relating to truth, in some way attracting us to what is true, we will be able to come at the matter from a "more Orthodox" angle. In fact, contemporary Russians do judge beauty and the arts according to criteria of truth, not merely the criterion of gratification alone. The social realists believe that art must in some way reflect the class struggle and must instill in the working classes a sense of dignity and hope. Believers adopt similar criteria, with the categories rather radically expanded, of course, to include all humanity. The arts must in some way reveal God in his creation.

"Orthodoxy is so magnificent a phenomenon," said a Catholic translator living in Vilnius, "because it makes icons of us all. Each of us becomes a work of art, reflecting God's glory." We can find this refrain throughout Orthodox sources. In the Russian mind, beauty or "the beautiful" is related to the category of truth. As the brilliant little film produced by

the Ukrainian Orthodox deacon and filmmaker Slawko Nowytski indicates, each richly decorated Ukrainian Easter egg is a theological document.[2] Each geometric symbol and each tiny stab of color reveal truth. In the mind of the believer, that truth has a real existence, just as beauty has a real grounding—not only on the fragile shell of the egg but also in the all-enduring and steadfast being of God.

Beauty, to be real, must be grounded in the carnate dimension of our being. But it must also be accessible to all who desire it. In the last chapter we saw how the secular mind admits to a longing for the intellectual possibilities that we as Christians possess. This is one argument for showing nonbelievers more than tolerance, for an embracing compassion on our part. Why some people believe and others do not is a mystery, but through the avenue of beauty, some dimensions of the faith experience are open to the imagination of "nonbelievers" as well. We as Christians can offer solace to others through what beauty we offer them. Like the Orthodox in the Soviet Union, I have known and loved many in my life who did not believe in God. I have seldom met a person who, even if he or she did not believe in the saving power of God, didn't wish to be convinced of it. In the "shared insight," the acknowledgment of beauty that we have shared, the Christian offers to others a moment in which they can overcome the tragedy of meaninglessness.

If faith in God is not a universal phenomenon, "awe and yearning" certainly are. Christians have an obligation to reveal the full range of the Christian mind and to touch others with their imagination. Secularism has cut off many of our contemporaries from mystery and community. Instead of surrendering culture to the secular mind, which cannot admit to the possibilities we embrace, we Christians should be more confident and aggressive in asserting our common vision. Chris-

2. *Pysanka: The Ukrainian Easter Egg,* produced by Slawko Nowytski, photographed by Thomas Ramsy, written by Kristi Duckwall, original music by Mark Byrn (Minneapolis: Filmart Productions, 1976). Slawko Nowytski has received acclaim for *Harvest of Despair,* his documentary on the Ukrainian famine.

tians in Russia and in the secular culture of Finland have shown such confidence, and in so doing they have attracted young people to the intellectual and creative possibilities of faith.

Russian Christian thinkers in contemporary Soviet times exude this confidence. For they assert that the most creative, most fully *integrating* thought is grounded not in rationalist analysis but in the experience of belief. This belief springs from our common life in the Spirit, and the hallmark of that life, the indication of its presence, is beauty—the inward beauty of a spiritual life that invests the whole of creation with its character. The Christian can offer the fruits of that beauty in a coherent, long-suffering life, in a work of art, in a song, in a kneaded loaf of home-baked bread. But such beauty must be offered freely, unconditionally, to Christian and non-Christian alike. The beauty of our world is offered to all, unconditionally, by its Creator. We as Christians must do no less. In the beauty of the Christian vision, the world is transfigured.

Integral Knowledge

The most effective way to demonstrate the principles of salvific beauty is to look at some basic assumptions underlying Orthodox Christian thought and practice in the USSR. When, for example, Reformation Christians look at the way in which Orthodox Christians arrange their churches and venerate their saints, they are apt to emphasize the cultic dimensions of Orthodox practice. Paying homage to saints in particular seems to pose the danger of encouraging believers to venerate the saints for themselves and in place of Jesus Christ, the true source of glory. Orthodox and Roman Catholic apologists often explain saints to thoughtful skeptics as individual "heroes" of the Christian life who exemplify virtue and reflect the glory of Christ. Yet this explanation is only partitive, and it appeals rather too directly to the individualist, rationalist mind-set of the questioners.

It is better instead to look to the vision of those who embrace the practice. In Orthodox practice the saints demonstrate an *integral* life, a wholeness of being; the individuality,

the specific virtue of their lives is secondary to the "God awareness" that permeates their consciousness. Humanity is transformed as it grows toward God. Saints "see" things more clearly. Orthodox Christians venerate them precisely because they, like us, have been separated from God, and they now show us that it is possible for our consciousness to be penetrated by that of the divine. They and the icons that portray them show us a spiritual beauty that, for the Orthodox mind, is a criterion for life in Christ, life in the church.

The saints are not the only expression of this spiritual beauty: it exists and can be recognized in others. Christians in Russia, when they are serious about the spiritual life and intent upon pursuing that life in the Spirit, take spiritual directors. Like the *startsi*, the monastic spiritual elders we encounter in Dostoyevsky's Father Zosima and other characters of Russian fiction, these spiritual directors are sought out by those who wish to consult with them. They are recognized as such because they radiate a kind of beauty, even though their advice can be sparse and homely in its direction and even though they are typically, like Father Zosima, self-deprecating. In the collected letters of Father John, a monk who died in 1958 at New Valamo Monastery in Heinevesi, Finland, we can catch a glimpse of a traditional old Russian *staretz*. In the excerpt that follows Father John chides a self-critical spiritual child who has become too dependent upon his direction:

> It is unreasonable, even sinful to think that you "would be lost" without me. Read the Bible and the Holy Fathers and be wise. What does my advice mean when I myself am groping my way? If I write something, I get it from the same sources. I am like a smoke sauna; I wash others clean, but I stay just as black.
>
> The Lord protect you.[3]

I know many laypeople in the Soviet Union who consult with a "spiritual parent." They revere the director and rely upon him or her for advice. The same practice is com-

3. Father John, letter 57, in *Christ Is in Our Midst: Letters from a Russian Monk*, trans. Esther Williams (Crestwood, N.Y.: St. Vladimir's Seminary Press, 1980), p. 56.

mon among devout Orthodox people in the United States and throughout the world. Believers in the USSR often make a pilgrimage to a monastery in order seek the counsel of a monk or priest or nun. I once met a group of women from a remote corner of Siberia who had traveled all the way to Kiev in the Ukraine to consult with a nun at one of the women's monasteries there. A visit to one's spiritual parent involves repentance, self-denial, and an examination of the details of one's life and priorities under the parent's guidance.

When asked to describe that inner quality of "spiritual beauty" and to explain how it is recognized, Russians most often rely upon categories of "intuition." "I can *feel* a sense of God's presence when I am with him," said a young Russian man who frequently goes to a monastery in Byelorussia to see a monk. A young woman from Leningrad, a good friend of mine, told me that the most meaningful weeks of her life were those few weeks she and her husband were able to spend in a remote Russian village near the wife of a priest who was pastor there. "Everything in my life suddenly seemed laden with trivia, with meaninglessness. She is a very spiritual woman—she obliterated my ordinary concerns and showed me how to convey what really matters to my children and even to the people with whom I work. She is the most beautiful person I know."

In seeking to characterize the wholeness, the *integration* of these spiritual teachers in the Soviet Union, we can look to a Russian philosophical preoccupation: the search for an epistemological "wholeness," an "integral knowledge"—in Russian, *tselnoye znanie*. Robert Slesinski is an American, a member of that group of Eastern Christians who have placed themselves under the jurisdiction of the Patriarch of Rome. (Although they are better known as "Eastern rite Catholics," in their rediscovery of their Orthodox roots, many of them, like Slesinski, better deserve to be described as "Orthodox in spirit.") Slesinski has pursued the theme of *tselnoye znanie* by studying several nineteenth-century and twentieth-century Russian thinkers, and I owe some of the following insights to him.

Long before any evangelicals in the West reacted negatively to a phenomenon they dubbed "secular humanism,"

Russian believers rejected certain premises of Western thought. As early as Ivan Vasilyevich Kireyevsky (1806-1856), who first coined the term, we see a sharp contrast proposed between the logical abstracts of Western thought and the "integration" that marks the thought of the East. At their worst, such contrasts can be artificial and needlessly triumphalist in their negativism about and condemnation of the West. Yet Kireyevsky and those Orthodox thinkers who succeed him consistently affirm the power of thought that flows from belief, which has at its core the "whole vision" of an integral, God-begotten creation.

If we look carefully at their claims, we see in these Russians not a wholesale condemnation of rationalism but a claim that it is an insufficient avenue to the wholeness of truth. This, after all, is a claim reminiscent of Claude Lévi-Strauss's assessment of the mythic mind. Above all, Kireyevsky challenges the pretensions to self-sufficiency in the rationalist position:

> If it [Western rationalism] would only recognize its own limitations, and see that, in itself, it is only one of the instruments by means of which truth is known, and not the sole way to knowledge, then it would also view its conclusions as only conditional and relative to its limited point of view, and would expect other, supreme and most truthful conclusions from another, supreme and most truthful mode of thinking.[4]

That truthful mode of thinking cannot be the province of the scholar or the philosopher alone; it belongs to the thinker who is centered in spiritual insight and who lives the spiritual life. *Tselnoye znanie*, "integral knowledge," flows not from partitive rationalism but from belief.

4. Kireyevsky, "O neobkhodimosti i vosmozhnosti novykh nachal dlya filosofi" ["Of the Necessity and Possibility of New Principles for Philosophy"], in *Polnoe sobranie sochinenii*, vol. 2 (Moscow: Theological Academy, 1861), p. 318. An English translation of the essay is available in *Russian Philosophy*, vol. 1, ed. James M. Edie, James P. Scanlan, et al. (Chicago: Quadrangle Books, 1965), pp. 174-213. The translation here is from Robert Slesinski's *Pavel Florensky: A Metaphysics of Love* (Crestwood, N.Y.: St. Vladimir's Seminary Press, 1984), p. 55.

We can see immediately how this distinction between Eastern and Western epistemology, between "ways of knowing," lends belief an intellectual dignity. Yet Russian secular thinkers have not accepted the necessity of belief for a "wholeness" of knowledge. They imitate, in effect, the secular rationalism dominant in Western society. In fact, Russia has suffered an inferiority complex throughout its history about "Western advances," particularly in the areas of technology. "Scientific socialism" in Russia, at its roots, betrays this anxiety: in each five-year plan there is an implicit or explicit desire to catch up with or surpass the West in technology. Yet Russian Christians have seldom shared this envy of Western advances with their secular countrymen. Believers in Russia often show an indifference to, even a contempt of, Western consumer items and technology. "What need do we have for such toys!" laughingly said an older woman when some Western Christians tried to press a few Radio Shack gifts upon her. "A book I would appreciate—but what does this do for the soul?" There is the distinct perception among believers in the Soviet Union that they have preserved an integral knowledge and an integral life: *tselnoye znanie* and *tselnya zhizn.*

A line of Russian and Ukrainian thinkers extending into the contemporary era has sought to strike a harmony between belief and post-Enlightenment thought. Aleksey Stepanovich Khomyakov (1804-1860), Pamphil D. Yurkevych (1826-1874), and Vladimir Sergeyevich Solovyov (1853-1900) have all been influential in the development of Orthodoxy in Russia. Each of them in a distinct way has continued to explore the contrast between abstract, logical, "partitive" thought and the "wholeness" of integral thought. It is useful for Western Christians to understand the way in which they envisioned the difference, for it has left a strong legacy in contemporary Christianity in the USSR.

Soviet believers regard the rational, secular mind as handicapped. In order to come to know a thing, the rational "post-Enlightenment" thinker tends to break it down into its constituent parts, "ordering" those parts according to a certain hierarchy informed by the analysis. This rationalist methodology works exceedingly well in coming to understand the *function* of a thing. One can see how it works. But it is less

successful if it seeks to understand the "nature" of a thing, what it is. "That is the problem with modern humanity," said a Soviet theological student. "Its perspective is confined to function—as if the nature of a human being were determined by the pure 'function' of its organism. But our sole function is not simply to eat, sleep, and reproduce."

Following the precedent of Solovyov (and through him from his teacher, Yurkevych), believers in the USSR would critique a sole reliance on empirical rationalism for confining the mind's capacities to "pure sensation" on the one hand and "pure reason" on the other. Empirically, says the Orthodox philosophical tradition, the rationalist must rely on pure sensation in order to draw a conclusion about "the world of appearances," the world that surrounds the observer. The rationalist must also rely on formal thought in order to draw a conclusion about "the world of ideas," the world of thoughts that exists within. Thus the rationalist is confined to a "pure self," isolated from an outward, "objective" reality.

In a shift from the usual discourse about God, the contemporary Orthodox believer in the USSR sees objective reality as rooted in God's being. "The problem with the rationalists, yours or ours," one of my Russian friends said to me in exasperation, "is that they argue as if their conclusions determined an issue. God exists, or he does not exist, independent of our or their conclusions about the matter." God as Creator is not remote from us—he has chosen, of his own divine will, to involve himself with us through grace. Creation is animate with his life; belief thus gives integral life to the assemblage of "facts" into which the rationalist mind renders experience. If we humans are indeed "reciprocally defined," intermeshed with each other in coming into our own identities, then even more so are we involved in a "lived relationship" with God. Our thought should always reflect this phenomenon of "relationship." It is not partitive analysis but rather an integral holism that is more representative of the state of creation.

Aleksey Khomyakov expresses what is worst in Orthodox triumphalism and what is best in Orthodox apologetics. He rejects the partitive tendencies of post-Enlightenment Western ra-

tionalism, claiming that dissection and segmentation distort the process of the mind. This impulse to "break down" an idea into its constituent parts necessarily frustrates the holism that is grounded in the Spirit. Khomyakov attributes this kind of rationalism to the entire Western church, both to the Roman Catholicism that has attributed an infallibility to the papacy on what he calls "rational" grounds, and also to the Protestantism that centers authority in the text on the same principle. In this aspect of his thought is centered his triumphalism:

> Seeking the sources of Protestant rationalism, I find it disguised in the form of Roman rationalism and I cannot avoid tracing its development. Without dwelling on abuses, I am concentrating on the principle. The Church inspired by God became for the Western Christian something external, a kind of negative authority, a kind of material authority. It turned man into its slave, and as a result acquired, in him, a judge.[5]

If we set aside for a moment the fact that Khomyakov has plunked utilitarian rationalism directly into the centers of those Western religious traditions that sought, often in vain, to combat its influence, we can see through the prejudices of the last century. Khomyakov's attacks spring also from his values: he identifies as the hallmark of Orthodox thought the pursuit of *tselnoye znanie*, "whole knowledge."

The philosopher Pamphil Yurkevych is typically Ukrainian in his synthesis of Eastern and Western insights. He concentrates on the distinct and concrete identity of every separate person more than Khomyakov and Kireyevsky do, but he centers that identity in an emotive quality that mediates the power of reason. He combines the contemporary philosophy of his day with a concentration on "the heart" drawn from the church fathers:

5. Khomyakov, "On the Western Confessions of Faith," in *Ultimate Questions: An Anthology of Modern Russian Religious Thought*, ed. Alexander Schmemann (New York: Holt, Rinehart & Winston, 1965), p. 51. Ironically, this essay was first written and published in French, and only later translated into Russian. Khomyakov's central thesis on Orthodoxy is "The Church Is One," in *Russia and the English Church*, ed. W. J. Birkbeck (1948; rpt. New York, 1953), pp. 192ff.

One who reads the Word of God with due attention can easily notice that in all the Sacred Books and in every divinely inspired writer the human heart is looked upon as the centre of all bodily and spiritual life of man, as the most essential organ, the nearest location of all the forces, departures, movements, desires, feelings, and thoughts of man with all their directions and colorings.[6]

Thus Yurkevych, like the Orthodox fathers who see prayer as seated in the heart, looks to the heart for the "healing" of the mind. The emotive part of our nature must temper the rational. Otherwise humans cannot properly understand what is real. Yurkevych views reason as involved in true understanding but by no means exclusive in its formulation. Reason prepares the ground. But it is the heart, which has the capacity to love, that can grasp the truth immediately. This truth is illustrated by the story of the disciples on their way to Emmaus. These men encountered Jesus and even conversed with him before, moved by their conversation, they finally "grasped" the truth of his identity. Not only faith but also true, "relational" knowledge springs from the affective dimensions of our being.

In modernity, however, the mind, schooled by secular rationalism, tends to resist integral thought and a sense of "integral relations." Just as the prevailing method of rationalist thought tends to break a thing down into its constituent parts, so also modern people tend to isolate themselves from those "lived relations" in which they are inextricably involved. It is only within the context of "God awareness," or what Solovyov would call "mystical knowledge," that we achieve any completeness of perspective. This awareness of God allows us to break free of the prison of self.

6. Yurkevych, "Sertse i Yeho Znachenie v Dukhovnoi Zhizni Cheloveka, po Ucheniu Slova Bozhia" ("The Heart and Its Meaning in the Spiritual Life of Man according to the Word of God"), in *Trudy Kievskoi Dukhovnoi Academii*, vol. 1 (Kiev: Spiritual Academy, 1860), p. 63. The translation from the Ukrainian is by Stephan Jarmus in his introductory treatise to Yurkevych's collected articles in *Tvori* (Winnipeg: St. Andrew's College, 1979), p. 28. This work, with Jarmus's excellent discussion of Yurkevych, is the only contemporary edition of the philosopher's writings.

Relational Thinking

Beauty or aesthetics is of such importance to contemporary Russians because it relies so fully upon the relational impulse. Most Westerners have a very hard time explaining why we react positively to something that "attracts." Once we apply rigorous analysis to the symphony we like or read an incisive review of the rock artist we admire, we may better understand why we are drawn into the music. But there always remains an element in us that *is drawn*. We "relate" to the music; we are an inextricable part of the subject that seizes us.

In the process of rational, abstract analysis we retain distance, and we have at least the illusion of control. As my insurance agent studies a contract, as my lawyer reviews her briefs, and as I assemble notes for a lecture, we each of necessity isolate "constituent parts" of things and manipulate them. We feel ourselves to be active agents, in control over our "data." Now this manipulation may be good for the task at hand. The problem arises when we feel this rational approach or "clear thinking" or even simple "common sense" to be an adequate way to deal with the world. Russian Christians feel that a respect for beauty and the ability to surrender to it correct the "arrogance" implicit in the rational mind—an arrogance arising in its illusion of control.

Russian Christians ascribe an inherent unity to the entire created order, an "animation" of the Spirit that is our bond with creation. The things we observe around us are not cold, dead "phenomena." Creation pulses with "relational life"— the life of the Trinity, of interconnected being, of organic interconnection. The Russian puzzlement with the phrase "personal Savior" is a sign of that perspective. Jesus as Savior of the individual is viewed partitively, apart from the wholeness of his mission; yet any Christian would admit that it is as cosmic Savior of all creation that he truly *saves*. Orthodoxy sees a distinct problem with individualism. It is a partitive term, one that cuts humans off from that very relational quality in which their humanity resides. With their philosophical tradition and their opportunity to publish freely, theologians in the Greek tradition provide a resource for the contem-

porary Orthodox academics in the USSR. The contemporary Greek Orthodox theologian Christos Yannaras reveals the perspective from which the Orthodox mind approaches the issue: "The person is not an individual, a segment or subdivision of human nature, as a whole. He represents, not the relationship of a part to the whole, but the possibility of summing up the whole in a distinctiveness of relationship, in an act of self-transcendence."[7]

This is a perspective upon the nature of the human. It is important because in very crucial ways, Western and Eastern Christians (and, to some extent, Americans and Russians) speak from differing perspectives in answer to the question, What does it mean to be human? Yannaras articulates the Orthodox mind, which distinguishes between the person and the individual. To place a pre-eminent value upon individuality makes separateness the most important constituent of identity. The Orthodox mind sees each human as whole and distinct, yet in that human being's *personhood* is the essential, relational element of his or her humanity. As individuals, we are sundered from each other. As persons, however, we necessarily imply and "sum up" each other. Again, the Trinity forms the model for humanity. If humans are formed in the image of a Triune God, then to be human is to be "one in essence" and at the same time "many in hypostases."[8]

From a Russian and Ukrainian Orthodox perspective, "individualism" is not a term that grasps the relational dimension of human nature. We love each other not as individuals but as persons. Rational analysis, while certainly "useful" to achieve certain ends, is simply insufficient—ultimately, even frustrating—in any attempt to grasp the wholeness and integration of all things. Orthodoxy's critique of modernity is no less true today than it was in the previous century. Empirical rationalists in both America and Russia suffer from the illu-

7. Yannaras, *The Freedom of Morality,* trans. Elizabeth Briere (Crestwood, N.Y.: St. Vladimir's Seminary Press, 1984), p. 21. For another excellent contemporary Greek discussion of "communal personhood," see John D. Zizioulas, *Being and Communion: Studies in Personhood and the Church* (Crestwood, N.Y.: St. Vladimir's Seminary Press, 1985).

8. Yannaras, *The Freedom of Morality,* p. 19.

sion of self-sufficiency. Mystic or theological perspectives are the most "relational" available to us; Christians believe that their perspective can provide a genuinely integral approach to the issues of our day. Yet in both America and the USSR, religious perception has been relegated to "sectarian" status. The rationalist, segmenting mind also attempts to segment us.

"Sectarian"—the word itself is partitive and rationalist in its presumptions. "Separation of church and state" is a contract under which Christians in both our societies must live. Yet, paradoxically, in an important sense the church can acknowledge no real separation between itself and the society of which it is a part, nor can Christians accept a "sectarian" label without doing violence to an integral Christian vision. A Communist friend told me that "churches in our society exist to meet the needs of believers." Churches are simply purveyors of the "cult," barred in many senses from life in the fuller sense of "culture." Yet cult and culture are inextricable. Very recently churches in the USSR have gained the legal status of "individuals," giving them some grounds for further rights. In essence the position of the church in the USSR is like that of the church in America. At best churches can gain the right to be "sects," individuals. The secular, rational modes of analysis remain in effect the only publicly sanctioned ones.

There are other parallels between the position of the church in our two countries. Whatever the relative "rights" any church possesses, in a secular society the church is subject to a governance that does not share its own integral presumptions. Christianity, both East and West, perceives an organic unity in the social framework; secular, rationalist presumptions see compartmentalization in the body politic. The American church, with both its right and its left hand, feels the resistance of the state and at points expresses its opposition to public policy. The Russian church also expresses its resistance, but in a more muted way.

The West too readily assumes that its own kind of Christian social activism should be normative. The assumption is that the Russian church, were it free of state restraint, would also express its mind in a way similar to that of the West. The

"relational principle" so strong in the Orthodox tradition, however, touches the nature of Christian activism as well. The Western church often allows its social categories to be defined by the prevailing principles of rationalist secularism. The Western heart, even in its generosity, opens itself to segmented *individuals* within an interest group or class rather than to the *persons* who are defined by their relationships to others. In accepting as primary categories those terms established by the secular mind—racism and sexism, feminism and homophobia, liberalism and conservatism—American Christians chop and dice their causes and their charity according to a recipe written by the secular chef. The Russian church has complied with the legislation of the state, but it has remained true to its own social vision. Beauty is a central principle in that vision. Through their theology and liturgical life, the Russian Orthodox have continually projected the integral life and relational thought that underlie the culture of their people. In coming to understand the Russian and Ukrainian church, Americans must appreciate the practical, social role played by the principle of beauty.

Beauty as a Social Dynamic

Vladimir Solovyov is much read in the contemporary Soviet Union because he, like those Orthodox thinkers who precede him, attacks the pretenses to "self-sufficiency" in rational analysis. The process of thought is itself isolating and partitive, and hence wrenches the knowing subject from the network of relationships that bind one to God and to others. God is not a force utterly removed from our reason but its sure foundation: without God, assembled "facts" become absolute rather than conditional. The "relational" element in all creation rests in the Triune God at its center. Solovyov emphasizes beauty as that principle which can reveal the "relational" element in creation.

Christ as the center of all creation provides an absolute standard of comparison by which we can determine that the natural world of fact is, as Solovyov describes it, "something condi-

tional, transitory, and not normal."[9] For Solovyov, Christ embodies the perfection of beauty, because Christ is at once material, spiritual, and immortal. Unlike Hegel and his school, Solovyov sees immortality or permanence as a necessary quality of perfect beauty. In his thought, then, beauty contains a real, objective element. It is grounded in concrete fact when, through its attraction, it draws us together into common life so complete that Solovyov borrows a Greek term, *syzygia*, to convey its intensity:

> Not to submit to one's social environment but not to dominate it, but to be in loving interaction with it, to service it as an active fertilizing principle of movement, and to find in it the fullness of vital conditions and possibilities—that is the relation of the true human personality not only to its immediate social environment and its nation but to humanity as a whole.[10]

Solovyov conveys a mistrust of "fact" that is somewhat alien to the American temper. One kind of American believer tends to integrate religious perception into the world of fact: Scripture becomes a part of that "world," and its claims are "literally"—that is, factually, verifiably—true. But in this light even the miracles of the gospel can lose their definitive element of wonder. Miracles are miracles, after all, because they violate the rule. The Russian religious impulse is to regard the world of fact itself as "conditional, transitory, and not normal."

Russian believers are suffused with a sense of the miraculous. They commonly make pilgrimages to certain shrines and pray before certain icons, and those places and those images then "break through" the natural world of fact for them. J. R. R. Tolkien is a Western thinker who also recognized the limitations of pure rationalism. He called it the "tyranny of fact," a tyranny that has seized hold of modernity. According to Tolkien, the artist has the power, in effect, to cooperate with the gospel in breaking this tyranny. Through the power of fantasy, or through what an Orthodox thinker might call the creation of beauty, the artist can allow us to

9. Solovyov, "Beauty, Sexuality, and Love," in *Ultimate Questions,* p. 132.

10. Solovyov, "Beauty, Sexuality, and Love," p. 132.

look beneath the transitory nature of this world and see that stirring truth which underlies it.

Tolkien's trilogy, *The Lord of the Rings,* now published in Russian, enjoys a vigorous popularity in the USSR; Russian Christian readers, of course, find within it the Christian artist acting out his redemption of the world. "That's precisely it!" said a friend of mine with enthusiasm after completing the work. "Frodo is engaged in the Christian quest—not only to save Christians but to save the whole of Middle Earth. This is *synergy*—our cooperation with God to save the world. We are all a part of a great fellowship." The popularity of fantasy in the USSR, *fantastika,* bespeaks a natural human hunger to penetrate the veil of "fact," to perceive a beauty where none is immediately apparent. As Tolkien observed, "Fantasy remains a human right: we make in our measure and in our derivative mode, because we are made: and not only made, but made in the image and likeness of a Maker."[11]

Tolkien helps the Western Christian to clarify the tremendous salvific power that the Russian Christian sees in beauty. For beauty binds together those who submit, collectively, to its attraction. It binds the subject, the perceiver, to the object that he perceives. And it will not succumb completely to the "tyranny of fact," the process of rational analysis by which we understand only *parts* of the world. It submits us to "the whole," to a wholeness in which we participate. Russian thinkers, then, do not see aesthetics as the passive, "individuating" light it can become in Western idealism. Christian idealism in Russia does not separate the arts from involvement in the world in a version of the "art for art's sake" perspective. Submission to beauty means not an estrangement from our society but a deeper involvement in it.

Russian Christians, like the old Bolshevik champions of "socialist realism," see aesthetics as involved in the social process. However, they center that social process in its divine source. Pavel Evdokimov, a Russian emigré of this century, sees beauty as a dimension of the Spirit, the source of unity

11. Tolkien, "On Fairy-Stories," in *Essays Presented to Charles Williams,* ed. C. S. Lewis (Grand Rapids: Eerdmans, 1966), p. 72.

among humans. Culture is the liturgy within which each of us enacts our common priesthood. Beauty is an expression of holiness, and through that realization alone can Christians "liberate" culture. Yet that act of liberation is not achieved primarily through philosophical discourse.

Tatiana Goricheva, herself a philosopher, is impatient with modern rationalist philosophers. "There is still too much philosophy in Russia today," she complains. Her complaint is the result of Russia's rationalist discourse about its own history and conflicts. Surrounded by philosophical concerns that could only describe the past, she felt hemmed in by discourse, utterly chained to a modernist belief in historical necessity. When her generation first encountered Orthodoxy's "relational perspective," she comments, "Christianity freed us from the oppressive karma of the past."[12] Yet, though she became a Christian, for some time she still felt herself to be a creature of discourse. For her, Christianity became a means of "self-expression." Her spiritual director then chided her for her constant reliance upon the word "I." It was then, through the example of others more attuned to the spiritual life than she, that she discovered a central quality of beauty: "I recognized that real beauty is silent and says virtually nothing."[13]

Real beauty resides in prayer and prayerful action. If Christians speak in this mode, the words they utter express not "themselves" but rather their common life in the Spirit. Therefore, if we Christians see the intimate connection between beauty and the holy, we will recognize the divine in all of creation and thus work to restore the dominion of God in his rightful kingdom. Beauty appears to us by means of our senses; it manifests itself to us in material form. If we remember the central place the image holds in Russian consciousness, we can draw a helpful parallel here. Just as Jesus Christ became incarnate in the flesh, so he becomes manifest through his creation by sensate, "incarnate" means. It is a kinetic, ever-renewing image that we humans perceive. Aesthetics, then,

12. Goricheva, *Talking about God Is Dangerous: The Diary of a Russian Dissident* (New York: Crossroad, 1987), p. 46.
13. Goricheva, *Talking about God Is Dangerous*, p. 43.

is material in its essence—we perceive beauty in changing, material form. Yet it is spiritual in its power—the immutable principle of *holiness* informs all Christian perception of beauty in whatever material, cultural form beauty manifests itself.

Westerners, even those who are attuned to Russia's voice, are by and large deaf to the tenor of theology in the Soviet Union. Although there have been some exchanges with the West, they have often been confined to peace and other social issues. What is more, the Russian church's "endorsement" of government goals is much criticized in Western Christian circles. The fact is that contemporary theology in the Soviet Union is deeply involved in the issue of Christian aesthetics, the question of beauty. Nor is that question removed from social issues—it is deeply, inextricably involved in the transformation of society. The "social engagement" of the church as an institution, however, is severely limited in Soviet society, which sees social welfare as the province of the state alone. The transformation has to occur through the prayer and the lives of believers as they work among others and affect their lives.

The American scholar James W. Cunningham has documented that Russian Orthodox laymen and clerics were very much involved in the social action preceding the Russian Revolution.[14] This is just one example among many proving that the Orthodox Church has been unfairly accused of compliant passivity; the fact is that Russian clergy and laity have raised their voices against the abuses of the state both before and after the Revolution. In recent years, however, the hierarchy and official church structure have endorsed general causes, most often peace issues—endorsement that has given the church a rare public voice at home and visibility abroad. This has been enough to rob the Russian church of all validity in the eyes of some Christians. From the *Newsweek* of the McCarthy era to some critical press reports of the present, there is an unbroken line of charges connecting the Russian church to political expediency, even Communist conspiracy.

14. Cunningham, *A Vanquished Hope: The Movement for Church Renewal in Russia, 1905-1906* (Crestwood, N.Y.: St. Vladimir's Press, 1981).

It is difficult to understand the expectations that some Westerners have of the Russian church. Some seem to desire defiance, others repudiation—like that of popular comedian Yakov Smirnoff—of the USSR. Seldom do Americans understand the church's internal dynamics. The issue of aesthetics may help to explain the stance of the Orthodox Church in the USSR toward social involvement. It may be true that the church's statements on peace serve the immediate political aims of the state, but it is also true that many Russian Christians view such statements as completely in harmony with the mission of the church. This is a country, after all, that lost twenty million in World War II. Indeed, in Orthodox seminaries in the USSR there is a real effort to build a "theology of peace," and those who reject the honesty of the motives involved must, in all charity, demonstrate the grounds for their suspicion.

It is wrong, then, to attribute all social concerns of the Russian Orthodox Church to the civil authorities or the KGB. This does a terrible injustice to the entire church through a political motive. Of course, critiques of any church are possible, and it is to be expected that American Christians will differ from Russian Christians with respect to specific policies. Yet Americans must grant Russian Christians the right to express a social vision, even if it is subject to the regulation of the state. The worship-based focus of the Russian church expresses not a static but a *dynamic* vision. A working committee of united Orthodox theologians, drawn from multinational traditions, made the following assertion in their statement distributed at the meeting of the World Council at Vancouver:

> This community which lives by the perennial liturgical *an-amnesis* of creation and redemption bears witness to Jesus Christ through its daily liturgy of intercessory prayer for and loving service to the world. Orthodoxy, or the right glorification of God in worship, results in orthopraxy or the life of prayer and service in the lives of individuals, groups, and congregations.[15]

15. *Jesus Christ for the Life of the World: An Orthodox Contribution to the Vancouver Theme*, ed. Ion Bria (Geneva: World Council of Churches, 1982), p. 12.

Orthopraxis, the dynamic principle of involvement in the world, flows directly from worship and from the beauty that worship evokes. The Russian church leadership endorses "peace" positions in harmony with those of the state in service to that principle. Likewise, dissidents like Evgenii Barabanov and Alexander Ogorodnikov often criticize the church's cooperation with state controls, yet the position of the dissidents, too, springs from a commitment to *orthopraxis.* Beauty, as the Slavs conceive of it, is a social principle.

Anatoli Levitin, the Orthodox activist now in exile, heads his treatise on Christian commitment with the title "In the Thick of Life"—*"V gusche zhizni."*[16] Levitin is as critical of the church compromised by capitalism as he is of the church in submission to a communist state. Christians, he asserts, involve themselves in contemporary issues for one reason: to build the kingdom of God on earth. That realm is, to the Slavic mind, "the Beautiful Kingdom." It is marked not by confrontation but by a quest for harmony and accord.

In these new, exciting days in the USSR, Christians at every level ache with longing for a new opportunity for *orthopraxis,* the opportunity to articulate prayer in direct, harmonious social action. The Popkovs are an example. Viktor Popkov is a veteran of Soviet jails. Now released from custody, working as a soccer coach and living in Moscow, he concentrates on the future rather than the past. He radiates both calm and resolution. All he longs for is greater social involvement and repeal of the anti-religious laws of 1929. He embraces the principle of *orthopraxis.* "Given the existing legislation, however," he notes, "we are limited in our ability to act on our own behalf." His wife, Soviet feminist and Christian activist Tatyana Gurevna Lebedeva, laments the theoretical direction of many feminist thinkers in the West because in their activism they fall victim to the intellectual process of segmentation and confrontation. "Feminism in the West can miss something essential in the human portrait," she maintains. "One sex can achieve nothing by excluding the other." A young seminarian

16. The essay is printed in *Stromaty* (meaning "Kaleidoscope") (Posev: Frankfurt-am-Main, 1972), pp. 65-151.

addressing an American delegation at the newly reopened Danilovsky Monastery in Moscow makes a similar point. "What we expect and begin to experience under *glasnost'*," he says, "is the opportunity to take up our social role in our society without segmentation and without discrimination."

Western commentaries upon the Russian church often miss the voice of mainstream Russian Christians. Official delegations meet, of necessity, their official hosts. And officially the concerns of the Russian Orthodox Church have focused not upon responses to Western social thought or opportunities for social action but rather upon the issue of world peace. This is a legitimate concern, yet critics often consider it to be a smoke-screen designed to hide the suffering Russian church from Western scrutiny. Now, when television documentaries in the USSR themselves highlight historical footage of toppled crosses and cathedrals exploded to make way for swimming pools, there should be less suspicion of these "official pronouncements" on world peace. When Russian bishops and theologians plead for peace and disarmament, they identify the principles of spiritual beauty and harmony as primary goals. And in this they are at one with those dissidents and Christian witnesses who have suffered in Soviet prisons, whose mute argument has been heard the more widely. Bishops and dissidents alike hope for world peace. The appeals that dissidents have leveled at their bishops have been designed to free the church to take up its social role. Christian activists in Russia do not protest against their bishops. They plead with them.

"Pastoral Aesthetics"

Americans often overreact to the "peace pronouncements" of the Orthodox church leadership in the USSR. On the one hand, as I have argued, they represent the heartfelt hopes of a generation seared by war. On the other hand, they also satisfy authorities and win the church some measure of public approval. Even those Russian Christians who argue that their church has allowed itself to be coopted by the state rarely attack these pronouncements on peace issues. They argue in-

stead for more assertiveness and courage from their leaders in resistance to state regulation of the church. The political pronouncements of the Russian Orthodox Church no more reflect the completeness of its intellectual life than an anthology of Fourth of July sermons reflects the mind of the American church, or our minister's invocation on Memorial Day reflects our theology. There is some of us both—American and Russian Christians—in our patriotism, but it cannot be mistaken for the whole.

The real heart of the Orthodox Church in the USSR beats much more persistently than its occasional public pronouncements would indicate. A new surge of energy has flowed through the Russian Christian mind in recent years, and that energy is centered in this issue of aesthetics, the root of that "dynamic principle of involvement" endorsed by the Orthodox theologians at Vancouver. The chief articulator of this aesthetic concern is Pavel Florensky (1882–c. 1945), a brilliant academic and Russian priest whose long years of imprisonment under Stalin should render him exempt from any suspicion of compliance with the state. In the USSR the Christian response to Florensky—who has been somewhat "rehabilitated" even in the secular academy—has been steadily enthusiastic. Widely read and deeply influential in the theological academies, he is valued as a thinker who is able to mediate the immaterial and the material, the contemplative and the active. A 1982 paper delivered at the Moscow Theological Academy provides insight into Florensky's significance: "Thus the road to the contemplation of Beauty is a road of concrete Church action, which gives the aesthetics of Father Pavel Florensky its exclusively pastoral nature, so that he can be said to be the founder of a new theological discipline—pastoral aesthetics."[17]

"Pastoral aesthetics" expresses the social dynamic of beauty. The theological academy in the Soviet Union views aesthetics as "pastoral" in that it *teaches:* it moves humans toward an engagement of the good. In its long history the Or-

17. V. Ivanov, "The Aesthetic Views of Father Pavel Florensky," *Journal of the Moscow Patriarchate* 9 (1982): 75.

thodox Church has endured many trials of oppression and persecution. It has learned to appeal to the affective, emotive capacities of humankind, an approach that allows it to survive and remain strong even when educational channels are inhibited or closed. In an Orthodox perspective, the affections as well as the reason must inspire social reform. Dialectical conflict is the evidence of injustice and "social sin." Reason can provide an analysis of the conflict. The affections, however, can inspire the vision of justice and social harmony that will lead to repentance and reform. Thus contemplation, an "attraction to the good," leads to social engagement, all encompassing, embracing all in love.

In the West, Florensky has often been eclipsed by the Orthodox figures in the Paris emigré community, figures like Nikolai Berdyaev, Pavel Frank, and Sergius Bulgakov. These Orthodox thinkers have forged the mind of Orthodoxy in the West, and they have justly earned a reputation on that basis. Florensky, however, remained in the USSR. His eclectic thought is in the Russian philosophical tradition. Seldom encountered in the West, his works have long been untranslated. (Robert Slesinski's study entitled *Pavel Florensky: A Metaphysics of Love* provides an excellent discussion of his thought, the beginnings of a biography, and a current bibliography of his work.) Florensky, who himself influenced some of the emigrés, has a stronger hold on Christians in Russia than do those figures better known in the West. "He is one of our own," said a teacher at the University of Moscow. "The emigrés left us and ceased to be a part of our experience. His thought took shape here, and he evolved with us through the days after the Revolution. He has lived the experience of contemporary Russia."

Some highlights of Florensky's biography help to explain his attractiveness to contemporary Orthodox believers in the USSR. Born in 1882 to a family relatively indifferent to religion, in his youth he resembled many contemporary Soviets—like those who, at the edges of the Easter procession, are drawn to its beauty but not yet committed to its teaching. Nor was Florensky conservative and "anti-socialist" in his politics. A student of physics and mathematical theory,

he became involved with radical social movements at Moscow University. Resisting the conservatism of the czarist church, he formed a "Christian brotherhood" modeled on the social theories of Solovyov. In these youthful days he advocated a utopian "free theocracy" in which the state would freely submit to the church.[18] Under the influence of this kind of idealism, he turned from a promising career in mathematics to enroll in the theological school of the university.

If we try to penetrate the spirit of the times and the man, we can understand why Florensky the theologian has reached the minds and hearts of modern Soviet Christian youth. Florensky's social principles were not the conservative endorsements of the established order. A social activist with a restless, eclectic mind, he turned from a secular academy that would have engaged his interests to the entrenched, conservative, and intellectually oppressive "established church." He endured its conservatism because he believed that the church would ultimately reflect a new social order. In short, like contemporary Soviet Christians, he rejected the oppression of the old monarchist order and accepted a politically socialist and utopian worldview. He was not pleased with the political and hierarchical organization of the church. At the same time, however, his spiritual needs drew him deeply into its sacramental life.

Before the Bolshevik Revolution of 1917, Florensky applied the full range of his intellect to his masterwork, *The Pillar and Foundation of Truth*.[19] Working with the image in 1 Timothy 3:15, where the church is described as the "pillar and bulwark of the truth," Florensky drew from the broad range of his scientific, philosophical, and anthropological

18. A discussion of Florensky's social activity and social thought is available in *Mikhail Bakhtin* by Katerina Clark and Michael Holquist (Cambridge: Belknap Press, 1984), pp. 135-38.

19. Florensky, *Stolp i utverzhdenie instyny: Opyt pravoslavnoi feodistei v dvenadtsati pis'makh* [*The Pillar and Foundation of Truth: An Orthodox Theodicy in Twelve Letters*] (Moscow, 1914; rpt. London: Gregg, 1970). The work has not yet been translated into English. For a discussion of Florensky's work (including a bibliography), see Slesinski's *Pavel Florensky*.

study in order to discuss the very nature of reason. He attempted to forge an inquiry into the nature of thought, and the epistemology that he shaped in this work has attracted the generations of believers who, like him, remained in the newborn Soviet Union and suffered through its trials and changes.

Florensky, like the Slavic Christian thinkers before him and since, was troubled by the radical separation in methodology between science and theology. When the Revolution came, however, it put an end to Florensky's hopes of founding an institute to integrate scientific and religious thought. Deprived of a parish during the early anti-religious campaign, yet identifying himself as a priest and believer, Florensky returned to the kind of work he had done earlier—physics and electrical engineering. As a leading figure in the famous "Electrification Campaign" and an editor of the Soviet *Technical Encyclopedia*, he took an active role in shaping the new nation. Like the millions of believers in the Soviet Union today, he never considered his Christianity an imperative to overthrow the civil power. Instead, he worked to strengthen its struggling economy. (Most famous among his technical achievements was the development of a machine oil that remains viscous under cold conditions—an invention that helped in the war effort and in the industrialization of Siberia.)

But these contributions, like those of so many other believers, did not protect him from abuse and persecution. Imprisoned in 1933 and torn from his wife and his work, he lived the remainder of his life in the bleakness of prison camps. Solzhenitsyn and others attempt to describe him in those years, but even the date and manner of his death are uncertain. The certainty is the importance of his legacy to Christian life in the USSR.

Florensky's quest for a Christian epistemology speaks to those generations raised in a society marked by a secular and materialist rationalism. Among young people in the USSR, the attraction to faith very often comes at precisely the chronological point at which young Americans tend to draw away from the church—when they enter more fully into the life of the mind. Many Soviet young people find empirical ratio-

nalism to be profoundly inadequate. One young student at a polytechnical institute put it this way: "Secular materialism can answer the question 'What?' but never the question 'Why?' It has no spirit." These questions about the "why" of things are those that Florensky has satisfied in his synthesis of the Orthodox intellectual tradition. He lived the Soviet experience, and in his writings he meets the needs of spiritually hungry minds for some intellectual substance. A self-contained theology cannot satisfy this century. Florensky's theology reaches outward, and in its emphasis upon beauty as a central principle it seeks to integrate the disparate "disciplines" into a coordinated, harmonic quest for meaning.

Florensky's thought is complex and in some respects controversial. The effect of his work on the contemporary Russian religious mind is easier to understand. "Pastoral aesthetics," drawn from his synthesis of Orthodox sources, makes beauty a socially grounded and socially engaging principle. It rescues beauty from the sterile, self-enclosed realm of private apprehension. In Orthodox eyes aesthetic privatism becomes an elitist and decidedly a-religious category. Marxism remains true to the social dimensions of art, and in this sense it can serve as a corrective to the privatism of American society. Yet Marxism sees the values by which beauty is judged to be relative and changing. Philosophically, Florensky rejects this relativism. In Christian terms he defines "inner spiritual beauty" as a distinguishing characteristic of the church. Beauty is not relative but transformative—it attracts us, it moves us, it changes us through its influence.

Florensky has an "iconocentric" vision. The icon is the central metaphor for his expression of the principle of beauty. He sees the human face itself, for example, as "portraiture" in its very essence, the revelation of the divine image. Grace and ascetic action in God's service illuminate the face as a reflection of the divine presence:

> This event is engraved on the ascetic's face: Let your light so shine upon men that they may see your good works and glorify your Father which is in heaven . . . luminous, beautiful, harmonious works that are the evident products of spir-

itual personality—but before every light the beautiful face, beautiful with a beauty radiating from the "inner light" of man, so that conquered by the attraction of this light, men may glorify the heavenly Father whose image is so shining on earth.[20]

Florensky sees the Christian life as itself a kind of iconography, a concrete metaphysics. The Christian, through a spiritual life, allows himself or herself to be fashioned into a vessel of the Uncreated Light. In Florensky's view, iconography is an expression of the Orthodox sensibility. Its genesis is liturgy, and its expression projects the image of the future age of the kingdom, allowing us to "leap to the other side of time."

The Western mind demands precision, and "beauty" seems so indeterminate a category. This, in fact, points to a problem with Orthodox thought in general. Khomyakov defined *sobornost'*, a difficult-to-translate notion of "collegiality, accord," a process at the heart of the church's being. Florensky's category of "beauty," which attempts to capture the principle of that accord, has a similar problem. It simply seems too vague a term to satisfy rationalist criteria. The American Christian sees the Russian Christian as having a distinct problem with exactness, with fixing upon questions of identity. That is why it is hard for the practical mind of the American believer intent upon understanding to take "beauty" very seriously. Just what *is* it?

Yet the principle of beauty is important because it helps to explain a different way of "defining." If the Orthodox see identity itself as a relational entity, then the act of definition, too, must account for relationship. The Western process of definition tends to be isolating, exclusionary. Florensky, relying upon the underlying "reciprocal awareness" in Russian thought, articulates a new principle of identity. He attacks first the very confidence underlying the Western process of definition. For example, the simple assertion "*A* is *A*" is what Florensky calls "blind in its immediateness," "dead as a fact." Florensky seeks to focus identity instead upon living act. *A*

20. Florensky, "On the Icon," *Eastern Churches Review* 8 (1976): 15-16.

does not exist "self-referentially," static and alive only "unto itself"; it exists in reference to all that is non-*A*. You, my reader, affirm yourself to be you through what Florensky calls the dynamic adoption *(usvoyeniye)* and assimilation *(upodobleniye sebe)* of all that is other than you. Simply put, your identity does not exist in sublime isolation: you are not "unto yourself alone"; you are "you" in relation to all that is *not* you. You are like the simple letter *A*, which cannot be *A* unless there is also a *B*, a *C*, and so on. Without your parents, your spouse, your children, your friends, your community—and, most importantly, your God—you would not be "you" at all.[21]

Like the Russians who respond to Florensky, Robert Slesinski recognizes that principle of identity as being at the core of a truly radical philosophical insight.[22] It is an insight for which the Russian mind has been prepared. We have seen in its Trinitarian thought and in its principles of dialogism and reciprocal definition that it is never isolating in its categories. Mikhail Bakhtin applied dimensions of this insight in his literary criticism, just as Florensky's inheritors apply it in their theology. It is, one can argue, an innate characteristic of Orthodox thought. Florensky states that what is "given" is blind, what is "static" is dead. An identity that is involving and relational is dynamic, perceptive, and life-creating. To define is to see the relationship of a thing to other things. If we understand identity as a function of our relation with other identities, we have grasped a central principle of the Christian life as the Orthodox live it.

"Mia Harmonia"—The One Harmony

"Beauty" is a relational principle. What it is in material terms will always vary with the material artifacts of our culture and civilization. Indeed, what Russians deem "beautiful" will not always attract Americans, nor will American "beauty" always

21. Florensky, *The Pillar and Foundation of Truth*, pp. 27-28.
22. See Slesinski's discussion of the passage in *Pavel Florensky*, pp. 86-91.

impress Russians. We differ in our judgments of bodily form, color, and line, of dramatic nuance, poetic image, and narrative shape. Yet the *principle* that underlies beauty is, in Christian terms, always the same and always an expression of our Christian life. If "exactness" can allow for an expression of relations, one can look at Russian Christian thought and express the principle with precision. That "relational principle" is harmony. It helps us to understand, in definite terms, what beauty conveys.

To rely upon beauty as a hallmark of the church, as Florensky does, or upon *sobornost'*, as Khomyakov does, presumes a unity in understanding. Orthodox believe, of course, that the fullest level of that unity exists among those who are most fully related in faith. Thus Orthodox commune with Orthodox. We share with all other Christians, however, some basic accord in our way of looking at the world. No matter how furiously I may argue with a conservative evangelical over a political issue, no matter how I might argue with Alexander Solzhenitsyn over his interpretation of America, I presume a common Christian understanding. Our fellowship in Christ is a harmony born of the Spirit; the Holy Spirit is the source of the understanding we share. As the early Eastern father Gregory Nazianzen preaches in his Pentecost sermon, in the Spirit we share the same understanding whereby we are all drawn into a single harmony *(mian harmonian)*. Harmony brings different elements into accord. It quells self-sufficiency and autonomy; it induces cooperation and peace. In charity and good works we see the concrete fruits of such harmony among us. This harmony lies at the heart of Russian ecclesiology: it is the guiding principle of beauty and "pastoral aesthetics."

Harmony is not a static principle. On the contrary, harmony "moves" one to action. It does this differently than compulsion or force. Russian Christians find it difficult to understand certain dimensions of American "militance" in the Christian life. "If you become one force among many forces," asked a friend, "don't you necessarily exclude yourself from those whom you attempt to influence? How can a Christian compel?" Our Western modes of persuasion rely upon the linear, dialectical models of rhetoric. This is a part of our reli-

ance upon the book as a central icon. When I teach "argument" in writing, I teach it as a pattern of clashes and linear dialectical conflicts that we seek to resolve by the victory of a single side. Americans often see Christianity in Russia in the same terms: as a force that must encounter in dialectical conflict the opposite force of Marxism. Likewise, "Christian evangelism" in the West so often expresses itself in rhetorical terms, as a force that must argue an unbeliever into belief. To the Orthodox sensibility, proselytizing smacks of compulsion, and nothing is more free than the gift of grace or its acceptance.

Relying upon other, nonrhetorical models, the Orthodox understand their position in a different way. The image moves the one who contemplates it, but it does so without compulsion. It offers many "planes" simultaneously; it does not feature two linear positions in perpetual opposition. The image persuades rather than confronts, draws one in and calms dissonance. Think of a visitor to a new church. She opens her hymnal to an unfamiliar song. Suddenly, everyone begins to sing in harmony. Her voice wavers at first, finding its part. Eventually, however, the song creates its own dynamic; it draws her voice into choral accord. Russian believers try to "draw" others into accord with them in a similar way.

Thus Russian Orthodox Christians approach the issue of proselytization very warily. Sergius Bulgakov speaks from this perspective when he writes, "Orthodoxy does not persuade or try to compel; it charms and attracts."[23] Indeed, given the relational principle of identity that Florensky develops, harmony is the only avenue to life in the Trinity. We are not our own; we exist in relationship to all that is other. We are shaped by all that is other. The command of love draws us toward harmony as an ideal.

This harmonic ideal should help to explain the attitude of Russian Christians toward evangelism. Soviet legislation against the church's right to educate its children is, of course, indefensible. Prohibitions against public witness to the faith are equally condemnable. (I should note, however, that in re-

23. Bulgakov, "The Orthodox Church," in *A Bulgakov Anthology: From Marxism to Christian Orthodoxy*, ed. James Pain and Nicolas Zernov (Philadelphia: Westminster Press, 1976), p. 12.

cent days I have seen the authorities relax some of these pro-
hibitions.) Yet it must also be understood that Russian Or-
thodox Christians approach evangelism and public witness
differently than Western Christians do. Individual evangelists
claim a great deal of attention among us. But, although Billy
Graham is well received in Russia, the emphasis of Russian
Christians is upon the entire witness of the church, never on
a single evangelist or interpreter.

The Russian Orthodox suspicion of "autonomy" calls the
whole community to consensus. In the Russian Orthodox lit-
urgy, no single vehicle to understanding—icon, music,
word—asserts itself over any other: the "harmonic principle"
prevails. Similarly, no single "interpreter"—inconographer,
soloist, or preacher—ordinarily assumes any dominance in
worship. And evangelism is a corporate enterprise. Typically,
the Russian believer thinks of the entire church as giving wit-
ness; his or her own efforts are but quiet reflections of that
common enterprise.

Whereas we Americans tend to enhance the Christian
reputation of those who achieve some visibility in the service
of the gospel—"heroes of Christ" like Mother Teresa and Billy
Graham—Slavic Christians typically value those who are ex-
traordinarily meek and reserved. I say "Slavic" rather than
"Russian" here because this sensitivity to spiritual beauty
marks Orthodoxy among all Slavs—Ukrainians, Carpatho-
Russians, and Byelorussians—as well as the Russians I cite.
Among them there are people who live as "monks or nuns
in the world," attending all worship services, giving long hours
to prayer, and working at unassuming secular jobs. Paradoxi-
cally, some of these individuals become famous for their
humility. Sometimes, like the Russian Saint Seraphim, they
retreat into the wilderness to continue their relationship with
God. Or, like the recently canonized Saint Xenia, they wander
like pilgrims in the urban landscape, intent only on charity
and prayer. They are the antithesis of the spirit of confronta-
tion. In their icons, they "image forth" the truth that "spiritual
beauty" requires a constant awareness of the harmonic ideal.

To be of "one mind" (Rom. 12:16; 15:6; 1 Cor. 1:10;
2 Cor. 13:11; Phil. 1:27; 1 Pet. 3:8; 4:11): this is a constant

theme in Russian Christian spirituality. That one mind is "the mind of Christ" (1 Cor. 2:16), which we possess through the gift of the Spirit (1 Cor. 2:11). The mind of Christ is the source of our *sobornost'*, our "collectivity" in the church. It is also the "mind" in us that perceives beauty, that is tuned to the principle of harmony.

Christians in the West respond more readily to confrontation as a theme. In a recent Lutheran sermon I heard the old adage "The Reformation is never over." But Americans must understand that to contemporary Christians in the USSR, confrontation seems an approach more secular than Christian. Florensky and other Russian thinkers use "dialectics" as a principle whereby the human encounters the divine, but in their thought the encounter leads to harmonic transformation.

Secular Marxists see that dialectical principle as the link in a chain of inevitable conflicts. Secular thought, East and West, has become hospitable to "an ethics of conflict." The world is resistant to the harmonic ideal, but this is to be expected: "Now we have received not the spirit of the world, but the Spirit which is from God, that we might understand the gifts bestowed on us by God" (1 Cor. 2:12). According to Russian Orthodox thought, we Christians possess in the Spirit a "shared consciousness." The life of prayer, so central to Russian Orthodoxy, involves not passive retreat but active engagement: prayer is the means we have of nurturing and sustaining that "shared consciousness." According to an influential theorist of prayer, the Byzantine monk Symeon (c. 949-1022), called the New Theologian, it is through the Holy Spirit that "we see God and Christ Himself living in us according to his divinity and moving around in a conscious (*gnostos*) manner within us" (*Chatechesis* 24).

There is another way in which this harmonic principle underlying the "theology of beauty" opposes itself to a spirit of confrontation. If indeed we are "reciprocally defined," if indeed our identity is relational, as Florensky indicated, then we as believers are inextricably involved with those who do not believe. The Sermon on the Mount defies secular rationalism; the Orthodox emphasis on beauty, however, inter-

prets its precepts in the light of Christian reason. Christians cannot sanctify intellectual or legislative compulsion any more than they can sanctify physical violence. Let us return to the lesson napalm teaches: the fire we visit upon the enemy is ultimately visited upon us. Compulsion distorts the icon of the human personality. When believers are called into daily contact with nonbelievers, as is the case in contemporary Russia, Christians sometimes make the same discovery the Orthodox intellectual Anatoli Levitin did when he expressed his admiration for a principled Communist general. There are times when nonbelievers as well display a sensitivity to "spiritual beauty," when they too are responsive to the harmonic ideal.

An American Christian may pose a confrontational question: "Yes, but are these people 'saved'?" The Russian Christian does not ask this question. Are those in the USSR who crowd around the church at Easter, hoping to be touched by the mystery—are they "saved"? According to Orthodox understanding, it is possible that the mind Christians share, our "common consciousness in the Spirit," may touch others, that it may play a role in forming them. It is possible that the "consciousness of the Spirit" may enter another before he or she is fully aware of its presence. The image of God exists in those whom a rhetorical evangelist would "confront." That image is of surpassing beauty. To respond to that image, to show it reverence, is to give witness to the gospel of Christ.

Viewed from the outside, the Russian church may seem to be an utterly static and conservative force. Russian Christians themselves, however, see their church as dynamic. The Christian aesthetic mediates the categories of the mutable and the immutable: it illuminates the principle of change in the church. Harmony is in itself an unchanging principle: spiritual beauty involves the quelling of autonomy whereby all are brought into loving, "trans-subjective" accord. Like its musical counterpart, however, this harmony is expressed through ever-changing patterns. Harmony does not mean the notes never change; if it did, every barbershop quartet would sing in a monotone. It simply means they change "in accord," with respect to each other.

So also the *medium* through which the kinetic, dynamic image of Christ comes into existence among us is by its nature material and hence mutable. Thus the medium through which we express the changeless harmony of life in Christ is of itself ever changing. Linguistically, politically, and artistically, the church will manifest herself in different terms in different ages. Just as the structures of language that bring us the biblical text inevitably change in "linguistic drift," so also the political and social structures according to which we live shift and move. We can never "re-capture" them. Jesus embraced the flesh and thereby rendered himself a material being. He now manifests himself among us in the no less vulnerable, mutable materiality underlying language, social organization, and culture. The unchanging God is manifest in change. "Beauty," the harmonic principle of our common life in him, is immutable.

The Christian Aesthetic in America

There is a fatigue, a tiredness to Christianity in the West. Tatiana Goricheva, the Orthodox philosopher, describes it with a special poignancy. Having come from an environment in which belief was a matter of utmost importance, she comes to a world that takes it for granted. The dissident comes to "freedom," and one day she comes to church in the West with these reflections:

> I'm beginning to hate not only myself but also these people. Given their "bourgeois" character one can understand the mood of the left-wing people, since it is indeed very difficult for those with another temperament and values to live in this sleepy and boring world.
>
> I go into the church and read the notices: renovation of the facade, advice for the family, keep fit, men's gymnastics and finally, "The Spiritual Resurrection of Russia, T. Goricheva." I'm in good company.[24]

24. Goricheva, *Talking about God Is Dangerous*, p. 101.

Goricheva's observations sound bitter and condescending—until she softens her tone with the recognition of a spiritual hunger in her audience, a hunger that humbles her. Despite her initial harshness, she penetrates the veneer of "normality" with which we in the West can cover our Christianity. If she, who has suffered so much for her faith, feels this estranged from the complacent Christians to whom she has come, what is in the minds of the many young people who have left our churches? Goricheva merely points out an alienation that afflicts many of us and our children.

In Christian aesthetics, there is a remedy for this ennui. Nor need the remedy reside in traditional answers alone. Christian artists live among us, eager to wake us up. Often we need only look at what is already there. Our own culture can confront our youth with the idea of God. The novels of Jon Hassler (*Staggerford, The Love Hunter*) can startle us with the divine luminescence of the ordinary event. The rock group U2 has alluded to God as the "last taboo" in the scheme of rock music, and in the audiences at their concerts one can see a Western parallel to the Russian masses crushing around the church at Easter. Christians can support with joy and enthusiasm those musicians, authors, and artists who respect the hunger for mystery.

Our models of education can be well served by a consciousness of beauty. Sunday school programs concentrate on a body of information: texts, dogma, doctrine. They pay too little concrete attention to the Christian notion of "spiritual beauty." If we encouraged exercises and curricula that propounded not abstract but concrete "truth," we could sensitize ourselves more fully to the Spirit within, the "common consciousness" that we share. We should encourage encounters with music and film. We should help our young people to engage and discuss rock music, books, and movies they encounter in their daily lives, and try to submit them to Christian perspective. If we judge a TV program "immoral," let's watch it together and discuss why. The purpose is not so much to dictate instruction but to discern the "mind of Christ" together.

In our moral behavior and demeanor as well, there is

an argument for a "harmony of the senses." Christians focus upon sexual license as an enemy in modern American culture. But it is not, of course, sexuality that we oppose. Perhaps we affirm too little the mystery, the joy in sacramental sexuality—the harmony among souls of which the harmony of "good sex" is an emblem. "Good sex" is not only licit sex; it is sex that is open to the possibilities of mutual pleasure and mutual growth. Sex as it is commercially glorified is, in reality, "auto-sexual," closed to the reciprocal definition that brings us full being. But there is such a thing as Christian sexuality, and perhaps we Christians in America should affirm it rather than spending our energies attacking its distortions.

Likewise, the ancient ascetic model that produces the teachers who sensitize us to spiritual beauty can restore a harmony of soul and body. The gluttony of our food ads isolates oral gratification at the expense of all others and urges a consumption of resources intended for others. Commercialization distorts our appetites. "Sensual harmony" calls Christians to an asceticism of the spiritual life that balances our bodies as well as our minds. Our own behavior implies not only our welfare but that of the world around us. The promise of Christian life is not health or wealth or even "happiness" as the world defines it, but a fullness of being possible only when we are of "one mind," the mind of Christ.

If Christian aesthetics implies a harmony among the senses, it also implies a harmony among ourselves. When we Christians in America become deadened to theological issues, we fall prey to political categories instead. When we engage each other, let it be on theological issues in a "dialogic" spirit— with the realization that we shape each other as we engage each other in discourse. It is certainly true that the political arena has become too important to Christians on both the left and the right. Our theology necessarily implies politics, but an awareness of our reciprocal definition, of our utter incapacity to "be" in and of ourselves, should oblige us to speak with charity to each other and to engage the mind of the other.

Applying the harmonic principle in Russian Christian thought inevitably will alter the psychological terms in which we view the human personality. Such insights as Florensky's

discourse on identity and Bakhtin's views on language should cause us to re-evaluate and correct the isolating models we have adopted, wholesale, from the secular sphere. The human personality is a complex constitution of interrelationships. We cannot find ourselves without discovering others. Christian support groups as well as pastoral counseling can serve and support this network of interdependence among us. It is the local community, not only the counselor, that best consoles and strengthens afflicted individuals. Vietnam veterans developed "delayed stress syndrome" partly in reaction to their own individual experience but primarily in reaction to their inability to reintegrate themselves with others. One veteran I know said of his fellow Americans, "I felt like a fraction: they canceled me out." Veterans were healed when they turned to each other.

And finally, if the harmonic ideal involves our relationship to the senses and to each other, it should call us to a new kind of social engagement. It may seem extreme to look to the church in the USSR—a church so long denied, by legislation, any but a "cultic" social function—for a model of social engagement. Yet it is precisely because the Christian community in America is so embattled that the Russian Christian model can be of some use. In its emphasis upon materiality, the Russian Orthodox Church has involved itself deeply in issues of culture. As a matter of fact, the Orthodox deny the possibility of separating "cult" from "culture." In their eyes the task of the Christian is to act according to his or her vision of a Christian society. Social reform, then, is a legitimate aspiration. Yet social reform sustains its energy not in an "application" of Christian principles to separate issues but in the charism of spiritual beauty.

Much opposition to the "social gospel" has arisen from purely political motives: the princes of this world often do not like what the gospel moves Christians to do. Yet there has been a legitimate reaction against the isolating nature of Christian social action, whether on the left or the right, whatever cause is being served. An exclusive focus on the dynamics of power can estrange believers from the totality of a lived Christian life. In his treatise on beauty, Pavel Evdokimov urges

Christians to actively assert their own "aesthetic," their realization of beauty in the material world, as they engage in their daily activity:

> The scientist, the artist, the social reformer will be able to find again the charisms of the royal priesthood and, each in his domain, as "priest" will make of his research a sacerdotal work, a *sacrament* transforming all forms of culture into the theophanic place: to sing the name of God by means of science, thought, social action . . . and art. In its own way, culture is conjoined with liturgy, it resounds the "cosmic liturgy" and becomes *doxology*.[25]

This kind of thinking challenges us Christians in America to a broader conception of social action and engagement. We Christians have become estranged from each other through our models of "confrontation." Through them we seek to implement separate, often conflicting issues. We even separate the causes themselves into partitive categories. In quests to eliminate sexism, racism, and ageism, we borrow from the secular world and segment reality into isolated parts. The "charism of a royal priesthood" is the attempt to restore us to "wholes." A consciousness of the beauty implicit in harmony can help to do that.

According to the Russian Orthodox mind, beauty quells autonomy. If American Christians develop a sensitivity to spiritual beauty, we will look for real areas of resonance in each other. Even in the arena of secular culture, we will cease to view ourselves as "kingmakers" or "dethroners" by virtue of whom we support and oppose. We can cease to rely upon the image of "the beast" in portraying those fellow human beings with whom we are, in Christian consciousness, inextricably blended. We will sustain our energy as Christians less in separate causes than in the unity of an ascetic Christian life. We can take it upon ourselves to affirm the harmonic Christian vision.

Having affirmed the power of harmony in the Russian consciousness, it is time to examine the issue of harmony be-

25. Evdokimov, *L'Art de l'icone. Theologie de la beaute* (Paris: Desclee, De Brouwer, 1970), p. 39.

tween Russians and Americans. Since we address Christian rather than secular concerns, we should conclude this discussion with a meditation on how we as Russian and American Christians evaluate ourselves. Only after an evaluation of our Christian self-image, surely, can we finally open ourselves to each other. Only then can we recognize the reciprocal definition, in the Spirit, that has already taken place between us.

Chapter Six

ONE NATION UNDER GOD

"Planting the Cross in America"

*F*or most of us babies of the early boom, the Pledge of Allegiance was a ritual of childhood. In my Detroit grade school, we held our hands over our hearts with real conviction. Somehow the pledge seemed a magical incantation against the terrors of the bomb, whose arrival we rehearsed in air-raid drills as we crouched, hands over our heads, in the hallways. We giggled and annoyed the teachers with noises, I remember, during those drills. But we were solemn during the pledge.

It made a big impression on us, then, when under President Eisenhower's smiling photo the *Weekly Reader* suddenly announced a change in the pledge. The two words to be added were small, but they were tantamount to placing an interpolation in the Lord's Prayer. When I took the news home and announced it at the dinner table, however, I made one mistake. I said that the president had ordered the change.

The most important thing about my dad's identity was summed up in his black torpedo of a lunchbox. This symbol announced him as a factory worker and a staunch union man. Upstairs in our attic he had stacked back issues of *Time* magazine, full of Eisenhower's campaign promises. If a visitor were unwise enough to mention Eisenhower in my father's presence,

down would come an old copy of *Time*, full of failed promises to savor. As an American vet wounded at the European front, my dad hadn't thought much of Eisenhower as a general either. "Glory boy," he called him—a term I wouldn't completely understand until I too wore a uniform. My dad saw Eisenhower as a union-spoiler and a too-long-silent accomplice of McCarthy. So you can understand why the mention of his name in our house was a signal for combat.

"President Eisenhower's changing the Pledge of Allegiance," I announced brightly.

"What for?" my Dad asked, glowering over his potatoes.

"They're gonna say just a couple more words," I answered with more caution.

"What words?"

"'Under God.'"

Inside myself—deep inside myself—I smiled. If this were to turn into a political argument, who could argue against the borrowed authority of the divine? Our teacher had piously explained that very day how America had always been a nation that God had abundantly blessed, and how we stood like a "torch of liberty" for all those oppressed people behind the Iron Curtain who could not worship God.

Yet silence ruled at our dinner table for a moment—exactly the kind of silence that reigned when I claimed my smaller cousin Sharon had *wanted* to walk in the knee-deep mud with her new red boots on, to amuse us bigger kids, and had *begged* us to stop poking in the mire with a long stick in a vain search for her one boot and a Buster Brown shoe. This, as silences went, was serious—a solemn "high silence." My father chewed meditatively, and I knew a judgment was being considered.

"Son," my father finally said, with an unexpected gentleness in his voice, "you gotta trust me. Whatever they tell you in school, God ain't no American. He belongs to everybody."

In some Christian circles, the insertion of those two words in the Pledge of Allegiance stands as a last great moment for Christian America—"one nation, under God." Yet through childhood and ever after, whenever I've repeated the pledge, I've had a moment of reservation when we come to those words. It is not, of course, that I don't wish to place my

nation under the lordship of God, the Ruler of Nations. It is just that I suspect that behind such words may lurk an appropriation of God rather than a subjection to him.

In the fifties, God was hardly a forbidden subject in the public-school classroom. Yet I remember so vividly the constant juxtaposition of God and nation as if the two were an alliance, a partnership. The nation, it seemed, was not exactly *under* God. America emerged as "one nation *with* God." "Red" Russia, of course, was one nation *without* him. The struggle was emblematically rendered in a host of magazine covers and very bad poems pitting the hammer and sickle against the cross.

This was the popular expression of the "civil theology" that still reigns. It is particularly apparent around civic holidays. Whereas the gospel taught one set of attitudes toward suffering and the poor, the lessons of blessed nationhood gave us prosperity as the necessary fruits of our liberty. Christ loved the poor, but he, unlike America, never promised to make them rich. And we children of the Slavic immigrant subcultures in the United States had our family feasts ended with woeful stories of the pain, starvation, and want from which our families had fled. After dinner, the older relatives would sigh over their memories. The "D.P.s"—refugee "displaced persons"—would remember the pains of the last war. And they would drink vodka, or weep, or do both. And we children would both bask in well-being and suffer guilt. We were to be grateful for our plenty, but at bottom we also felt somewhat uneasy about enjoying it.

For all these complex reasons, going to church around the Fourth of July has always filled me with discomfort. Earlier in this book you met Ike and Faye, my Mennonite farmer friends who live a model of the simple life. Shortly after we moved to Lancaster, Ike and Faye invited my family and me to their Mennonite services. We reciprocated by inviting them, on a Sunday over the weekend of the Fourth, to our Greek Orthodox service. For the holiday the parish celebrated the liturgy outdoors just before the picnic set in a local park. Every weekend of the Fourth, Byzantium seemed to blossom in the middle of Pennsylvania Dutch country, and barbecue smoke mingled with the smell of incense.

I had prepared my friends for the radical sensuality of our services, and I had prepared them for its ancient forms. But I hadn't prepared them for our Fourth of July celebration. For these Mennonites, inheritors of state persecution in Germany, studiously avoid intermixing civil and religious symbolism. They avoid it so rigorously that their Amish cousins still wear clothes that fasten with hooks and eyes instead of buttons, in abhorrence of the brass buttons that used to adorn the coats of the king's soldiers. And here, in the midst of many people who spoke English with an accent, we concluded ancient Greek melodies with "God Bless America" and "America the Beautiful." An American flag adorned the space before the altar. And the sermon celebrated the joys of living in this country, which had brought the Greeks of my parish, islanders from Cos and Chios, to the life of peace and prosperity that by and large they enjoy.

My Mennonite friends were fascinated by the service, which praised God in what was to them an exotic way, but they were made uncomfortable by those very American displays I thought they would find most familiar. "Do you always keep a flag in front of the church?" asked Ike with polite reservation. ("Oh, in a lot of parishes we have a Greek flag, too," said a member of my church in response—and confused the couple further.) "And do you usually sing patriotic songs after the Lord's Supper?" queried Faye. They didn't seem to be bothered at all by the icons and the kissed crosses. They found an American confusion of God and country the most difficult dimension of a Greek Orthodox service.

Ike and Faye had a good time at the picnic afterward: the Greek Orthodox, who are under normal circumstances hospitable to a fault, virtually burst with hospitality when someone does them the honor of joining them in worship. And after some explanation, I think my friends came to understand that the honor paid to God was not of the same order as the honor paid to country. At least Ike and Faye came to understand that the Orthodox *think* they've got the problem sorted out. But I think they still had some suspicions. And so, to be honest, do I.

The history of the Greek Orthodox in this nation has

made them, on the whole, less critical of civil religion than other Orthodox. The Greeks have, from ancient times, made a gift of their culture. In their pattern of diaspora, they have grown used to transferring allegiance from one civil power to another. Civil politicians come as welcome guests to court support at Greek Orthodox conventions. At times Greek Orthodoxy can become a function of Greek ethnicity and Greek-American political interests. Michael Dukakis, raised Greek Orthodox, married outside the faith and did not raise his children within it. Yet Greek Americans within the church still claim him as a living trophy of their achievement.

The Orthodox Slavs in America, on the other hand, have found the adjustment to the American civil order more difficult. Just as the USSR is made up of many culturally distinct republics—of which Russia is only one—so also Slavic immigrants to America are of distinctly different origins. Their villages were often remote; they were a kaleidoscope of distinct identities sustained by a common Eastern Christian ethos. Coming from remarkably isolated and immobile peasant cultures, Slavs in America had to plunge immediately into a rushing stream of change. Soon after they came, they witnessed the collapse, in war and revolution, of that Christian Orthodox order which had sustained them. After centuries of meek compliance with the civil order, they found themselves to be critics of the American culture that now surrounded them. And due to political clashes between America and the newborn USSR, these immigrant Slavs sometimes found themselves to be under the suspicion of those in power.

In fact, Americans did not receive the Slavic immigrant of Eastern Christian background on the same religious terms as those of other Christian traditions. Their insights, no matter how passionate, seldom emerge in the public arena unless they relate to political rather than theological concerns. Whether these Eastern Christians be liberals or conservatives, doves or hawks, Orthodox or "Eastern rite Catholics," Ukrainians or Russians, the American public has tended to engage them on one issue. Whatever they say, other Christians hear them in one context. These Orthodox become expressions,

contradictions, or confirmations of the central civil creed—
God's battle against godless communism.

Thus many Orthodox Christians in America, especially
those whose origins lie in East Europe, exhibit in a particu-
larly acute way the stresses of civil theology in the United
States. In Orthodox terms it is simply a bad theology. It is
oversimplified, relativistic, and triumphalist. In expressing
their discomfort, these Orthodox provide a reasoned critique
of assumptions that the "mainstream" American Christian can
unwittingly and passively accept.

There is one widespread American attitude toward re-
ligion that Orthodox find just as chilling as constitutional
atheism. That attitude is expressed in a quote from Eisen-
hower, sometimes cited in the Orthodox press, that could
easily have been culled from my Dad's attic collection: "Our
government makes no sense at all unless it is founded on a
deeply held religious faith and I don't care what it is."[1] It is
this startling relativism that many Orthodox find a threat.
"Secular religiosity," general and relativist Christian sentiment
voiced by any political leader, undermines the power and vi-
tality of any specific theology. It mocks real conviction.
Likewise, in its singular focus on America as moral agent, it
challenges the utter lordship of God over all nations. Only a
strong sense of history, not as nations but as a church, can
save Christians from subjecting God to the state.

Reverend Peter Haskell, while serving as an Orthodox
chaplain in the American navy, expressed the deepest fears
of Orthodox Christians who daily face the demands of a civil
religion:

> Orthodox people have withstood the onslaught of Turks and
> Mongols and Communists around the world, but the attack
> of American civil religion is much more insidious because
> the issues are so very unclear and kept so very unclear. The
> difficulty is that we cannot see where we stand or where
> they stand. Even patriotism, a sincere love of this country
> which I have and which I think many people have, can be

1. Eisenhower, cited in "American Civil Religion: A History,"
Concern 9 (Summer 1974): 9.

prostituted into an abandonment of Christianity in the name of the extreme relativism of this secular faith.[2]

This is a true paradox of Orthodox Christianity. In the USSR the faith that lives within a Communist ideology not only survives despite its difficulties but even develops an encounter with its radically secular culture. Few Orthodox thinkers in the United States or in the USSR have predicted an end to the Christian tradition in Russia. Yet here, in the "nation under God," Orthodox express fears of becoming extinct under a generalized national Christian pietism.

Some Orthodox in the United States, feeling themselves now to be primarily American rather than ethnic in identity, have placed their claim on America through a new assembly of saints. Saint Herman and Saint Innocent of Alaska, for example, have been canonized in the last decade. Although Russian in origin, they acknowledge the Alaskan route of the first Orthodox in America. The hymn to Saint Herman, often sung in Orthodox churches in the United States, makes the cultic role of Saint Herman clear:

> O Blessed Father Herman of Alaska,
> North Star of Christ's Holy Church,
> You planted the cross firmly in America.
> The light of your holy life and great deeds
> Guides those who follow the Orthodox way.

Slowly the icons of Saint Herman, a Russian monk who served native Aleutian Indians in Alaska, have found their way into the Orthodox churches of varying national groups in America. Ironically, then, the icon of a Russian monk is one expression of "Orthodox Americanness." Understandably, Orthodox find it fitting that acculturation to America should occur in purely Orthodox terms. For although Orthodox thought is a champion of dialogic consciousness, dialogue demands conviction, and the foundation of conviction is the firm bedrock of a secure identity. Relativism and the general dissipation of theological distinction in the interests of a fervent "American

2. Haskell, "American Civil Religion: A History," *Concern* 9 (Summer 1974): 9.

Christianity," however, threaten Orthodox identity. The Orthodox fear that civil religion will level the voices of all speakers to but one dull monotone. In order to plant their cross on this soil and survive, Orthodox of all ethnic origins must raise their own distinct voice above the level of general Christian sentiment.

A Captive Church

In one way or another, all Orthodox in the United States confront the national theological legacy of the "new Manicheism," the theological sundering of the world into two moral-national camps. Orthodox Slavs in particular bear in their divisions and past struggles the wounds of American civil battles. If we examine a few neglected corners of "Russian" Orthodox history in the United States, we can see how the Orthodox Church here suffered in an odd synchrony with the Orthodox Church abroad. The suffering of the Orthodox Church in America, of course, is of a different order, but its genesis is similar. In the United States as well as in the USSR, Orthodoxy can be the captive of political categories. And those categories ultimately affect Christians of all traditions.

Since the Russian Revolution in 1917, American Christians have regarded the Christians in the USSR as a "captive church." With justifiable outrage and horror, Americans have responded, often in the best way they knew how, to Stalinist persecution and post-Stalinist abuses of state power over the church. Orthodox Christians in America—many of them Ukrainian, Romanian, and of other East European extraction—have also taken part in a "captive nations" movement that protests Soviet domination of their native homelands.

The assembled emigrés in the United States, however, constitute a political entity among themselves. Immigrants to the United States, much as they love their lands of origin, inevitably become creatures of the political order in this country. American politics as well as the politics of the homeland define them and shape them. Domestic American issues as well as those issues that prevail abroad help to form the very iden-

tity of those Orthodox Christians for whom communal identity is so precious. Often the Orthodox in the United States find that political categories, both domestic and foreign, prevail over those that bind them in unity as a church.

Even those who champion Christians "held captive by communism" or who seek to raise the voice of "captive nations" can find themselves held captive by categories that exist outside the church. Inevitably, this occurs whenever the forces of hatred and isolation prevail over those of love and dialogic engagement. Hatred of the enemy—namely, the Russian enemy—has been the strongest historic force to mute the voice of the Orthodox in the United States and to hinder their Christian witness. It is this hatred that has obscured the rich resources of modern Orthodox thought.

The history of what is sometimes called "the Russian Orthodox Church" in the United States is a complex one, filled with the same tortuous divisions and unending mitosis that affects most church bodies in America. It is not the place of this study to develop that history.[3] Yet some aspects of Orthodox history in the United States can challenge popular misconceptions about the Orthodox in America. After all, in Russia or Greece or Romania, the national identity of the Orthodox is self-evident. It is in this country that this identity becomes problematic; through it those Orthodox who either defined themselves as "Russian" or defined themselves in opposition to Russia came to terms with their new American home.

Today Americans are surprised to learn that most of those known as "Russian" Orthodox in the United States are not precisely Russian in ethnic origin. They came from the Carpathian regions of the Austro-Hungarian empire, an area that today is divided among Czechoslovakia, Poland, and the Ukrainian republic of the USSR. The inhabitants of *Karpatska Rus'*, or "Carpathian Russia," were among the most western of peoples who had adopted Byzantine forms of Christianity.

3. Such a history, written from the standpoint of the Orthodox Church in America, is available in *Orthodox America, 1794-1976: Development of the Orthodox Church in America*, general ed. Constance J. Tarasar (Syosset, N.Y.: Orthodox Church in America, 1975).

When they arrived here, the majority of them were actually in communion with Rome as "Eastern rite Catholics." Although they were Orthodox in ritual and custom, long ago Catholic monarchs had placed them under the ecclesiastical jurisdiction of the papacy.

These immigrants were the foundation of what became known as the "Russian Orthodox" community in America. Father Lawrence Barriger, an ethnic and religious historian, explains that even the name of these people became a matter of bewildering controversy:

> The Carpatho-Russian people did not possess a sense of national identity since they never had their own country, but were a subject people. The confusion over their name illustrates this. In America Carpatho-Russians referred to themselves as "Carpatho-Russians," "Uhro-Russians," "Uhro-Rusyns" ("Uhro" meaning "Hungarian," that is, "from Hungary"), "Carpatho-Rusyns," "Rusyns," "Russians," and the Vatican insisted on calling them "Ruthenians"—a term which many found onerous.[4]

The identification of these people as "Russian Orthodox" laity is a matter first of ethnic politics. Had they come to the United States a generation later, many of them might have become defined by others as "Ukrainian" or "Czech," in terms of their region of origin. Yet they came merely as Slavic peasants emigrating from a land ruled by an alien bureaucracy. A good many of them, in fact, saw the Russian czars as champions of the Slavs. They came to America, a country without any religious structures to receive them. Although they had an Orthodox mind-set and observed Orthodox ritual, they were placed under the jurisdiction of Irish bishops who had little sympathy for their customs. (Their married clergy, for example, sometimes scandalized their celibate Roman counterparts.) Motivated by a desire to return to Orthodox roots, the charismatic priest Alexis Toth in Minneapolis led his people in a movement to be received as "Orthodox." He peti-

4. Barriger, *Good Victory: Metropolitan Orestes Chornock and the American Carpatho-Russian Orthodox Greek Catholic Diocese* (Brookline, Mass.: Holy Cross Orthodox Press, 1985), p. 125.

tioned the somewhat startled Russian bishops in the United States—bishops whose task was to administer the religious vestiges of Russian rule in Alaska and the American Northwest—to take him into the fold of Orthodoxy.[5] Thus, in ethnic terms, the "Russian" Orthodox in the United States were adopted children.

Father Toth's movement grew. Duly received and welcomed by the czarist Orthodox hierarchy, the parishes were composed largely of workers in the urban East and miners in the anthracite region of Pennsylvania. Their adopted "Russian" identity, then—which would draw much political attention over the next generations—emerged in the light of their desire to express their Christian faith in their own Orthodox way. In the ritual of their fraternal organization, the Federated Russian Orthodox Clubs, initiates felt both the pride and the anxiety of these laboring immigrants, a minority both in the empire from which they had come and in the country to which they had immigrated. The ritual warns, "For centuries, some of our Russian people have been ruled by foreign conquerors, but have continued to call themselves Russians, to speak the language and to follow Russian traditions."[6] Unfortunately, the initiates developed a Russian identity just in time to face the consequences of the "Red scares" that swept America in spasms after 1917. Many of these people were involved in union activity in response to the exploitation of their labor, and after the Russian Revolution they often felt the effects of anti-Bolshevism. These suspicions of Communist sympathies were so prevalent that a 1922 study focusing on them was entitled *Bolsheviks or Brothers?*[7]

A Russian identity, then, was the outgrowth of the re-

5. See Keith Dyrud, "The Establishment of the Greek Catholic Rite in America as a Competitor to Orthodoxy," in *The Other Catholics*, ed. Keith Dyrud, Michael Novak, and Rudolph J. Vecoli (New York: Arno Press, 1978).

6. "Federated Russian Orthodox Club Initiation Ritual," unpublished paper, p. 5. Available in the Immigration History Archives of the University of Minnesota.

7. Jerome Davis, *The Russians and Ruthenians in America: Bolsheviks or Brothers?* (New York: George Doran, 1922).

ligious and ethnic independence declared by these "Rusyn" people. Nor was the transition an easy one. Some of the Carpatho-Russian immigrants remained under the jurisdiction of the Vatican, which after Father Toth's defection had granted these Eastern rite Catholics a kind of autonomy. Eventually the constraints that Rome imposed on this community—including an enforced celibacy for clergy, contrary to Eastern Christian practice—produced a second wave of repatriation to Orthodoxy. This new movement, under the direction of Father Orestes Chornock, was received by the ecumenical patriarch in Constantinople in 1938. The fact that it was received as a separate Carpatho-Russian jurisdiction, under the principle of submission "neither to Rome nor to Moscow," proved that a shift in identity had occurred.[8] Russian hierarchs, in suppressing the customs and manner of communal chant favored by these "Rusyns," had alienated some of the people who had once been drawn to them.

This pattern of loyalty to a firmly controlling Rome on the one hand or repatriation to a more diverse Orthodoxy on the other hand made this ethnically similar community into a cornucopia of religious loyalties. To this day, in many a coal town of Pennsylvania, competing sets of onion domes and three-bar crosses preside over two or three churches, each of them proudly claiming its own separate street corner. And on a Sunday morning the same extended family, whose ancestors in Europe lived within shouting distance of each other, can separate to attend liturgies in a host of churches, churches whose cornerstones read—in Latin or Cyrillic script or in various combinations thereof—"Russian Orthodox," "Greek Catholic," "Carpatho-Russian," "Byzantine Catholic," or even "Ukrainian Catholic" or "Ukrainian Orthodox."

By the end of World War II, then, a new set of competing identities had asserted themselves over essentially the same people. And one group of them, by virtue of their earlier return to Orthodoxy, had adopted the designation of "Russian Orthodox." By 1945 the children and grandchildren

8. For a complete history of the Carpatho-Russian Orthodox diocese, see Barriger, *Good Victory*.

of those whom Father Toth had led into the Orthodox Church constituted the heart of the Russian Orthodox laity. American-born and English-speaking, these people had seen the Depression and watched their parents struggle for fair working conditions. Politically astute, largely New Deal Democrats with working-class sympathies, many of them had served as soldiers in World War II. The American military often chose from among them for translators to aid in the U.S. alliance with the Russians during the war, and these men on duty in Russia sent letters home, some of them printed in the Orthodox press, lauding Russian sacrifices in the war effort and reporting crowded churches and moving liturgies.[9] Stalin had re-established the patriarchate of Moscow in order to gain support for his war effort. Many Slavic Orthodox laity in the United States responded favorably to this move. An Orthodox editorial anticipated that this restoration might end divisions among Orthodox in the United States: after all, it had been the Revolution of 1917 that had confused canonical authority among Orthodox in North America.[10]

The Russian Orthodox press in America developed a positive attitude toward the Soviet Union. (Remember that these Americans were the children of Slavs who had seen Russia as their potential liberator from an Austro-Hungarian bureaucracy.) Returning veterans even welcomed Soviet absorption of the lands from which their parents and grandparents had come. On the very brink of McCarthyism, John Reshetar, Jr., wrote, "After a thousand years of life under foreign rule, the Region was reunited with the *rodina* or birthland."[11] (As anti-communism swept America with the zeal of

9. See, for example, Major Oleg Pentuhoff, "A Visit to Russia," *Russian Orthodox Journal* 18 (June 1944). Pentuhoff wrote, "Best of all, we saw what made Soviet Russia tick: without a doubt, it's the indomitable spirit of the people" (p. 7).

10. Unsigned editorial, *Russian Orthodox Journal* 18 (June 1944): 18.

11. Reshetar, "Recent Developments in Soviet Transcarpathia," *Russian Orthodox Journal* 20 (Mar. 1947): 8, 28. Reshetar's response to charges against him appears in *Russian Orthodox Journal* 21 (July 1947): 3, 30.

a new Crusade, many an Orthodox layperson would live to regret words uttered in those first years after the war.)

This was the atmosphere of optimism that prevailed when the Cleveland Sobor ("Sobor" is the term Slavs give to national church councils) met in 1946. The laity of this council still wanted a church independent of foreign control, yet they also wanted a reconciliation with the long-estranged Russian patriarch as a "spiritual leader." They mandated negotiations with the Orthodox Church in Moscow for such an arrangement. The hierarchy, in large part "great Russian" and emigré in its sympathies, opposed such a reconciliation. And the other ethnic Orthodox churches in the United States, by now enjoying secure ties to their own home territories, understandably stood clear of a move that could only involve them in further turmoil.

Thus the Cleveland Sobor, with its overtures toward Moscow, ended just as the cold war began. And the cold war began before any real negotiations had been initiated. At this time Americans barely knew who the Orthodox abroad were, let alone the ones in their very midst. McCarthyism, then, hardly aimed its main thrusts at the Orthodox Church in America. Yet its barbs wounded that church very deeply. When, in 1947, Archbishop Gregory arrived in the United States at the invitation of the Orthodox Sobor in America, he announced that he wished to "unite spiritually" the faithful in the United States with the Orthodox Church in Russia.[12] American Orthodox thus saw a new role for themselves. In the atmosphere of suspicion growing after World War II, they hoped that they would constitute a link of understanding between America and Russia. Ironically, the very first attacks against these Orthodox came not through civil politicians but through Christian leaders in the United States. The real issues, of course, were complex. Yet Christians drew on a full reservoir of very simple, undiluted hostility against the Russians.

A man whose name is familiar to many Americans

12. See "Archbishop Gregory to Seek Unity of American Groups with Church in Moscow," *New York Times*, 18 July 1947, p. 22, col. 7.

headed the list of attackers. A then "up-and-coming" monsignor in the Roman Catholic Church, Fulton J. Sheen, led the campaign against the Russian archbishop Gregory. Accusing the patriarchal ambassador of being "a professor of atheism at an atheistic college," the soon-to-be-bishop Sheen began a career full of offenses against the Orthodox community in the United States. The "atheistic college" of which he spoke, after all, was the Theological Academy in Leningrad, the very existence of which was a hard-won concession from the civil authorities then in power. When Sheen claimed that the Russian bishop's mission was "to win over the Russian Orthodox Church in the U.S. for Stalin,"[13] he appealed to popular sentiment, but he hardly did justice to the Orthodox laity who had invited Gregory here. Fulton Sheen, then, awakened the hostilities of an Orthodox community only recently estranged from the "Eastern rite" of Catholicism. And corresponding Catholic outrage over the spreading Soviet domination in Eastern Europe spilled over into church relations in the United States. Thus the first stirrings of McCarthyism were treated in the Orthodox press as a specifically Catholic, "Vatican-inspired" phenomenon.[14]

The Christian Cold War

As the cold war deepened, however, the hostility toward an Orthodox reconciliation with the patriarch proved to be much broader than that of Bishop Sheen and the Catholic press he charmed. The leadership within the Orthodox Church itself began to change in orientation. A postwar flood of immigrants—intellectuals and former "imperial Russians" from Paris as well as ethnically Russian war refugees from displaced-person camps—took a role in directing church affairs. Hierarchical appointments in the seminary and the bishopric

13. Sheen, *Russian Orthodox Journal* 21 (July 1947): 15.
14. See "A Prophet of the New Atomic Age," *Russian Orthodox Journal* 20 (Oct. 1946): 15; and *Russian Orthodox Journal* 21 (July 1947): 7.

favored these European newcomers to the American scene. This caused a peculiar configuration among Orthodox Americans, one possible only in the midst of a cold war. For it was these newcomers, responding to the anti-Communist trend in America, who led an "Americanizing" movement against a reconciliation with Russia. In contrast, the American-born inheritors of Father Toth's "return to Orthodoxy" now found themselves in the dangerously uncomfortable position of appearing to be apologists for the Soviet Union.

The same tensions afflicted even those Carpatho-Russians who had formed an autonomous diocese under the Greek patriarch in Constantinople. Although in 1938 they had deliberately rejected affiliation with both Moscow and Rome, some members of the diocese felt a rekindling of their pro-Russian feelings during World War II. Father Stephen Varzaly, editor of the diocesan newspaper *Vistnik,* adopted a stance sympathetic to Stalin in the early 1940s. In the closing days of the war, he urged Bishop Orestes Chornock to accept a diocesan reconciliation with Moscow. When the bishop refused, Father Varzaly led an acrimonious schism of parishes affiliating themselves with the Russian patriarch. Thereafter the younger laity of the diocese, fearing the political effects of Father Varzaly's schism and his increasingly pro-Soviet stance, openly declared their American identity. In reaction to the "Russophiles" they changed the name of their organization to *"American* Carpatho-Russian Youth." Significantly, they also expanded the role of the group to promote not only the Orthodox faith but also "true Americanism, loyalty and allegiance to the government of the United States of America."[15] This accommodation to the civil climate prefigured what would happen in the larger Slavic Orthodox community.

The priests and laity in the "Russian Orthodox" community who supported an ecclesiastical union with Moscow felt themselves pressed on all sides. They faced both the postwar refugees and an anti-Soviet climate so fierce that it evoked genuine fear. They responded, however, with vigorous argu-

15. Barriger, *Good Victory,* p. 143. For a history of the "Varzaly schism," see Chapter 6, "A House Divided," pp. 135-49.

ment. Reflecting their political heritage as champions of the working-class "common man," they emphasized the elitist identity of the new "great Russian" immigrants. Some even proposed establishing a Christian political-action committee to combat McCarthyism. One priest announced, "The time has come for all people to . . . establish God's kingdom and His rule amidst the injustices and unfairness of those of property and privilege, so that true worth of the individual may be established and not be judged by wealth and social status."[16] Given the climate of 1946, such explicit pronouncements on behalf of social justice would soon become unwise. Within the year, such sentiments would be confined to full-page (and anonymous) ads in the Orthodox press "to promote reconciliation and peace" between the United States and the USSR.[17]

The popular American press, of course, came out strongly in favor of the newer immigrants' anti-Communist and (in the case of those who identified with the Ukrainian community) anti-Russian position. *Reader's Digest, Time, Newsweek,* and other popular magazines were hardly theological journals, yet they were widely visible. Long indifferent to Orthodoxy, these publications suddenly involved themselves in the politics of the Orthodox Church. And they did not hesitate to join the religious press in making pronouncements—often inaccurate ones—on religious matters. Thus the *Christian Herald* virtually ignored the Orthodox in Russia in its focus on "Christianity and communism," and the *Digest* claimed that Orthodox objections to the sensationalist film *The Iron Curtain* were fomented by "Soviet agents."[18] In reverse of previous patterns of ethnic history, it was not the recent Russian-born or Ukrainian-born immigrants whose loyalty was being questioned. Rather, the American-born laity—many of whom were World War II veterans and all of whom had sponsored the postwar immigration—were the ones whose loyalty to their

16. Vladimir Lilikovich, "For a Better World," *Russian Orthodox Journal* 20 (Dec. 1946): 6.

17. See, for example, *Russian Orthodox Journal* 21 (Aug. 1947): 5.

18. Citations and responses can be found in *Russian Orthodox Journal* 21 (Oct. 1947): 25.

own country was questioned. Ironically, monarchist Russians found instant acceptance in this land of rebellion against a monarch, while the populist, New Deal "Hunkies" (as the ethnic Carpatho-Russians were often called) were deemed to be "soft on communism."

These American-born laypeople came to their own defense. In an open statement they noted that their condemnation of communism as ideology had been long-standing, and they accused the new refugees of condescension, of an "arrogant attitude."[19] Two brothers, Peter and Paul Fekula, were emblematic of the Orthodox laity who fought off charges of pro-Communist sympathies, and who continued to argue even in that era for an "arms compromise" between the United States and the USSR. They repudiated the accusations of "fellow traveler" that had been leveled against them. In fact, Peter Fekula ridiculed the "Russian experts" in the State Department and chafed against the "cloak-and-dagger" role of the mere intelligence functionaries in which Russian-speaking American Slavs were so often placed. In the midst of the McCarthy years, he felt strongly that the Slavic Orthodox in America should offer themselves as a channel to understanding the Russian mind. The Fekulas claimed, in fact, that the recent emigrés, with their lack of American political experience, would soon find themselves "used."[20]

Clearly, however, in the competition for national attention, the American-born Orthodox were outplayed. In the McCarthy turmoil Russian church hierarchs saw an opportunity to wrest control of the church structure from an increasingly aggressive laity. Further, the McCarthyism so prevalent in the Christian community gave the foreign-born Orthodox instant access to popular notice. Whereas the working-class, immigrant "Hunkies" had been largely neglected by their fellow Americans, the atmosphere of strife between the United States and the USSR had won a new attention for recent im-

19. Paul Fekula, "An Open Letter to His Eminence, Metropolitan Leonty," *Russian Orthodox Journal* 24 (Jan. 1951): 12.

20. For the text of a committee report and speech by Peter Fekula, see *Russian Orthodox Journal* 26 (Oct. 1952): 21-24.

migrants from the Continent. Leaders in the Orthodox Church used the American press to confirm their own anti-Communist credentials and to chasten those laity who had opposed them.

Ukrainian nationalists had long sought a separate national identity and a separate ecclesiastical structure from the Russian Orthodox domination that had been imposed upon them for centuries. The new postwar immigration strengthened their numbers and their influence within both the "Eastern rite Catholic" Church loyal to Rome and the various Ukrainian Orthodox jurisdictions that had arisen in the New World. These Ukrainians were closely related to the Carpatho-Russian laity; in fact, they were ethnically closer to this group than the "great Russians" themselves. Thus, in a development possible in American ethnic politics, some of the ethnic nephews and nieces of those who had formed the "Russian Orthodox Church" in the United States now became champions of a "Ukrainian Orthodox Church." This Ukrainian movement, which aligned itself with the suffering of those Ukrainians who had been oppressed and starved under Stalin, saw its Orthodoxy as an expression of a legitimate national identity. Adherents wanted nothing to do with anything "Russian." Ukrainian Orthodoxy had its own history in the United States and Canada, and a constituency reinforced by the new wave of postwar refugees from central Ukraine. Assisted by the American civil hostility to the USSR, they succeeded in winning widespread publicity and support in the United States.

The Russian emigrés chose hospitable parishes among the "Russian" jurisdictions available to them. From them the American public received a new genre of stirring "captivity narratives" describing suffering under the Bolsheviks, and they became the expression of a "non-Communist" or "anti-Communist" Russian identity. By 1950 people from this group had already acquired positions of authority at the seminary and in the hierarchy. They had impressive academic credentials, which allowed American academies to award them prestigious appointments. The American press responded to them, and the "Voice of America" employed them to broad-

cast sermons, lectures, and news of the immigrant communi-
ty to the Soviet Union.[21] And they entered, in large numbers,
the newly burgeoning intelligence community of the Ameri-
can government.

It is true, of course, that without these emigrés, the Or-
thodox community in the United States would have lost a
great resource. The great scholars of this tradition in the
West—Alexander Schmemann, Georges Florovsky, Vladimir
Lossky, and most recently John Meyendorff—emerged from
this group and gave the Orthodox visibility and voice. But the
story of those laity who shouldered the burden of the Or-
thodox Church in this country, and who themselves had their
own hopes for the future of the church—this story has long
been obscured, lost in the glare of Soviet-American hostili-
ties. After all, the emigré intellectuals had a Continental rather
than a Soviet past. The already-American laity, however, had
their roots in the coal fields of Pennsylvania and the gritty
ethnic neighborhoods of the Northeast. They well knew the
difficulties of living as Orthodox in the United States. Unfor-
tunately, their voices were seldom heard.

Fear, as a matter of fact, moved many of these laity to
eventual silence. And one cannot blame them. Earlier, their
elders who had become involved in union organization
frequently found themselves tagged with the "Bolshevik"
label. And now their fellow Christians, even their fellow Or-
thodox, were accusing them of Communist affinities. I inter-
viewed the son of a priest who served a Pennsylvania parish
that remained under the authority of the Moscow patriar-
chate through the McCarthy era. He reported a meeting, late
at night, between his father and an Orthodox friend who was
also a priest but affiliated with a group that opposed patri-
archal authority. "You'd better rethink your position," said
the friend. "You know what happened to the Japanese during
the war? You'll end up with your family in some camp in
Oklahoma."

This may not seem so unthinkable a threat when we re-
alize that the leader of the largest Russian Orthodox group in

21. See *The Orthodox Herald* 1 (Oct. 1952): 3.

the United States was making charges of "subversion" against his co-religionists. Camps, after all, were within the immediate memory of many recent refugees. And very disturbing rumblings were emerging from the most unusual of sources. On the floor of Congress in September 1950, Senator Hubert Humphrey called for "an emergency interim detention system," an idea that could easily have frightened those who, in the thirties, had seen even relatives deported for union activity. "We would pick up the . . . dangerous Communists and put them in internment camps, and protect the safety of the country at once," said Humphrey. "I want them removed from the normal scene of American life and taken into custody."

It may seem extraordinary that those who were Christian should allow themselves to be intimidated by a matter of church politics just a generation ago. Yet the state, not the church, is the sower of such fear, and it stands ready, in any generation, to exploit factions within the church as well as within its own body. The civil press and popular American religion were heavily involved in the anti-Communist and, by extension, "anti-patriarchal" campaign. The press routinely— as it occasionally does now—identified press releases, publications, and pronouncements of the Russian Orthodox Church as "Communist-inspired" and "Kremlin-directed." Even superpowers became involved in parish politics.

In the kind of scandal that still occasionally disfigures the Orthodox Church in America, one faction in a parish, styling itself as "anti-Communist," would attempt to take advantage of the political climate in order to gain control of church property. In the fifties, the popular press and politicians became involved in these disputes. There were many parish suits in civil court in which congregations loyal to ecclesiastical authority in Eastern Europe had to fight the claims of those who championed themselves as "anti-Communist" Orthodox. A case attracting national attention was the complex case of St. Nicholas Cathedral in New York.

The state of New York, in passing a law to remove Communist influences in the Russian Orthodox churches in the state, had prepared the ground for a press carnival. The law evicted Archbishop Benjamin, a Russian patriarchal ap-

pointee, from his seat in the cathedral, granting tenancy in-
stead to the larger "Metropolia"—a jurisdiction separated
from Moscow. Although the Supreme Court eventually over-
turned the eviction, popular attention to the case reflected the
published minority opinion: any church canonically loyal to
Moscow was "a foreign and unfriendly state masquerading as
a spiritual institution."[22] What the state of New York could not
enforce, the State Department did. The State Department
voided the visa of the next bishop who arrived from Moscow,
Bishop Boris. The rationale for this action, like that for so many
others, was political: it was presumed to be Bishop Boris's in-
tention, as a representative of a "foreign and hostile power,"
to head and subvert an American church organization. Effec-
tively deported, Boris flew home. In retaliation, the Soviets
expelled an American Catholic priest from the USSR.

Many of the wounds of the era have healed. The patri-
arch granted the "American Orthodox Church" its full canoni-
cal independence in 1970 (though some critics have seen even
this permission as "Communist inspired"). Yet to this day the
Orthodox Americans of that era and those who followed them
have a clear awareness of what a dominant "civil religion" is
capable of doing in America.

Although Americans choose Russia as illustrating one
of their greatest fears—that church should become subject to
state—American Christians too can confuse loyalty to God
with loyalty to the state. Both Russia and America have been
guilty, each in its own way, of blurring the distinction. It is
the task of those Americans "caught between"—those who
find themselves spiritually linked to one nation and at the
same time bound by ties of love and kinship to another—to
offer perspective on the issue. Orthodox Christian Americans
have been rejected and repudiated by their fellow Christians
not on the grounds of their doctrine but on the grounds of

22. Case 344 U.S. 94 (1952), pp. 109ff. See "The Case of the St.
Nicholas Cathedral in New York," *Harvard Law Review*, repr. *Edinii
Tserkov* 9 (Oct. 1955): 17-19. The quotation is from the text of the minor-
ity opinion, Robert H. Jackson, *New York Times*, 25 Nov. 1952, p. 31,
col. 8.

their spiritual association with ecclesiastical authority in Russia. American to the core, they are at the same time informed and nurtured by the lessons of the Russian soul.

This is not, of course, to deny the legitimate grievances of so many Orthodox, and certainly of so many "Eastern rite" Ukrainian Catholics, against policies that have oppressed them. The Russian civil authorities, in both czarist and Soviet times, have used the church as an extension of state policy. The Orthodox churches in their home territory have also endured an unacceptable degree of government regulation and influence. It would be unthinkable, certainly, to import that kind of influence to America. But it is important to realize the extent to which the climate of American civil religion and the neo-Manicheism of its hostility to Russia have helped to mute the Orthodox voice in the United States. "Ukrainian Orthodox" and "Russian Orthodox," sometimes originating from the same ethnic group, are unable to meet long enough to voice their common theology. Romanians, Serbs, and others divide and subdivide into jurisdictions defined by their distance from a hierarch in a Communist-dominated nation. Greeks, happily removed from the issue, are not anxious to become involved in it. Nor have they helped to remedy the situation. In a position to provide their own viable model of Orthodox unity, the Greek Orthodox have been too absorbed in their own ethnicity to do so. And American Christians, understandably enough, cannot make sense of the mess they confront in us. Nor will the mess be resolved until we can put aside Russia's politics and listen to the voice of her church.

The Enemy Within

American "assimilation" makes great demands of those who come here. Our popular press and civic lore emphasize the economic successes, in particular, of each wave of immigrants. But a price is paid. Studies of immigration in the United States again and again reveal the alienation in the first generation, the divided loyalties of the second, and the conflicts to be resolved in the third. Martin Marty and other scholars have

documented the centrality of the "ethnic" experience in American religion; Scotch Presbyterians, Dutch Reformed, and German Lutherans can all empathize with the conflicts of American Orthodox by finding similar patterns embedded in their own history. What other traditions do not share, however, is the continual stress of conflict, now spanning generations, between the land of birth and the land of ancestry. For America has lived at psychic war with the Soviet Union from the earliest days of the USSR's existence.

The "wartime ethic" that sporadically dominates America's relationship to Russia has itself become one of the hallmarks of American religious identity. In the current political climate and the search for a Christian political ethos, the issue of our mutual hostility becomes even more acute. Now that the Soviet Union and the United States once more seek to define a temporary truce in search of an arms accord, no doubt the "evil empire" speeches will once more seem confined to the pulpit. The media will center its attention on Pat Robertson, Jerry Falwell, and other overtly Christian figures as examples of the "ethos of war." In truth, however, virtually all politicians can call upon that reservoir of hostility and evoke it in terms of Christian zeal. Politicians and preachers both, when they wish to tap the well of common national purpose, evoke the apocalyptic scriptural images. They thereby suggest—and sometimes actually depict—a "final battle" between Russia and the United States.

In an American context, such images of Russia are so usual that we expect them. Even those many Christians who do not believe such images come to take them for granted. But when Christians abroad call these images to our attention, their startling character emerges. I recently interviewed, for example, the now retired Orthodox primate of Finland, Archbishop Paul. Frail yet alight with a quiet humor, the archbishop is one of the last surviving monks of Old Valamo. He entered the ancient Russian monastic center as a Finnish novice early in this century. The monastery was trapped in the Russo-Finnish War, and he returned as a refugee to his native Finland in the winter of 1939-1940. From Finnish Karelia he saw his homeland appropriated by the Soviet Union, and

he is of a nation that has in its history repeatedly fought bit-
ter, bloody wars with the Russian enemy who haunts Amer-
ican fears. Yet he is astonished at our own national and Chris-
tian paranoia about the USSR.

Leaning over his desk and peering at me intently, he
asked me a question. "I have heard that there are Christians
in America who interpret the Bible in such a way that they
see the last battle on earth, the Armageddon, being fought be-
tween Russia and the United States. Is this true?"

I explained that such Christians existed, but that the
European press perhaps exaggerated their numbers. Yet his
smile told me that he knew what was widely reported in
Europe: that President Reagan once commented in a prayer-
breakfast speech that such an idea "made a lot of sense."

The archbishop paused for a moment, and the smile
faded. He then spoke with great seriousness, and with all the
authority of a bishop: "What a terrible, tragic misuse of Scrip-
ture! It is contrary to the very Spirit of the church." He then
changed the tone of his voice and spoke as a single Finn: "I
am not a political specialist, but in these days it seems to me
and to many Finns that in recent times the USSR has been
more active in promoting policies leading to peace. The USA
seems to follow after—but why so reluctantly?"

This is a man who, as a young monk, took the few icons
and supplies he and his brothers could gather, loaded them
on sleds, and pulled them across the ice to the Finnish border.
This is a Finn who, as he fled, passed the frozen bodies of his
countrymen, their icy blood spilled like rubies in the snow,
victims of a war against the Russians. This is a bishop who,
with all the authority of his church, condemns the apocalyptic
imagery with which some American Christians bless their fear
of their enemy.

Archbishop Paul, despite his indignant passion, cannot
fully realize the grip those apocalyptic images have on the
American soul. For in a pluralist society that shares few sym-
bols, American Christians often rely upon those few civic sym-
bols that bind them to the secular culture rather than those
troubling theological symbols that set them apart. When the
need to build a quick consensus arises, politicians can easily

appeal to that one image that identifies a common foe, a common enemy both civil and religious: godless communism. Russia. The beast. And in that agreement they not only satisfy the civic demands of identity but draw upon a common source of biblical imagery as well. The "state of war" between the two nations is thus reinforced and perpetuated; opposition to this common enemy becomes a condition of one's Christianity, one's national identity, and, if need be, one's admission to the United States. Periods of detente have been temporary because a symbolic state of war is our natural condition. American civil theology insures continuation of the cycle.

Russia thus becomes, in effect, more than what she is. When Christians neglect the Uncreated Light of Christ in favor of the lamps of civic virtue, then the power of darkness spreads through the Christian mind. Russia, once she is identified as God's archetypal enemy, seems to grow ever stronger, ever more threatening. Demonology outstrips Christology, and devils romp where angels no longer tread. Those who have half-forgotten their disagreements on dogma can seize upon their common outrage against those Communists who resist all religious dogma. In the first chapter of this book we explored the long tradition behind this ritual exorcism of the heathen, this self-perpetuating state of war between the forces of God and those of his enemy. The captivity narratives of the Puritans, in their delineation of the primal war between the Christians and the heathens, the settlers and the Indians, use an alliance of religious and national symbolism in their portrayal of the enemy.

The Indian has created for us a resilient paradigm both religious and secular, an icon of "the enemy within." Like the Puritan narrator Mary Rowlandson, Christian Americans can be assured of their own election as a nation when they focus upon the enemy. Like Mary Rowlandson, an American Christian can blur the distinction between cultural identity and Christian commitment, assuming that the mind of "the other" harbors a depravity not present in one's own. The Indians, after all, provided us with our first argument against "moral equivalency." American Christians drove the Indians from their midst, **pagan and Christian** alike, with a confidence that

the Indians were in essence unredeemed. The gnawing doubts, which emerge even in Mary Rowlandson's almost reluctant humanization of the Indians who had shown her some kindness, needed to be quelled. Her way of thinking in effect denied the enemy a "real existence." The enemy existed merely in counterpoint to the nation of the elect.

It is as adversaries in the war between good and evil—or, if you will, as the "forces of freedom" pitted against the "forces of totalitarianism"—that American Christians frequently characterize Americans and Russians. I find the most startling misinformation about the Russians routine in my local community. "They don't have Christians over there," confidently asserts my barber. "All the churches are closed." "All their priests belong to the KGB," claims a neighbor. When a few of those priests visited my home as a part of a visit to the United States, I thought it would be a great idea to take them on a stroll through my typical American neighborhood. We were greeted with self-styled "Christian" demonstrators and harassed with Scripture quotations via a bullhorn. The Russians have become our moral exiles, the demons in our postmodern captivity narrative. Russia has become our appointed moral inversion, and Russia's evil is necessary to prove our own good. Thus we are surely as much creatures of the hammer and sickle we fear as of the red, white, and blue we love. "Belief in Russia," as demon, as depraved, has become a central dogma in the American civil creed.

Even in our sins, we Americans mirror those whom we fear. Just as we have succumbed to a "civil cult" because we have so few Christian images that bind us as a people, so the Russians have great difficulty in extricating themselves from a "civil cult" because they have so many Christian symbols that bind them to their nation. The czars nurtured a Byzantine religious symbolism that saw kingly authority as a reflection of the divine. The heritage of that symbolism is still strong in the USSR today. Those czars and national leaders who brought Russia to national unity still retain a religious aura. For example, Alexander Nevsky, who defended Russia against Swedish invasion, was revered as a saint in the Orthodox Church. He is also, to this day, celebrated as a civic hero. In

a modern composition on Nevsky hanging in the Tretyakov Gallery in Moscow, the Soviet artist borrows from the triptych style of icons to portray the Russian state. In the great film on Alexander Nevsky by the Russian director Eisenstein, the hero is similarly invested with religious symbolism. In one of the scenes of this product of "socialist realism," we see an icon of Christ on a processional banner. It is not a loving Christ; it is the same Christ whom Ivan the Terrible bore into war on a battle standard. It is a severe Christ of threat and warning, his face glowering at any who would dare penetrate the Russian homeland.

The "Christ" of Russian civil-religious art looks sternly upon the prospective invader. While American civil-religious symbolism has been oriented toward the enemy within, the heathen in our midst, the symbolism of Russia has been oriented outward, toward the invader. The Russians have less difficulty than we do in agreeing upon a common store of symbol. Although they are in fact a highly variegated people, their pronouncements and theories about themselves are replete with the assumption of a united identity and a common will. When applied theologically and projected upon one's own people, this assumption can work wonders of loving insight. But applied politically and thrust outward against an enemy, this common identity and will is capable of a hatred that can chill the soul.

I have relied upon a Christian narrative, the captivity narrative of Mary Rowlandson, to provide a glimpse into the darkest niches of American Christian identity. For a corresponding glimpse into the gloomiest corner of the Russian soul, however, we must rely upon an icon, one called *The Miracle of the Icon of Our Lady of the Sign*. Like every Russian icon, it tells a story. Two Russian cities, Novgorod and Suzdal, were once at war. The citizens of Novgorod had an icon of the mother of God that they much revered. Like all icons of the Virgin, this one was an emblem of the special mercy and tenderness that God visits upon his people. Because the people of Novgorod held this icon in special reverence, they carried it before them as a standard when they marched in battle against the soldiers of Suzdal.

As the two armies met, a marksman from Suzdal let fly an arrow. The arrow hit the icon squarely in the eye. The arrow was an assault upon that image which promised, to all the citizens of Novgorod, forgiveness and the embrace of divine love. In divine retribution, so the legend goes, the mother of mercies blinded all the soldiers of Suzdal—and, of course, won the war for Novgorod. Hanging in the museum in Novgorod is an icon portraying this event. There the mother of God, with an arrow emerging like a grotesque horn from her image—an icon within an icon, the image of peace within the maelstrom of war—sends out a blinding light upon all the troops of Suzdal. And there, once wrapped in the embrace of lovingkindness, the Christian soul takes delight in revenge.

Thus Russians, too, can be blinded by a compromise between their civic and religious identity. The soldiers of Suzdal were also Christians. And in the light of the gospel, any enemy is fully invested with humanity. Yet in the moment conveyed by the icon, these soldiers from Suzdal became like the "praying Indians" of Mary Rowlandson, exiled from Christian identity and humanity together by virtue of their role as invaders. By the same token, both Russians and Americans can easily express a loyalty to the state much greater in its power and impact than their loyalty to the gospel or their loyalty to the church.

My point here is not to argue from a pacifist perspective, which I cannot in conscience adopt, though I have tried hard to do so. Rather, my point is to argue that as "reciprocally defined" human beings we have been given an injunction to love—that is, to open ourselves to the other, that we may in some measure be transformed. We have no right to exile the enemy from the human race. And if the enemy also commits himself or herself to Jesus Christ, we are obliged to search in that identity for an avenue to self-abandoning love. Our words and our images must move us now to plead for forgiveness—from each other. When the citizens of Novgorod beg the mother of God to heal the blindness of the soldiers from Suzdal, then will the icon heal itself. When Mary Rowlandson sees in the Indians an image of herself and her God,

when Americans look to Russians and Russians to Americans for a reflection of their own humanity, then will the image of God within us be restored.

"He Who Lives by the Sword"

I know a fine Baptist family in Kiev. They have four strapping, healthy sons. They all attend prayer services—long ones—twice a week. The older boys sing in the choir and have a circle of Christian friends. The family prays together and is bound to each other with all the spiritual warmth of a family who lives in the presence of God. They read the Bible daily. At table in their home, they radiate a devotion and an uncompromising commitment to God that permeates them all and binds them as one. They are a portrait of the Christian family that any Southern Baptist would enthusiastically endorse.

At the time I wrote this, the oldest son was entering the Soviet army. When I told him that I knew of Baptists in the States who would regard his service in the Russian army as a tragic enslavement, he was incredulous. "It's a duty. Of course I serve my country; I love my country, and it has provided me with many benefits. You must tell them not to think that the gospel reigns only in their own land." I know a good, pious Orthodox boy who crosses himself with the stump of an arm. He lost his hand to a landmine—which we Americans, no doubt, supplied to the Afghan resistance. Fine Christian boys died in Vietnam, dazed by the ambiguities into which their countrymen had thrust them. Fine Christian boys, wearing Soviet uniforms, also died in Afghanistan.

President Reagan's inopportune statements about Russia and its evils have of course received wide publicity in the Soviet Union itself. When Pat Robertson or other Christian spokespeople make similar statements, they most assuredly find their way into the conversation of Russian Christians. "Your people don't know us," responded one old Russian lady testily after she emerged from church. "How can they say our country is evil?" She then added, rather chauvinistically, "Are

there any pure Orthodox Christians in America?" Another Russian, a monk, spoke more philosophically. "Your president refers to us as 'the source of evil in the modern world.' His statements prove that he has not meditated very effectively on the problem of evil." I explained that President Reagan had made these statements when he addressed an audience of evangelical Christians, in an effort to gain their support. The monk's response was measured. "I've met few Americans, but I wouldn't want to believe that an entire nation would see us as the source of evil in the world. Surely your Christians can see the theological flaw in his analysis."

Indeed, President Reagan has repented, after a fashion, for that particular remark. And in the twilight of his presidency, he has engaged his Russian counterpart in a direct arms agreement. Our presidents hear from secular Soviet leaders. But presidents hear very little from Russian Christians. I have an open letter to President Reagan given to me in 1984 by a simple priest. It is entitled "It's time to know," and the priest wrote it in a white heat immediately after the president made his much-criticized statement. The priest refers to the suffering Russia endured during World War II. Russia's twenty million dead, of course, encompass the loved ones of the entire nation. The priest accuses the president of making no discernible attempt to know the Russian mind and heart. And he includes a reference to the saint and national hero celebrated even in secular Soviet lore. "Remember the statement made by our great saint, the blessed Alexander Nevsky, when he said, 'He who comes to us with an open hand will receive hospitality and a welcome; but he who comes to us with a sword in his hand will die by the sword.'" The priest perceives a threat in American presidential rhetoric, and he responds in kind. The enemies Russia has known have come as invaders. Russia has never fallen to an invader, says the priest. Let Americans, who know so little of war, beware.

Although one occasionally meets a Russian Christian who will say, in private, that he or she has welcomed the "get tough" policy of the post-Carter years, the clear majority in the Christian community are taken aback by American attitudes toward their nation. On the whole, the Russians are

much better disposed toward us than we are toward them. In fact, I don't think they fully realize the metaphysical role they play in our national mythos. Yet the truth is dawning. In the past several years Russian Christians have become uneasy about their fellow Christians in the United States. Many Russian believers would like to join that Soviet mother who asked me, "Don't your Christian people know all those bombs are pointing at us, and at our church?"

I did, as a matter of fact, relay this question to Cal Thomas—Reverend Falwell's former press secretary for the Moral Majority, and a political writer in his own right—when he spoke at an evangelical round table meeting near Philadelphia. Mr. Thomas dismissed the question with mild annoyance. He observed merely that the intention of the missiles was clearly to protect against the Soviet threat, not to destroy Russian churches. It would be hard, I suspect, for the young Russian mother to understand this distinction so clear to an American Christian lobbyist. Nor would she understand the trust that some fundamentalist Christians place in a "rapture" that would save us from the terrors of the bomb. One Russian, a veteran of World War II, said to me, "We have seen so many horrors. We cannot count on such a rapture to take us out of miseries we create for ourselves." It is true that the peace statements of the Russian church most often reflect the position of the civil leaders. It is also true that they often reflect the heart and mind of the Russian church as well.

Some commentators equate the current Orthodox revival in Russia with an intensely retrogressive, almost mystic nationalism. This is a secular assessment. For the most part, political commentators do not know the nature or the mind of the Russian church. Indeed, the previous chapters overturn their assessment, revealing that in dialogism and "relational identity," the strongest thrust of current Russian Orthodox thought is toward reciprocity and engagement of the other. Yet the church in Russia, too, must beware of national chauvinism. There is in fact a tendency toward a new emphasis on nationalism and nationalist imagery that affects factions in the church as well as conservative secular forces in the Soviet Union. A cautious alliance with Gorbachev and the forces of reform

promises to temper this trend in the church. Nevertheless, the estrangement between Americans and Russians is profound, as deep in the superficial spasms of "détente" as it is in our long interludes of cold war. Just as this estrangement feeds the neo-Manicheism of American "civil theology," it also nurtures the undercurrents of nationalism in Russian Orthodoxy.

This nationalism no longer draws its sustenance from a czarist past. The czars, after all, can no longer strengthen and comfort those in the church who serve the state's will. And anyone who thinks that the Central Committee of the Communist Party would act as the church's patron, or that a KGB agent would endure the discipline of an Orthodox monastic order to infiltrate the church, knows nothing of Orthodoxy or Russia. If there is an isolationism among Russian Christians in a mirror image of the neo-nationalism of conservative Christians in the United States, it builds upon the imagery of World War II, known in Russia as the "Great Patriotic War."

One problem that we American Christians have in understanding Russian Christians is that we tend to assume a total estrangement between them and their atheistic leaders. We accept commentary on Russian "barbarity" in Afghanistan, Russian "untrustworthiness" in observing treaties, and Russian "brutality" in Eastern Europe with the tacit assumption that if there are decent people in Russia, they would surely agree with us. We don't realize that there are indeed many good people— Christians among them—who would argue with our assessment of international affairs. They might even respond with a polite but firm condemnation of our actions in Nicaragua, our clear economic support of South Africa, and our domestic history of repression of people on the left. It would be limiting our God too much to assume that in such a disagreement one or the other of us is utterly without grace. It is crucial for American Christians to realize that Russian Christians operate according to a different set of assumptions about their history. In order to understand the mind of today's Russians, one must look with great care, concern, and sympathy at their interpretation of their recent past.

World War II, for the average American, is a war in which perhaps a relative or two fought, even died. It is a war

in which America came to the assistance of a struggling Europe in order to defeat a moral monster. It is a war that has etched the number "six million" into our consciousness, in honor of the six million Jews so mercilessly slaughtered. Our national imagination has stamped the suffering of that war most fully on the victims of the Holocaust.

For the Russians, however, World War II is a different portrait altogether. It is a war in which virtually every Russian lost a family member, a war that left their nation utterly destitute. Although they are aware of and grateful for the temporary alliance they had with America, they believe that they had to "go it alone" on the Eastern front, and that many of the Western powers tolerated Hitler for so long primarily because he was anti-Soviet. (Until recently the embarrassment of the Stalin-Hitler pact had been tucked away in the national consciousness, sometimes explained as a tactical maneuver to give the USSR time to re-arm.) Russians feel that Western sympathy for their intense suffering is limited, and that only they can fully understand how their nation and their nation alone bore the full fury of the Nazis and ultimately defeated them on their own Russian front. The number "twenty million" is imprinted on the Russian consciousness—twenty million Soviet dead. "May their memory be eternal"—*Vyechnaya pamyat'*—is the oft-repeated liturgical prayer for the dead chanted in the Orthodox Church; the Russian mind still hears the echoes of that refrain.

At Mamayev Hill in Volgograd, the Soviets have built a monument to the martyrs of the war. Russians are a people of the image, and with a supreme sensitivity to the image they have constructed a memorial that carries the pilgrim through a virtual re-enactment of the suffering of the war. The hill cradles a huge domed vault, gilded in mosaic, that commemorates those who gave their lives against an enemy. Capping the hill, which is itself composed in part of the bones of thousands upon thousands of dead in a mass grave, is the statue of Mother Russia. Her sword is raised against the invader. She bends her head back, exhorting her people to continue the struggle. And she leans, robes unfurled, in the perpetual wind sweeping off the Russian steppes.

It is true, as commentators are quick to point out, that Stalin too is responsible for his own share of Russian martyrs. Solzhenitsyn stamped that into our American consciousness, and today in Russia such suggestions are openly heard even in the speeches of Gorbachev himself. Yet to confuse the sacrifice of the war with the immense scandal of Stalin is tantamount to reminding Americans of our virtual genocide of the Indians or our enslavement of the blacks. Americans may recognize the charges as true, but that does not alter their symbolism or their consciousness. The suffering of the Gulag is a national tragedy, a disgrace that many Russians still cannot face; World War II, however, sheds a redemptive light on Russian suffering.

In its hospitality to the image, the Russian church has always taken into itself the mind and the responses of the Russian people. The church has also absorbed much of the symbolism of the war. Priests and hierarchs now celebrate memorials specifically devoted to the dead of the war. In parish churches, on those religious holidays that call for the names of the dead to be written down for commemoration, the slips of paper mount like a blizzard of memories. Such memories, as any veteran of any war can tell you, hurt with a special pain. On these days the people with memories weep, and the church itself acts as a great embrace to comfort them.

On national holidays the priests wear on their cassocks the medals they earned in World War II, which has become incorporated into the religious consciousness of the people. It has become a symbol of all the great suffering of the Russian people in this terrible century, and we must respect that symbol. Images are sacred in Russia, and World War II has left a hallowed imprint. It shows a terrible insensitivity to complain, as some Americans do, that people who live in such unattractive apartment buildings should not lavish so much money on memorials. Even worse is suggesting to Russian believers that, after all, the war is past and they should now let it slip into history. The war is an archetype of their suffering.

Let our relationship to our own Vietnam veterans teach us Americans a lesson. Danger lurks in our ignorance of another's anguish. If we Christians in the West show by our

insensitivity that we do not recognize the mind and heart of the Russian church, Russian Christians will interpret this as a rejection of the gift they have to offer the Christian world— their pain. For Russia views its suffering as redemptive. Suffering has become as much a constituent of their Christian identity as prosperity has become of ours. And we too must learn—just as the Vietnam veteran learned—to make of suffering an expression of love.

The alarming lurchings of the stock market, the erratic dollar and fears of an economy run amok—these threaten the long trust we have placed in prosperity as an emblem of our "one nation under God." Whereas we thank God for the bounty he has showered upon us, we also harbor in our hearts an anxiety that it may be snatched away. Russian Christians have endured war and suffering. Ukrainian Christians have endured a momentous famine, imposed on them under Stalin; they too have faced war and suffering, and even a suppression of their national identity. Christians throughout the USSR have endured persecution and harassment. Yet at every liturgy they chant the Beatitudes with a great sense of triumph—for that grand inversion that informs each blessing celebrates the law of his kingdom. The Christians in the Soviet Union can teach us Americans to be stoic in our spirituality.

Enemies or friends, the Orthodox in the USSR are as human as American Christians. Both of us have served as copies for the same icon, and both of us can show unique flaws in its execution. Just as we Americans can waver in our commitment to Christ through our fear of the enemy within, Russian Christians can be diverted from their rich understanding of the law of love by their mistrust and fear of the foreigner, the invader. Their acceptance of suffering and their ability to endure it are their greatest strengths. Their suffering in the last war was a sacrifice made on behalf of all of us. Without them, we Americans could not have won the war. If we seem to reject the gift of that suffering, if we refuse to respect their image of themselves, then they in turn may well neglect the image of God in us. They will see us, as they have seen so many in the past, as but another threat, another trial.

And the two of us—the two great nations whom God has blessed with a special and mutually complementary manifestation of himself—will be powerless to live the pledge of the gospel. The princes of this world with their court of analysts and commentators will, once more, have held off the blessed kingdom.

"Blessed Are the Pure in Heart"

The pledge of "one nation, under God" holds a certain spell over both America and Russia. For Christians in America tend to idealize a lost "Christian past," an era in which the gospel was at one with our civic purpose. And Christians in Russia still speak with confidence of a "holy Russia," a baptized nation embodying the spirit of God's kingdom. The Russian church celebrated the thousandth year of that kingdom, with great solemnity, as this manuscript emerged in 1988. Archbishop Pitirim, an accomplished scholar who is head of the publications office of the Moscow patriarchate, speaks of Slavic Christianity as one of the great "Christian visions" of the early Christian world, and clearly the church in Russia and the Ukraine nurtures an image of itself as hallowed. For both Russians and Americans, the identity of our nationhood, our collective being, is in some sense sanctified. Yet however much Christians in Russia and America wish to suffuse our nations with God's being, we must be careful of the way we express the desire. We must be careful even of the way in which we pray. The idea of "one nation, under God" will be a travesty if we seek to confine God to one nation.

The contemporary insights into the mind of the Russian church can help American Christians understand those whom they might otherwise exile from the "one mind of Christ." But more importantly, these insights might offer us the very means to live the promise of peace. Baptism is, as the early Anglo-Saxons understood it, the "bath of full being." And as we understand that our being is not limited to ourselves individually or nationally but is intermeshed and relationally defined, we will indeed extend the reign of the gospel and

hasten God's kingdom on earth. Each of us has surely in some small way seen, in precise terms, the concept of "reciprocal definition" at work. There has been someone meaningful in our lives whom we have misunderstood, disliked, perhaps even hated. Through prayer and through life in the Spirit, we have overcome the barrier that cut us off from that person. And now, years later, we understand. The barrier itself was a means by which we came to a greater understanding; without the opposition, there would not have been the resolution. And the being of that person, his or her identity, is now inextricably intertwined with our own.

God in his mystery makes our *inter*relationships the means whereby we *come* into relation with him; this is a fundamental component of "sacrament." Of two people placed in juxtaposition or opposition, he makes one the means of salvation for the other. And nations, too, can partake in that very mystery. We Christians of America and Russia, simply by reaching a greater understanding of how each of us envisions and lives the gospel, can live that gospel more fully. If we cut ourselves off from that understanding, reject it or mutilate it through our suspicion and hatred, we are turning ourselves away from God's grace.

Scripture again and again defies Western, individualist notions of responsibility. Nations, too, can sin. And it does a Christian no credit to acknowledge his or her own personal sinfulness and yet at the same time reserve as if in some bank of pride the moral superiority of his or her own nation. Christians in Finland accept as a truism what it is hard for Christians in Russia and America to fully understand: the welfare of the world rests in the interrelationship of our two powerful countries. The idea of a Christian America, like the idea of a holy Russia, is but a promise. It is our task in both nations to fulfill it, and neither of us shall be Christian or holy until we see and respect the Christianity, and revere the holiness, in the other.

The developing theology in contemporary Russia is fully "Orthodox," yet it applies that Orthodoxy in a postmodern context. And it calls upon all of us inheritors of the postmodern world to abandon certain notions that we hold dear.

The first and most important of these ideas is that of individual or national "purity," of self-sufficiency. Kireyev and Khomyakov challenged the notions of identity and definition prevalent in Western rationalism. By the end of czarism, however, the ideas they introduced had calcified: in religious nationalism *sobornost'* became a kind of parody of itself. Orthodox thinkers before the Revolution of 1917 were already reacting to this condition in the church, and in contemporary Orthodoxy in the USSR we find the outgrowth and the evolution of their thought.

The pure creatures *(katharotes)* that God wants us to be possess a purity of heart and conscience: "Blessed are the pure in heart, for they shall see God" (Matt. 5:8). This purity calls for a self-abandonment, a forsaking of notions of self-sufficiency before the wholeness, the completeness of God. Yet Christians in both Russia and America can conceive of purity differently.

Our immigrant forebears came to America and found a new model of speech imposed on them. "Good English" presumes a kind of purity of speech, "good manners" a purity of behavior. Often our "democratic models" actually imposed expectations upon our immigrants and their children which suggested that to be different was to be "un-American." America, then, promoted its own notions of political and cultural purity. It "converted" those who came, that they might be absorbed.

Russia, on the other hand, repeatedly faced invasion from without. Its faith became in itself a hallmark of national identity, so that for many centuries to be Russian was by implication to be Christian and Orthodox. "Russianness" became a function of faith itself. The Russian church in czarist times did not absorb the stranger but defined itself against the stranger.

This sin embedded within the Russian church under the czars is similar, then, to that sin which rises up like smoke from the ruins of our American "manifest destiny." American and Russian Christians alike have been convinced of their "purity." In both Christian communities there has been the presumption of an inner cohesion, a self-sufficiency. And the

illusion of moral self-sufficiency—the conviction that a single nation, a single ethnic group, a single race, or even a single gender embodies virtue—is the root of primal human sin. Russian and American Christians together have indulged in self-exaltation, and both together are now called to a mutual repentance.

Through the crucible of its sufferings in modernity, through its shedding of czarist privilege and its persecutions in this century, Orthodoxy in contemporary Russia has undergone a cleansing. Orthodox thinkers have resurrected models of dialogue and reciprocity from their own patristic sources. They have applied these models to the Christian situation in modernity, and they offer both their own church and the American church an answer to our mutual dilemma. The theological and psychological implications of "reciprocal definition" challenge our flawed notions of purity. Contemporary Orthodoxy develops its anthropological emphasis in accord with its patristic heritage. The self does not become a psychological enclosure defining one's being against all others; one's identity becomes a function of all those with whom one has entered into engagement and relation. The gospel injunction to love, then, becomes itself a call to engagement—a call to enrich even further the constituents of "self." And the call to live the gospel makes a broader claim on all believers than a call in one's private psychological life to obey the dictates of God's law. Living the gospel demands that one be a distinctly social being, that one engage one's culture in the fullest possible way.

Christians are not isolated in their faith, for their faith calls them into loving association with others. Christians organize themselves into communities, churches, and traditions not merely because such unions are inevitable. They claim those communities as the constituents of their being. It is natural, then, that Christians should value their specific communities as distinct, precious expressions of their Christian life. What is more, Christians would not be honest with themselves if they did not see their own perspectives as normative: I understand Orthodoxy to be the fullest expression of the Christian life, or I would not be Orthodox. Yet the Chris-

tian identity is also "relational." Our separate Christian identities contain the anthropological expression of our Christianity. In my engagement with other Christians I have come to a fuller understanding of what it means to be Orthodox. In engaging other expressions of the Christian life and in coming into relation with those who live them, I have fulfilled an injunction of the gospel. I have come to love the image of Christ as they perceive it, and thus I have come to know Christ more fully.

This "anthropological vision" calls me to question my former models of identity yet more fully. As a young boy I was instructed to speak "good English" and to regard other forms of language as corrupt or impure. Yet the more I learned about language, the more I learned that such images of purity were an illusion. English is a fascinating creole, taking grammatical shape under the influence of other tongues. Slaves, forbidden to speak their own dialects, nevertheless expressed the understanding and structures of their native tongues in their adaptations of English, and thus their descendants enriched the shape and texture of our language. Russian, too, is like a linguistic gumbo, with great rich chunks of other tongues and tasty bits of slang intermixed and becoming one with that delicious, normative language known as "Russian." Thus even the languages by which we identify ourselves ever change and come into being through our very intermixture.

Assisted by the Russian Christian insights that underlie "dialogism" and relational identity, Christians in the West can further alter the way in which they look at the world. The Western mind, which so values rational processes as expressed in the "hard sciences," has imagined the mind of God to be engaged in his creation. God, having created the world, sustains it as well, and Western thinkers often see the laws by which the universe operates as evidence of his sustaining power. God is manifest in "the way *things* work." Yet there are also processes by which history proceeds, by which literature comes into being, by which language is understood. Here too, surely, the Spirit is ever engaged. Whereas in looking at creation we Western Christians tend to project God *outside* ourselves—"ruling" the world, as it were—in looking at

our own interrelationships we can see the Spirit at work *within*, ever defining us in relationship to each other, ever bringing us to fuller being in himself.

Through language, for example, we come to understand each other. Yet the words by which I communicate these thoughts to you at this moment are not "my" words alone. They are the product of my interrelation with Russian Christians and the tradition that nurtures them. Insofar as these words have been appropriated by you, the reader, and processed through your understanding, they are yours as well. Or rather, they "belong" to none of us. They exist on the page as mere symbols, agreed upon but arbitrary. But in our minds they exist at the edges of our interrelation, as I communicate myself to you. You have received, imperfectly through me, the insights of your fellow Christians in the USSR. And in receiving of their minds in Christ, you have become *one* with them.

God's Word, then, becomes *ours* as well in the acceptance. In the Trinity, God is God as his own being is reciprocally given and received in the three integral Persons defined in love. That "Trinity" is the emblem of a process whereby I, in love, grow ever more fully human as I share my being with others and take in their being in response. In the life of the Spirit, I too exist not only unto myself, as a "person," but also *relationally*, as I define the "personhood" of others and in turn am defined by theirs.

The Ethics of Engagement

We Christians in both cultures, Russian and American, find ourselves embattled. Although the secular culture in both our countries has begun to realize the crisis of its own relativism, its search for a solution expresses itself in "post-Christian" terms. Secular thinkers seek a substitute for or a successor to faith. In both the United States and the USSR, Christian resolutions for dealing with contemporary issues are neglected. The legal system in both cultures defines religion in essentially "utilitarian" terms. The church, as the secular mind sees

it, is not the fullest expression of our "collective being" but merely one organization that provides a function, a service. In Russia the law sees that service as essentially "cultic" in nature. In the United States that service is more broadly conceived but still rigidly limited. Certain symbolism, behavior, and expressions proper to our faith may not be allowed in a broader secular context.

The contemporary Orthodox models of mutual engagement can help us to alter our definitions of the sacred and the secular in order to deal with this contemporary situation of the church. The solution is surely not to define ourselves in terms of the secular world, speaking its idiom, adopting its images, espousing its causes on its own terms. But to resist secular culture militantly can easily shut us off from those whom we must engage. Christians in the USSR propose a solution to our common dilemma: to carry with us our own Christian vision of the world, and to convey that vision through our images, our demeanor, and our interrelationship with others. If Christians perpetually wear a mask in dealing with the secular world, then after a time we will question which is the mask and which the true identity. But if we seek to affect that world directly, in dialogic encounter, we will inevitably influence and shape the being of those whom we engage. Our models, then, should be dialogic, for this is the model we find in the gospel.

The dialogic ethic demands that we concentrate more on relational, egalitarian models than on hierarchical ones we have inherited from previous ages. Humans are incarnational beings; we Christians express the "mind of Christ" in the world of which we are a part. If, for example, I oppose abortion, as my own tradition does and as I am called to do, I feel obliged to do so dialogically. The charge of "murder" hurled at a doctor or a pregnant young girl is confrontational; it does not enter the mind of that person in order to understand what resides there. But once I engage the ideas and values that inform the act of abortion, I can confront and expose the values of its supporters. And I will also expose the values that inform my own decision.

It is the *values* which inform the decision that we should

be engaging in our battle for human life, for peace, for social justice. Likewise, those who oppose us are right to engage us dialogically in turn. They are right to point out inconsistencies if we defend the right of the unborn to live but show an insensitivity to the life of the mother, the poor, the enemy. The validity of our position resides in its respect for God's gift of life, but it does no good if we cannot bring others to listen. As I see it, Christians should not work for "Christian-inspired" legislation before they work to build a consensus of values in the broader culture. The legal battle for Christian principles can tempt Christians, like the princes of this world, to judge themselves according to criteria of political victory or defeat. The Christian task is rather to engage in dialogic encounter in order to spread ever outward the values that inform their position.

I once met an American Christian student traveling in Russia. He was scandalized that Russian Orthodox Christians rejected the concept of "street-corner witness"—passing out tracts, confronting others with a Christian perspective. He told me that he regarded the Orthodox Church as "Communist-inspired." The student equated his own approach with "Christian witness," and attributed its absence in Russia to civil interference alone. Yet active proselytizing has never been an Orthodox approach to Christian witness. In the Orthodox perspective, one who evangelizes must engage and permeate, not assault. Proselytizing is confrontational rather than dialogic; the will that accepts Christ must be utterly and absolutely free.

The same principles by which Christians engage the world should, of course, guide their relations with each other. For when our politics becomes exclusive, we place the dictates of politics before those of God. In a complex, "relational" world, ambiguities are inevitable. Some Christians support certain reform movements in Latin America that other Christians deem revolutionary. The first task is to recognize the mind of the other: two "opposing" Christians may discover that they both seek to further precisely the same goal through opposite political decisions. The debate is then a tactical one, and it is on those grounds that Christians should conduct it.

There is something in a Vietnam vet that loves and understands a Soviet vet of the Afghan war, despite the opposition of their causes. The extent to which Christians nurture a common mind, based on the furtherance of God's kingdom and not the kingdom of this world, will promote the possibility of a future resolution. To cut another off from contact is to limit, by an act of free will, the possibilities of God's grace.

And finally, the implementation of these principles helps us to come to a new understanding of possibilities for peace. Dialogism should not cut us off from anyone who will engage us. Christians in Russia have endured legislative limitations that have allowed for abuses, false accusations, arrest, and false imprisonment. Yet the very people so persecuted have given consistent witness and shown consistent tolerance to the nonbelievers. They have rejected confrontationalism and shown a constant capacity for engagement. In Tatiana Goricheva, Irina Ratushinskaya, Viktor Popkov, Mikhail Bakhtin, Vladimir Poresh, and the many other Soviet Christians you have met in these pages, you have seen Christians who have turned the very limitations imposed upon them into opportunities for expressing the fullness of the Christian life. It is a blessed irony that those Christians who have been silenced the longest are the best embodiments of the dialogic spirit.

Christians in the West should most certainly remember those Christians in Russia who have been falsely imprisoned and accused. They should be vigilant in making public the names of any who may still be abused, in monitoring human rights, and in championing the church. They should follow carefully the current reforms in the Soviet Union and judge their effectiveness in alleviating the plight of their fellow Christians. But they should also remember the same abuses in other countries—South Africa, El Salvador, perhaps even the United States—without making of the Soviet Union a twisted icon of the beast. The dialogic ethic involves encounter. The person who seeks to understand the enemy will gain at best a friend, at worst an enemy whose threat is better understood.

The manifestations of "godlessness," wherever they occur, are not different in nature. "Godless communism" is

no more antithetical to Christianity than the godless secular-
ism that Christians in America face every day. The dialogic
ethic allows one to see, even in the face of the godless, the
very image of God. Those nonbelievers who crowd around
the Russian churches on Easter eve, drawn to the mystery—
they too are the ones who have haunted the fears of conser-
vative American Christians. In the insights of Christian Rus-
sia, we have encountered many thinkers who were once
godless. In them we may come to understand not only the
enemy but ourselves. In the shadow of our missiles, after all,
who does not live in the land of the godless?

To see ourselves as reciprocally defined and to under-
stand that in loving dialogue we engage in a God-begotten
process is to realize that the Christian mind has something to
offer the world. "Unity," a "oneness in Christ," does more than
express a pious sentiment. Christ boldly enjoins us to love,
for love fundamentally alters the constituents of our identity.
Such love is indeed his new commandment (John 15:12), for
in love is the self ever renewed. We are the product of our
interrelation. When we Americans come to understand the
Christian mind of Russia, we become intermeshed with those
whom we once feared. In the mind of Russia lies an image of
the risen Christ that American Christians seek. It is the very
icon in which Christ breaks down the gates of Hades.

This is the icon borne before the processions that wind
around Russian churches on Easter, the feast of feasts. It is
called, simply, "The Resurrection Icon," or sometimes "De-
scent into Hades." It is a familiar image—yet, like many fa-
miliar images, it eludes those who do not strain to see what
it portrays. The eyes are first drawn to Christ, resplendent
and shining. And the eyes are tempted to stop here and rest
on the brightness of his risen body. Yet the light from that
body shines not only for itself: it illuminates all that it touches.
The light is the "text" of the icon. Before Christ lie the shat-
tered gates of hell, broken and splintered at his feet like the
wood of the conquered cross. And rising toward him, hands
outstretched, two figures at opposite corners of the icon lift
themselves from the gloom. They are Adam and Eve, parents
of us all; and their faces, so long hidden in the utter loneli-

ness of darkness, now shine in the sun of the Uncreated Light. Around them rise also the hosts of the prophets and saints and fathers and mothers of the Old Testament. The light draws a multitude out of the shadows of death.

This icon shines out from the Christian mind in the darkness of every age. And in this generation Christ rises to break down the gates of our own hell—the hell of our own self-enclosed and self-absorbed individualism. The Uncreated Light illumines us, as he illumines Adam and Eve and all who come after. He awakens us into a discovery of the community drawn to his brightness, the "collective" and Spirit-permeated self to which we belong. Yet how persistently the darkness can hold us in isolation—suffocating and humid, almost palpable, as if it had the real "substance" that medieval commentators attributed to it. The gates of such a hell are strong.

In the army I heard a barracks story in my unit. It wasn't verified, but it was passed around a lot. There were three burned guys who had come back from Nam. They had gone through the process of enduring and healing their wounds— the excruciating pain, the surgeries, the adjustment to a new image in the mirror. They finally went, on a pass, to a restaurant together. They picked a really upscale place, complete with waiters, tablecloths, and little tables nestling near plate-glass windows facing the street. The management refused them service. Their scarred image, it seems, was "troubling" for the clientele. Those guys, as the story went, trashed the place—decked the waiters, overturned serving carts, hurled tables through the glass. And in our hearts, each time the story was told, we cheered them.

For a long time the American people refused to encounter the image, their *own* image—the one they had wrought—in their returning veterans. Then they made new ones, cleaner and more titillating, from hired hands and celluloid, and they paid to see them at the movies. They preferred false pictures to the mirror.

Then one day I saw Oliver Stone's *Platoon*. On the screen I saw images that were faithful, icons I could recognize. There was one character in particular who drew me. Who was it that this guy reminded me of? Who was it—I struggled to sift

through my memory, shuffle through the portraits of medics who had served with me, the faces of GIs on stretchers and on pillows. I struggled to restore that whisker-shadowed face from my past. Then suddenly it struck me. It wasn't a vet at all. The face was the *actor's*. This was Ivan, Ivan Kane. A student I'd taught, a kid whose papers I'd corrected, whose expressions I'd helped to shape. It was *him* up there! And through him, I was seeing a truth I had longed to see for twenty years of my life. Through his acting, he was faithful to a kind of suffering. And through one whom I had had a small part in shaping, I was able to see a part of my own past redeemed. There was a kind of joy that seized me even as I wrestled with my freshly remembered grief. That is what it means to be reciprocally defined.

If we hate and distort the Russians, we will nonetheless be shaped by them. If we look to their believers in an effort to fathom their life in Christ, we will be shaped as well. The first option will scar us even as we despise them; the other will make us free. We are like the citizens of the old Russian city of Novgorod, the ones who loved the icon of the mother of God yet portrayed her as she blinded the advancing soldiers of the enemy. Yet the real blindness—the blindness to God's all-encompassing mercy—was only their own. We humans are images of our Creator. In refusing to revere him as he manifests himself in each of us, enemy and friend, offender and offended, we "flaw" his creation. We then become what we produce—distorted icons. And only in the Spirit of our oneness, our reciprocity, can we be restored.

One day those many years ago during the spasm of my life when I was an army medic, I stopped at the back of the army hospital at Fort Sam Houston for a smoke. It was a hot San Antonio night, and after a bone-crushing day of training I longed to be left alone with my self-pity. The cricket chirps seemed to rasp in a scream. How could this be only the beginning? I wondered.

I sighed to myself as I saw a vet patient approach in the darkness. In the shadow of the dumpster, he offered me a light. His match flared, and its cruel instant of clarity etched the kind of face just beginning to grow familiar to me. He still

had a lot of reconstructive surgery to go through. The lava of his scars spilled down his cheek and over his jaw. It was napalm's kiss.

We smoked in silence for a moment, and he studied my unmarked face as the scarred often did. I looked away with the unease peculiar to a novice medic. Would he notice I wasn't looking—or should I look?

But he wasn't paying attention to what I was thinking.

"They tried to do it to Charlie," he said, using the familiar GI slang for the Vietcong. He said it without emotion, as if he were talking to himself.

Then, after a drag on his cigarette: "But they did it to me instead."

Let napalm and the bomb once more force upon our reluctant minds a fundamental insight. Whatever we seek to visit upon the enemy in our anger, our fear, our frustration—we will also visit upon ourselves.

We are Christians. We cling to hope. The icon of the risen Christ shines out from the land of the enemy we have most feared. If its brightness draws us close, we can see ourselves in its light. We are all veterans of a lost war. Twisted by our hatred, shrouded in the darkness of our fears, God's image has been distorted in us. Wounded and scarred, we have imagined ourselves into a terrible loneliness. But now believers who have endured all the sufferings of modernity show us how to heal our minds of the cuts and slashes of an unrelenting empirical rationalism. They can help us feel a confidence in our own Christian thought. The Christian intellect is united in the bond of the Spirit. It is bold. It is full of power. It restores mystery and community and beauty as central concepts among us.

The illuminating icon of our incarnate God flashes out, and we see ourselves and others in its Uncreated Light. Its energy is born in love, not love as a pale sentiment but love as an integrating and unifying force that challenges the limits of the "self." All the cosmos, every atom of flesh and earth and water, is charged with holiness. It surges through creation

as we cooperate with our Creator in sharing it. Let that icon draw us deep into the mystery of a shared life in the Spirit. Let it burst the gates of hell. When we see and revere God's image in the face of the enemy—only then will we find God in ourselves.